CELTIC

CELTIC

DESIGN AND STYLE IN HOMES OF
SCOTLAND, IRELAND, AND WALES

DEBORAH KRASNER

Photographs by Ken Kirkwood • Foreword by Jan Morris
Design by Kathleen Herlihy-Paoli

VIKING
STUDIO
BOOKS

VIKING STUDIO BOOKS
Published by the Penguin Group
Viking Penguin, a division of Penguin Books USA Inc.,
375 Hudson Street, New York, New York 10014, U.S.A.
Penguin Books Ltd, 27 Wrights Lane,
London W8 5TZ, England
Penguin Books Australia Ltd, Ringwood,
Victoria, Australia
Penguin Books Canada Ltd, 2801 John Street,
Markham, Ontario, Canada L3R 1B4
Penguin Books (N.Z.) Ltd, 182–190 Wairau Road,
Auckland 10, New Zealand

Penguin Books Ltd, Registered Offices:
Harmondsworth, Middlesex, England

First published in 1990 by Viking Penguin,
a division of Penguin Books USA Inc.

1 3 5 7 9 10 8 6 4 2

Grateful acknowledgment is made for permission
to reprint *Passing the Time in Balleymenone:
Culture and History of an Ulster Community,*
by Henry Glassie. Copyright 1982
by the University of Pennsylvania Press.
Reprinted by permission of University of Pennsylvania Press
and The O'Brien Press, Dublin.

ISBN 0-670-81849-6
CIP data available

Printed in Japan
Set in ITC Galliard and Caledonia

Thank you to the musicians who play Celtic music,
which inspired and sustained the work on this book,
and thank you to my family,
who danced to that music with such joy and grace.

This book is dedicated to those dancers:
Michael and Abigail and Elizabeth.

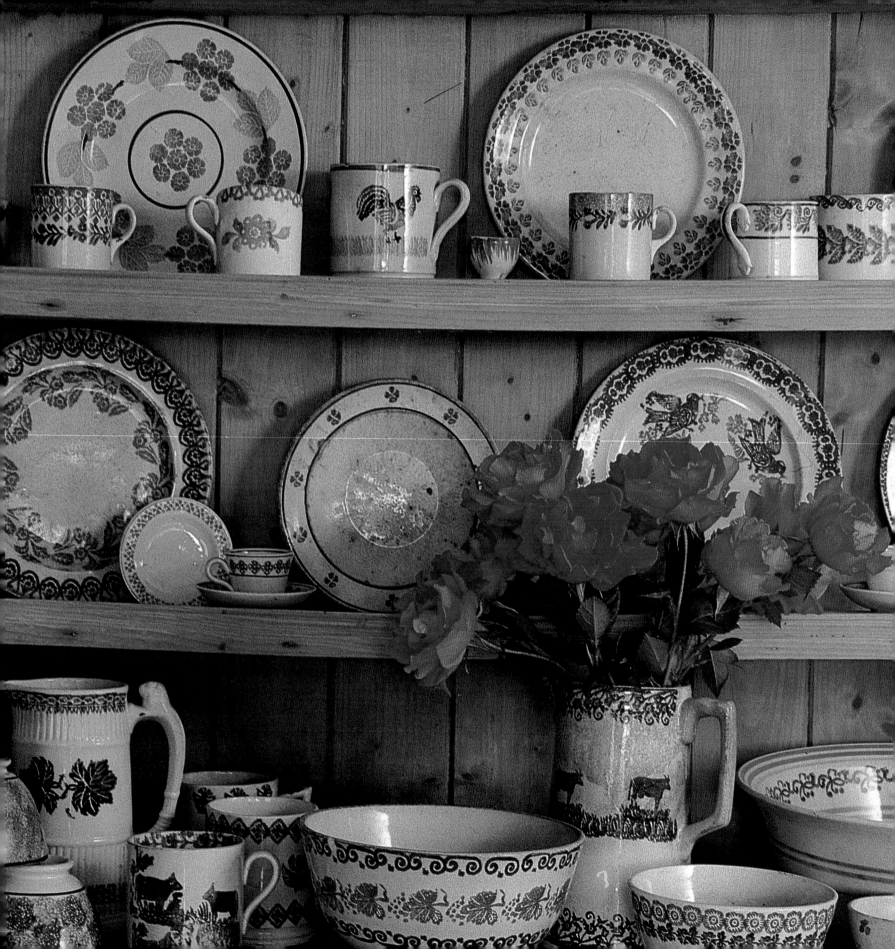

CONTENTS

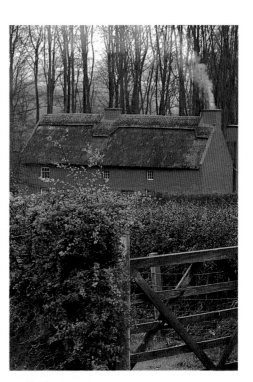

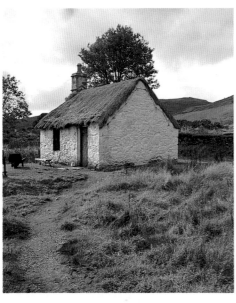

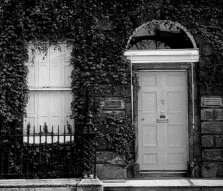

FOREWORD

onderfully evocative is the idea of the Celts, those high-spirited, vainglorious, horse-loving, poetical people who inhabited much of Europe before the rise of the Roman Empire. With their Druidical mysteries and their elaborate art forms, they reach down to us with a compelling allure from the far reaches of time. Their arcane devices appeal instantly to all lovers of the transcendental. Their reputation for panache is perennially attractive. Celtic craftsmanship in gold and bronze is peculiarly thrilling, and the image of the Dying Gaul, indomitable even in death at the hands of less beguiling conquerors, can touch the romantic heart still.

The territories of the Celts once extended from the Atlantic to the Black Sea, from Ireland and Spain to Turkey and Rumania, and similar tastes and attitudes are apparent wherever they have left their relics. Today their world exists only in the westernmost parts of old Celtdom, in those countries along the Atlantic shores of Europe popularly known as the Celtic Fringe. Celtic languages are still spoken there. Celtic characteristics still show, and one may identify a building style that can justifiably be called a Celtic vernacular.

Nowadays, though, that vernacular is not flamboyant at all but essentially simple, showing its origins only in the line of a cottage, the shape of a farm, rough-hewn masonry, or elemental patterning. It is as though all that was showy or symbolical in the Celtic tradition has been subsumed by time, leaving only the fundamental matter below. The woad-painted horsemen have galloped away, the Druids have left their mistletoe groves, but the tough instinctive roots of their culture have remained embedded down the centuries.

This book deals with three principal regions of the Celtic Fringe, all within the British Isles. In these countries, far from Rome, the Celtic foundations of life were never destroyed, but history built upon them superstructures of quite different kinds, as Vikings, Saxons, Normans, and Englishmen variously imposed their dominions and their manners upon the Irish, the Scots, and the Welsh. It is not just a book about a Celtic style; it is about styles that have developed in a Celtic environment—not only the indigenous underlying strengths of farms and cottages, but Palladian splendors, Georgian elegances, modernist innovations, and imported graces of many periods and many kinds.

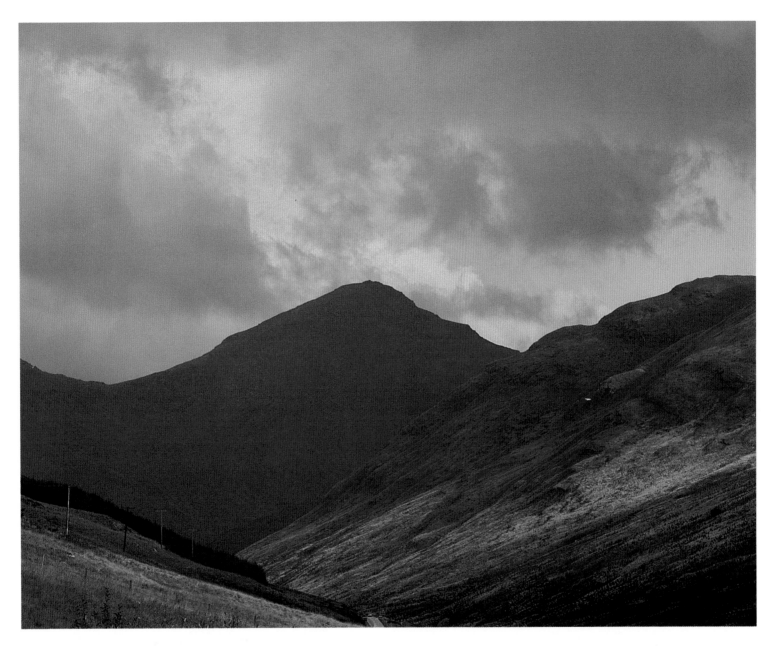

The buildings in these pages, then, run the gamut from truly organic innocence to utterly alien magnificence. What they have in common is this: that they are set in ancient homelands of the Celts, that they generally share some sense of immanence and continuity, and that in architectural and domestic terms they represent what has happened to one of the most fascinating and formidable of all the civilizations of antiquity in the last territories of its survival.

—*Jan Morris*

ACKNOWLEDGMENTS

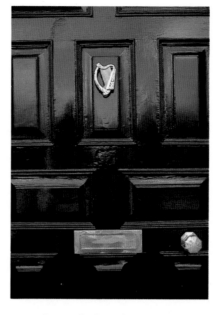

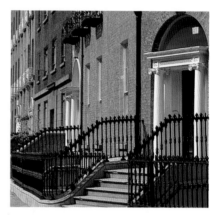

esearching this book has provided an unexpected and joyful lesson in the warmth and near-limitless extent of Celtic hospitality. To all those who opened their doors, showed me their homes, and spoke freely of their relationships to them, I offer many thanks. To all those whose houses were finally used in this book, my thanks are even greater still.

So many people that I met in the course of my travels were outstandingly generous with their time, teaching, hospitality, and friendship. In Scotland, thank you to Mike Gonzales, Mae Boyd, and their daughter, Rachel; and thanks to Lisa Davidson, a great mate. For their many good ideas, contacts, and help, thank you to Janet Barnes, Ian Gow, Juliet Kinchon, and William Buchanan.

In Ireland, I am especially grateful to Mary Ryder—thank you for all of your help. Thank you too, Maria Rogan, for your tireless driving and companionship. A very special thank you to Myrtle Allen for providing me with the wonderfully hospitable experience of Ballymaloe House. Finally, I am obliged to Patrick Scott and Elizabeth Mosse for their help.

In Wales, thank you to Jill Morgan, Gwenda Griffith, Sioned Llewelyn and friends, and a very big thank you for all kinds of help to Dafydd Elis Thomas, M.P., and Marjorie Thompson.

This book would be less than it is without the invaluable help and support provided by the British Tourist Authority, the Irish Tourist Board (Bord Faílte), the Northern Ireland Tourist Board, and the Wales Tourist Board. Thank you all so much:

your knowledgeable assistance and practical help greatly aided the research for this book.

I would also like to thank Aer Lingus, British Airways, and DanAir for their support.

I would like to take this opportunity as well to thank the folk museums for their gracious permission to allow us to photograph a representative cottage in each region of this book. Thank you to: St. Fagan's, Welsh National Folk Museum; Ulster-American Folk Park; and the Auchindrain Folk Museum. We gratefully acknowledge permission to photograph from the Mackintosh House, Hunterian Art Gallery, University of Glasgow.

For making the locations sing, my thanks go to Ken Kirkwood for the superb pictures. And, for her careful and extensive help in coordinating the photography, thank you to Margaret Kirkwood.

The Kirkwoods and I are extremely grateful to Colin Loader and Charlotte Wylie at Metro Photo Lab, London, for their skill, diligence, and attention to detail in processing the photographs of this book.

I am grateful to Kathleen Herlihy-Paoli,

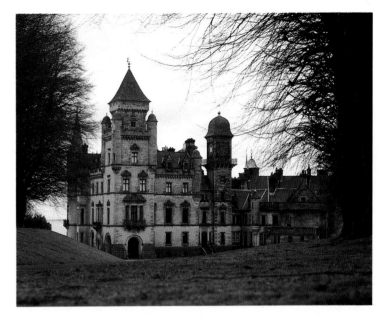

who understands the rich texture of Celtic living, and has made it manifest in this book.

Here in Vermont, so many people in my community have been generous with their time, help, and enthusiasm. I can't name all those whose interest and excitement have cheered me on, but I do want to take this opportunity to thank them. Special thank yous are due to Lawrie Brown for all his help, and to Martha Litch for lending me her Irish books. Thank you also to the reference librarian at the Brattleboro Library, and to the patient librarians at the Southeast Vermont Regional Library, who have been tireless in their pursuit of interlibrary loans. Farther north in Vermont, Simon Pearce kindly gave me a wealth of personal contacts in Ireland for which I am indebted.

Michael Fragnito of Viking Penguin has encouraged me for some years, and it is thanks to him that I have finally published a book, one which I hope will justify his trust. Thank you, Barbara Williams, for editing this manuscript with warmth, tact, skill, and panache. Thank you, Roberta Pryor,

for your support and loyal representation.

Many authors have informed me. I am most grateful to the works of Christopher Alexander, Kevin Danaher, Henry Glassie, Jan Morris, John Prebble, and Raymond Williams for their eloquence and scope. I am responsible for any errors of fact or interpretation, but these writers provided towering examples of passionate reflection on people, homes, and cultural identity. It is their work which has enabled me to enlarge upon the context of the interiors of this book.

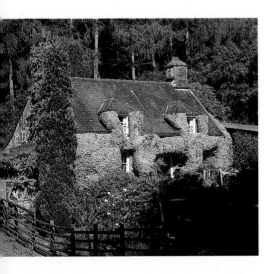

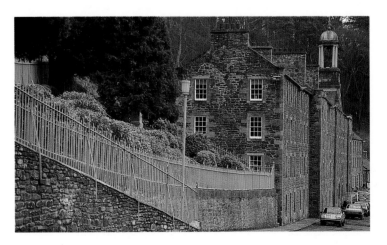

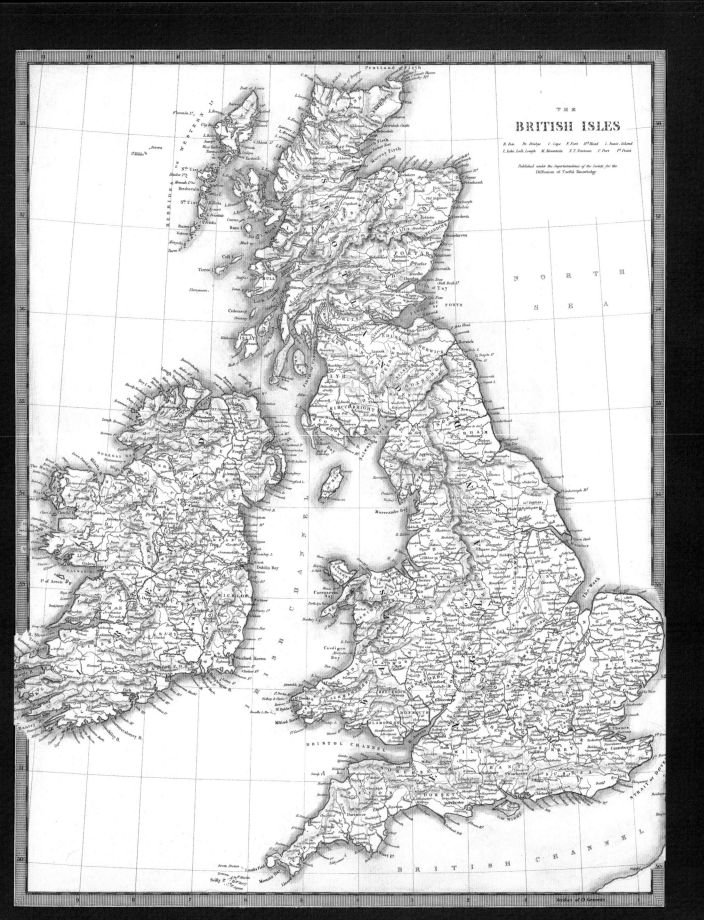

THE
BRITISH ISLES

B. Bay. Br. Bridge C. Cape F. Fort Hd. Head I. Innis. Island
L. Lake. Loch. Lough M. Mountain N.T. Newtown P. Port Pt. Point

Published under the Superintendence of the Society for the
Diffusion of Useful Knowledge.

NORTH
SEA

HEBRIDES OR WESTERN I.

BRITISH CHANNEL

BRISTOL CHANNEL

BRITISH CHANNEL

INTRODUCTION

I have on my desk two postcards, one from Ireland and one from Scotland. They each show a portion of a cottage facade—part of the front wall, a window, and a doorway. In one, the wall is made of bumpy stones overlaid with rough whitewash; the door is painted yellow within a precise white frame. The edges of the stones that frame the doorway are neatly set and dressed, sharp and true, and they make a straight edge that casts a clean-lined shadow. It is Scotland.

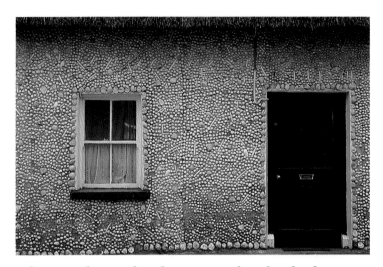

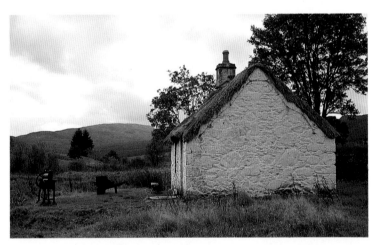

The second photograph was taken from a vantage point slightly farther away, and the line that marks the union of the cottage to the earth is just visible. It is soft and wavy, that line. The bottom edge of the wall slopes as it travels from the corner of the house toward the doorway. The whitewash on this house is also fresh, but it is softer and disguises less the stones underneath; perhaps it is thinner. The slightly worn wooden door is painted a muted green, the front step slopes lower in the center, and the stone edges of the doorway and window openings are curved and soft, almost melting. It is Ireland.

Welsh cottages are different still. Long and low, often unwhitewashed, their gray rocks speak to the earth they emerged from without major change.

Uncluttered by added color, decoration, or artifice of any kind, beyond the usual additions and accretions that long use and changes in circumstance require, these valley-loving longhouses nestle into sides of hills, or shelter below mountains in strings of lowland settlements.

Such stony contrasts of straight and upright, soft and undulating, bare and ground-hugging—they tell us a great deal about the landscape and natural resources of the regions they arise from, as well as about the people who built them and live in them. Traditional or vernacular houses like these do not just sit in the landscape, they grow from it, out of it, the plentiful and malleable materials of landscape becoming re-formed into the materials of shelter. And the forms that such shelters take are in turn a reflection of those materials, of what is possible; as well as a distillation from practical experience of how best to respond to and work in union with landscape, climate, and culture.

The Celtic regions of Scotland, Ireland, and Wales lie on the periphery of England. Their natives, even if they are British by rule, tend to define themselves as Scots, or Irish, or Welsh. They conceive of themselves as inheritors of independent cultural traditions, as members of a separate nation, as a people whose history is importantly different from, although intimately connected with, that of the English.

The physical configuration of these regions also reflects their relationship with England. The two portions that are British without a great deal of violent strife, Wales and Scotland, are physically connected

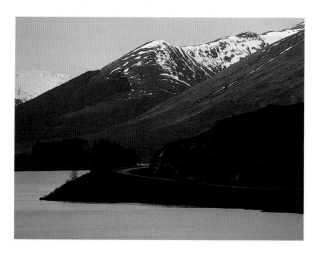

Scotland, Ireland, and Wales, then, together with the Isle of Man, Cornwall, and Brittany, are referred to as "the Celtic Fringe," those regions/countries/nations that are (except for the Republic of Ireland and Brittany) part of Great Britain, but not of its center. The common threads of their Celtic identity are expressed in a variety of ways. Psychologically, they arise from different political and economic conditions that throughout each region's history have led to shared preoccupations with themes of attachment, exile, emigration, and return. Further, Celticness is sometimes expressed in terms of a relationship to one of several Celtic languages, whether they

to England. Scotland's long and outstretched landmass comprises the northern end of Great Britain, scattered with out-islands to the west (the Hebrides) and the far north (Orkneys and Shetlands), its border with England marked by the Roman-built Hadrian's Wall. Wales projects west from central England, its sole contiguous eastern border marked by portions of the Usk, Wye, and Severn rivers. To the north, south, and west, Wales ends in a grand series of coastal whorls, cliffs, beaches, and inlets.

The divided and torn island that is Ireland lies separate from Britain, although its parts stretch toward the other two regions of this book. The Irish coast from Dublin to Cork is easily accessible from Wales by boat; the northern and eastern coasts of Northern Ireland reach toward Scotland's western shore.

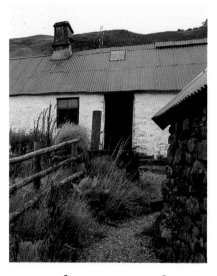

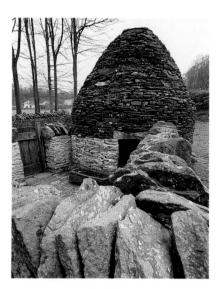

be called Irish or Erse, Scots Gaelic or Welsh. Celtic language is an expression of separate nationhood; it is a tie to an ancient history and tradition. Its use varies within each of these regions, as well as among the regions of this book. Historically, the use of Celtic language has reflected the vigor of a nationalist movement. In all three regions, there were periods in which native language was outlawed and driven underground, expressing, as it did, opposition to English domination.

Another aspect of the regions' independent nature can be seen in the development of native literary, architectural, spiritual, and social forms. In each region,

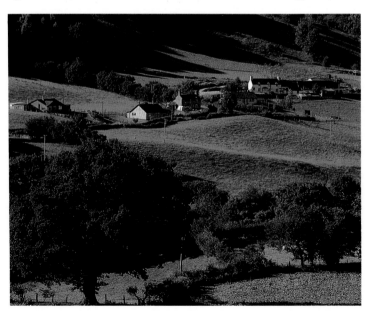

succeeding waves of incomers, particularly Norman and later English, have left their mark on nearly every one of these traditions.

This book is both a look at how domestic architecture and interiors reflect the status of these regions as cultural (and, in the case of the Republic of Ireland, as political) nations and an attempt to provide a social context for those homes and the lives people lead within them. The houses here were chosen for their cultural expressiveness, visual presence, and sense of place. There are other and outstanding books that examine the many notable castles and manor houses of some of these regions. Although I have included some compelling examples of such homes as well as some newly constructed or renovated structures, this book grew out of a desire to show how the traditional and vernacular buildings of these regions have been transformed over time. These buildings are the unselfconscious voice

of Celtic cultures; they are vital expressions of a sense of place.

As an American writing for an audience assumed at least in part to be unfamiliar with British history, I have selected somewhat varied perspectives from which to frame the concept of Celticness. Each regional section looks at similar material in a different way, in hopes that these particular points of view will together imply a wider frame of reference. Thus, Scotland's chapter focuses primarily on economic, geographical, and literary forces that shape our view of her history. Ireland's chapter is a brief architectural and social history that contrasts the life within vernacular cottages to the designs developed by the gentry. Wales' chapter focuses mostly on history, language, and culture in an effort to illuminate that region's independent spirit and resistance to English domination. Because many of the forces examined in one section also apply to the other regions of this book, I hope that what is detailed in one place will be seen as background in another.

As must be obvious by now, the term "Celtic" is used here as a regional designation. This book is not an exploration of the "Celtic revival," that late-nineteenth-century surge of interest in Celtic traditions of literature and form; nor is it an examination of the ancient and now nearly lost smoke-filled "black" houses of the Celts. Rather, it is a close look into some homes in these Celtic regions, in hopes that the interiors will delight the eye as well as illuminate their physical and cultural context.

The idea for this book came to me while I was listening to traditional Celtic music, imagining a *ceilidh* by a turf fire. (*Ceilidh*, pronounced "kaylee," is an evening spent with neighbors around a hearth, telling stories and singing.) I hope the spirit of *ceilidh* informs this book, and that the homes pictured here provide a visual counterpart to that rich and resonant ritual.

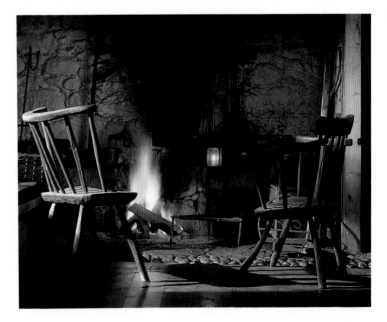

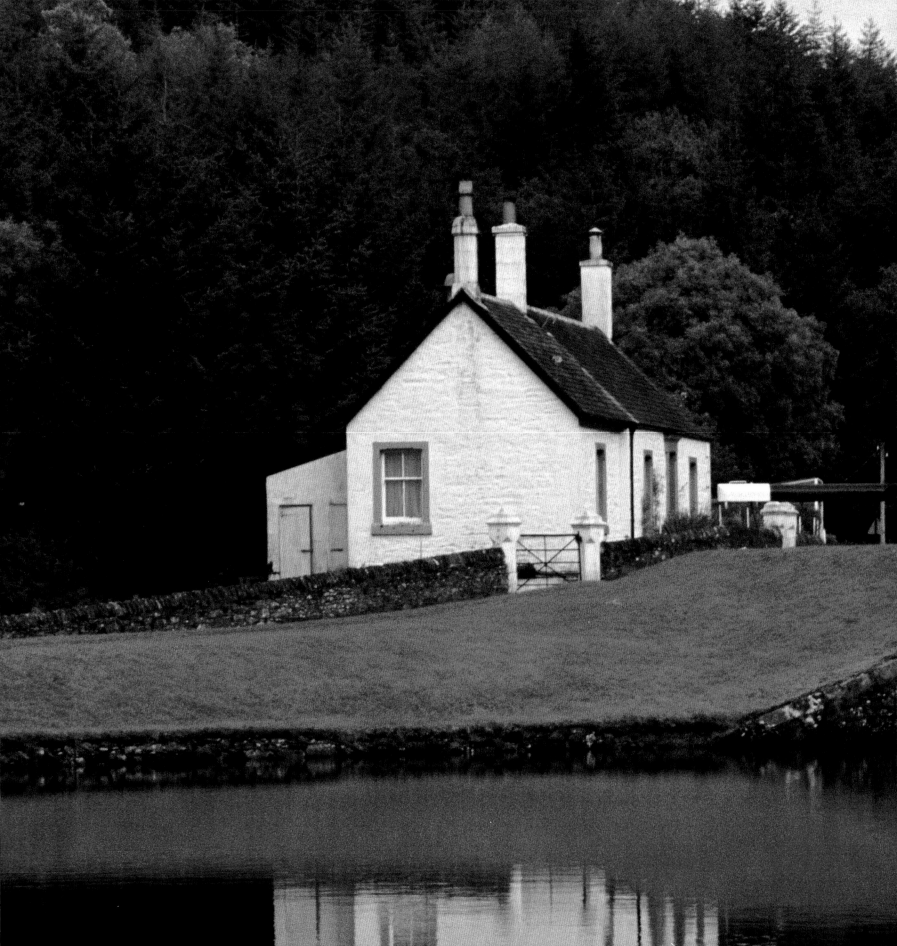

Scotland
Alba

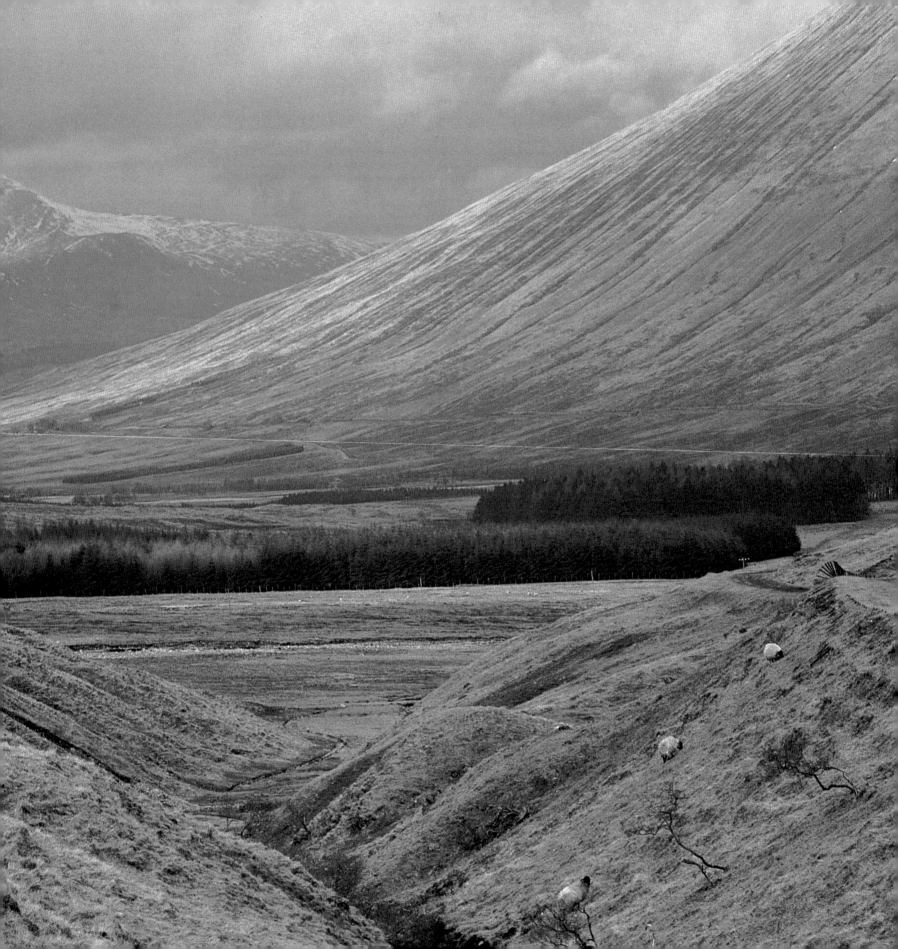

SCOTLAND

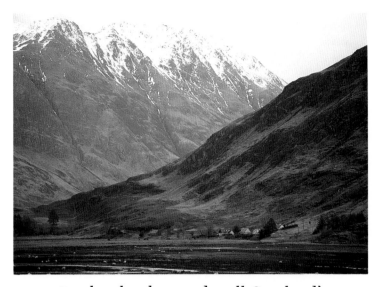

The landscapes of the Celtic Fringe are justly famous for their beauty. Scotland's mountains, glens, and lochs, set in a sparsely treed green, allow one to see for many miles. In rural places, heather and bracken glint through the mists, or glow under the frequent rainbows. The land rises and dips, flowing to lochs that provide habitat for the salmon for which Scotland's smokehouses are renowned.

In the north, widely scattered small white cottages hug the flanks of hills that are remarkable for their emptiness. Along the west coast, small communities linked only by vast stretches of empty landscape cluster in patches along the coastline. Across the water, bits of land hump up on the horizon, marking the islands of the Inner Hebrides, where people still lead isolated lives prescribed by weather.

In the south, where Scotland's two most important cities, Glasgow and Edinburgh, lie, the land is flatter, veined by rivers moving to the great ports that gave rise to those cities' industrial and financial bases. And farther south still, the land softens and gentles its way to the English border, merging with the extraordinary landscapes of Northumberland under a never-ending sky.

The landscape and the buildings upon it, closely observed, tell Scotland's story: to travel the Scottish landscape is to see a huge area devoid of trees that was once deeply forested. Starting from the border regions in the fourteenth century, when the English often put the torch to the enemy's land as well as to his crops, through to the Union of Crowns in 1603 (from which point English industry was fueled by Scotland's timber), the land became progressively denuded and devastated. Because timber was scarce and stones plentiful, house forms evolved to best use the materials at hand. From the earliest wattle-and-daub or circular stone beehive huts, such as those built on the island of Iona in 563 by the Irish missionary monk Columba; to the long, stone one-story houses with integral barns or byres (known in Scotland as "but and ben" and brought to the Orkneys and Shetlands by Vikings); to the cruck-framed houses built well into the beginning of the nineteenth century, which

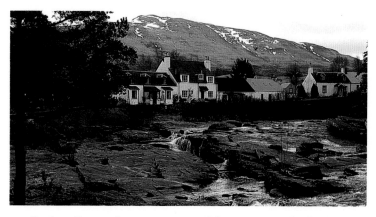

used precious wood only for the roof supports; the materials and architecture of these homes express the culture, resources, and living conditions of their makers.

In the now barren and nearly empty Highlands, where sheep are most often the only living creatures visible upon the landscape, small and extremely isolated whitewashed stone cottages or the occasional grand home of a vast feudal estate can sometimes be seen. The pattern of isolated housing that is so curiously characteristic of the northern Scottish landscape was created by a series of events called "the Clearances." This sad chapter in Scotland's history, which lasted through much of the nineteenth century, entailed the deliberate destruction of the clan system of communal tenancy, the reestablishment of feudal rights of ownership, the flattening of ancient villages, and the forced eviction of human inhabitants in favor of sheep.

The Clearances came about when absentee owners of vast Highland estates realized it was more profitable to rent land for grazing for the new and hardy breed of Cheviot sheep than to allow the small farmers to continue to use it for crops. Without regard for the attachments Highlanders had for land farmed by their families for generations, owners evicted their clansmen on short notice, without provision for adequate shelter or alternative means of livelihood. Houses were razed and precious wooden roof supports burned before their owners' eyes by representatives of the landlord; the aged and infirm were forcibly removed from those houses and left to lie on the ground. Sometimes people spent whole winters living in holes or in the lee of gravestones. Some inhabitants were removed by "benevolent" landlords to infertile strips of coastal land, where they were told to become fishermen. Others were forced onto ships bound for the New World, traveling against

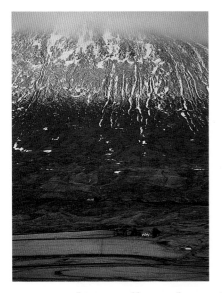

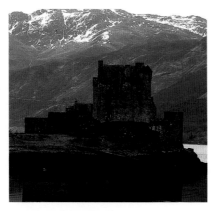

their will, without family, friends, or community, in ships whose conditions were compared to those of slave ships.

Today the Highlands' rolling and unpopulated countryside is still owned by two or three major proprietors. Now the largest source of income is from tourism, but the emptiness of the unoccupied landscape can still be overwhelming. It is this forced abandonment that was the source of so many of those emigrations of which Scottish stories and songs are full, beginning with that most famous of all Scottish songs, "Loch Lomond."

In the south of Scotland, the course of development was profoundly different, in that climate and geography promoted the growth of cities. In Glasgow's case, the industrial base of the city was formed first by its port and position on the great Clyde River. This provided the setting for the growth of the tobacco and shipping industries, followed in the nineteenth century by the growth of shipbuilding and the emergence of the steel industry. These industries glorified Glasgow as an industrial

center without peer (a reputation so firmly entrenched that it persists today, in spite of Glasgow's visible industrial morbidity). A close look at the names of Glasgow's impressive mansion-lined streets, such as Virginia Street and Ingram Street, reveals that they were named in honor of the tobacco industry and its barons. These barons were also linked with Northern Ireland, through trade connections as well as through family.

The vigor of Glasgow as a port with worldwide connections had a profound effect on the fine art, architecture, and decorative arts produced by its natives. For instance, the nineteenth-century French-invented jacquard loom was first used on a commercial basis by the handweavers of the nearby southern Scottish city of Paisley. The shawls they produced, based on Kashmiri-Indian designs, became famous throughout

the world. In spite of the fact that the Paisley weavers were by no means the only manufacturers of these shawls, they made the name of their city synonymous with a pattern whose popularity endures today.

Similarly, close study of the sinuous grace of Glasgow-style art nouveau, as created by anonymous masters of decorative arts and architecture as well as by such notables as architect Charles Rennie Mackintosh and painter James McNeill Whistler, show their debt to the conventions, forms, and colors of Japanese prints, brought back to Glasgow by trading ships.

creation of that vertical style of building known in Scotland as tenement flats.

Tenement flats are apartment houses or blocks of flats organized around central tiled "closes," or halls. Nineteenth-century tenements for workers often consisted of one room, lived in by a whole family and, perhaps, a lodger or two, with sanitary accommodations relegated to the yard behind the building. But tenement flats for the middle class were often large and extremely well appointed, fitted with luxurious bathrooms, large kitchens, and many built-in box beds. Glasgow's impressive housing stock, with large, affordable flats still available to the middle class, owes a great deal to the tenement builders.

Glasgow today is a city with an intense and sophisticated cultural life, a place of grandly proportioned flats and houses, still a city of collectors. Galleries, auctions, shops, and street markets flourish. Although much has changed in the last thirty years, and it is no longer possible to buy a Whistler "for a

In spite of the vitality of the city, its expansion was limited by the proximity of surrounding feudal property as well as by large plants and factories on the edges of the city. These limits combined to encourage the

song" at one of Glasgow's auction rooms, some remnants of that trading fever can still be seen in private homes, and in people's attitudes toward collecting.

Scotland's other great city, and its financial center, is, of course, Edinburgh. It is a grandiose city, a city of a confident and Anglicized bourgeoisie that has been linked directly with England through banking, commerce, and trade from the 1707 Act of Union to this day. It is also a very beautiful city, thanks both to geography (the Old Town) and pioneering town planning (the New Town). The Old Town, built around a castle high on a hill, exudes a romantic charm, while the New Town is possessed of an unmatched elegance.

The New Town was planned— strict rules limited house heights and distance from the street, and specified a consistency of building materials and color. Happily, the crescents, squares, and wide streets of the New Town are even more livable today than they were at their inception in the late eighteenth century. Robert Adam, one of the most famous of all Scots architects, son and brother of two other great architects, was responsible for both the interiors and exteriors of some of these notable structures.

Some Edinburgh dwellers also contributed to a sentimental revision of Scotland's heritage. Reveling in the beauty of the New Town, now populated in part by English-educated absentee landlords of cleared or soon-to-be-cleared Highland estates, and by a newly rich, urbanized, and upwardly mobile middle class, they had become so comfortably Anglicized that they were entertained by and reeducated through a fictive national history found in the novels of Sir Walter Scott. These novels (which even today influence outsiders' picture of Scotland) presented a glorified and heavily romanticized view of the Highland chief as noble savage clad in a kilt. They prompted a fashionable trend toward "Highland" entertainments, in which some members of the class that had destroyed Highland society

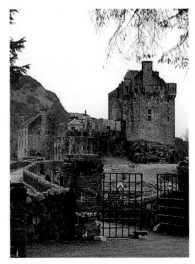

pretended to *be* Highlanders within the opulent drawing rooms of Edinburgh.

In contrast to these compelling fictions, Scotland, like the other regions of this book, had a bardic tradition in her native tongue. The last accessible remnants of that tradition are found in the poems of Robert Burns.

Sir Walter Scott, although he was an admirer of Burns, and thought himself a nostalgic Scottish literary patriot, neverthe-less by his example and great popularity sent novels about Scotland out of the mainstream of Scottish literature and firmly into a substream of *English* literature. Scott, of course, was not the only one responsible for suppressing native literary traditions, or for creating Scottish myths—such celebrated literary forgeries as *Fingal*, which pretended to be authentic Celtic poetry by Ossian, was an early example of the same phenomenon.

While Scott, among others, shows the riskiness inherent in mythologizing national character, there is an important and not-to-be ignored element in Scottish concerns and behavior that has had a profound effect on architectural as well as social history. It is a straightness, like the clean-lined cuts that edge the stone wall of the cottage, a consistency of both intention

and result that is a legacy from precepts and traditions of Scottish Presbyterianism, which holds rigorous notions of right behavior, action, and belief. It is often expressed as a kind of idealism.

Scots also hold a most significant and important sense of respect for intellectual invention and experiment. This philosophical and somewhat utopian bent (albeit through a kind of canny as well as benevolent capitalism) led not only to the creation of a series of settlements for workers on the outskirts of Edinburgh's New Town but also to such architectural/industrial/social experiments as New Lanark. Designed by owner-entrepreneur David Dale as a centralized mill town and worker village

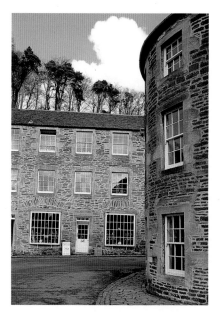

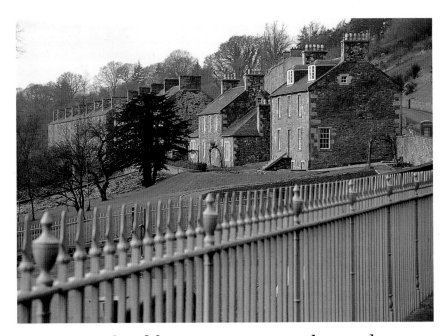

populated by as many as two thousand workers in a valley at the headwaters of the Clyde, it was an innovative experiment in human engineering. In the early part of the nineteenth century, Dale's son-in-law, social theorist Robert Owen, created such worker-improving embellishments as an Institute for the Formation of Character and his well-known School for Children.

Today this tradition of respect for utopian forms and tolerance of idealistic motives is still very much alive. It is reflected, for example, in the continued legal existence of the Faslane Peace Camp on Gare Loch, site of a Polaris submarine base. It is the only local council-approved (and therefore permanent) peace encampment in all of Great Britain, and although there are many Scots indeed who do not agree with the protesters, there is a strong conviction among them that

this visible dissent must be allowed and even assisted by protection of law.

Today Scotland is both "North Britain" and not. North Britain she is in terms of language, membership in Parliament, taxes, and (most would say) present-day architecture and culture. And yet Scotland is also very much a separate place. You feel the border even if you don't notice its markings. The air seems to sharpen, the accents begin to shift, there is a kind of pride, a confidence, that shows in a glance. And although many of the shops on the High Streets are branches of English giants, what is sold within them is often different. Scotland publishes her own newspapers, and they reflect a more liberal point of view than those of the south. Laws governing religion, education, and social welfare are Scottish laws, invested with sovereign independence since the Act of Union, and those who wish to litigate those laws must train in Scottish universities. Scottish folk music, perhaps the most direct inheritor of the Celtic tradition left today, thrives in traditional form as well as in new and original incarnations. And the legacy of the myth of the Highlands also persists in the Games and convocations that mark the summer calendar, as well as in the tartan-wrapped toys of the tourist shops.

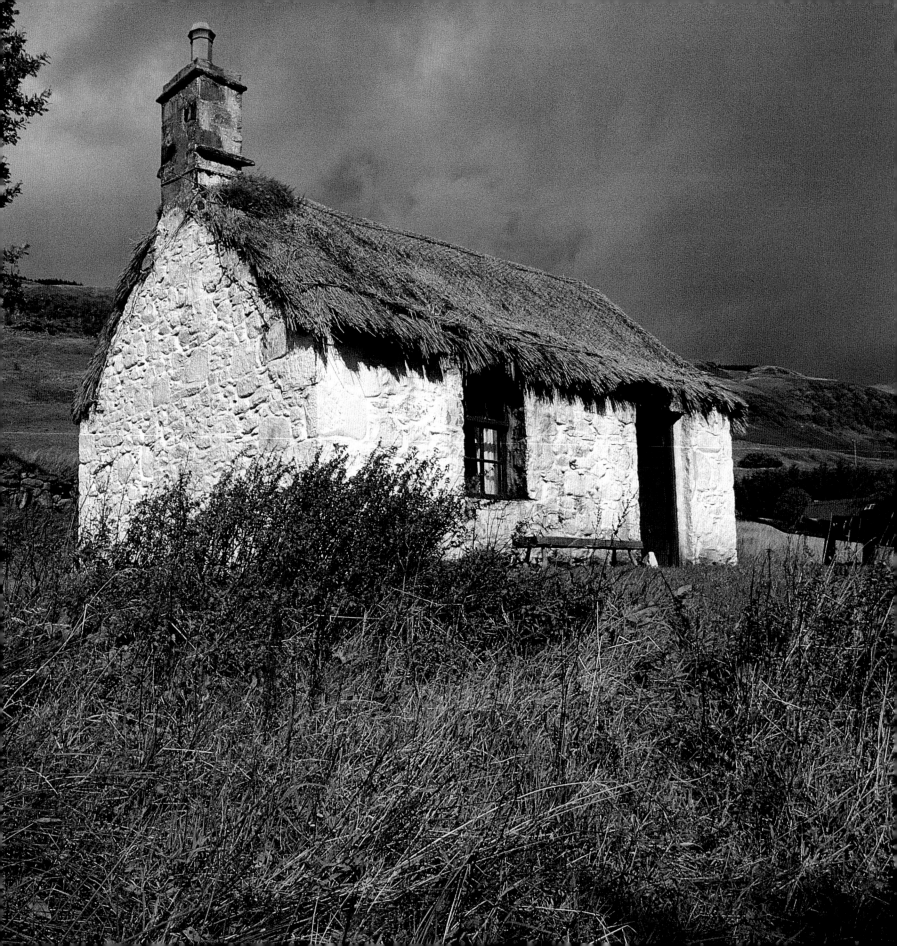

WIDOW'S COTTAGE

Prior to the mass evictions of tenant farmers, known as "the clearances," Highland communities consisted of clusters of houses. These aggregations were different from villages in the English sense, as they were not organized around churches, shops, or greens. Rather, they were a rural collection of cottages and barns surrounded by communal farmlands.

Auchindrain is the last such Highland settlement still in existence, although it is now unpopulated and functions as a museum. It was a living community well into this century, however, and the houses retain the identity of their last inhabitants.

The Widow's Cottage belonged to a woman who was, after her husband's death, a sort of ward of the community. Clans took responsibility for caring for their own aged and infirm, and the owner of this cottage was the beneficiary of such care. Her home is a particularly beautiful and contemplative example of rural Scottish cottage-living.

This one-room, chimney-gabled stone structure has a built-in and curtained box bed near the hearth. Arranged around the walls of the other end of the room are boxes and cupboards for food, cooking, and dining things. A table holds the center of the stone floor, lit by the windows before and behind it. Outside the front (and only) door, sheltered by the roof overhang, a wooden bench catches the sun's warmth.

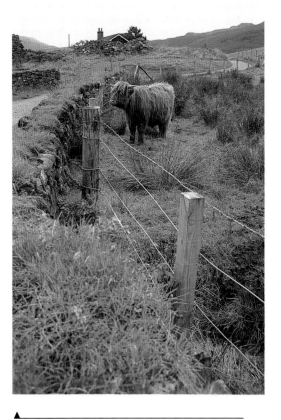

Highland cattle are a distinctive, if shaggy, breed.

A steep thatched roof and walls of roughly whitewashed stone mark the exterior of this typical Highland cottage. The window and door face south, where a bench provides a place to sit and dream.

Nearby, an unused plow is silhouetted against a barn covered with corrugated metal.

11

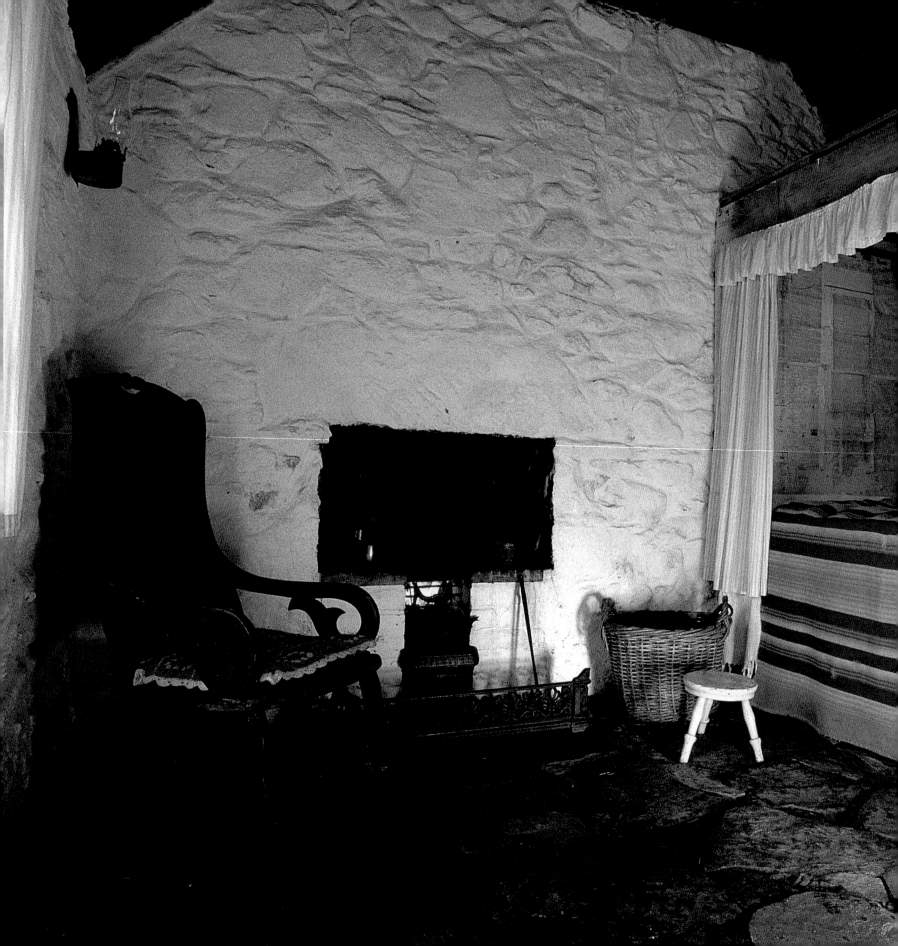

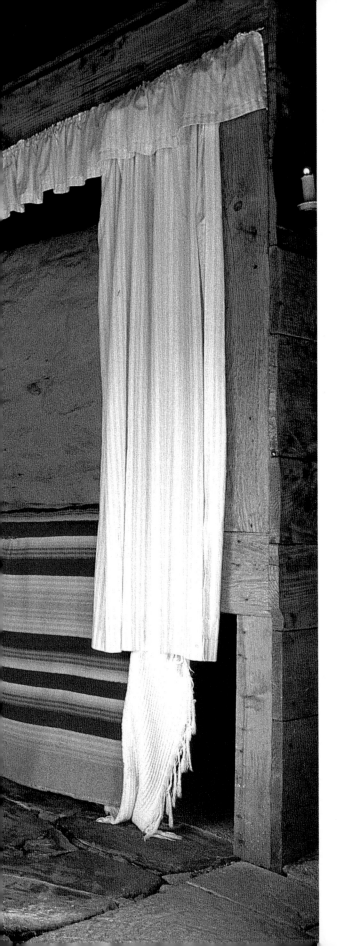

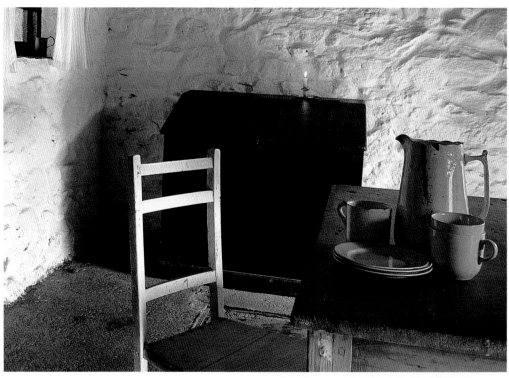

The freestanding table functions both as workspace and dining area.

Like many cottages in the now unpopulated Highlands, this house sits isolated in the landscape.

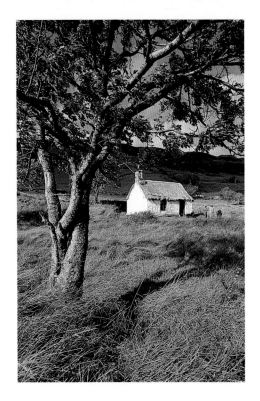

A box bed is built into the cottage's northwest corner, next to the hearth. The bed is high, to catch the rising heat and to provide storage space underneath. White hangings, often edged with decorative crochet work, and rough-spun striped blankets and covers are traditional bedclothes all over northern Europe.

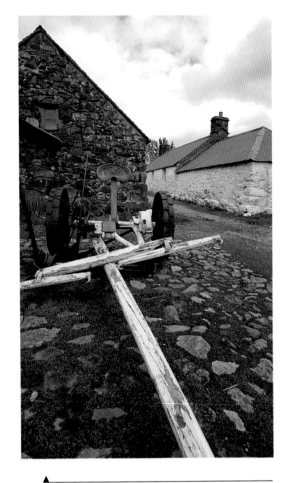

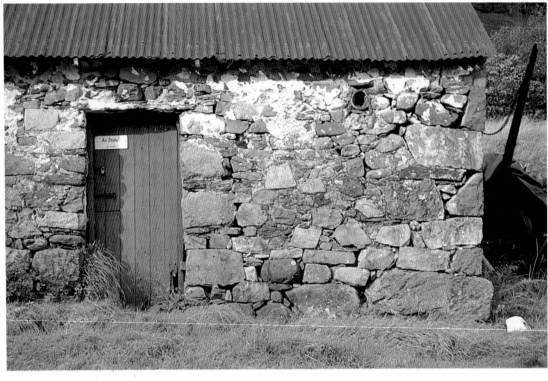

Houses grow from available materials: here, stones are the earth's most abundant crop.

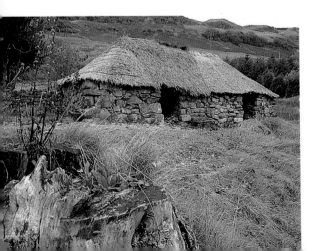

Stones were carefully fitted to make this barn, and the small hollow pipehole provides ventilation. Iron roofs replaced thatch in this century.

Grass and stones, thatch and rubble show yet again the intimate relationship between buildings and land.

Straight-edged, stark, and simple: such characteristics of Scottish vernacular architecture are readily apparent in this view of a neighboring house at Auchindrain.

A dresser holds china on top and cooking gear below. The small north window lights a dim corner.

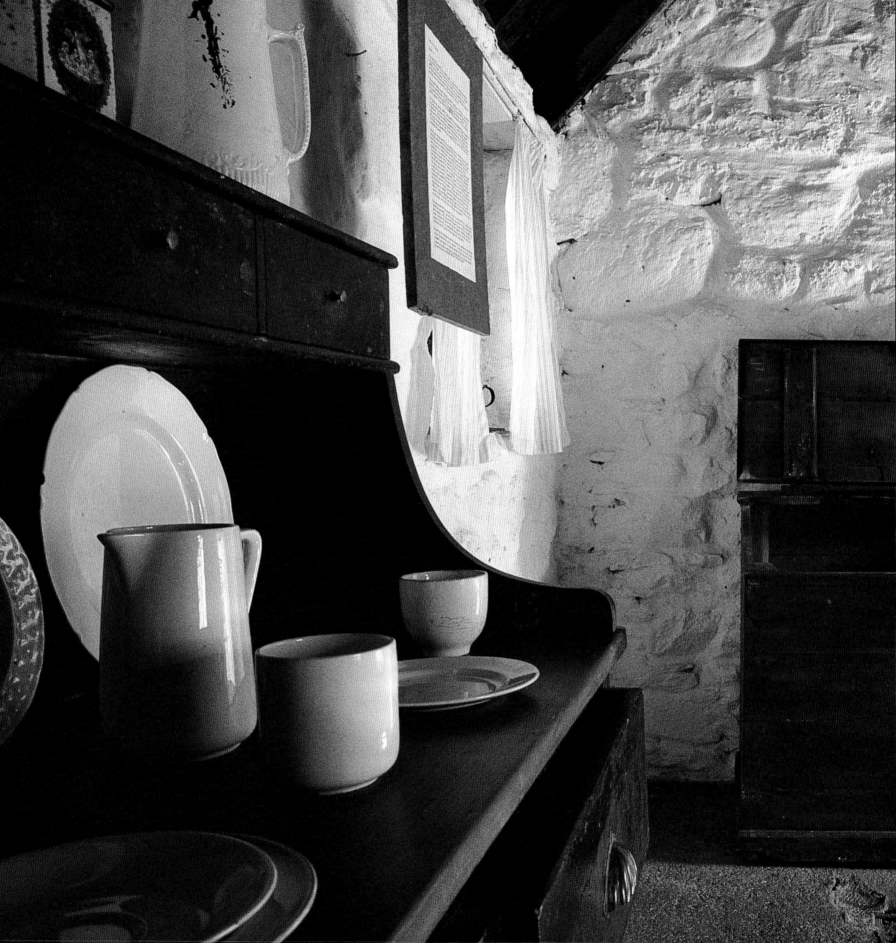

INVETERATE COLLECTOR

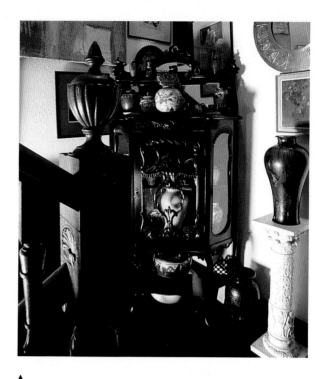

T he owner of this house in Glasgow is a political scientist and academic, but he is a collector most of all. The multitude of objects in his home is the result of nearly constant looking, trading, research, and delight. He approaches his collecting with the rigor of a scholar and the sensibility of an aesthete. Rising early, he spends every Saturday searching through stands at open markets, looking for objects to enhance his already staggering collection. Sometimes he is systematic, as when he set out to find every book ever printed by John Blackie, the publisher who commissioned Charles Rennie Mackintosh to design Hill House and who also commissioned artists to design covers for the books he printed (a portion of this collection now faces front-cover-out on special shelves designed by the owner for his living room); at other times his scope is wider, as when collecting art nouveau pottery from diverse British and Continental sources.

The house is large and filled to overflowing with the objects of his quests. Rooms often have collections several layers deep on any one surface—a William Morris chair might have its original fabric cushion draped with a layer or two of other Morris designs, sitting next to a table of the same period also draped with cloth and anchored by a piece of pottery contemporary with it. Even the most unexpected or modern pieces in a room offer a surface for displaying a collection: in the small upstairs sitting room, the narrow top of the television set is home to perhaps thirty art nouveau glass paperweights that shiver delicately as one walks across the room.

Perched in a corner of the stairway landing, this Scottish "Aesthetic period" cabinet dates from 1888.

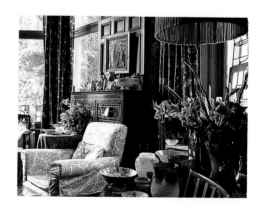

"Strawberry Thief" is the name given by William Morris to the flower-print curtain fabric still produced by Liberty.

Most of these Blackie-published cover illustrations are the work of Talwin Morris, but one or two are by Charles Rennie Mackintosh.

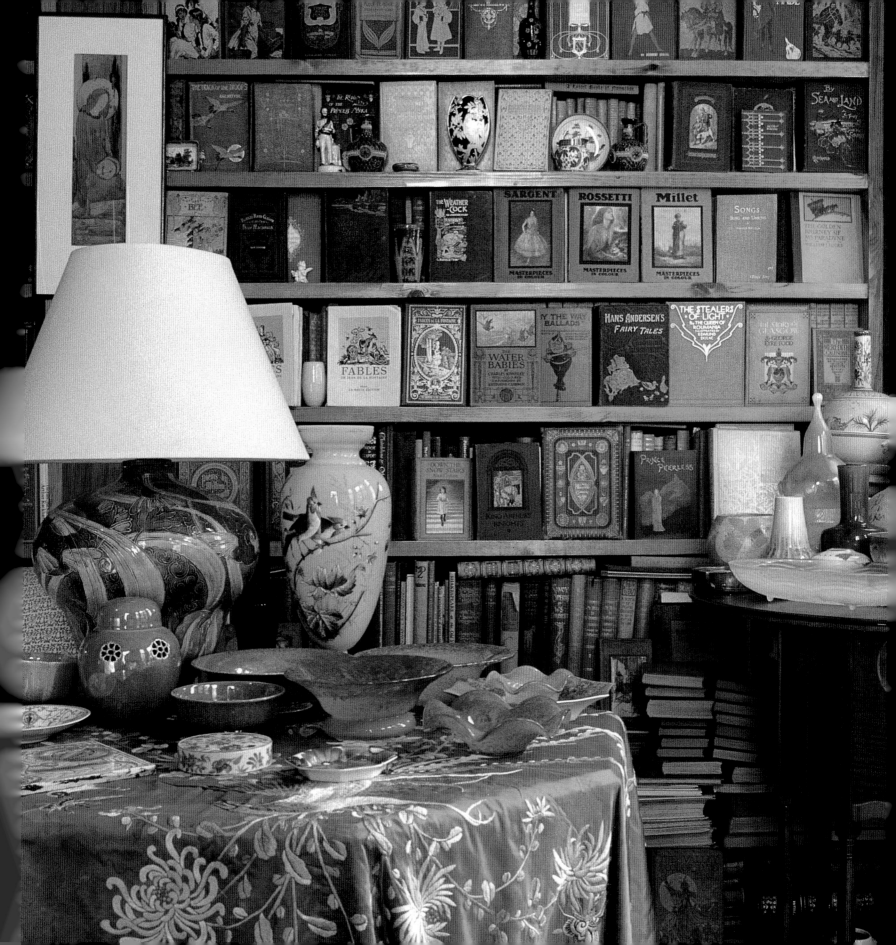

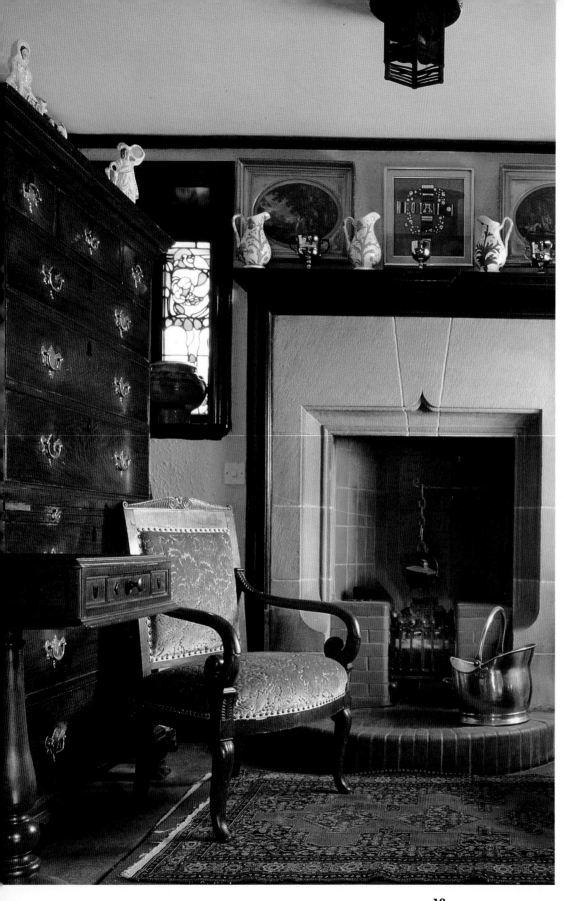

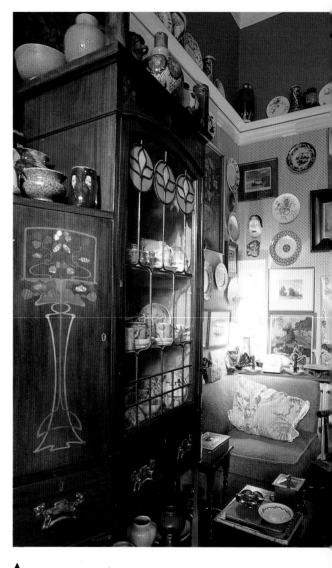

A Scottish art nouveau china cabinet holds some of the original china designed by Mackintosh for Miss Cranston's Tea Room.

The sitting room fireplace is crowned by Royal Doulton china and Tudric, a high-silver-content pewter once made by Liberty's. The picture is a cartoon by Sir Edward Burne-Jones.

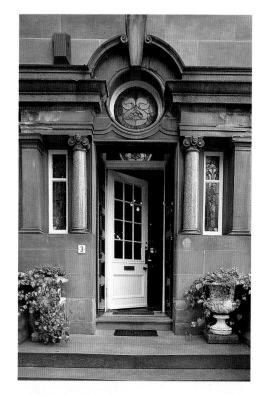

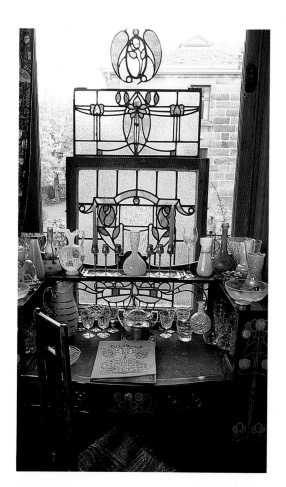

The front door gives no hint of the treasures that lie beyond.

Art nouveau glass, some of it by Lalique, graces the top of a similarly art nouveau desk. The stained-glass window of the same period is Glasgow-made.

Anglo-Indian décor is featured in this corner of the wide upstairs landing: both the carpet and the daybed fabric are from India.

This double-handled vase is a product of Liverpool's Della Robia Pottery at the turn of the century.

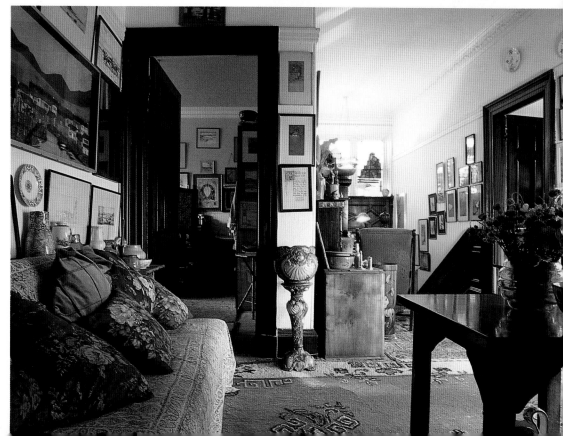

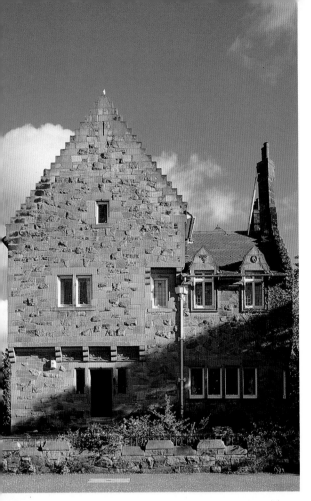

◄ *A side view of the exterior presents a very Scottish steep roof profile.*

More art deco objects line the wall above the bed. ►

▼ *The art deco bedroom contains pottery by Clarice Cliff, as well as choice pieces of Poole Pottery on the top of the wardrobe.*

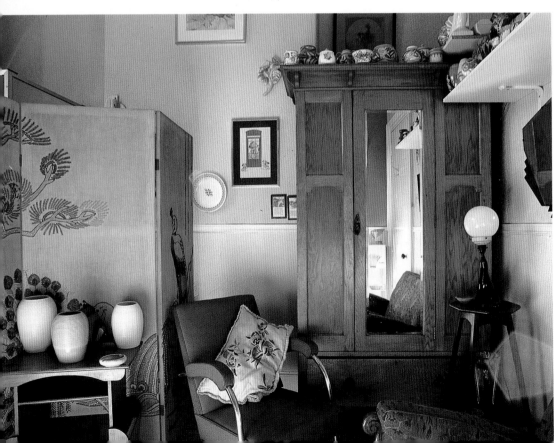

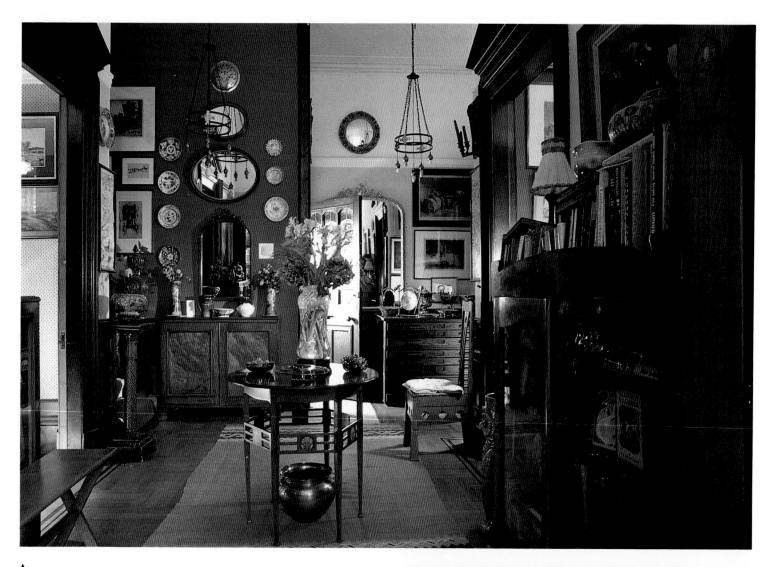

The center table in the front hall is an illustration of the extensive Japanese influence on early art nouveau. The vase on top is Vaseline glass.

Upstairs in the small sitting room, the mantel holds another art nouveau glass collection.

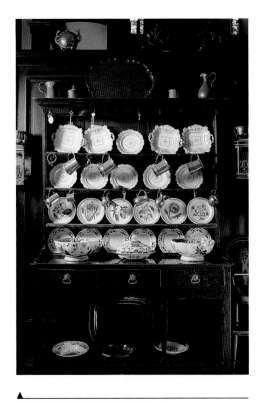

A dresser just outside the kitchen holds Scottish and Chinese plates.

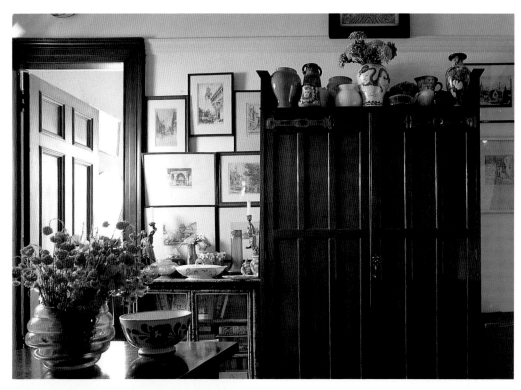

The etchings form a collection of works by Muirhead Bone celebrating the Glasgow Exhibition of 1900.

Late-nineteenth-century and twentieth-century art by Glasgow School painters hang near an unusual art nouveau desk found in Dorset. The couch fabric is also a William Morris design.

DRIFTWOOD LOFT

O n the outskirts of Edinburgh, down by the docks in Leith, is an area of buildings that once serviced the shipping industry. In times past, when animals provided the power to move things from place to place, this building was a stable for dock horses shipped from Northern Ireland.

Two artists, Liz Ogilvie and Bob Callender, were attracted to the building by its lavish space. A huge area now made into their studios comprises the ground floor; upstairs is a smaller frame structure carefully organized into a home.

When they first bought the building, they gutted the structure, replaced the roof, and put in new windows. In the middle of this work they went on a trip to Finland. While there, their planning for their Scottish home was influenced by the way Finnish interiors are trimmed with natural wood accents, and by a kind of Nordic minimalism that allows the pure forms of things to stand free in space and be visible.

The home is thoughtfully organized, and the bare quality of it is made possible by the large storage core that holds their extensive book collection, as well as many of their other belongings. The main room, which functions as kitchen, dining room, and living room, is furnished with the primitive furniture they built from the driftwood that floats to the shore near the bothy (a stone building once used as a temporary home for migrant workers) they rent as a country retreat, as well as with some choice Jacobean furniture from Liz's pink-sandstone-castle childhood home.

A contemplative corner of the austere master bedroom shows the minimalist sensibility of the owners.

In the main room, the dining table, benches, chair, and kitchen cabinets were all made from driftwood washed ashore near the bothy.

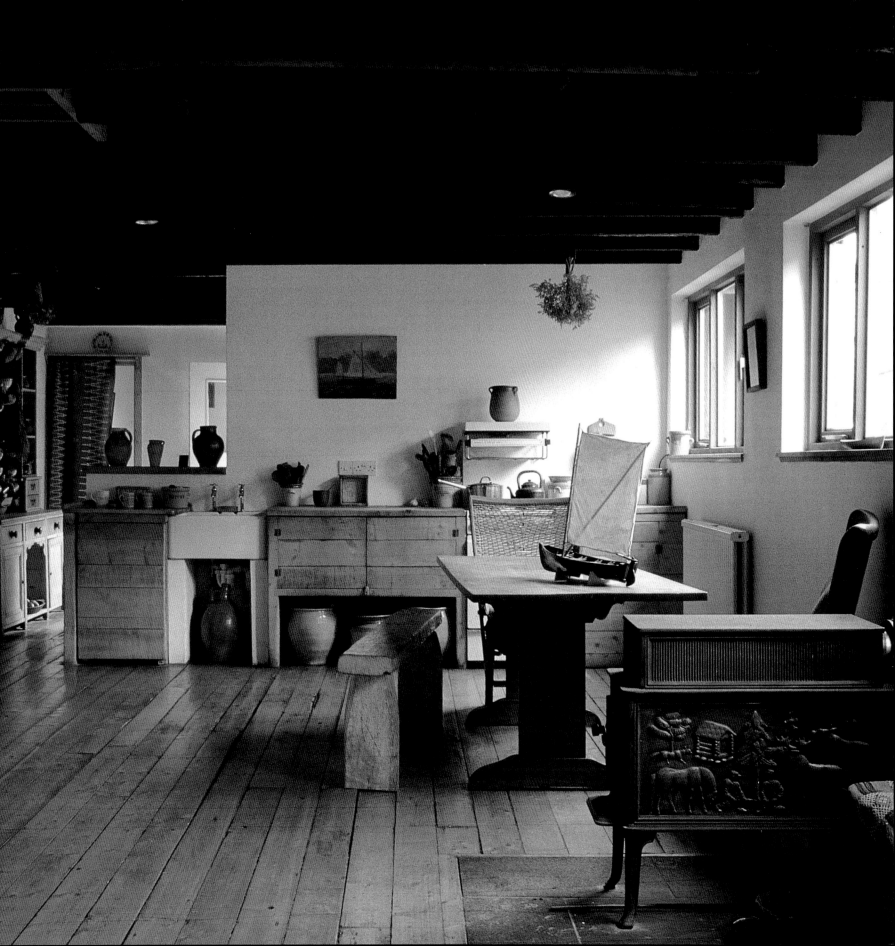

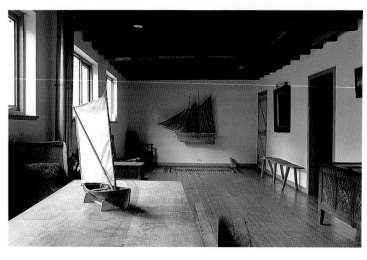

▲▲

Built from driftwood, the bench marks the edge of the doorway into the storage core, where the owners keep their book collection.

▲

Single oars, washed ashore after storms, decorate the ceiling beams. The chest at right is Jacobean.

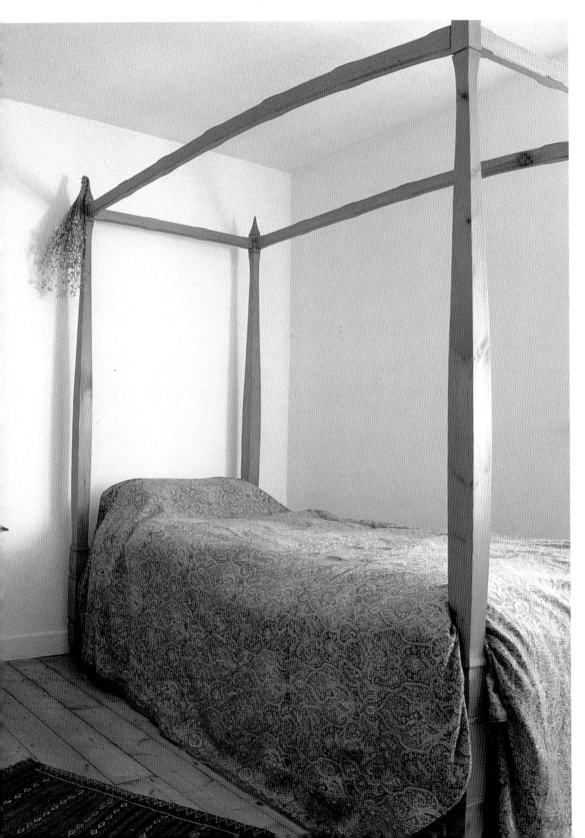

This bed in the guest room is newly made, but it was modeled after Liz's childhood four-poster.

A Jacobean chair functions as pure sculpture in this carefully edited, museum-like environment.

A Devotion to Wood

As one of Scotland's many English "incomers," Tim Stead was attracted by the relative freedom and isolation of life in the Borders. Stead is noted throughout the British Isles as a maker of chairs, tables, and cabinets, but his furniture also reflects his training as a sculptor.

Stead and his wife, Maggy, bought an old stone farmhouse and steading six years ago. Its interior reflects their special affinity for natural materials, in particular for the sinuous forms inherent in wood. While most builders and cabinetmakers work with planed planks of often exotic woods, Tim Stead has used unplaned, wavy, and bark-edged slabs of local and indigenous woods to make ingenious furniture and architectural fittings. Surfaces undulate into almost art nouveau curves; doors feature openings, cracks, and deliberate splits that reflect the joining of several parts of one tree trunk. Each door in Stead's house is unique; each addresses the function of a door in a different way. Working within a loosely defined community of craftsmen and artists based in Scotland, Stead has also collaborated on designs in metal and stained glass that further enhance the house.

Feeling himself a "wood parasite," Stead has recently organized the first community woodlot in Great Britain. To that end, he has made a series of hand-carved wooden axes to pay for woodlot and planting-land purchases. The "Axes for Trees" project reflects his concern for ecology as well as his desire to replace resources he uses in his work.

A tour-de-force on a domestic plane: the kitchen's warm wood tones and eccentric details invite delight. Even the lampshade is made of wood.

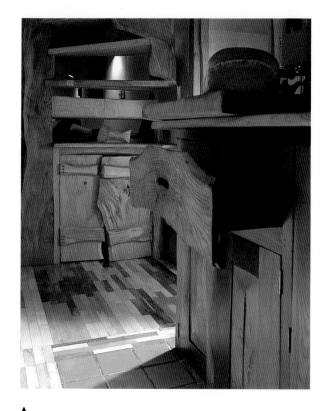

This corner of the kitchen illustrates Stead's careful craftsmanship. Each set of cupboard doors is different, and even the drawer front follows the growth lines of the tree.

A relaxed wooden man contemplates the garden.

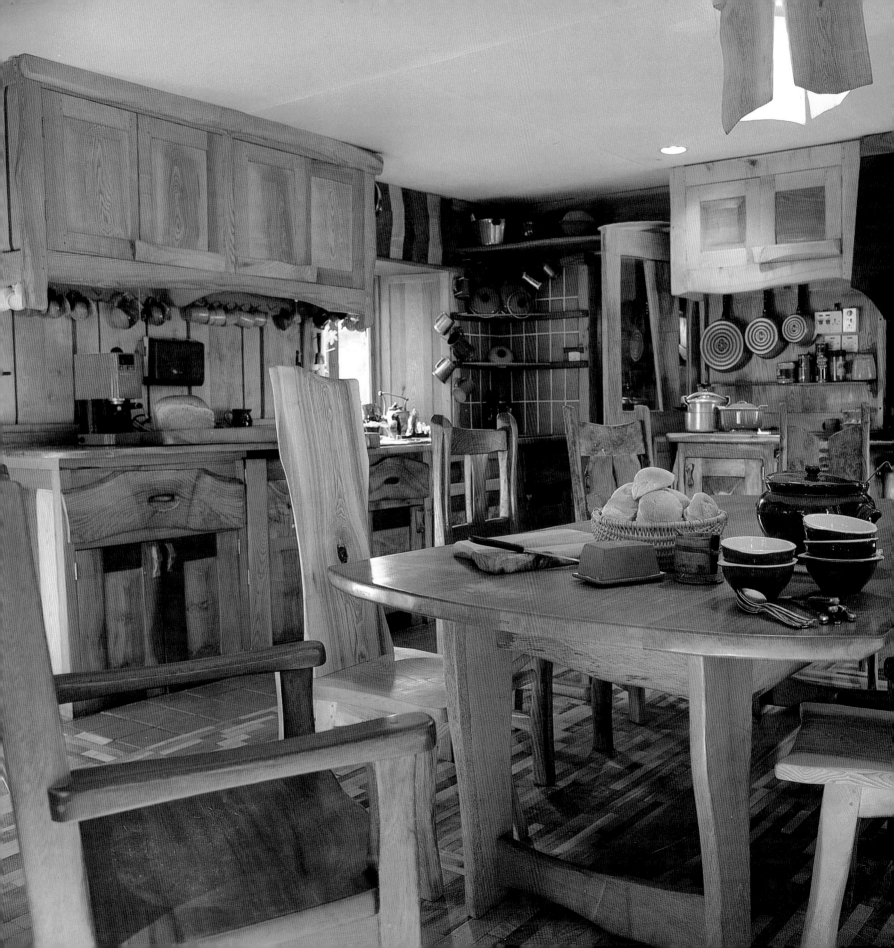

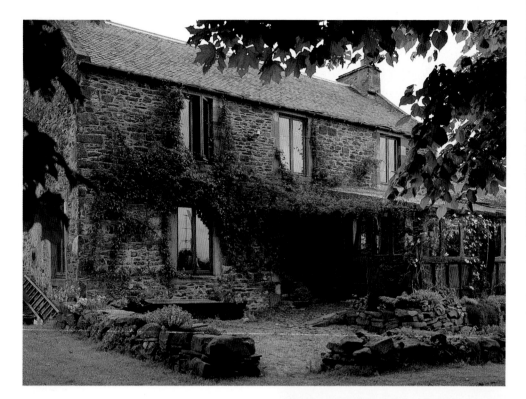

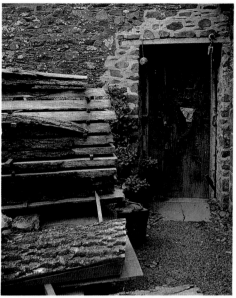

Wood drying on racks provides a contrast in texture to the old stone walls of the workshop.

All of the windows in the house are large double-glazed replacements designed to conserve heat and increase light in the interior.

Many variations on the forms of chairs are visible in the living room. The fireplace paneling is carefully fitted together from different woods.

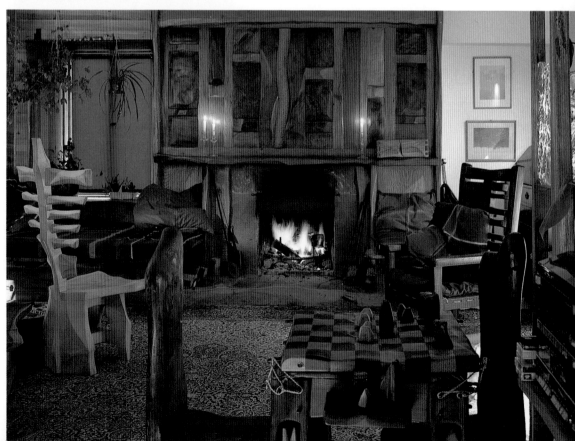

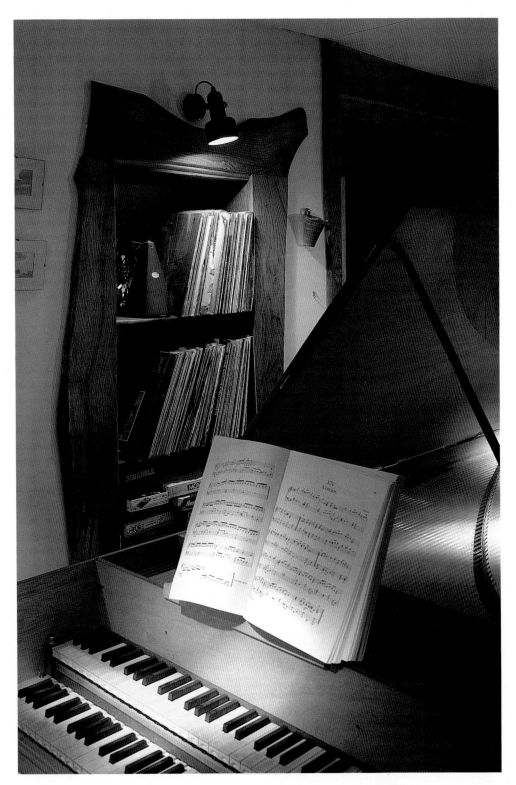

Sweeping curves of wood trimming the record alcove echo the arching form of the piano lid.

This wooden sink is a technical marvel and triumph of craft.

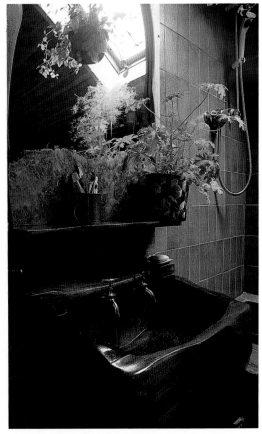

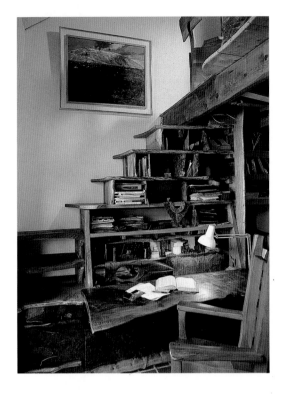

Appropriately, for people who use the record of growth in wood to create form, a plant-filled conservatory has been added to the original structure.

Building into the stair treads allows the desk to have lots of cubbyholes.

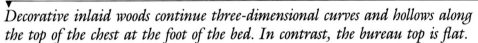

Decorative inlaid woods continue three-dimensional curves and hollows along the top of the chest at the foot of the bed. In contrast, the bureau top is flat.

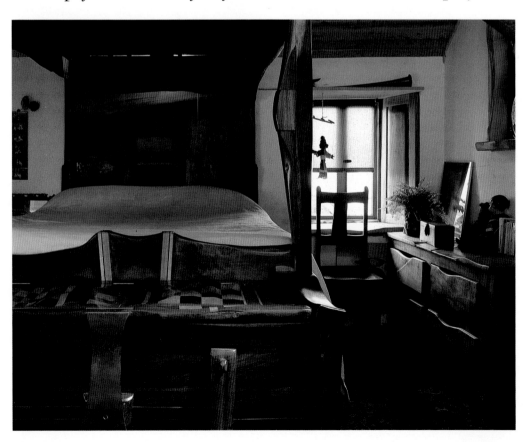

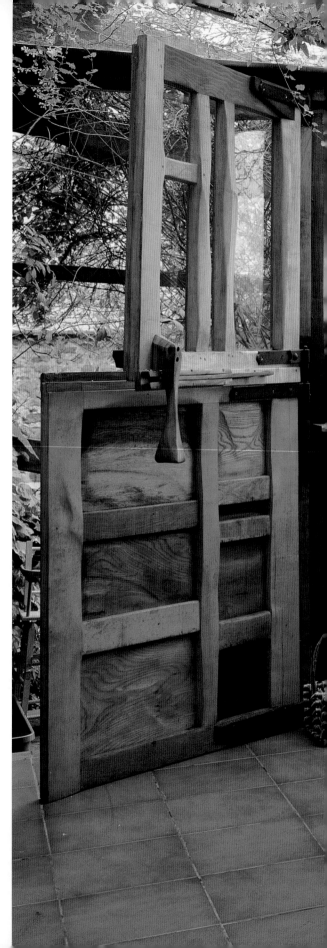

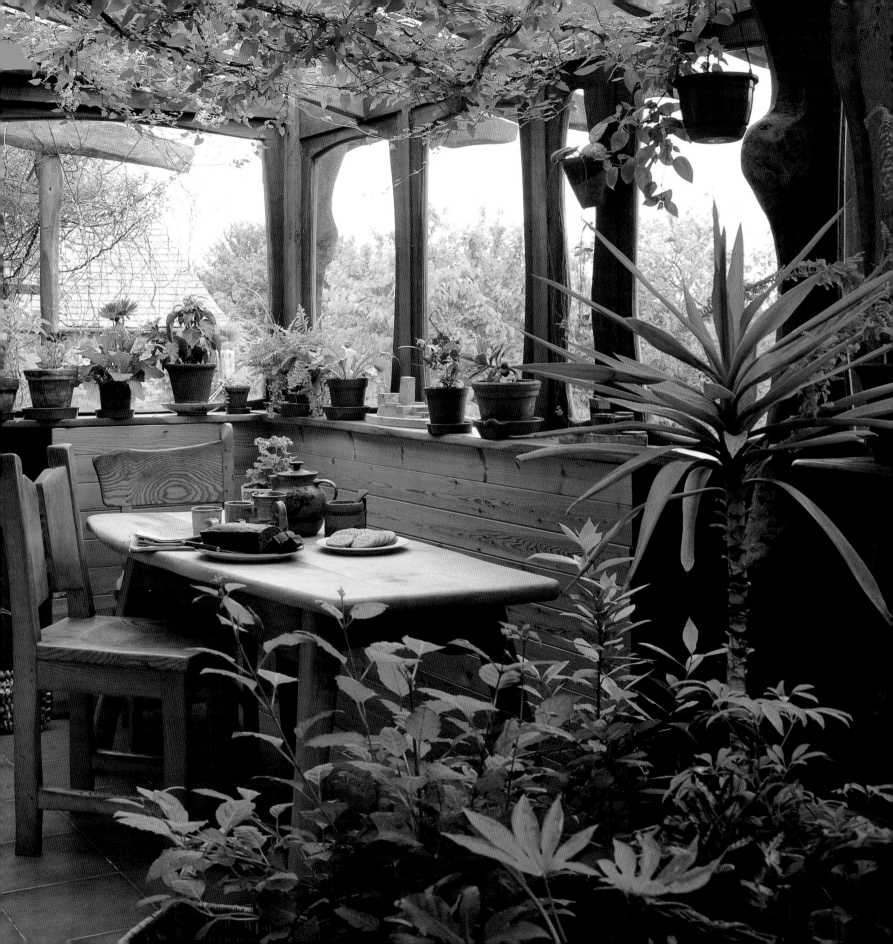

C. R. MACKINTOSH'S HOME

The Mackintosh House, now part of the Hunterian Museum, University of Glasgow, is a faithful reconstruction of a town house renovated in 1906 by and for Charles Rennie Mackintosh and his wife, artist Margaret Macdonald. Unlike the more well known Hill House, a masterpiece of architectural and interior design that Mackintosh built from scratch, this idiosyncratic and personal interior was created within the strict confines of an ordinary Glasgow terrace house. As such, the house shows Mackintosh's vision and ideas even more clearly than would new construction.

Architecturally, the changes were relatively minor: although none of the windows on the front facade were altered on the exterior, in the interior of the studio–drawing room the upper portions of the windows were screened with linen from ceiling height to picture-rail level to provide a continuous and lowered sightline. To the same end, and at the same consistent height, new, dark picture rails were added around the walls of the dining room, hall, and stairway, where additional dark strapping (in the hall) and taller doors gave a coherent tone to the rooms. In addition, several side windows were enlarged and reproportioned. Two interior walls were removed by the Mackintoshes—one to create the L-shaped studio-drawing room and the other on the floor above to create the master bedroom of the same shape.

However, the modestly changed architecture was only the beginning. It is the furniture, fittings, and surface

Inlaid with the same small squares that are this home's theme, the desk spreads its wings in front of the windows. Above the desk, the window rail's squares of purple glass catch the light. A white linen screen rises from the rail, to block the top of the window and maintain a continuous line.

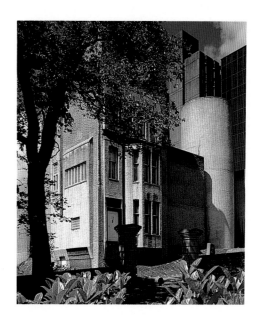

Although the original row house no longer exists, its fenestration has been replicated exactly in the Hunterian Museum's reconstruction.

The walls of the stairwell from the first floor to the second floor bedrooms are striped black and white. At left, the pierced door leads to the drawing room.

decoration working in union with the slightly altered structure that shows Mackintosh's unique vision. Limiting himself to a palette of black, gray, and white, with touches of purple and metallic tints, Mackintosh designed furniture, fireplace mantels, lighting devices, stained-glass panels, wallpaper, and stencils. His wife contributed watercolors and decorative panels. Each room was carefully planned, both in terms of furniture placement and in terms of mood. Many of the furniture designs were prototypes of designs for other projects, such as the series of Tea Room restaurants he designed, and for such private projects as Hill House and Windyhill.

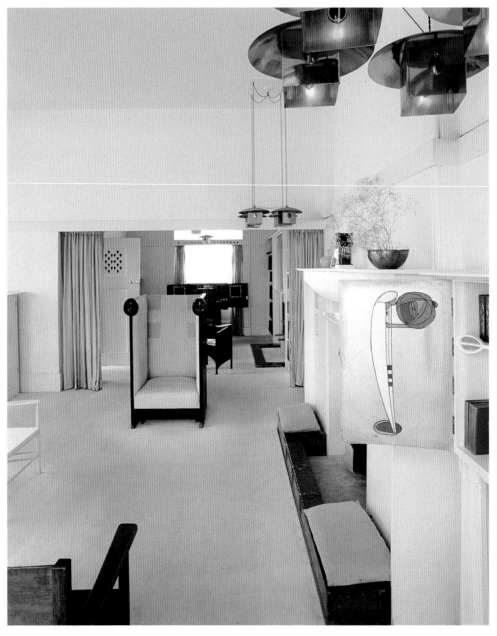

In this view from the front of the room to the rear, it is easy to see where the dividing wall once was.

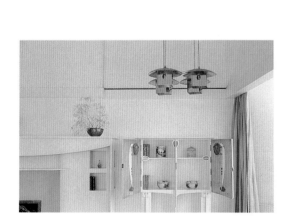

White-painted cupboards and white fireplace niches mark the street-facing end of the sitting room. Four identical lighting fixtures further emphasize the plate-rail level of the cut-off window.

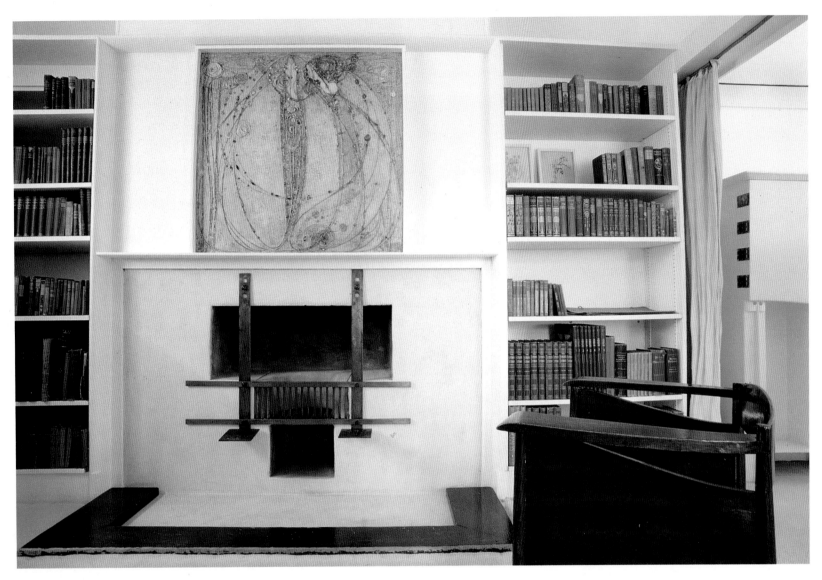

The influence of Japanese forms on Mackintosh is readily visible in this fireplace design. The frieze above the fireplace is the work of his wife, artist Margaret Macdonald.

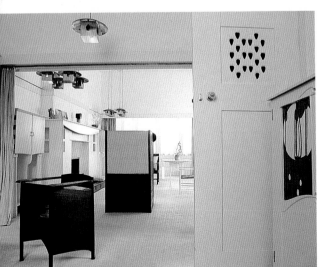

In such pristine and monochromatic environs, everything stands out.

White carpet stretches the space and increases its luminosity.

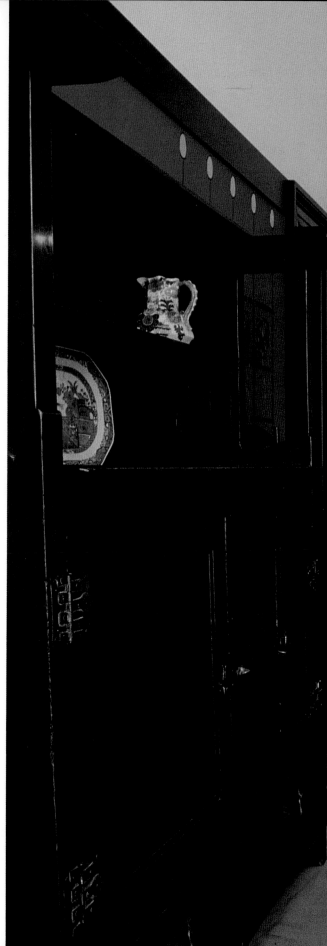

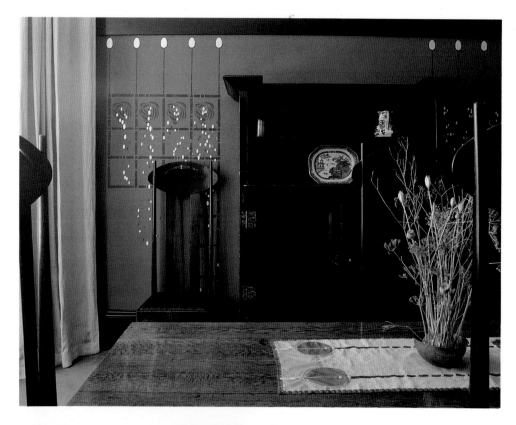

Reflective silver paint was stenciled on the dark dining room walls.

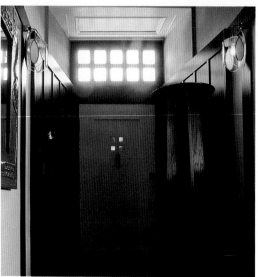

Black strapping marks the plate rail and the transition of the wall from color to white. This division makes the upper wall read as if it has a deeply coved ceiling.

Purple stained glass inset into the front door beams down the length of the narrow hall. The window over the door has been filled with a grid.

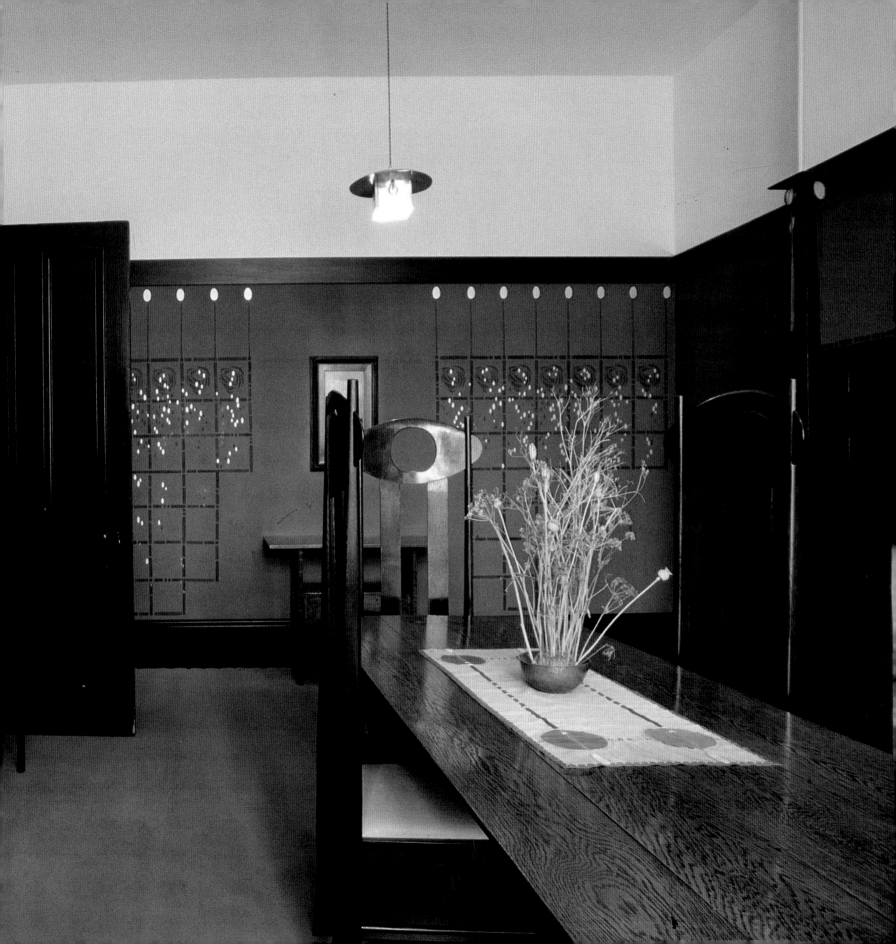

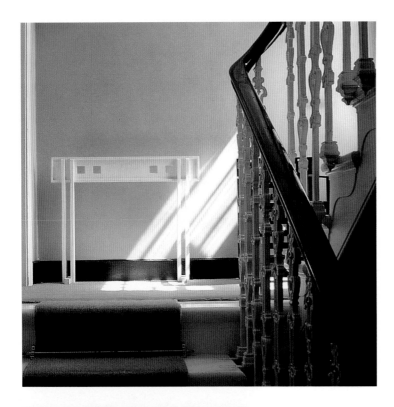

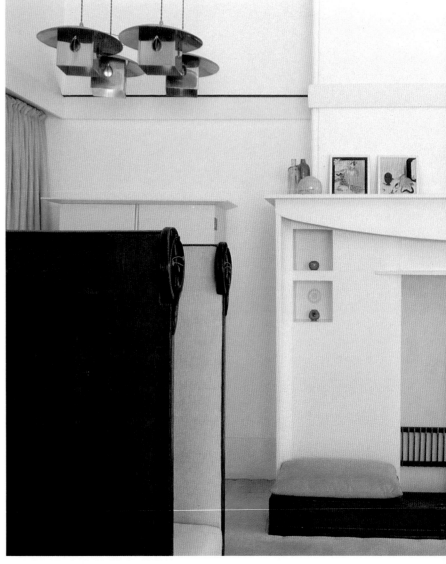

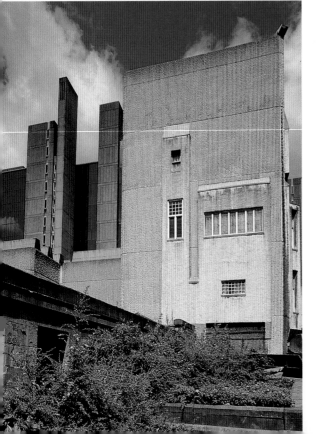

Striped by rays of sunlight, a painted table sits on the half-landing.

Everything in this home was planned—even the lines of the grate reflect the patterns of the furniture.

Another view of the Hunterian Museum shows how the Mackintosh House windows contrast with the rest of the building.

Embossed silver insets continue lines carved in wood. The chair cutouts play positive/negative with some of the same motifs.

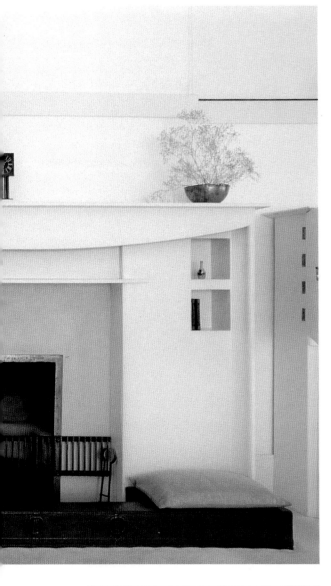

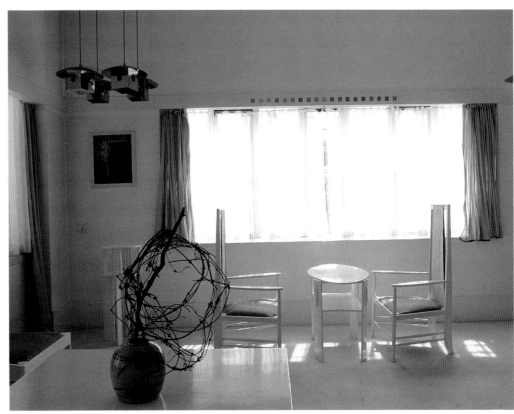

White furniture in an all-white room makes every shadow and detail more striking. Here, twisted twigs make a strong design statement.

Pictures rest along the plate rail above the graphic cupboard doors. Flowing lines, strong contrasts, and art nouveau curves mark the paneling and cutouts.

The stencils in the dining room were planned around furniture, and have blank spaces where chairs will be placed. Notice how the chair stiles are the same distance apart as the vertical wall stencils.

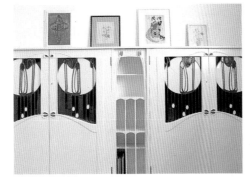

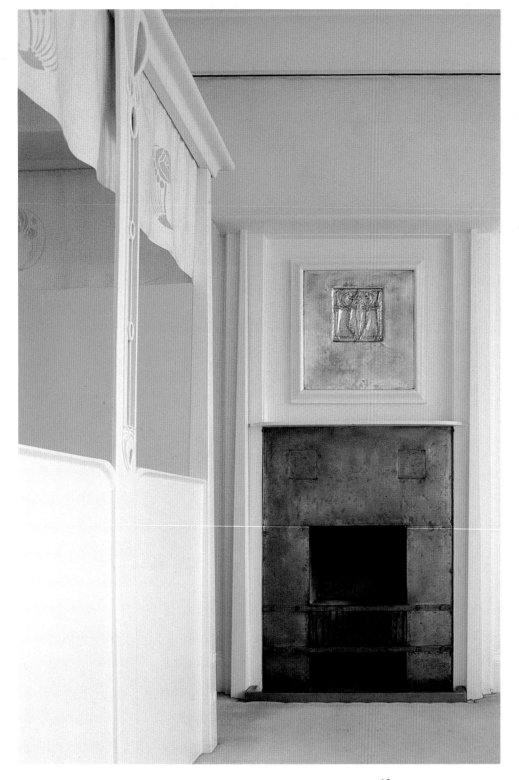

Art in hammered silver decorates the master bedroom mantelpiece. The double bed is at left.

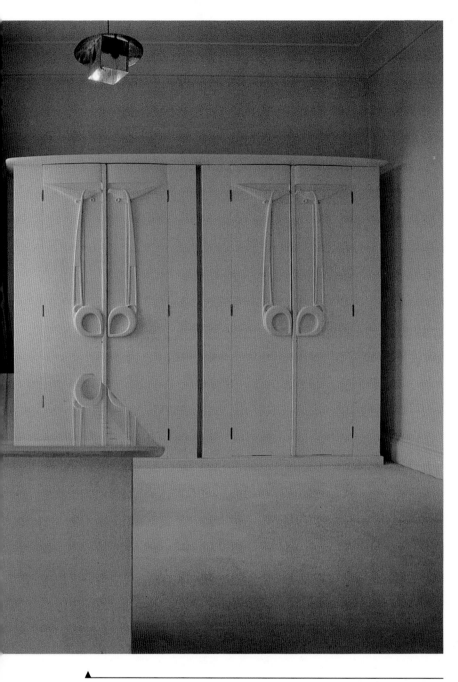

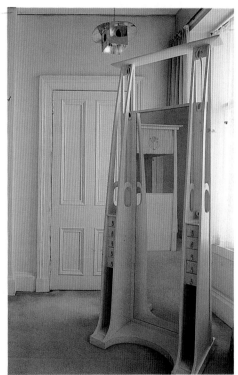

This full-length mirror may have been a prototype for a similar one in the master bedroom at Hill House.

Twin wardrobes fill the wall at the end of the ell. The glass-topped dressing table is set in front of the windows.

The marriage bed, hung with cloths designed and embroidered by Margaret Macdonald, fills an alcove.

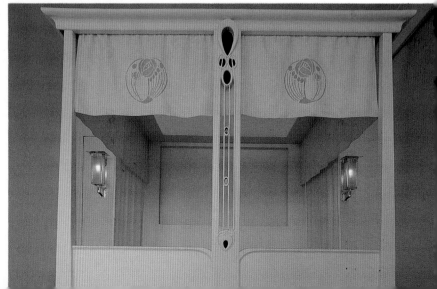

POSTMODERNIST TENEMENT

Architect John A. M. Cowell, in collaboration with architect-builder Ian Milliken, gutted a tenement flat in an emerging Glasgow neighborhood and turned it into a personal and postmodernist open-plan home. All of the original interior walls were removed, as well as the ashes between the joists used in the original construction as soundproofing. Modern cork soundproofing was installed under a Scandinavian wood floating-floor system, which was also used to construct the wide boat- and cacti-filled ledge that frames the main room. Interior doorways and the built-in bed feature neoclassical pediments that are held up by Mackintosh-style posts.

The space is extremely well organized. A tiny new foyer was constructed, backing onto a central storage core. The core, which extends the full height of the flat, is carefully divided into file cabinets, wine cellar, wardrobe space, and clutter containers.

Tiny boats perch over the tops of doors in the foyer, and the whole flat has something of the feeling of living aboard ship, as the space is so carefully planned and contained. There is also a sense of fun—a high corner of the living room holds a tiny *trompe l'oeil* painting of books by Callum McKenzie; and model boats careen merrily along most horizontal surfaces.

Cowell attributes his boat passion to his mother's ancestors, who were all "Cape Horners." Ships and sailing are in his blood, and he follows that most Scottish tradition of bringing back and transforming the best from "away."

Boats of all sizes sail along the ledge at the far end of the room, which is furnished with design classics.

Mackintosh-style pillars frame the entrance from the living room into the tiny reception area.

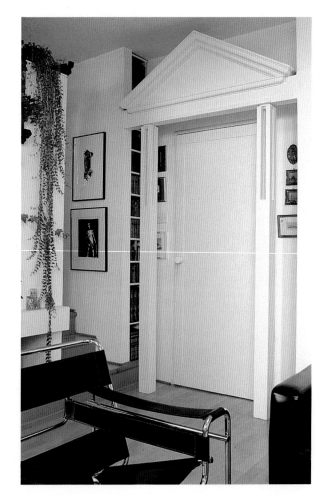

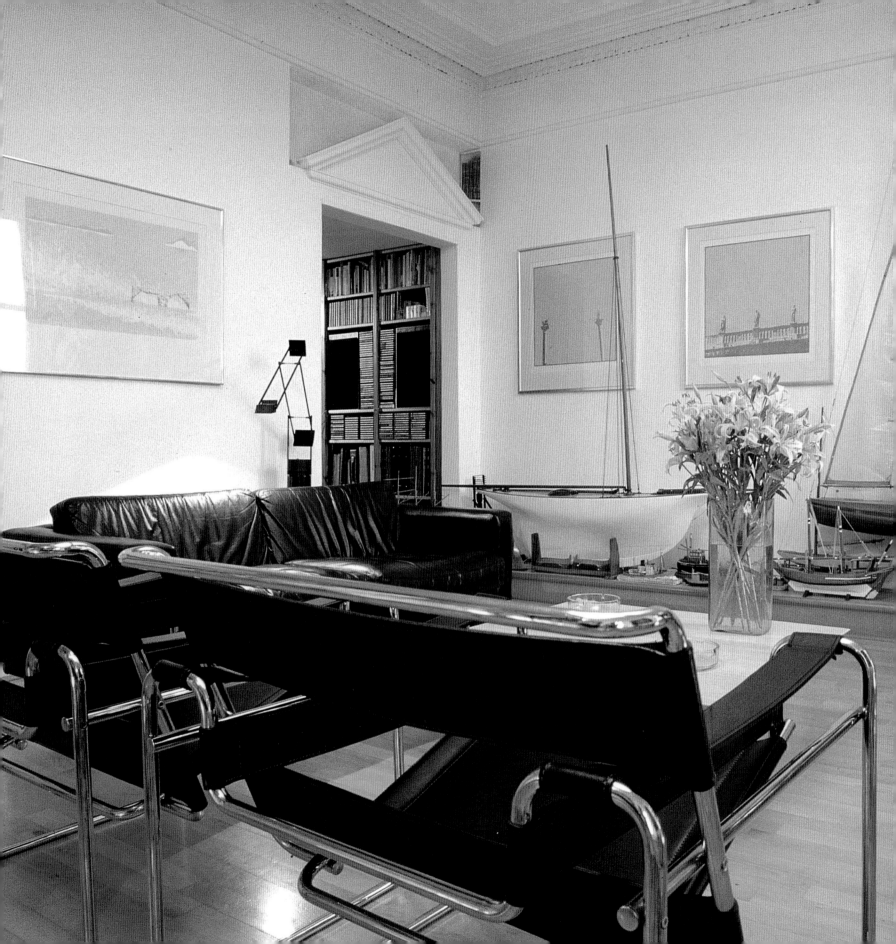

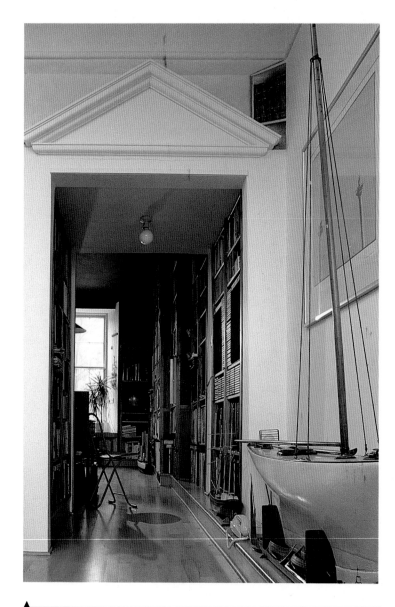

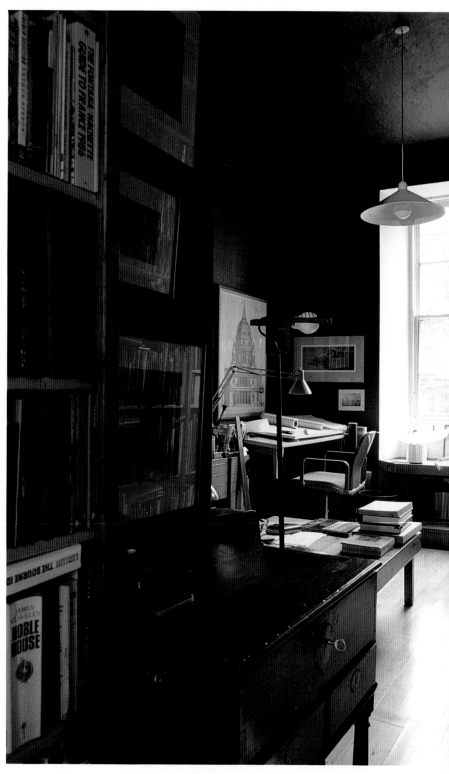

The tiny trompe l'oeil *painting of books in the high corner above the doorway announces the entrance to the dark green library/study.*

The study's dark green walls anchor the space, and provide a strong contrast to the light-filled front room.

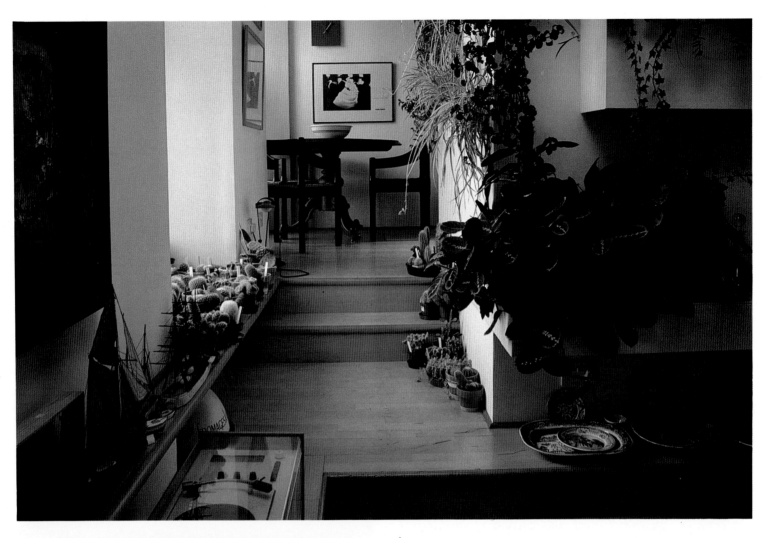

▲
The kitchen and dining area have been built several steps up, to create a more intimate setting.

◄
Plants spill down into the living room from the high kitchen's half wall.

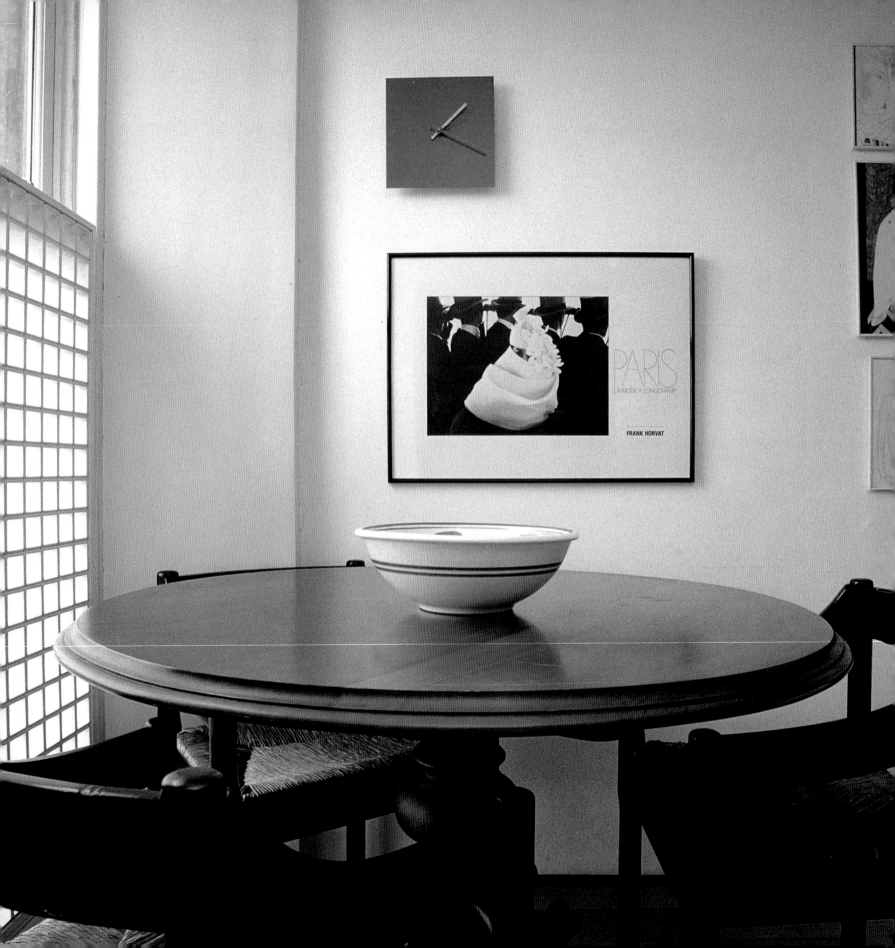

PARIS
LA MODE A LONGCHAMP

FRANK HORVAT

A gridded privacy screen across the lower window continues the Mackintosh theme.

The building facade, in the guise of an ordinary Glasgow tenement streetscape.

More kitchen planning at work: note the triple floating drawers. The low wall behind the counter holds the plants whose leaves decorate one wall of the living room.

The kitchen is compact and carefully planned: all of the proposed equipment and supplies were measured before the spaces were designed.

PARISIAN-STYLE TURN-OF-THE-CENTURY

John Cunningham is a painter who lives in an undivided studio and flat originally built for the noted Scottish painter John McGhie and his French wife in the 1890s by architect Sir John Burnett. The building, Albany Mansion, is on Glasgow's Renfrew Street, down the road from Charles Rennie Mackintosh's masterful Glasgow School of Art. In fact, it is believed that Burnett (who was on the board of the fledgling school) was responsible for getting Mackintosh the commission to design it.

This is now the last undivided home and studio of the period still standing in Glasgow, and, happily, it is still being used in the way in which it was intended. It features a duplex studio-salon—the lower part is a double-height cube lit by massive skylights. A fireplace warms an intimate seating area under the balcony. The upper portion functions as a working studio.

In addition to its spacious working environment, the living portion of this apartment is also gracefully appointed. Featuring a wood-paneled entrance hall and dining room, as well as a large kitchen and several bedrooms on the second floor, the architecture reflects a standard of elegance that, like similar Parisian-style artist's spaces of the same period built along New York's Central Park West, reminds us of a time when Paris was the center of the art world, and French graces were the artistic and social ideal.

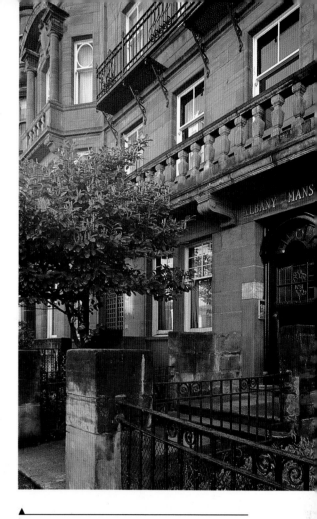

Albany Mansion's wrought-iron fence matches the upper balcony railing. The front door and interior stair rails are similarly ornate.

The upstairs studio is still in use.

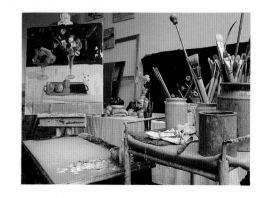

Tall windows in the Parisian-style salon reach almost two stories, and the Chinese porcelain on the table is a reminder of Glasgow's cosmopolitanism.

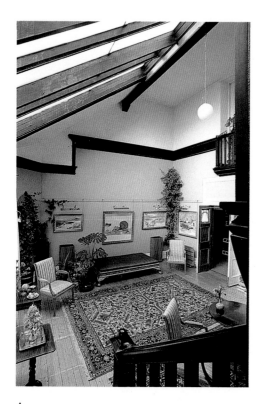

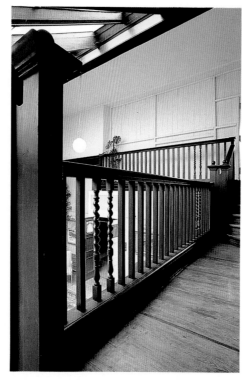

This view of the main salon, taken from midway up the original stairs, shows its grand scale and extraordinary light.

Edged with a distinctive balustrade, this balcony above the salon leads to the now closed-in upper studio.

The wide divan is from India, and is made from carved and gilded wood. The paintings above are the work of the owner, John Cunningham.

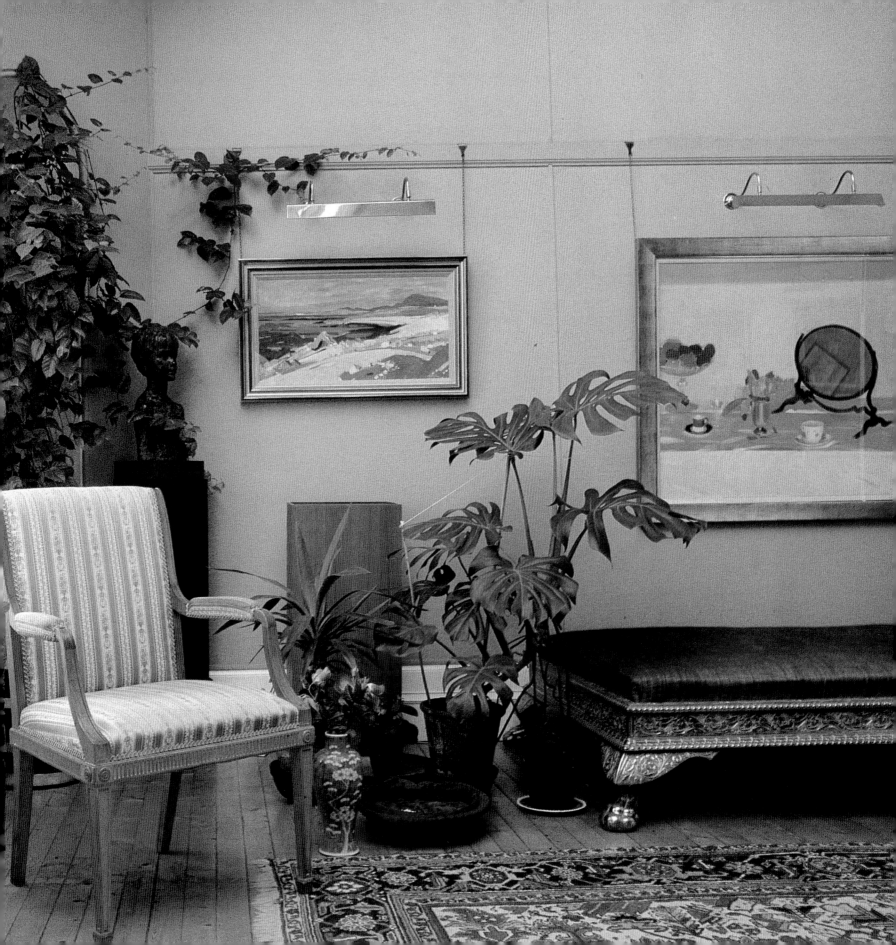

The paneling and fittings in the bathroom are original to the flat. Some years ago, when the brass door lock needed repair, it was brought to an old locksmith who actually remembered fitting it into the door when the building was new and he was a young apprentice.

Three half-painted doors off the wood-paneled kitchen provide plenty of graphic interest.

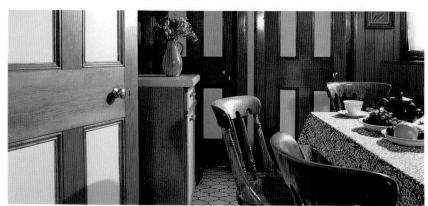

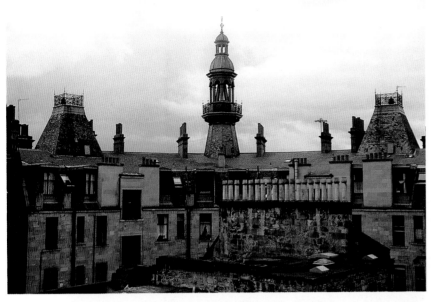

Glasgow's skyline looks much as it did when the building was new, in this view from the salon windows.

Still-life materials and finished work are arranged along the walls, bathed in pure north light.

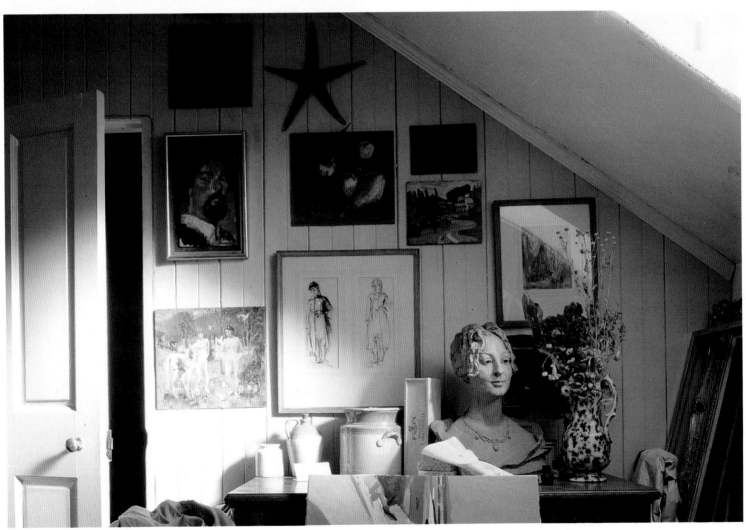

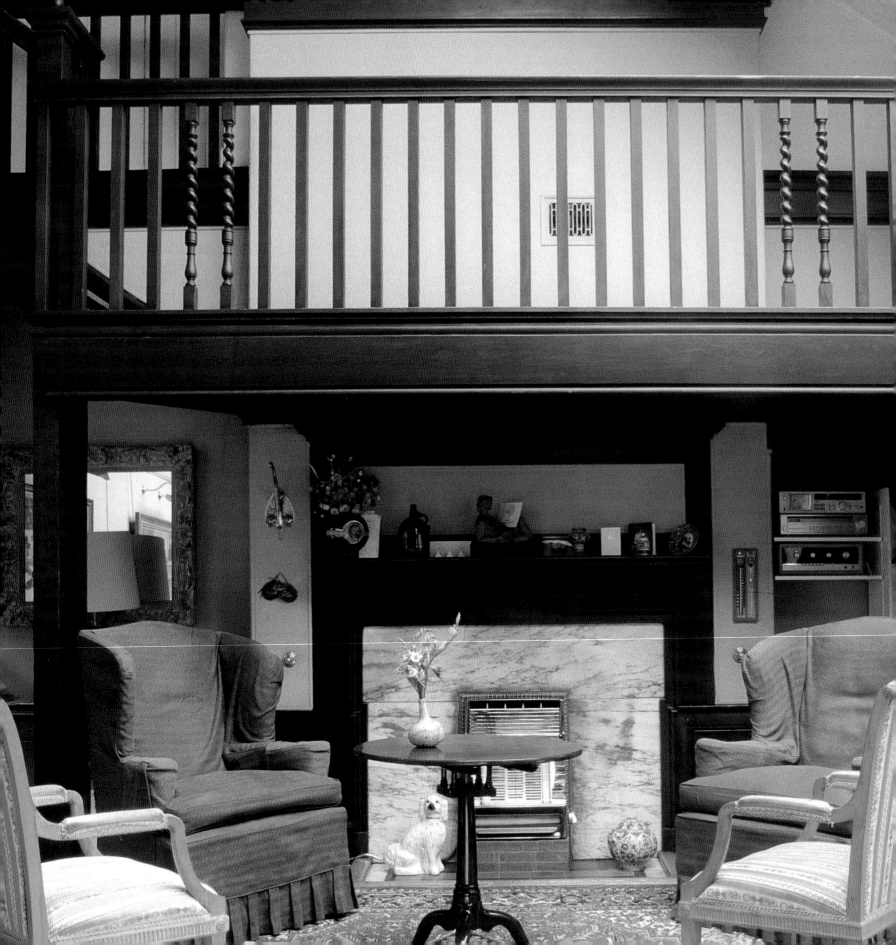

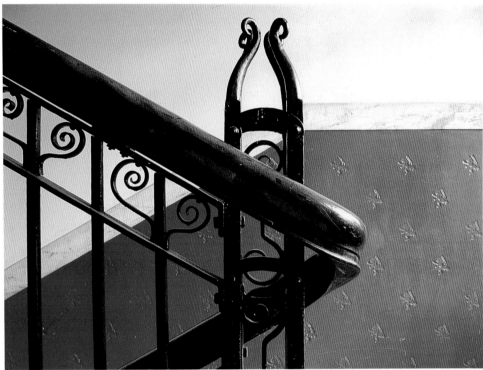

The public stairway that links all the flats in building is yet another example of art nouveau crafts-manship. The stairwell walls are enhanced by stencils.

Comfortable seating forms a circle near the hearth under the balcony.

From the common hall, the front door of the flat is distinguished by impressive woodwork and a stained-glass window.

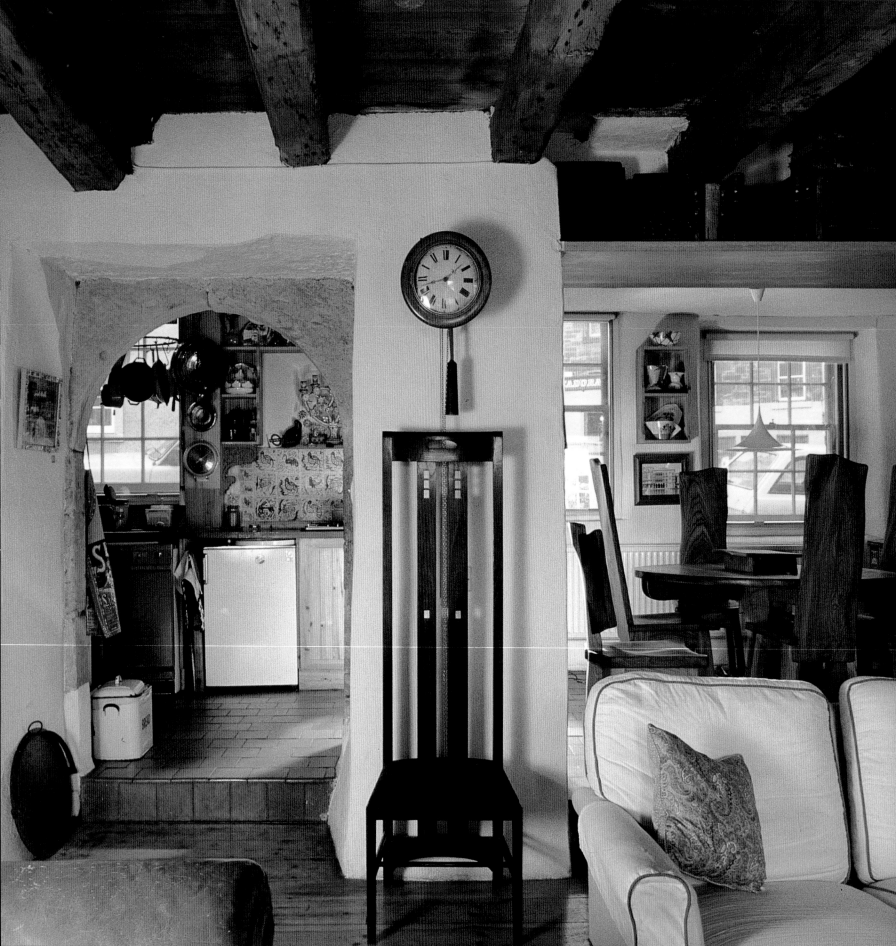

OLD AND NEW CONTRASTS IN A SEVENTEENTH-CENTURY HOUSE

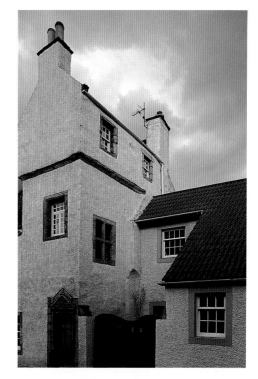

Murray and Barbara Grigor are filmmakers who have done noted film studies of Charles Rennie Mackintosh, Frank Lloyd Wright, and (with architect Robert A. M. Stern) a television series on American architecture. Their seventeenth-century home near the Firth of Forth Bridge reflects their wide range of interests. Furnished with Mackintosh chairs, both originals and reproductions, as well as with pieces made for them by local craftsman Tim Stead (see page 28), the heady mix also includes kilim-covered sofas, faux-marble bookcases, and a postmodern-style bed designed and executed by Mr. Grigor. Contained within a series of vertical living spaces, the levels are linked through a steep, winding stone spiral staircase.

At left is the original seventeenth-century house. The plaque over its doorway names the original owners. The low building on the right is the new Grigor-designed studio.

The garden is filled with sculpture by such Scottish artists as Ian Hamilton Finlay, as well as with polished marble columns from building sites and a fresco on an old and crumbling wall. Reached via the garden is the film studio, designed by Grigor, who calls himself "one of world's few amateur architects." It is a fine modern contrast to the old house, with a light-filled conservatory at the garden end and industrial stairs leading to the second floor. The studio is filled with whimsical objects, personal mementos, and pieces from exhibits the Grigors have organized and designed.

Silhouetted by a floor light set in the fireplace, the back of a Mackintosh chair becomes a graphic statement.

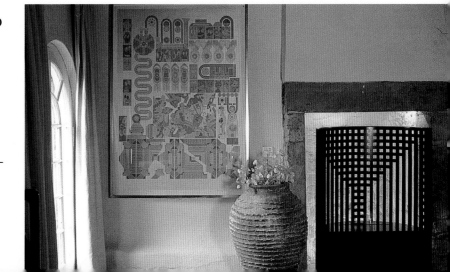

Centered between kitchen and dining room is an Italian reproduction of a Mackintosh chair.

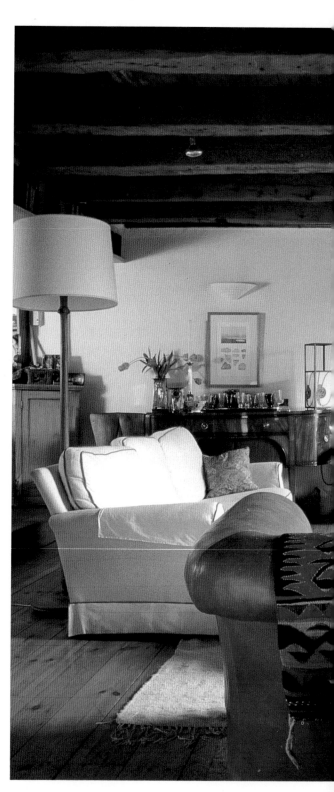

Art nouveau silver and a copy of a Mackintosh-designed lamp compose a period tablescape.

Mackintosh also designed the hanging light over the piano.

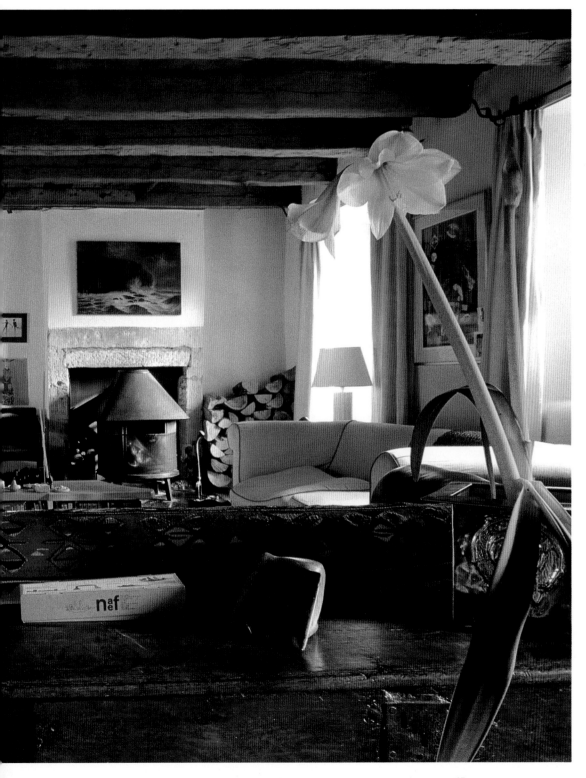

▲

The bathroom has its own hearth, as well as a metal tree-sculpture-cum-toilet-paper-holder by witty Scottish artist George Wyllie.

◄

The living room's low ceiling is emphasized by massive beams. A leather sofa is draped with a kilim rug.

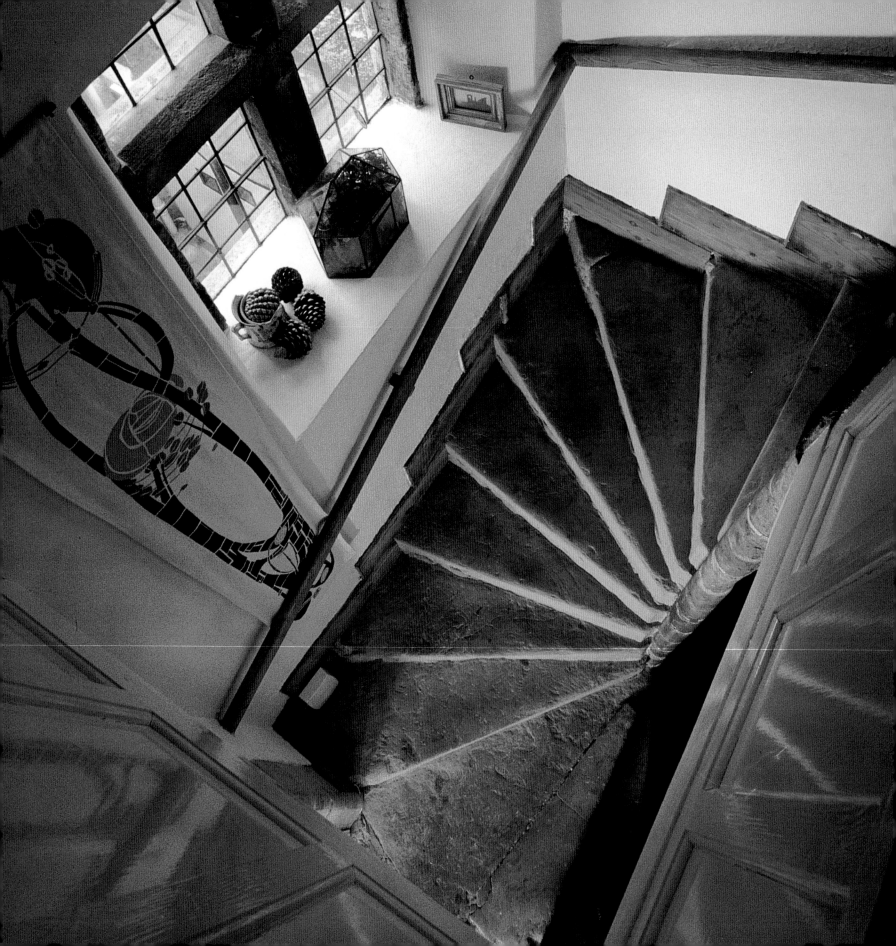

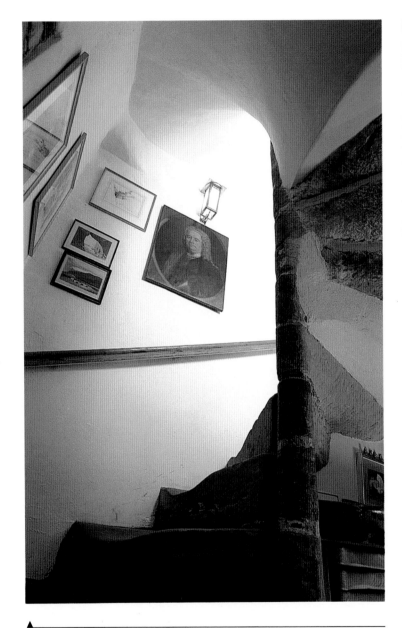

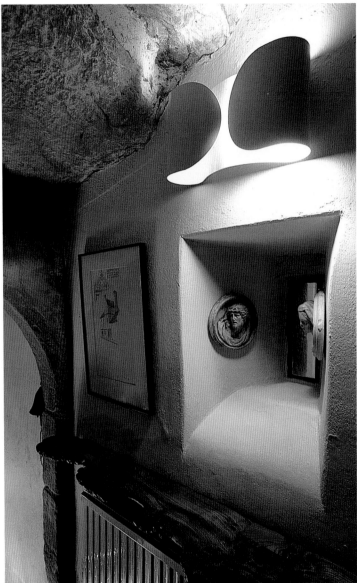

▲
Built in next to the stairs, and echoing the form of the treads, is a custom piece by Tim Stead.

▲
This tiny window faces the courtyard to the street, and shows the thickness of the building's stone walls.

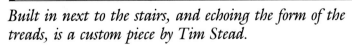

◄
Stone stairs spiral up the height of the structure. The windows are an early example of casement style.

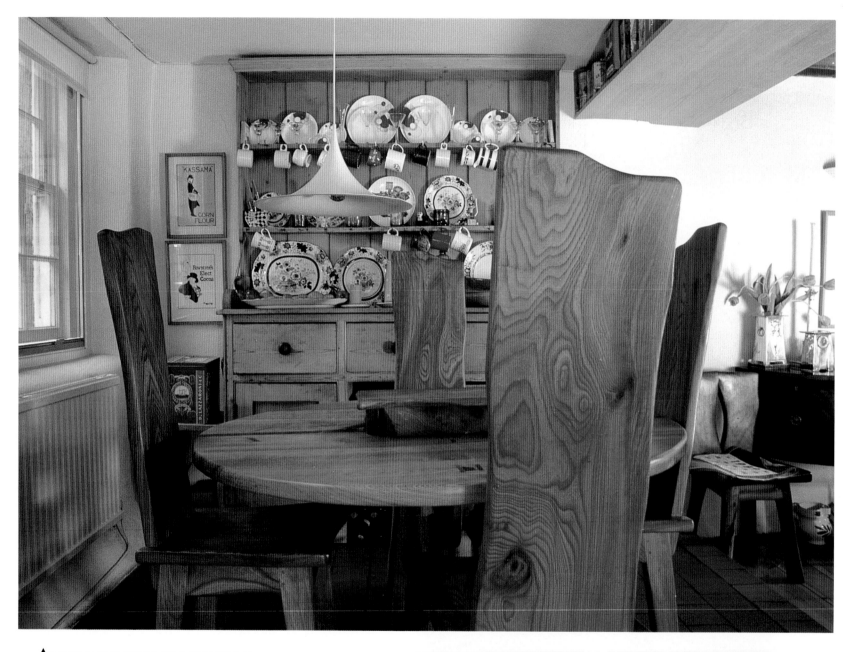

Chairs by Tim Stead contrast with a Swedish hanging lamp and a more traditionally shaped china cupboard.

An ornate stone pediment crowns the front door; the wooden gate at right leads to tiny front court and studio.

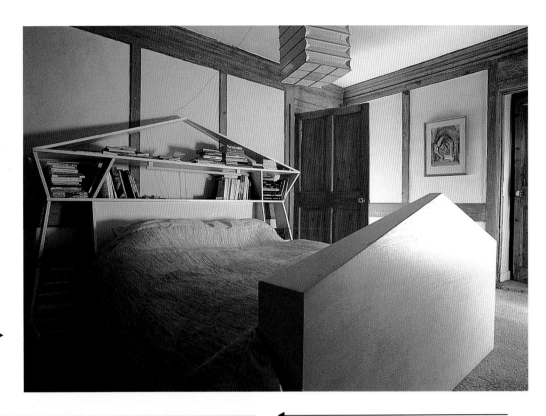

The postmodernist bed was designed and built by Mr. Grigor, who plans to marbleize the surface.

The painted and pedimented bookcase in the study is another Grigor creation. One or more of the family cats can always be found in residence.

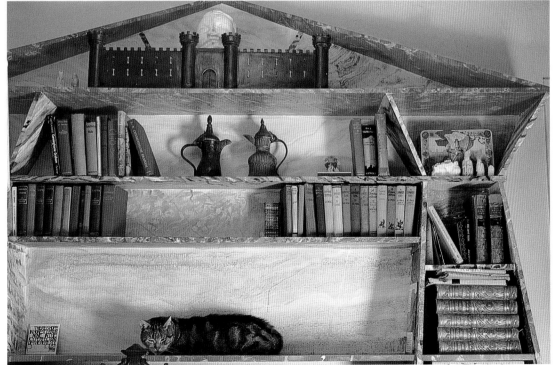

PALLADIAN PROPORTIONS

Owned by a painter and his textile-artist wife, this beautifully proportioned home sits within its high gates in the middle of a village not far from Edinburgh. The house is a textbook example of the beauty and appeal of Palladianism—the scale of the structure, both in the internal relation of the windows to walls to rooms as well as in the strict external symmetry of the facade, is immediately perceived as embracing, comfortable, and dignified.

The owners, although they appreciate the beauty of their home, are not awed by it. They have painted the kitchen a rich shade of persimmon, and have filled it with homey furnishings, sentimental objects, and artworks. The drawing room is a glittering assemblage of white and silver, treated and edited much like a sculpture to be lived in. Not all of the paint on the walls was applied by the owners—the mural that lines most of the top-floor corridor is thought to be original to the house.

The furnishings of the interior were purchased at just a few country sales soon after the purchase of the house, twenty-six years ago. At that time, furniture and decorative objects tended to be undervalued, and much Continental furniture and bric-a-brac was available in ordinary sales and auctions as a result of widespread nineteenth-century Scottish incursions into foreign markets.

Two small buildings frame the entrance drive: one is a painting and drawing studio; the other is a rental cottage.

In the front hall, an upholstered bench holds recent work, while antique paintings hang on the wall above.

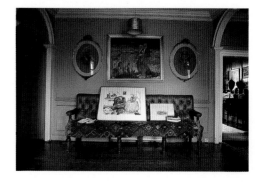

Classical, symmetrical, and yet very Scottish in its height and steepness of roof pitch, the house sits behind its wall on a hill above the village.

The extravagant lines of the couch are a pleasing contrast to the architecture's strict symmetry.

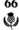

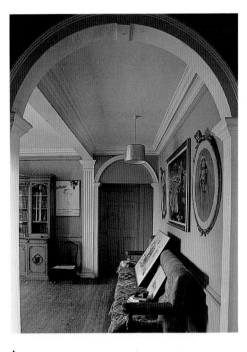

The front hall forms a horizontal axis along the front of the house.

Touches of brass brighten a black and white corner.

An easy chair dappled with afternoon light sits next to the hearth. Linens dry on the fire screen.

Delicate tracery on the drawing-room wallpaper continues the floral theme of the carved fireplace. A glass collection sits on the mantel.

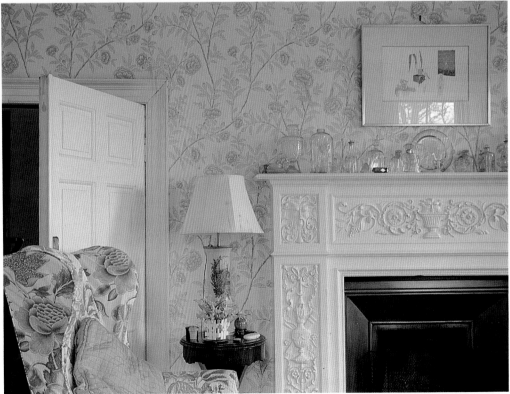

Croquet mallets prop a door.

The elegant craftsmanship apparent in the richly grained paneling in the dining room exemplifies the quality of this home's construction.

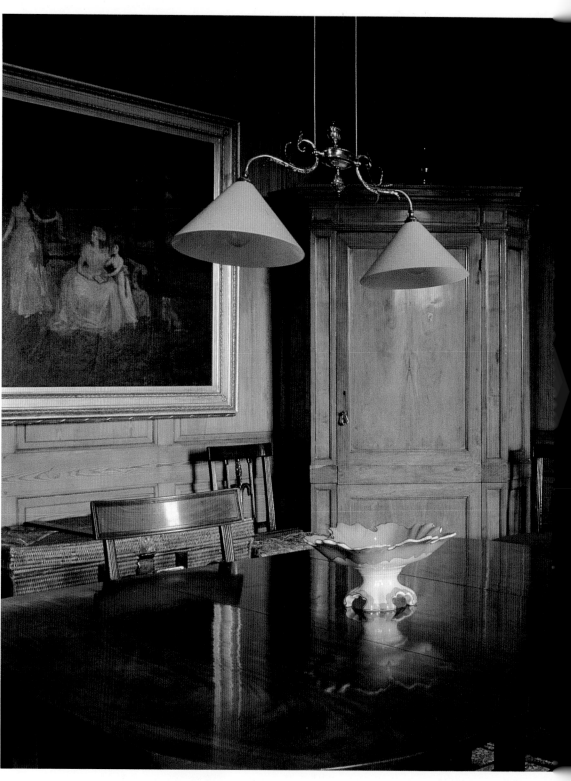

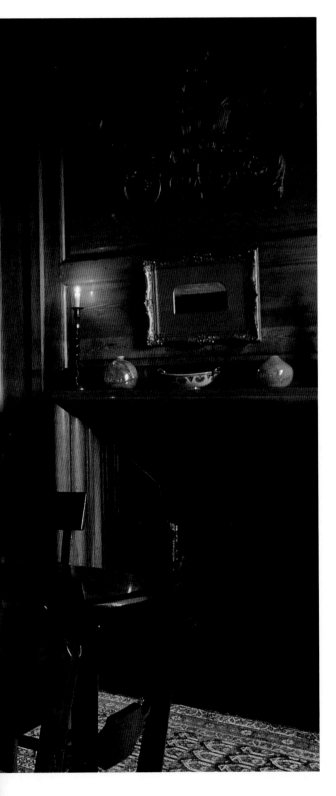

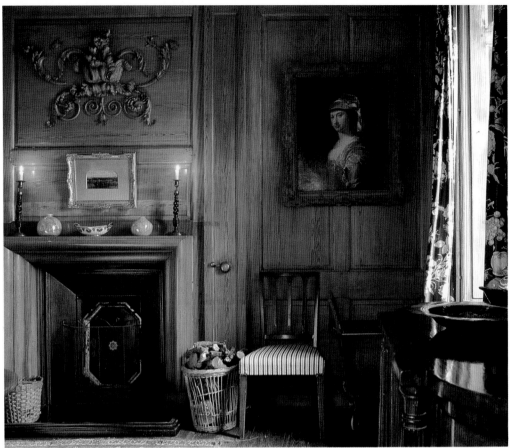

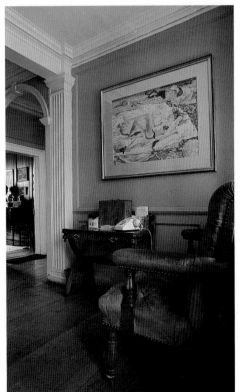

▲

Although by no means a period room, many of the furnishings are Regency. The fireplace is fitted with a coal grate.

◄

White-painted columns have a sculptural quality against the ochre-painted walls.

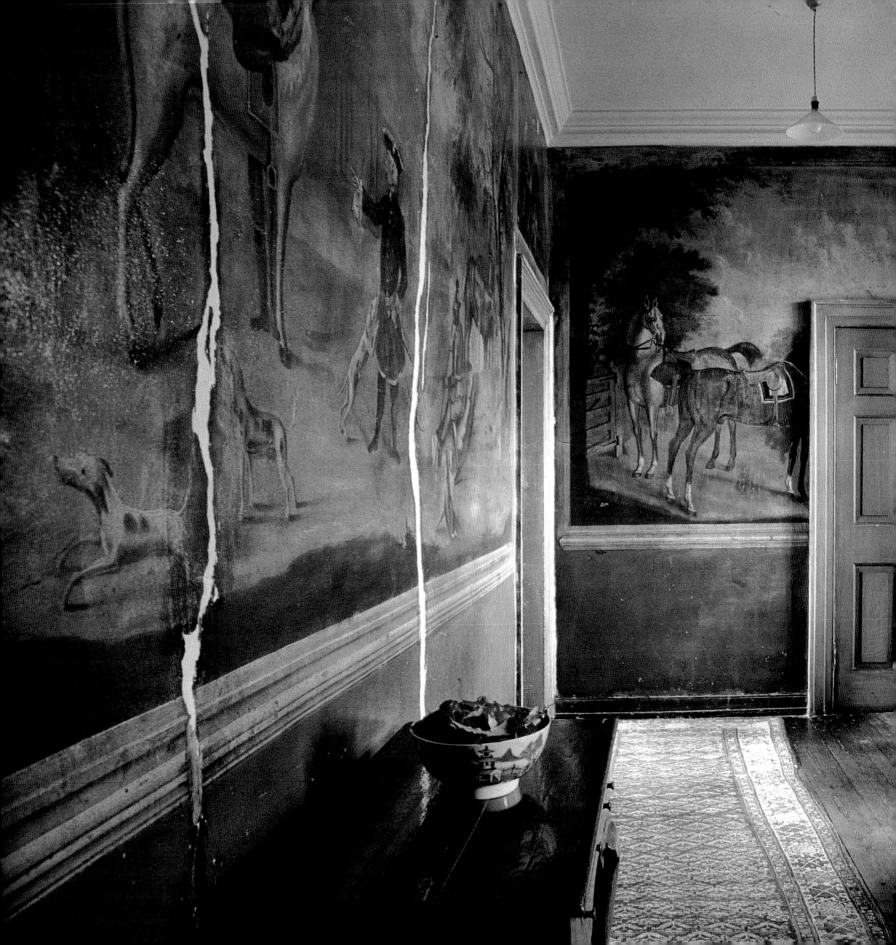

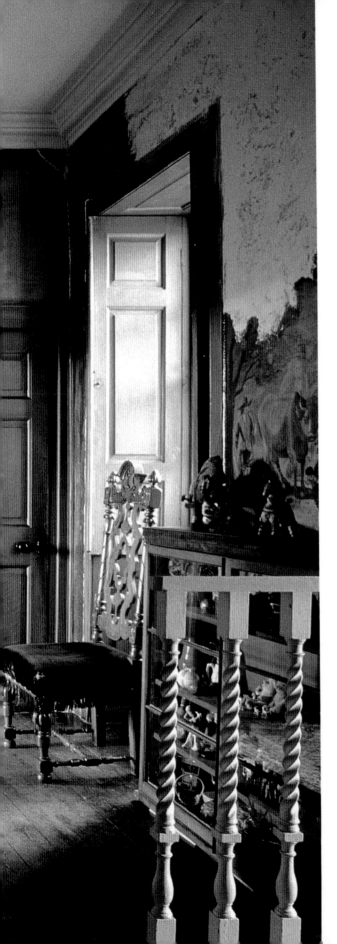

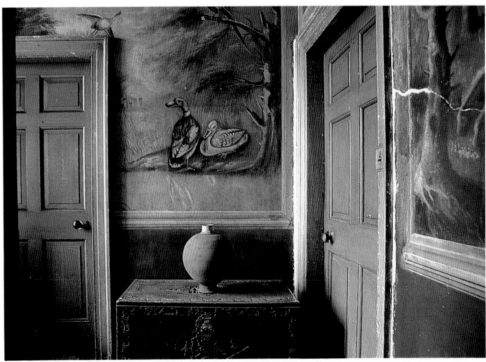

The mural on the third floor is painted along every wall of the hallway. It is thought to be original to the house's construction.

The crack in the wall has been repaired but not painted over to preserve the mural's integrity.

Pine paneling in the bathroom strikes an informal note.

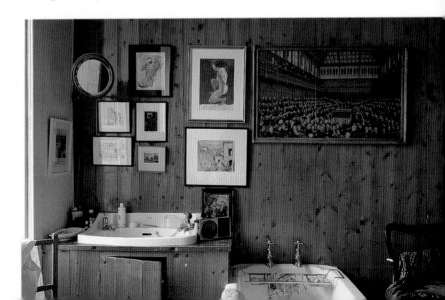

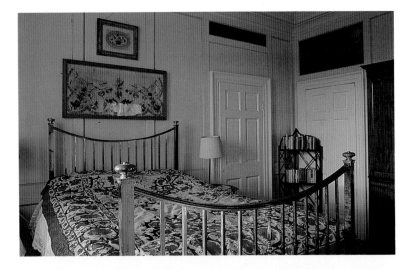

The house contains many beautiful brass beds: the head- and footboards of this one sport a distinctive curve.

A daughter's room has wallpaper made to look like swagged and gathered fabric panels.

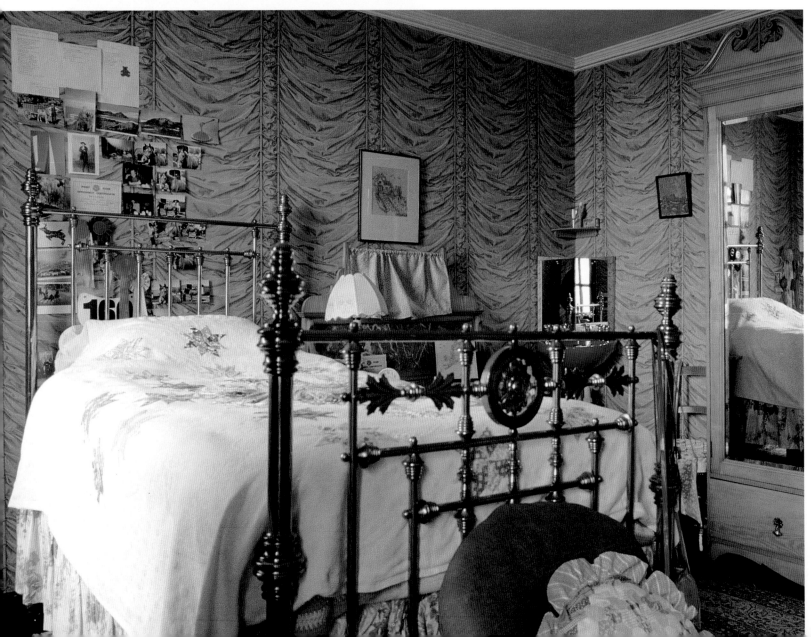

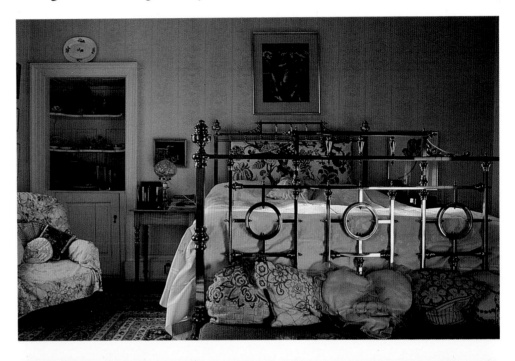

Brass glitters in sunlight cast from the bedroom window.

A Victorian bureau mirror reflects a brass bed of the same period.

Yet another bedroom centered around a beautiful bedstead; this one has a more Gothic air.

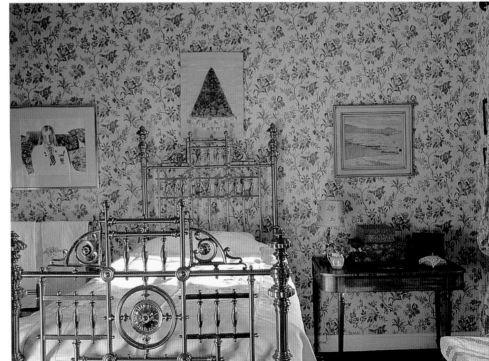

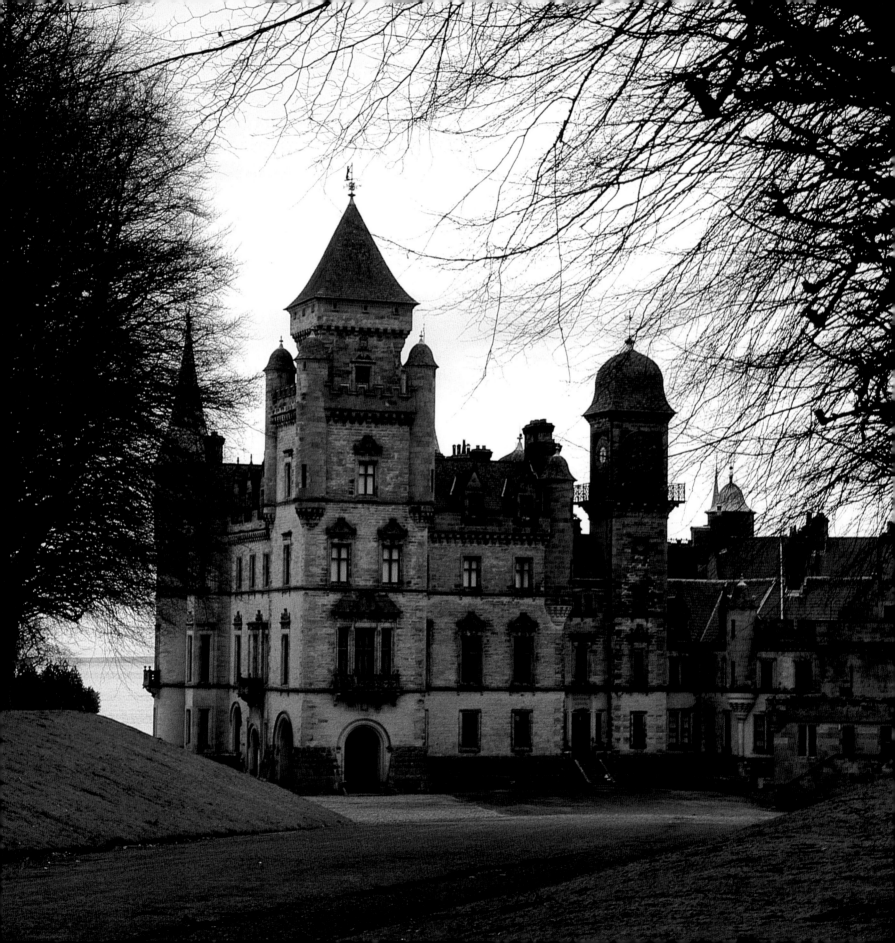

DUNROBIN CASTLE

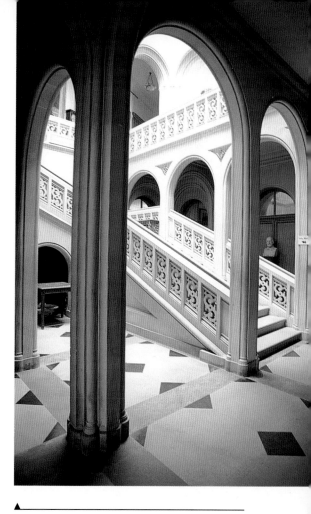

Dunrobin Castle is the largest house in the Northern Highlands of Scotland, and is the seat of the Countess of Sutherland. Parts of the castle date from the early 1400s, but it is the early-nineteenth-century Clearances, during which five thousand people were removed from Sutherland lands, that made the estate notorious.

Harriet Beecher Stowe came to visit Dunrobin as part of a tour of the British Isles after the success of *Uncle Tom's Cabin.* Some Scottish journalists, appalled both by the mass eviction of small subsistence farmers as well as by the lack of publicity that attended it, tried to interest Stowe in the Highlanders' plight. Reasoning that her sympathies would inevitably lie with the oppressed, they tried to inform her of the clearances being carried on around her as she stayed with the Sutherlands. But, as the landscape surrounding the castle remained beautiful and undisturbed and her hosts remained charming, they were unable to persuade her to tour the area and see for herself. In fact, she was so convinced by arguments that justified clearance as an "improvement" that she described the process as "an almost sublime instance of the benevolent employment of superior wealth and power in shortening the struggles of advancing civilization."

Today, although Dunrobin is still known as the site of some of the harshest episodes of clearance, it is also a remarkable showplace, filled with important collections and mementos of the family and of royal visits.

The entrance hall is lit by an atrium. The inlaid floor is marble, and the stairs, railing, and columns are all carved stone.

Formal gardens link the land between the castle and the sea.

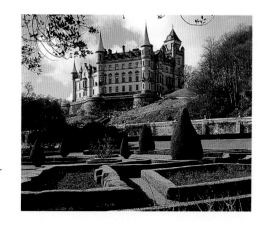

After a disastrous fire in 1915, portions of Dunrobin castle were rebuilt according to a design by Sir Robert Lorimer, a noted Scottish architect.

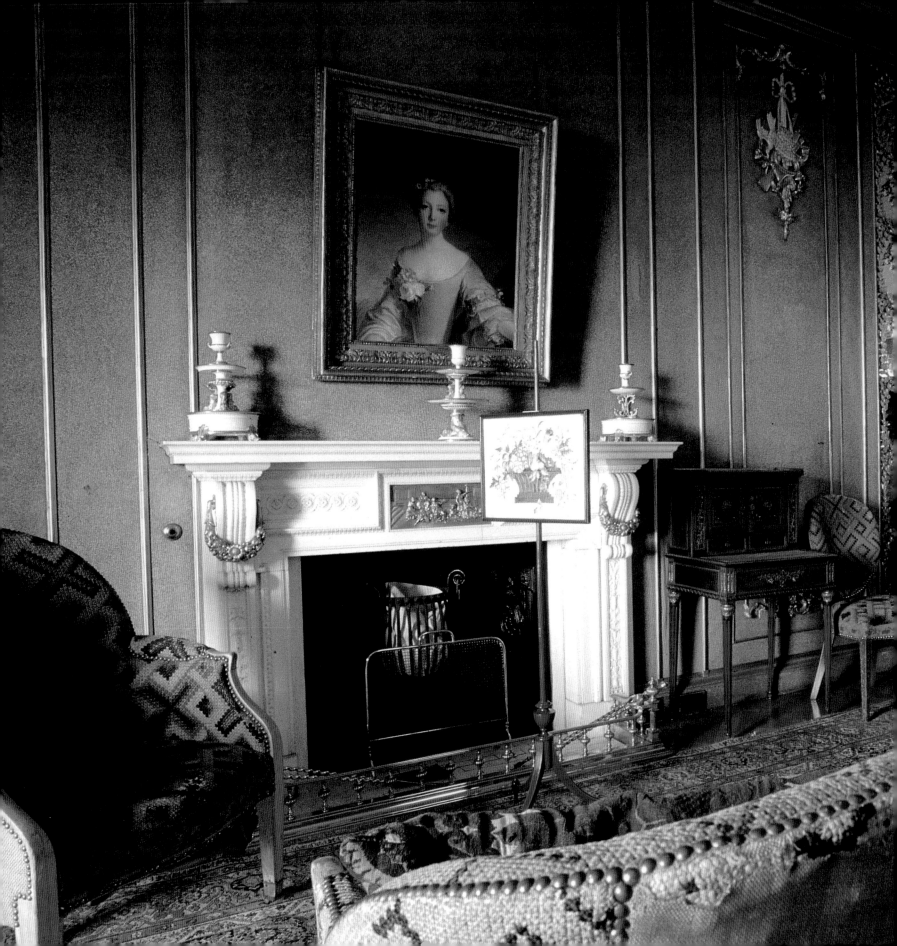

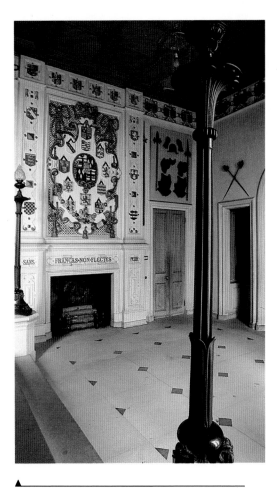

A candelabrum is perched on a marble column to elevate the glow.

The large armorial panel over the entrance-hall fireplace is an expression of Sutherland pride.

This room is called the Green and Gold Room. Its original decoration in the French style, completed in 1921, remains unchanged. The subject of the portrait is the daughter of the Duc de Bourbon.

Deep-green walls set off the gilded frames of family portraits.

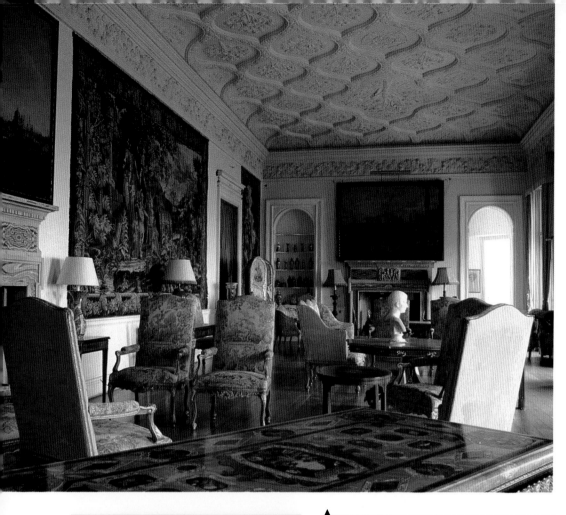

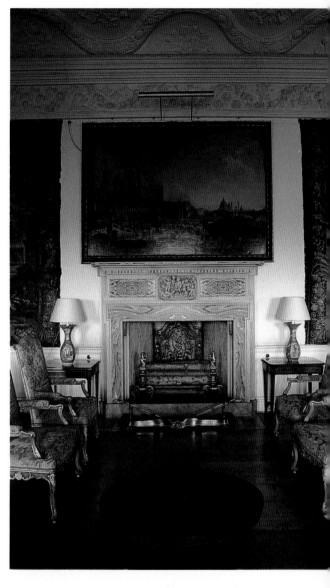

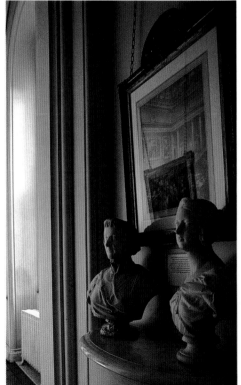

The drawing room has a fine decorative plaster ceiling, a feature of many of Scotland's most notable homes. Itinerant stuccodores, most of them from Italy, made important contributions to houses all over Great Britain and Ireland.

Two busts sit on a small table, guarding the corridor.

The library, which was designed by Lorimer from spaces formerly used as a bedroom and a dressing room, is paneled with sycamore. The round "rent" table on the right is edged with drawers, and was used for collecting debts from tenants.

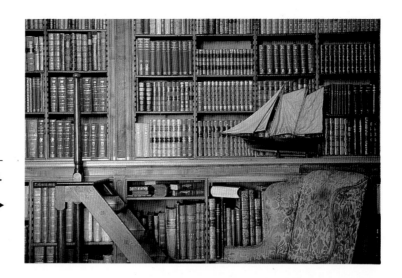

Tapestries fill the gap between chair rail and plaster work.

This library contains over ten thousand books, many of them relating to Scots law and to nineteenth-century Highland development.

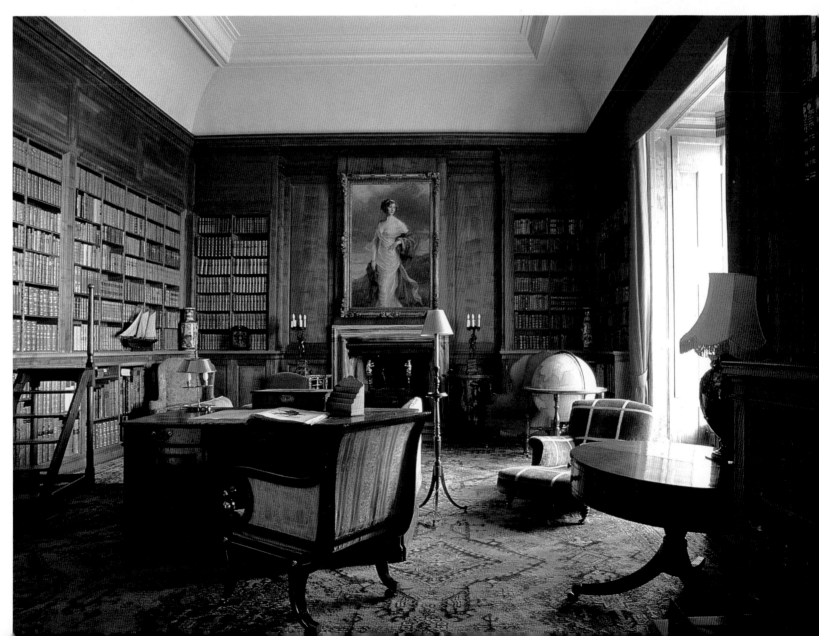

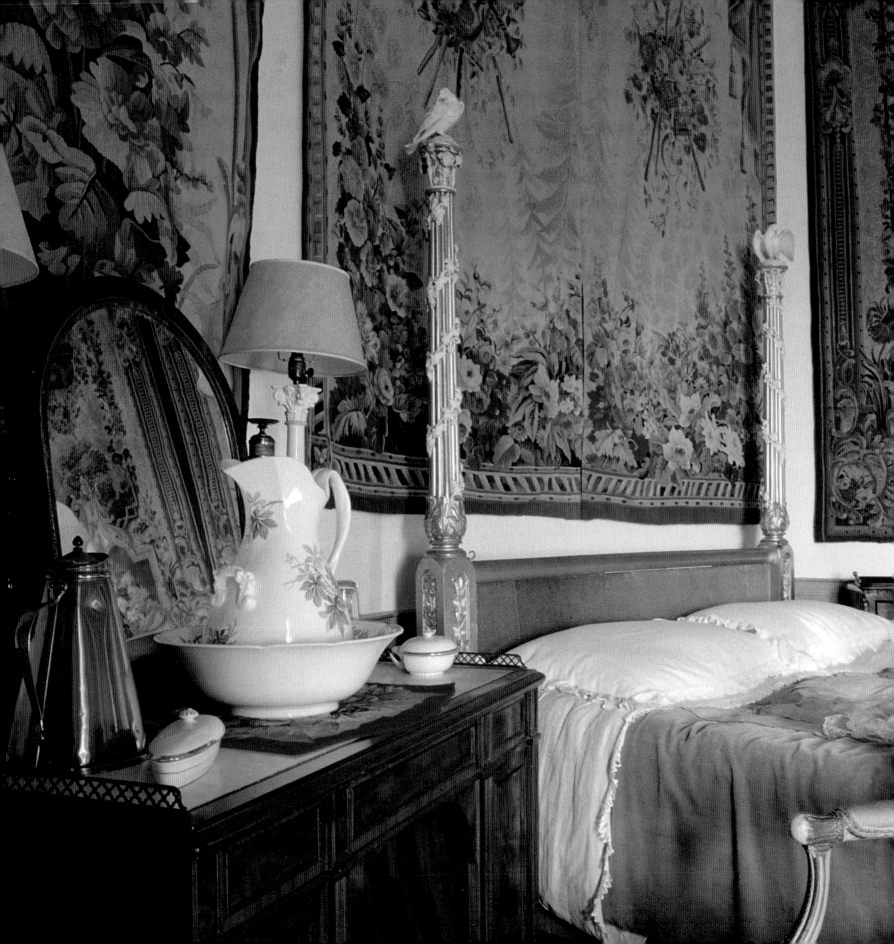

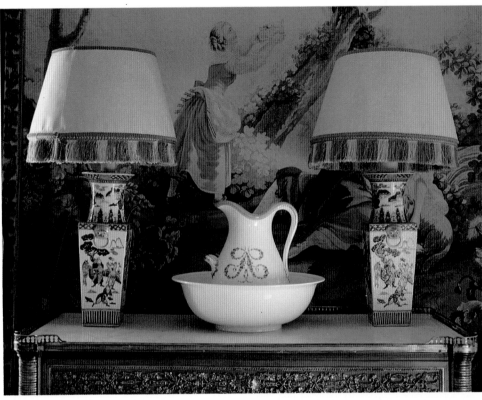

Fringe on the lampshades matches the colors in the tapestries.

This gilded four-poster crowned with birds was slept in by Queen Victoria in 1872. The tapestries on the wall were commissioned for that royal visit, and have pictures of Dunrobin centered in two of them.

Crocheted lace on hanging christening gowns and Battenberg lace on the tablecloth further embellish a corner of the nursery.

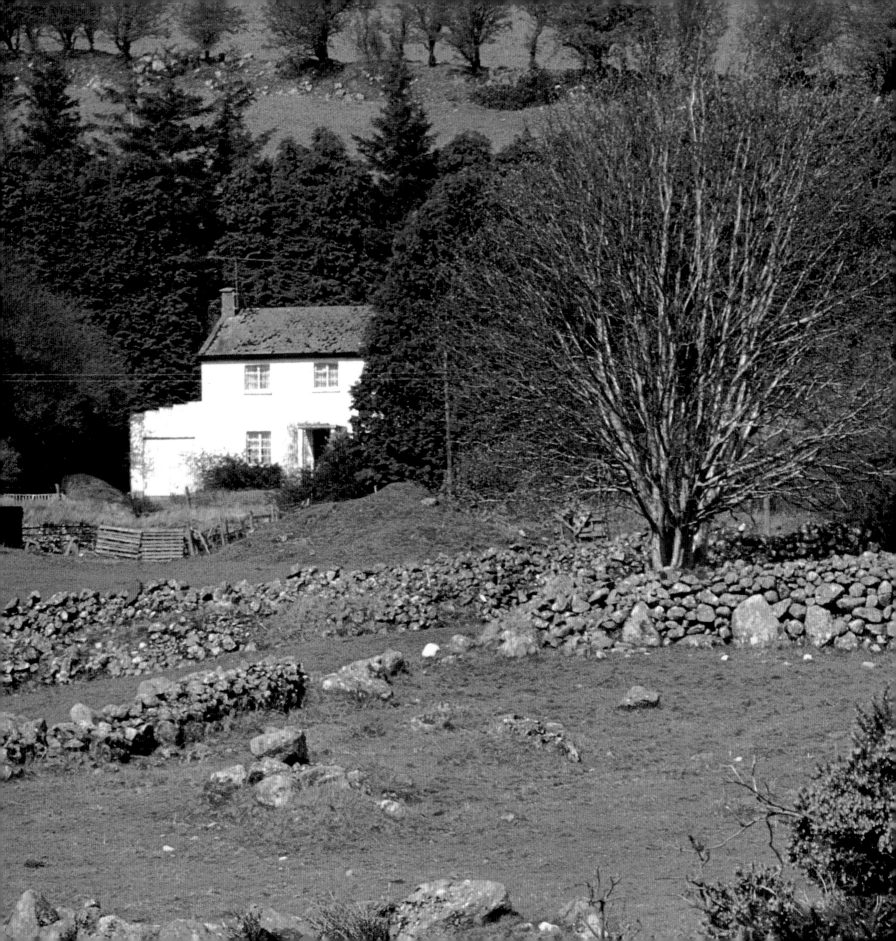

Ireland
Éire

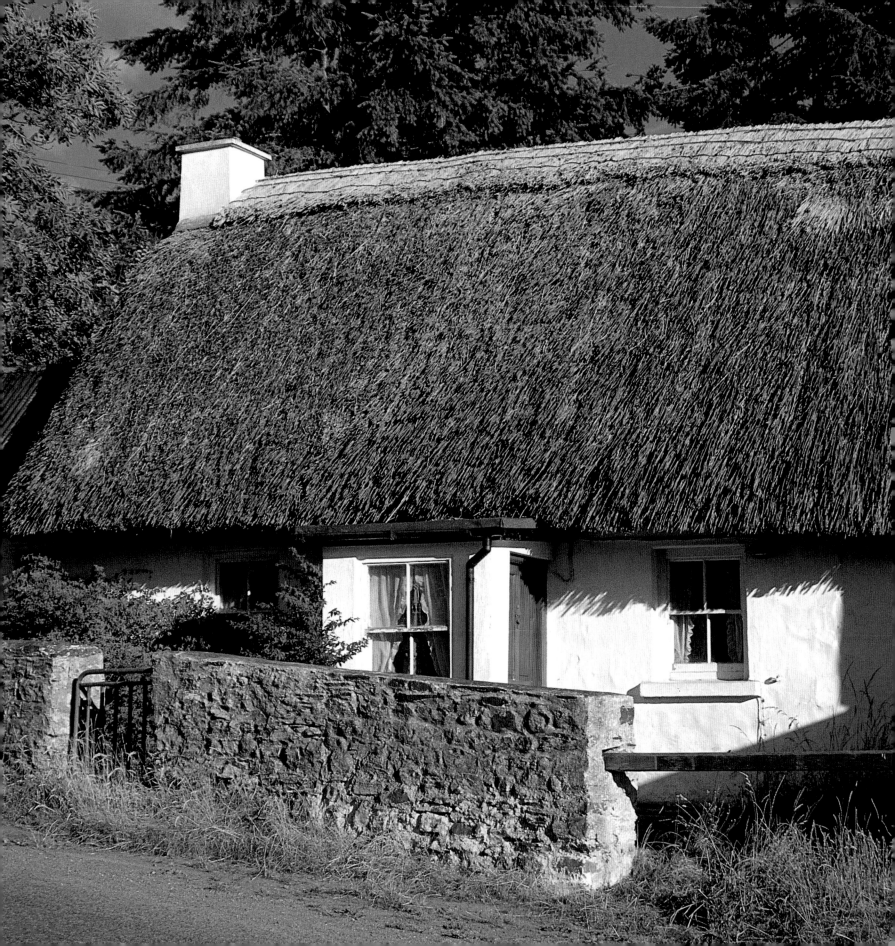

IRELAND

reland. Eire land. Its name alone conjures a wealth of images, sounds, textures, colors, and even smells. Turf fires, peat bogs, a fiddle reeling notes like smoke. Soft colors cross-hatching the landscape, all shot through or surrounded by every green ever imagined. Bright white cottages, low-slung thatch (scarcer now than ever, replaced with stiff metal softened by rust). Vales, mountains, craggy islands, soft round hills, lochs, sweeps of land pointing into the sea. And across that land, whispering, shouting, singing the language with an unequaled mastery, the people of Ireland occupy a landscape that bears witness to their determined efforts to abide well within it.

Ireland's people move through her varied locales with a love for the particularity of each small familiar place enlarged by an exhaustive and continually recounted history. Irish songs, stories, and chat delight in exact naming, making their elements immediate, comprehensible, and intimately connected to both the speaker and to the hearer.

Traditional Irish cottages offer some of these same delights, their soft facades proclaiming their interior organization most directly. Organized (centered, even, by

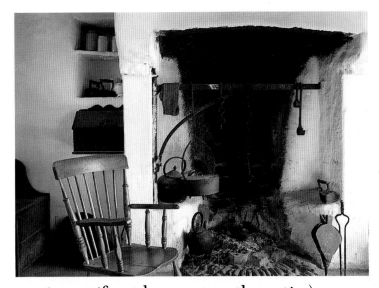

sentiment if not by exact mathematics) around the fire, the front door leads directly to the heart(h). Traditionally, this, The Room, was home. Meals were (sometimes still are) cooked on pots slung from iron cranes over a turf fire. The fire anchors the center of the house, and that center soars to the full height of the roofline, keeping the smoke aloft and letting the space rise with one's spirits. Traditionally, mealtimes brought table and chairs out from the walls, and social (*ceilidh*) time sent the tables back to the edges of the room and stools forward in front of the fire. Furnished with a comforting symmetry, in cottages with a central chimney the wide hearth wall is balanced by a china- (and, in earlier times, sometimes chicken-) filled dresser in the center of the opposite wall. Formal occasions brought the adjoining parlor into stiff use. As one looks at the facade of such a cottage, one can see that the single window on one side of the door marks

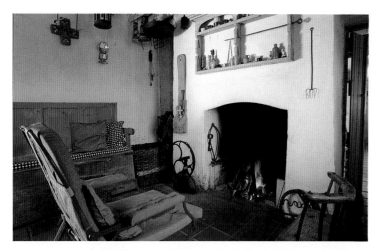

the parlor. The window(s) on the other side of the door light The Room and perhaps a small bedroom.

It is the wide hearth, the bright center, that is the starting place for Ireland's ever-widening ripples of culture, social organization, and sense of place. Henry Glassie, in his extraordinary *Passing the Time in Ballymenone*, says:

Visually, conceptually, and socially, the kitchen is poised to join its people to the world beyond, which expands away from the red fleck of the hearth, drifting from light to dark, heat to cold, dry to damp, familiar to unknown, controlled to uncontrolled. The hearth is the center of the dwelling, the dwelling of the house, the house of the home place; then fields roll, broken by hedged ditches, to merge with other farms. Edges are lost in fields scattered beyond. The home's mode of organization extends in space as fields join, gathering the warm homes of the upland into the center of each townland,

before fading toward cold, wet, unoccupied peripheries. The community is comparably a thing of centers, not margins.

The history of Ireland most discussed around such hearths is well known, spread by song after song. The episodes include stories of risings; of the days of the landlords; of famine; of Land League; and finally, of struggle for Republic that won independence for twenty-six counties, and conflicts within Union to Britain in the six counties of Ulster. In the telling, such stories of Ireland can act as lessons, projecting forward into the future as well as harking back to the past.

Ireland's houses often serve as landmarks in her stories, and the forms of the houses can still remind us most directly of her political struggles. From the modest

cottages from which subsistence farming sustained (until famine) her often impoverished inhabitants to the grand homes of the Norman-Irish conquerors, these stand in contrast to the vast country estates of Protestants granted land by Cromwell. Not only do the architectural styles tell us about their builder's resources and ideals, they also tell us about the social life within.

The quintessential thatched and whitewashed cottage that started my reflections on Celticness was Irish. Built most often of stone whitewashed with lime produced by burning other local rocks, sometimes crucked with wood to support the roof, and sometimes corbeled with stone or locally made brick, the cottage marked the center of the homeplace. This cottage grew from the materials that surround it, gathered small piece by small piece in creels woven

from local grasses and carried on the backs of local people and their donkeys. Every inch of the house came from particular places nearby, and was put together by people one knew and could name. The form of the house was determined by the strength of those materials as well as by local traditions, which may be a way of saying the same thing. Around the house, sometimes attached to it, lay byre and stable, perhaps also outbuildings for livestock as well as for turf and hay. Farther away from the buildings, hedgerows and stone walls further marked areas for cultivating and grazing, the closest-to-home area referred to as the infield and the farther land called the outfield.

Such houses were traditionally built with their backs to a hill and their fronts to the sun, in *clachan,* a cluster of cottages originally occupied by members of the same extended family. Like similar settlements in Scotland and Wales, these communities were composed of communally organized and clan-based tenant groups in which responsibility for aged, infirm, or orphaned members was shared. (Another regional cottage form with gable-ended chimneys, known in Ireland as "byre cottages," were similar to ones in Scotland, essentially long rooms in which humans inhabited the hearth end and animals

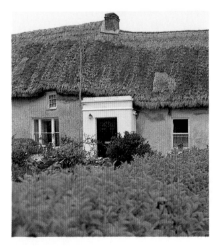

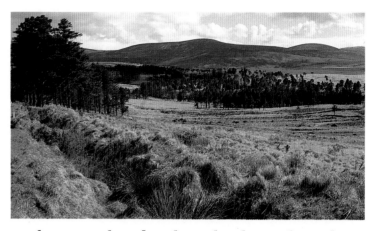

the other.) But whatever the type of cottage, and whatever the original pattern of its settlement, now that roads for cars divide the landscape with a stricter economy than foot-worn paths, newer houses huddle to face the roadside regardless of patterns of light.

The economical interior organization of such vernacular homes is also notable. Built one room deep, traditional cottages link two or three rooms in a row. Sometimes the room(s) that flank the hearth room (The Room) are further subdivided to make that portion of the house two narrow rooms deep. Often ceilings are lower above the flanking rooms to create a loft space used for sleeping, reached by a ladder or two from the side walls of The Room.

Today, although new houses and renovations tend to be built in concrete block with walled entrances that block a direct path

to the now closed-in hearth, the scale and symmetry of traditional Irish cottages are sometimes maintained, albeit with more interior divisions and with harsher edges.

In contrast, grander houses arose out of different traditions, and their forms reflect varied identifications and influences impressed upon their builders and owners. In the mid-seventeenth century, houses were classified and taxed by the number of hearths they contained, reflecting differences between those with the income to support a large house and those unable to do so. Houses on large estates were then fortified and later castellated to protect the rich from the poor; these great estates spawned the grand country and urban houses of the gentry. In their diverse architectural styles, interior organizations, decorative effects, and site considerations, these houses of the upper classes reflect their then very different lifestyles and preoccupations.

In the early eighteenth century, one effect of the Penal Laws (which stripped Catholics and other dissenters of property

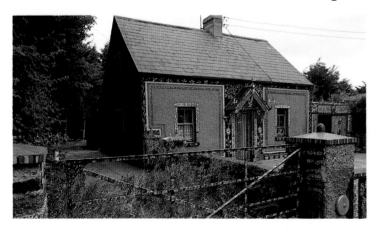

and educational, electoral, and other civil rights) was to enable Protestants eager to assume aristocracy to build large homes in the new Palladian style. Using native craftsmen, their local and often naive renditions further refined the style into a subgenre now known as "Irish Palladianism." These charming buildings ranged from brick town houses in the emerging city of Dublin to additions and renovations of existing rural cottages, sometimes with the addition of second stories and with new roofs slated rather than thatched.

Later in that century, some of the by now established landlords rebuilt the villages of their workers with aesthetics as well as increased profit making in mind (and sometimes, perhaps, with the intention of improving the prospect from their own homes). Such villages (including some settlements for weavers in both the north and the south of Ireland) were planned with what was hoped to be adequate provision for hygiene, comfort, and profitable working conditions. These new villages were to their landlords unquestionable improvements over the mud-floored "rude cabins" formerly occupied by those workers.

With many of the same motives for comfort and aesthetics, in 1757 a "Commission for Making Wide and Convenient Streets" was established in Dublin, to aid and control that city's elegant development. Dublin's mid-eighteenth-century building boom produced scores of well-proportioned town houses clustered around squares, the interiors distinguished by elaborate rococo plaster work and the exteriors by a widespread architectural feature: a well-framed doorway capped by a leaded fanlight. Although these Georgian doorways have become something of a Dublin trademark, they are also visible in scores of other Irish towns.

Like thatched cottages, whose interiors through long use expressed perfectly the social needs of their inhabitants, Irish

Georgian houses also developed established forms that revealed and defined social patterns. Both town and country houses conformed to the same general format, although urban sites squeezed the necessary rooms into a more vertical pattern.

In their rural form, Irish Georgian houses became emblematic of a lifestyle. They look box-like, with a hipped roof that slopes up to a central chimney, and a facade distinguished by symmetrical window bays strung on either side of the entrance. Often surrounded by miles of wrought-iron fences, the houses were approached by long winding driveways that were guarded by gatehouses (sometimes miniature versions of the house itself) and elaborate gates.

The interior layout of such homes is comfortingly predictable to those who know the habits and mores of their builders. In its simplest form, the Georgian country house is read as a series of layers, the extremities assigned to servants, and the middle assigned to the family. Thus the basement is divided into kitchen, servants' hall, and cellars; the ground floor organized around a square hall with twin rooms to the right and left. These are (on one side) the study and breakfast room and (on the other) the withdrawing room and the dining parlor. The next floor might have seven or so bedrooms for the family. In larger and more elaborate houses there might also be a billiard room and perhaps a circular saloon on the ground floor, with a gallery and dressing rooms on the bedroom floor. The attic was invariably reserved for servants' sleeping quarters. These houses, which are visible all over Ireland, were so liked by the gentry that they had them reproduced on smaller scales for their tenants.

By the nineteenth century, Georgian houses had evolved into "villas" (villas later became the name used for suburban detached houses, but their original meaning referred to these post-Georgian substantial homes). Early villas of the nineteenth century were distinguished by their neoclassicism, often graced with such

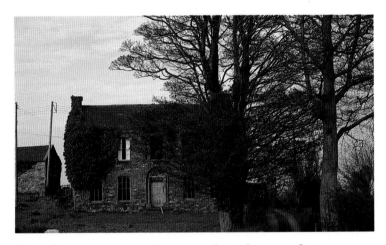

details as Ionic columns that frame the doorways. The romantic idealism expressed in the neoclassicism of upper-class homes of this period can at least partly be read as a response to issues of Union.

Famine, which tragically and unnecessarily marked the midpoint of the nineteenth century in Ireland, was in large part but not entirely an interruption to the building activities of the landed gentry. Curiously, however, within the twenty years subsequent to Famine, when more than a million Irish people died of starvation, and a further million emigrated, most substantial Irish country houses were graced by the addition of a large plant- and flower-filled glass conservatory, which provided a pleasing vista from the drawing room.

The vastly different ways in which domestic architecture reflects class are not exceptional to Ireland or even to other Celtic regions: they are characteristic of our whole human cultural history. What is interesting about today's perspective on

Ireland's housing, however, is the many ways in which we idealize the forms of such houses at both ends of the spectrum. We find ourselves fascinated by country-house living, and by the traditions and practices of interior decoration that characterize them. And on the other side, many of us have romanticized the furniture, artifacts, and lifestyles that characterize cottage living. Irish cottages, because their forms are so typically "home-like," small in scale, and accessible, lend themselves particularly well to such idealization.

The interiors of the houses that follow span a range of traditions, from modest to grand, from vernacular to designed, from old to new, and from both the Republic of Ireland and Northern Ireland. Their diversity reveals Ireland's varied forms as well as her resonant culture.

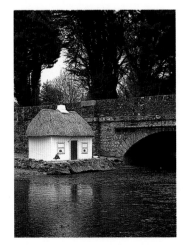

MELLON COTTAGE

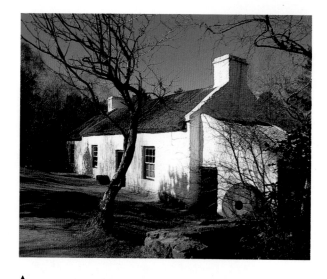

The Mellon family of Pittsburgh trace their ancestral home to this early-nineteenth-century farmstead, which is now part of a group of cottages in the Ulster-American Folk Park in Northern Ireland. Although this house was built only a century ago, it is very similar to cottages of a century or two before that. A typical example of the kind of small farmstead from which many immigrants left Ireland for America, it was from here, in 1818, that Thomas Mellon (then aged five) and his family emigrated. He later wrote that it was this house that formed his mental picture of "home."

This internal picture of "home" as a modestly scaled whitewashed cottage with a low overhanging roof is extremely pervasive. So many Irish, Scottish, and Welsh settlers carried its image with them that it has become a kind of memory-embedded icon of American architecture. With a change of materials from stone and thatch to wood clapboards and a slate roof, it is very close in form to the archetypal "Cape Cod" house built early in this nation's development, as well as being one of the most popular house forms in suburban housing of the second half of this century.

Inside as well as out, this house exemplifies an Irish cottage: the hearth centers and dominates the interior, and is balanced by the china-filled dresser and table set against the opposite walls.

Thatched, whitewashed, and melting along the edges: Mellon Cottage's softness exemplifies an Irish cottage.

Hearths provide heat, a place to cook, and a social center. The iron cranes are used to suspend pots over the fire.

Set against the back wall, the dresser holds spongeware and delft.

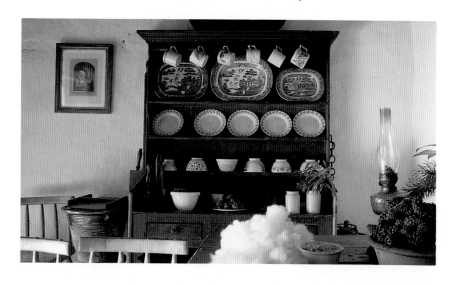

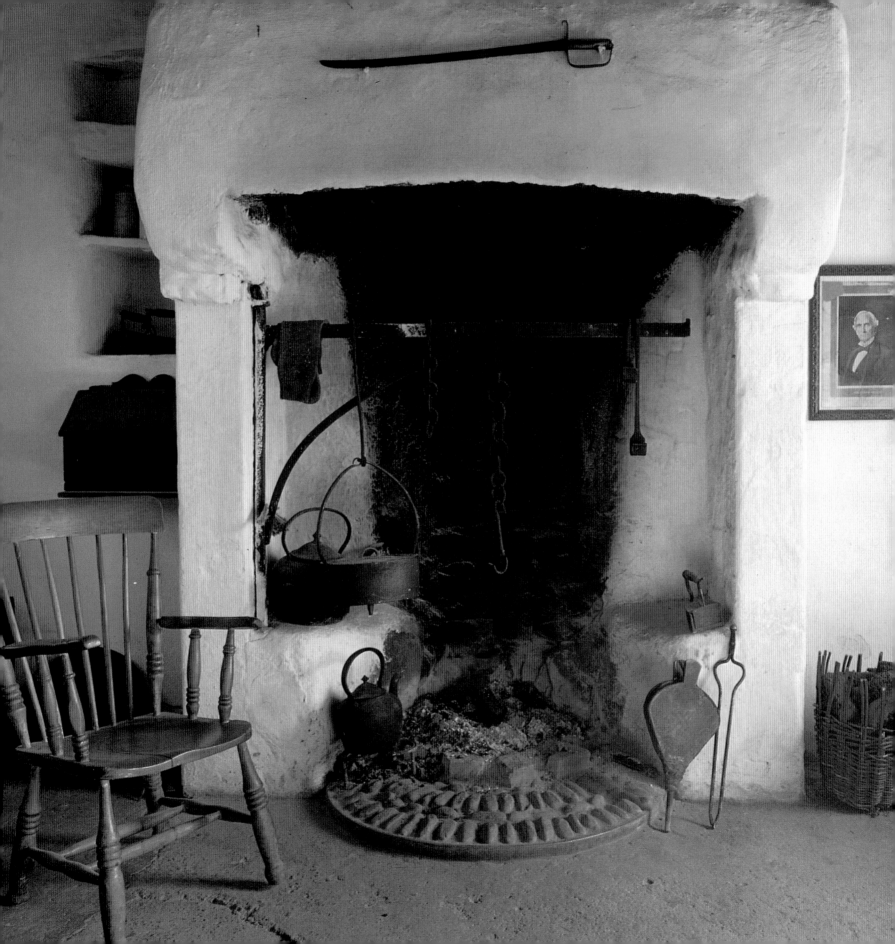

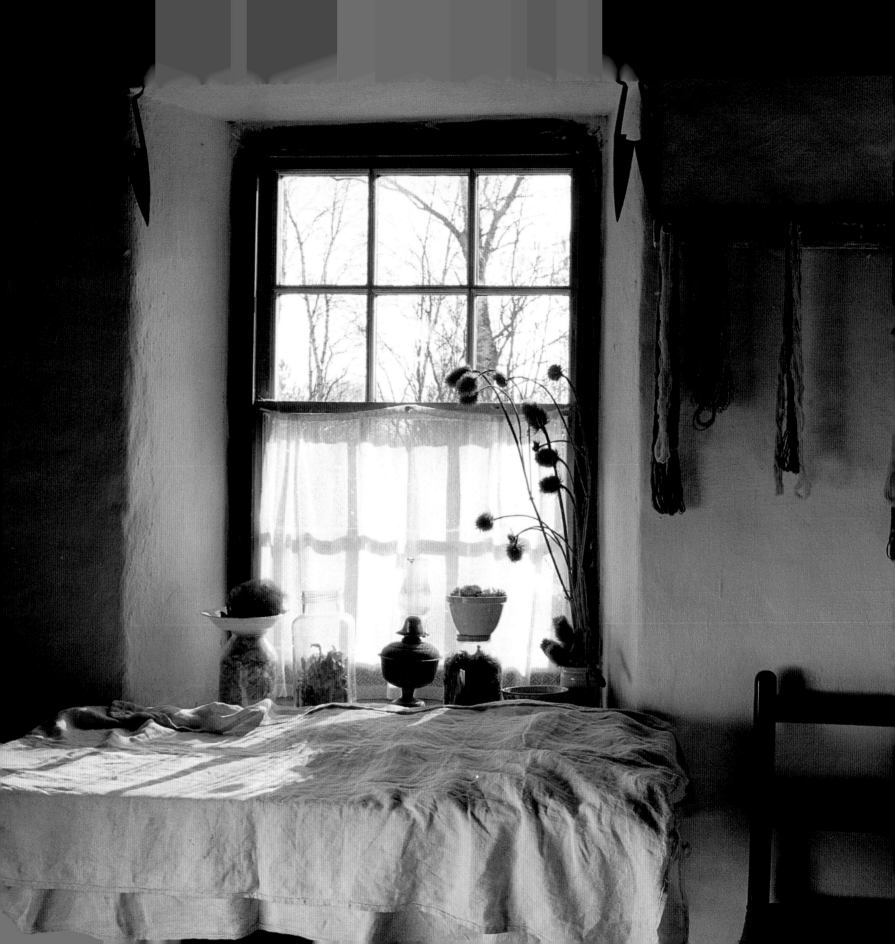

A metal jug and bucket rest on a pine worktable with brass pulls.

An ornate Victorian clock adds a luxurious touch to the interior.

The window is half-curtained for privacy. Potato-based bread is rising under the cloth.

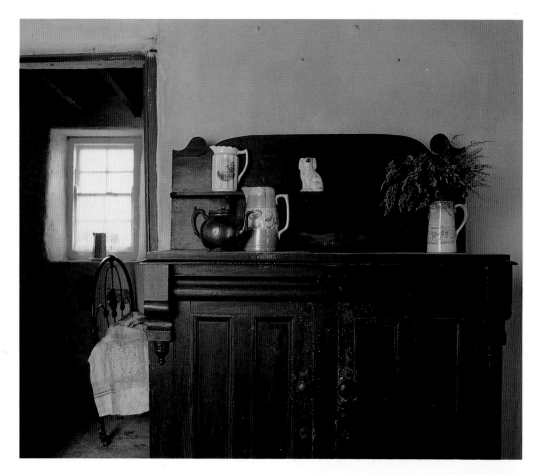

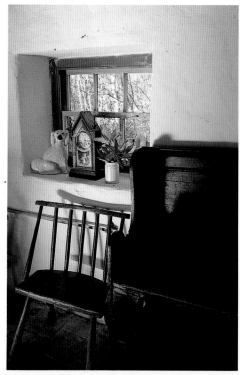

▲

A corner of a back bedroom off "The Room" can just be seen.

▲▲

A famine chair sits beneath the window. Settles like the one at right were sometimes used for sleeping.

→

A Dutch door makes it possible to be private and social at the same time—you can talk through the opening without inviting the visitor to step inside.

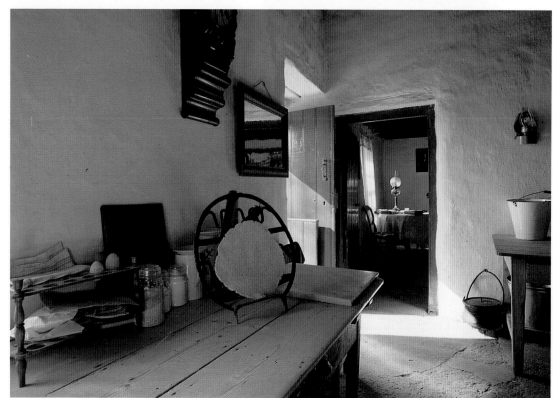

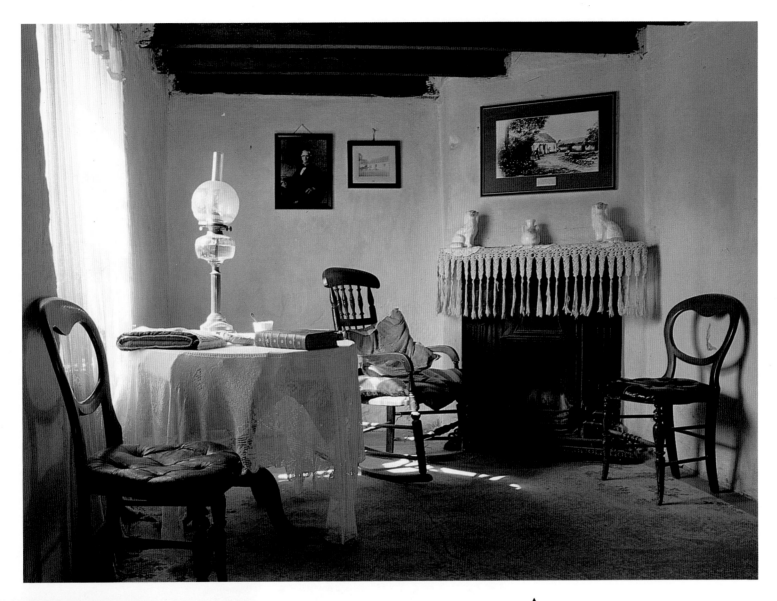

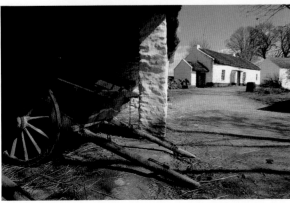

The stone barn, set at a right angle to the cottage front, defines one side of the farmyard.

Decorative cloth trims the mantel in the small formal parlor.

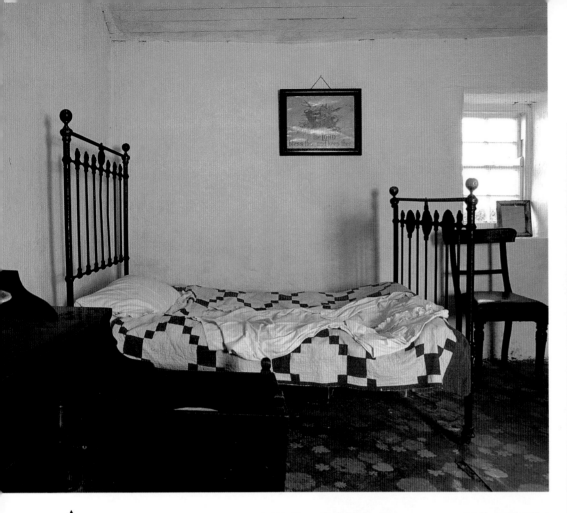

Irish patchwork quilts are quite often red and white. This pattern is known as "Single Irish Chain."

A cradle rests on the floor next to the parents' bed.

Private sleeping space was a great privilege that most often went to the aged or infirm.

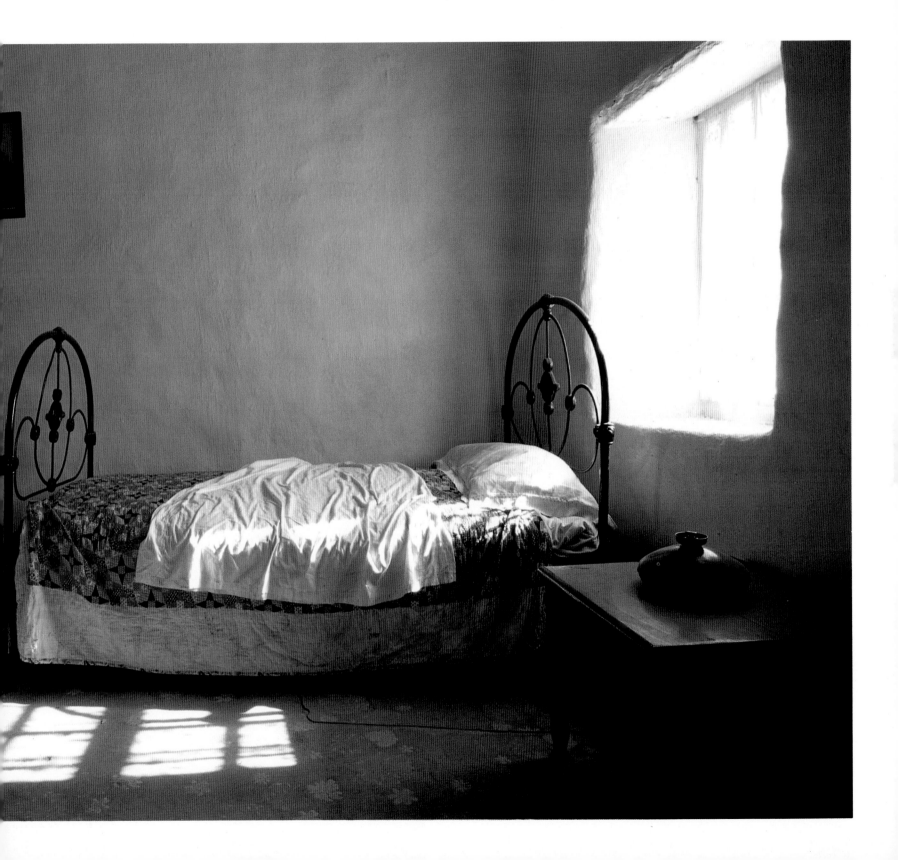

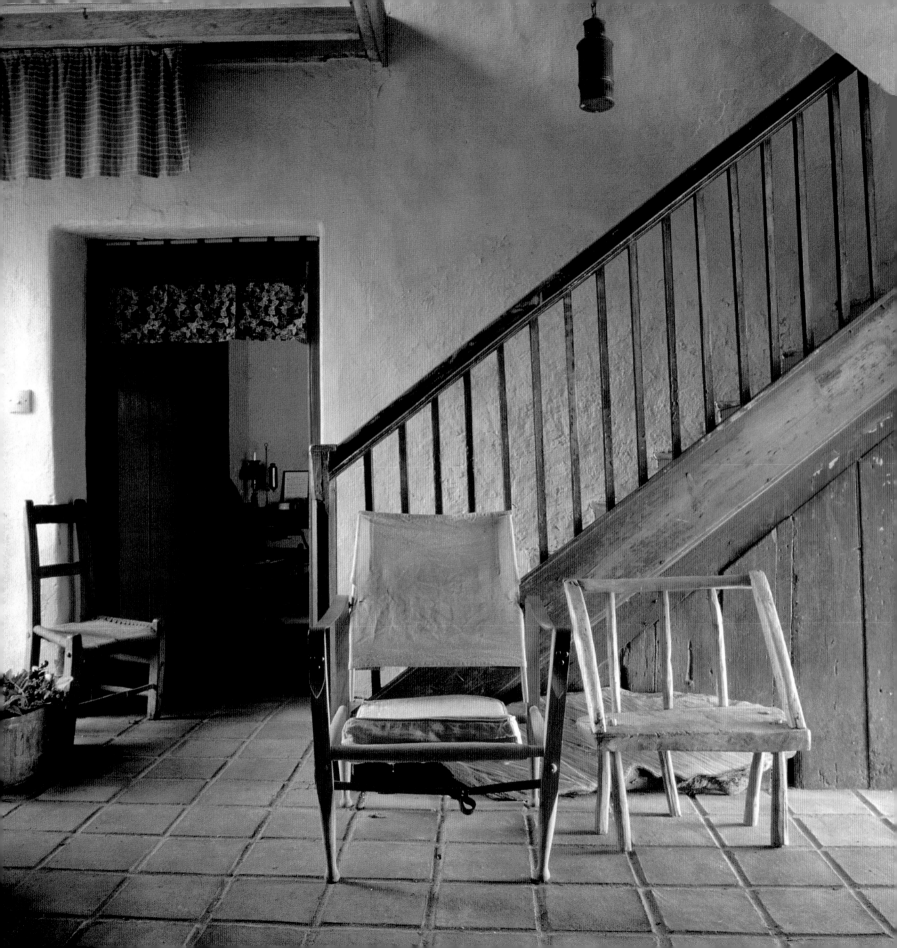

ARTFUL FARM

Noted painter Patrick Scott lives in a restored mews house in Dublin (see page 111) and on weekends repairs to an old farm complex in the Wicklow hills. Although both of these homes reflect his extraordinary talent for creating comfortable and stylish interiors, it is the welcoming and simply furnished weekend place that best exemplifies an ideal vision of home. It is not surprising, therefore, that more than one visitor has called it "the place in all the world I would most like to live."

When Scott purchased the property in 1963, the buildings had been abandoned for several years. Built in the 1820s of granite, the small farmhouse was connected to the old stable and long barn. Scott broke through the common walls of these structures to create a series of living and working spaces. The stables became a kitchen with a small sleeping loft above, and the long one-roomed barn remained open to the rafters, functioning as both studio and dining room.

The house is furnished with a mixture of artist-designed objects and Irish vernacular pieces, many of them found or cheaply purchased when others thought them valueless. These furnishings reflect Scott's appreciation of the old-fashioned and once common elements of Irish rural life. Fireplaces still have their cranes (or new ones) for cooking pots; a Connemara-made basket coop for chickens sits decoratively on the floor of the old barn; dressers filled with spongeware grace every ground-floor room; and traditional blue-and-white-checked horse blankets have been made into heavy draft-stopping curtains on doors and windows.

A famine chair sits next to its Scandinavian canvas-and-wood cousin.

All of the beams have been white-washed to make the ceiling seem higher. The pine piece over the fireplace was made to hold iron poles, or spits, for roasting meat over the fire.

A wall-mounted dresser (one of many) holds blue and white china.

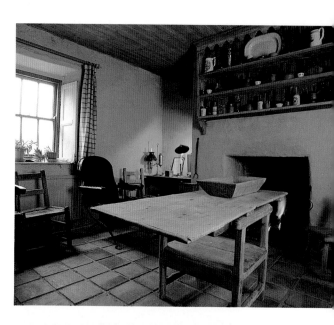

The basket on the floor at right is a chicken coop from Connemara.

A settle flipped into a table is set in the center of the room. Double-duty furniture makes living in crowded settings easier.

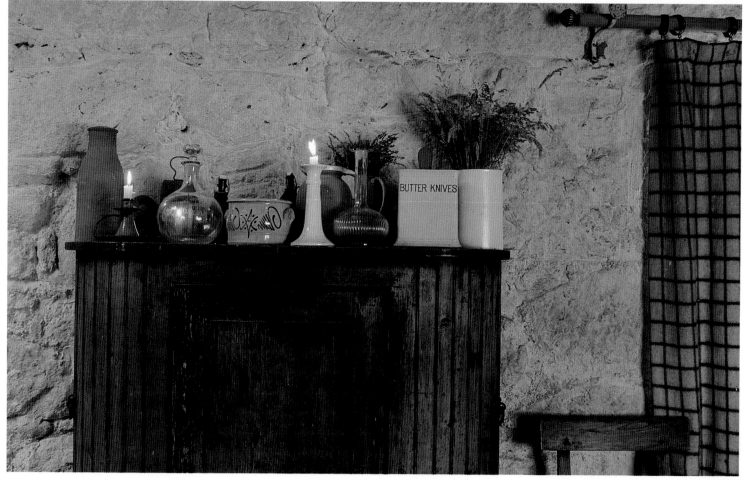

▲
Metal pincers used for holding primitive lights made from flaming bulrushes sit on the windowsill.

◄
The thick blue-and-white-checked horse blanket does such a good job keeping drafts from the house that the candles don't even flicker.

►
Terra-cotta tiles have replaced the original floors and serve to unify the renovated spaces.

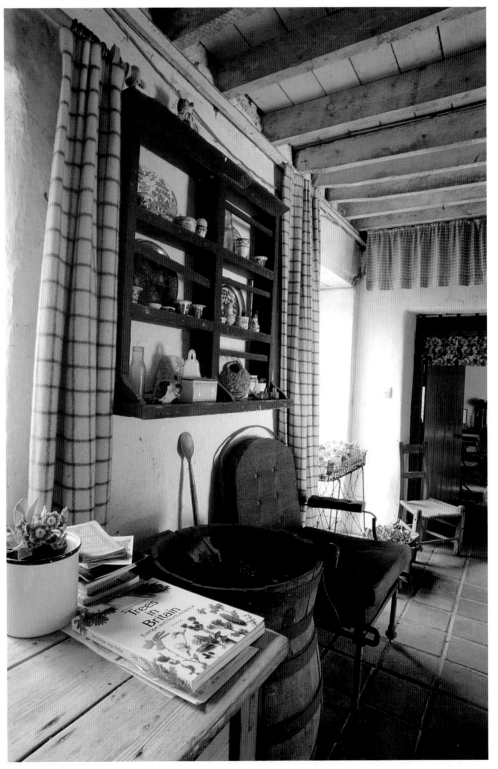

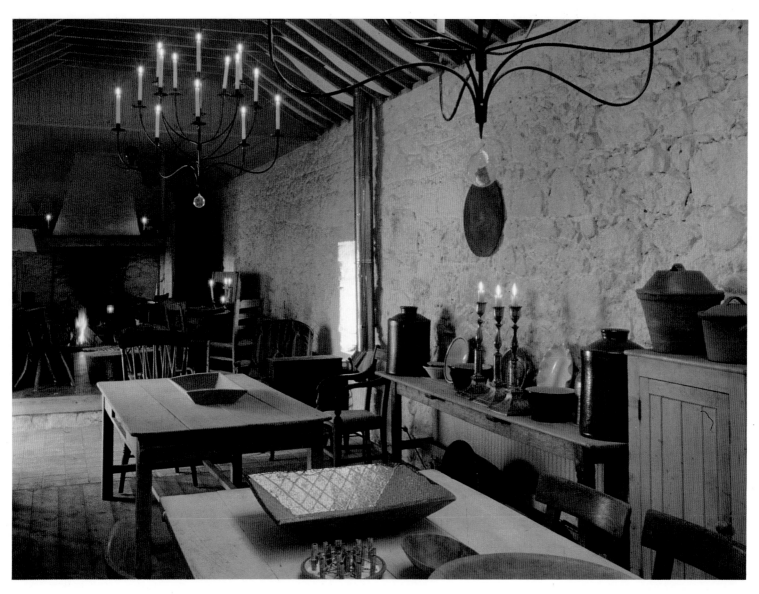

In the long barn that is now both studio and dining room hang two large wrought-iron chandeliers designed by Scott.

Candles provide a glow that can't be achieved with any other form of light.

Famine chairs cozy up to a peat fire in a vignette that could have taken place almost anytime during the last hundred years.

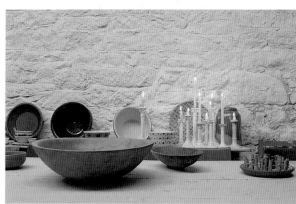

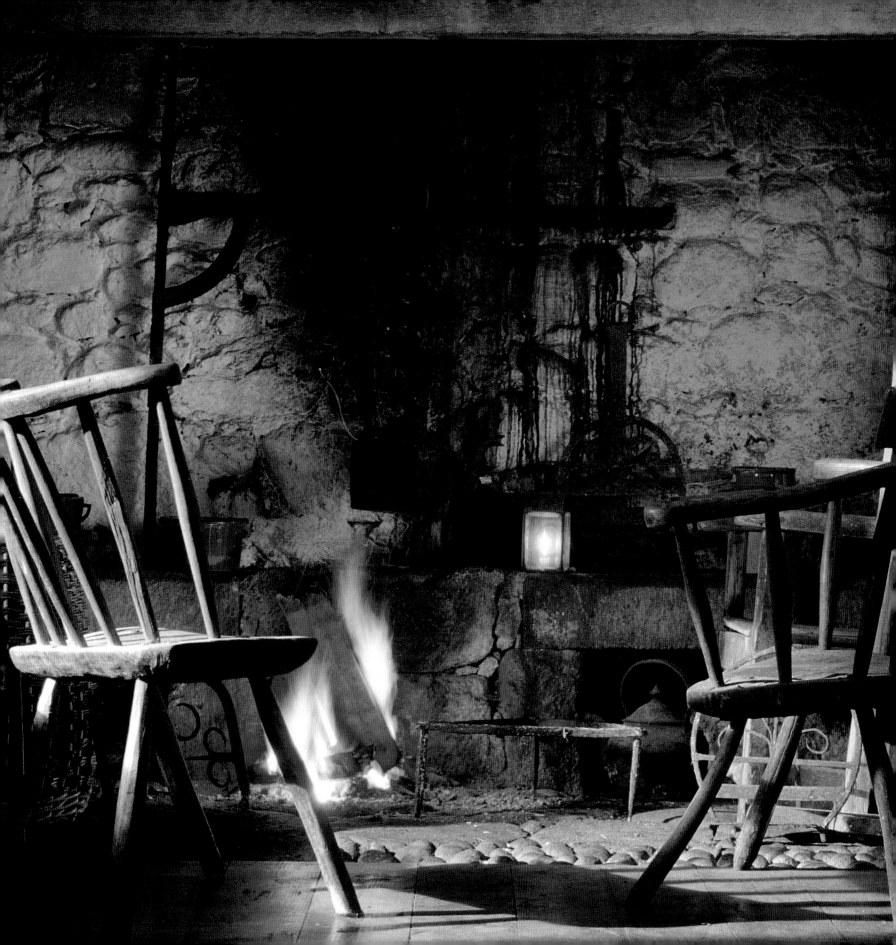

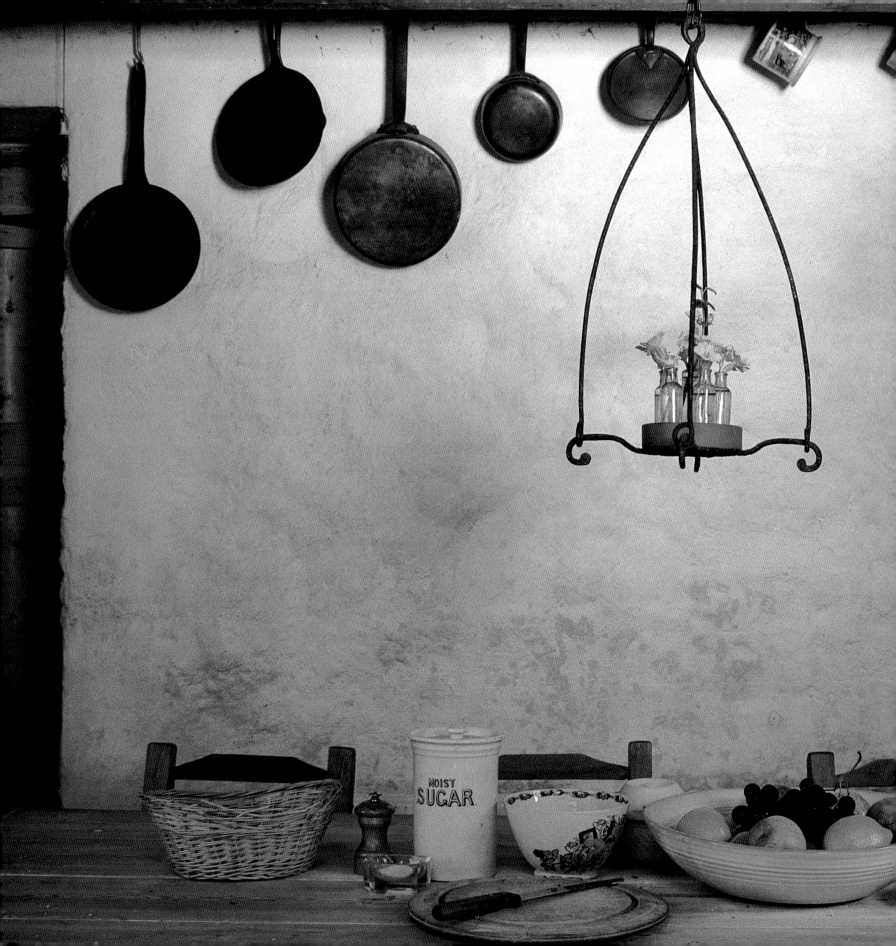

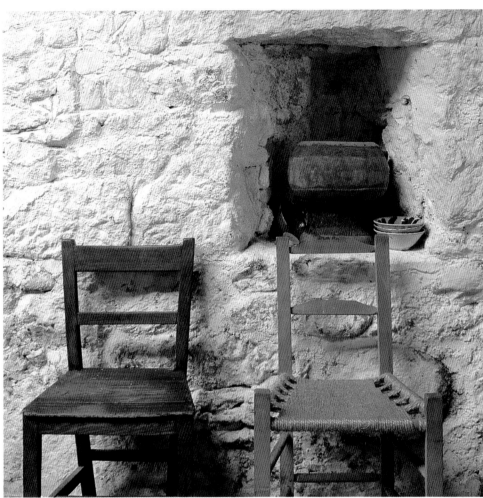

Two traditional slat-back wooden chairs show subtle variations on a common theme.

Artful still-life displays have been arranged above and on top of the scrubbed pine kitchen table.

The original house, shed, and barn are now merged into a single building for living and working.

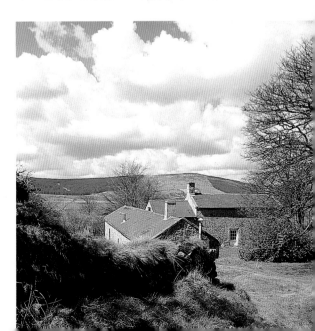

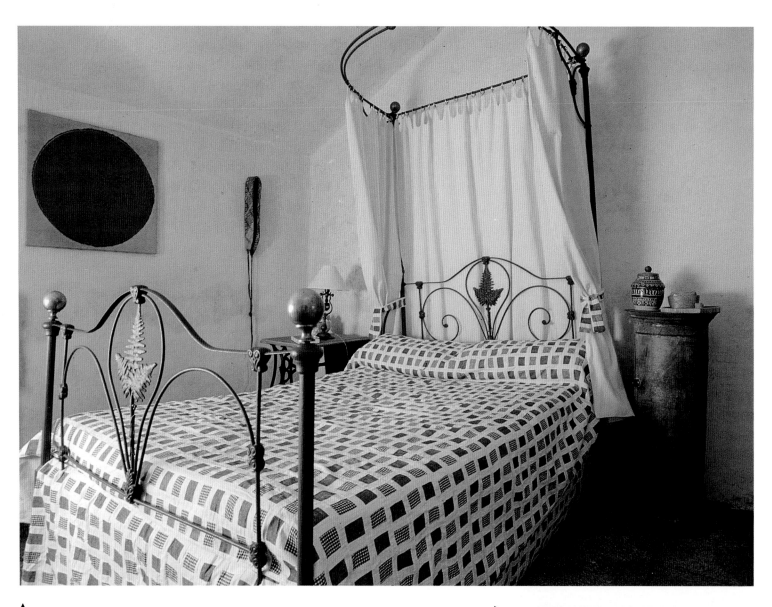

Scott has extended and amplified the headboard posts of his brass-and-iron bed into new partial canopies.

Two round adjustable mirrors flank a third fixed reflector on top of the bureau.

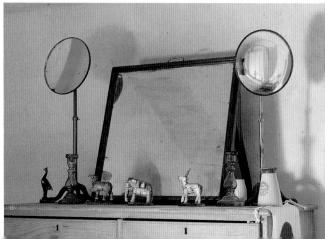

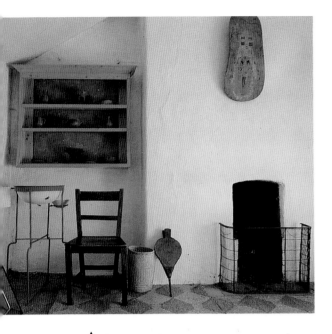

The interior of a cupboard has been painted blue in this corner of one of the upstairs bedrooms.

The pine-paneled bathroom is also rich in atmosphere and resonant detail.

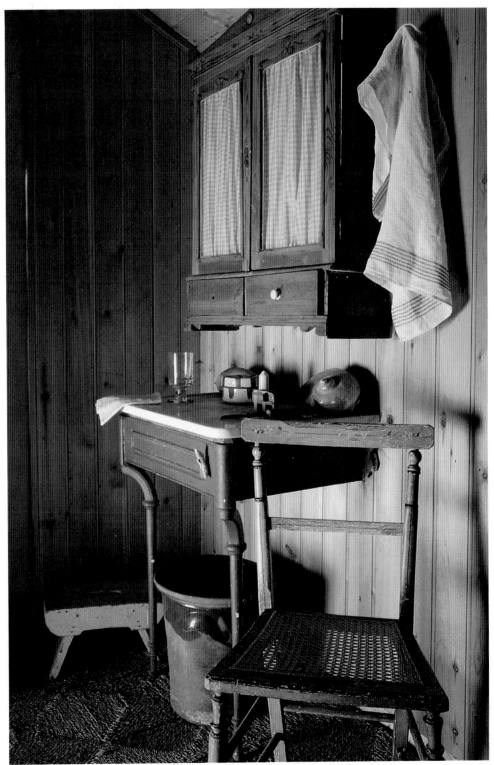

MEWS HOUSE, DUBLIN

Pat Scott's mews house is near the center of Dublin. Like many such mews houses, the side that faces the town house to which it originally belonged is characteristically decorated with neoclassical freezes to provide a pleasing vista from that house. The street side (now the front of the converted mews house) has a more functional appearance.

Once one passes through the front gate and into the house, however, pleasing vistas abound. Scott's aesthetic sense glories in rich detail, and the town version of his home carries a sophisticated wallop. Although the house essentially consists of one large room downstairs with bedrooms above, the arrangements within that room are so carefully planned that it feels more spacious than it really is. Rich color and pattern delight the eye, and everywhere you look there are small vignettes that further enhance the setting. Comfortable couches frame the sitting area, surrounded by shelves filled with books and crafts. Nestled under the iron spiral stairway, a dining table commands a longer view of the room. On the far wall, next to glass doors leading to the garden, a secretary holds porcelain by potter Lida May.

A small kitchen at the front of the building is entered from the foyer. A tiny cobbled yard in front, and a carefully landscaped garden in the rear, extend the home's living space in fine weather.

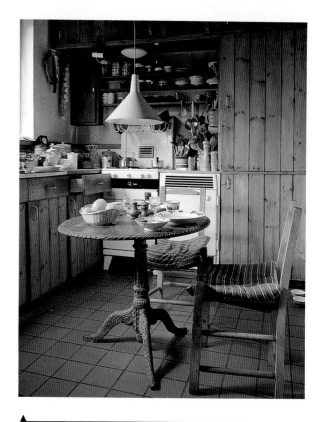

An old round side table sits exactly in the center of this small kitchen.

An iron spiral staircase connects the two levels of the house. The painting is by Patrick Scott.

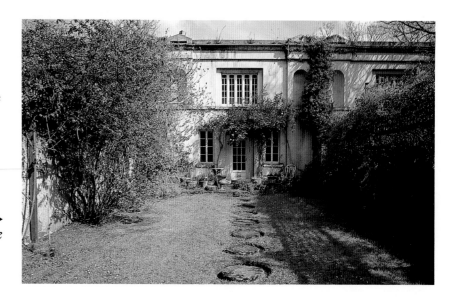

The "front" of the mews house faces the back garden, where it would have been seen from the rear of the town house.

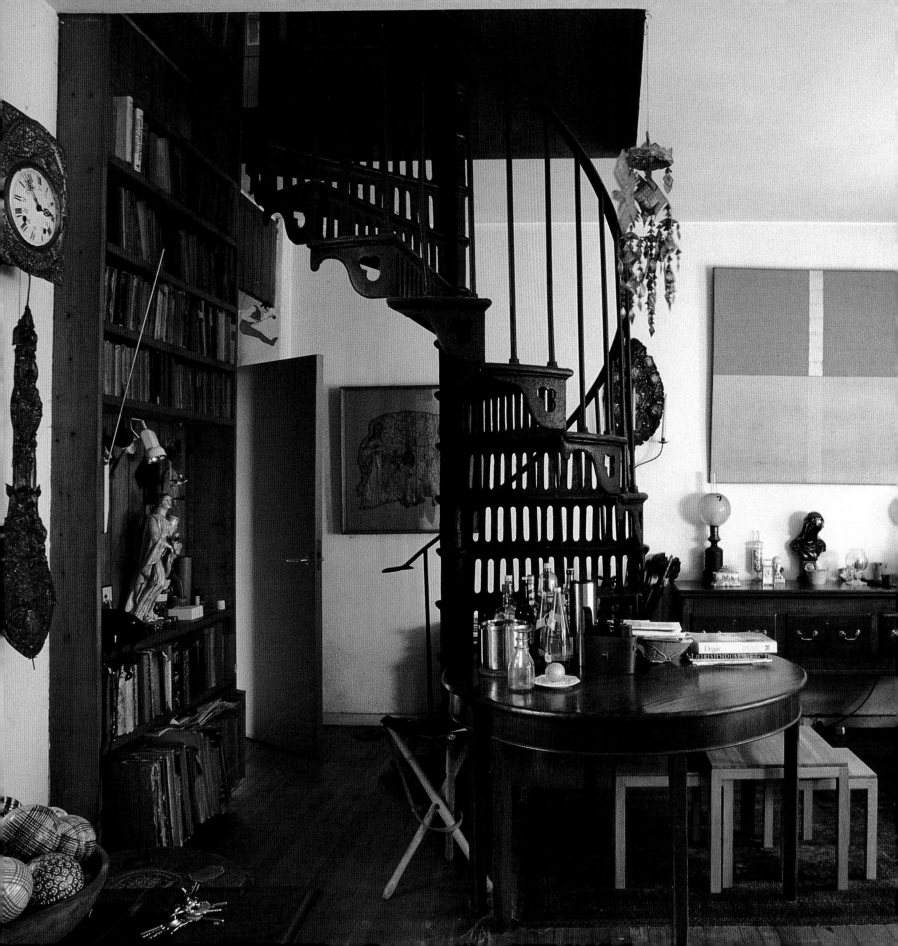

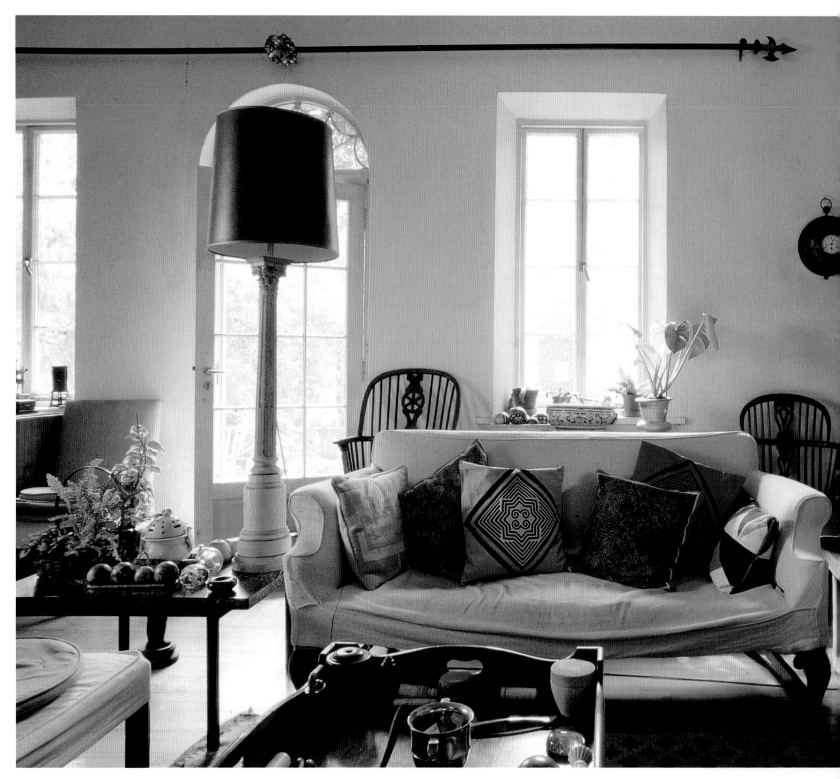

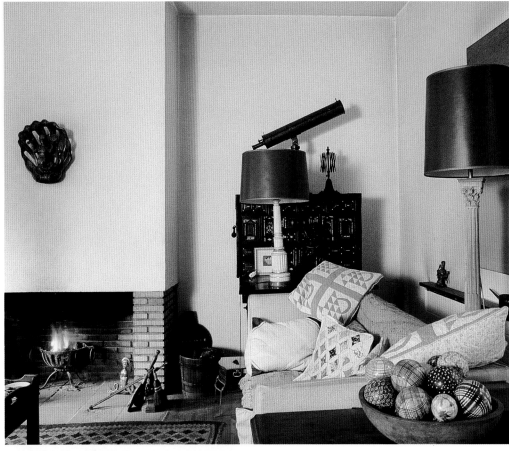

▲

Patchwork pillows increase comfort. Antique ceramic carpet balls (for indoor bowling) add more pattern.

◄

Thin winter light casts long shadows from a group of objects displayed on the windowsill.

◄◄

Generous couches surround the fireplace in the main room. The arched-window door leads to the back garden.

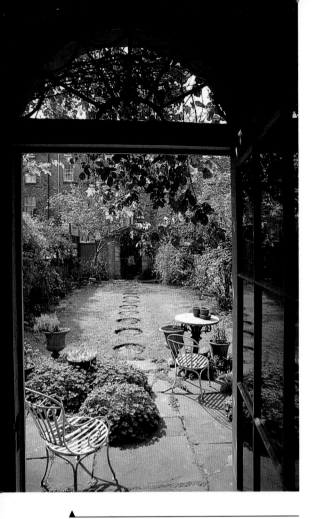

A lion's head surrounded by ivy and crowned by a pedestal marks the end wall of the garden.

A small paved dining terrace links the house and garden.

The modest scale of the house can be appreciated when one looks through doorways that reveal the complete front-to-rear axis.

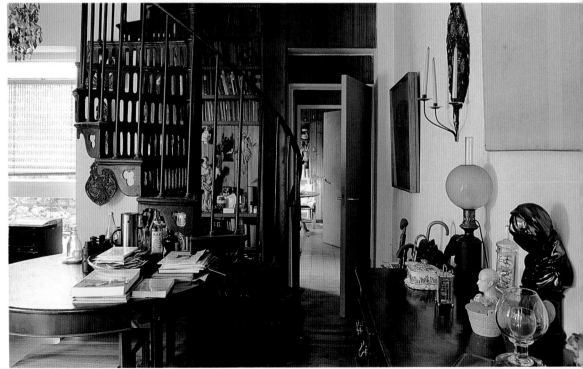

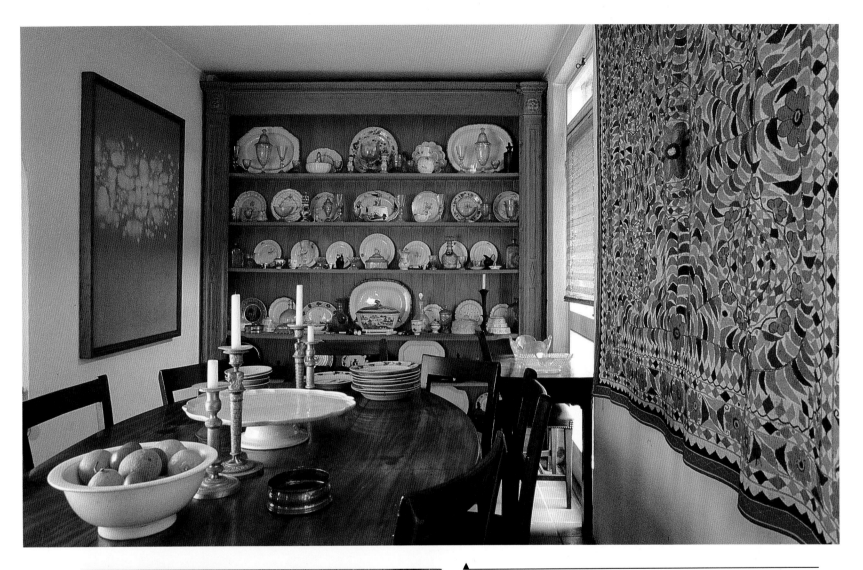

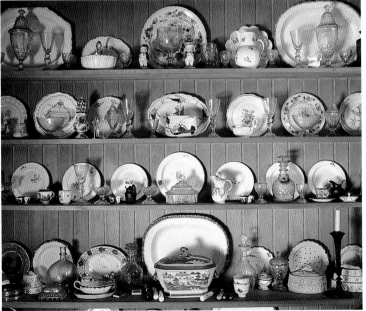

A massive china-laden dresser covers the back wall of the small-scale dining area.

A wide assortment of traditional china and Irish crystal provides a rich visual feast.

POTTER'S HOME

S tephen Pearce, son of potter Philip Pearce and brother of glassblower Simon Pearce, is one of Ireland's most well-known potters. His home and studio are built on land next to that of his father in Shanagarry, County Cork. Pearce divided the recently expanded building into public and private portions. The public space, which includes a showroom and studio, is accessible from the entrance courtyard.

The new tower connects to the original house via a one-story addition.

The straightforward stair rail, balcony balustrade, and traditional-looking slat-back chair were all designed by the owner in the spirit of vernacular Irish furniture.

The owner designed the adjoining home and built many of the interior fittings himself. As a result, the house reflects his personality and the rhythms of the hand. The white-walled interior features a great deal of natural wood in cabinetry executed or designed by Pearce. In the kitchen pine shelves display dinnerware and cooking pots. The open configuration and pale wood of the balcony railing allow light to pattern the living room hearth below. On the balcony, a bed carved with cutouts of the moon and stars was a gift Pearce made for his daughter, Lucy.

The recent addition was built in reaction to the compactness of the original house, and was influenced by New England house and barn forms. Built upward rather than out, and linked to the original house by a mudroom corridor, its vertical spaces feature new bedrooms for Pearce and his daughter, as well as a private studio at the top. Outside, across the front lawn, a long rectangular pool reflects the new tower.

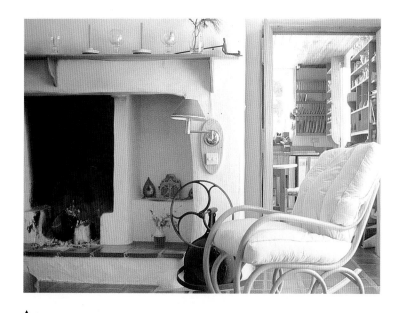

The mantel is a plain pine shelf. A display niche and sitting area have been built in on the raised hearth.

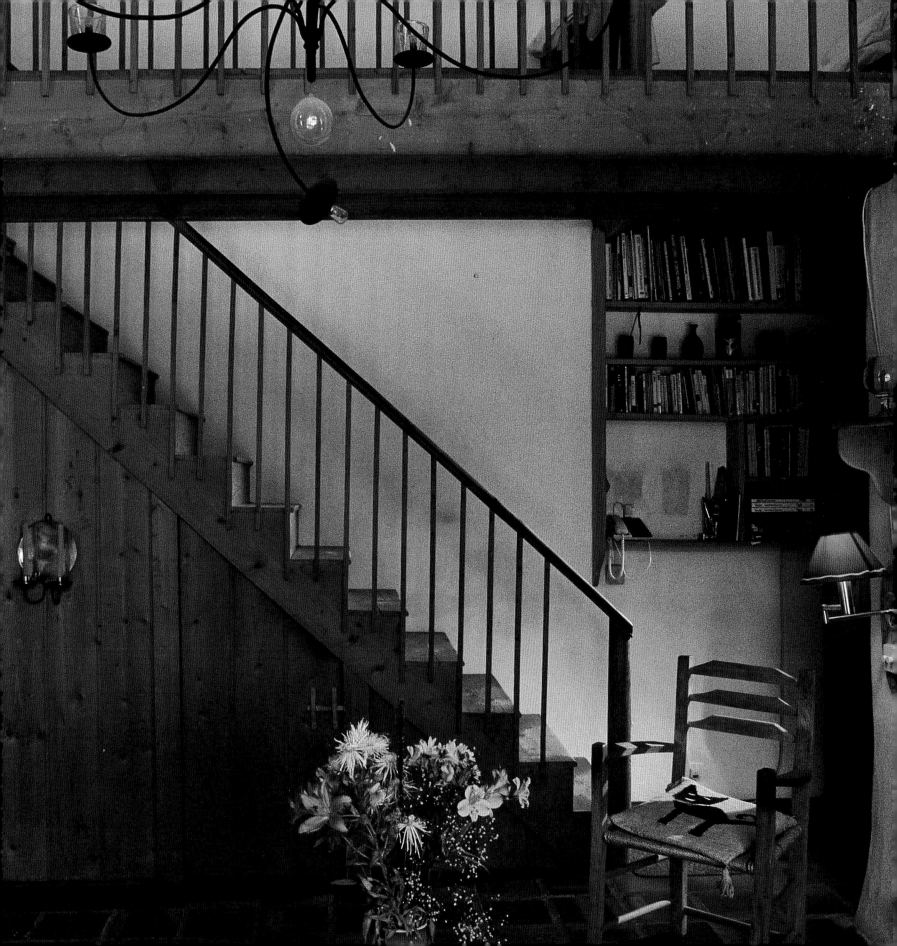

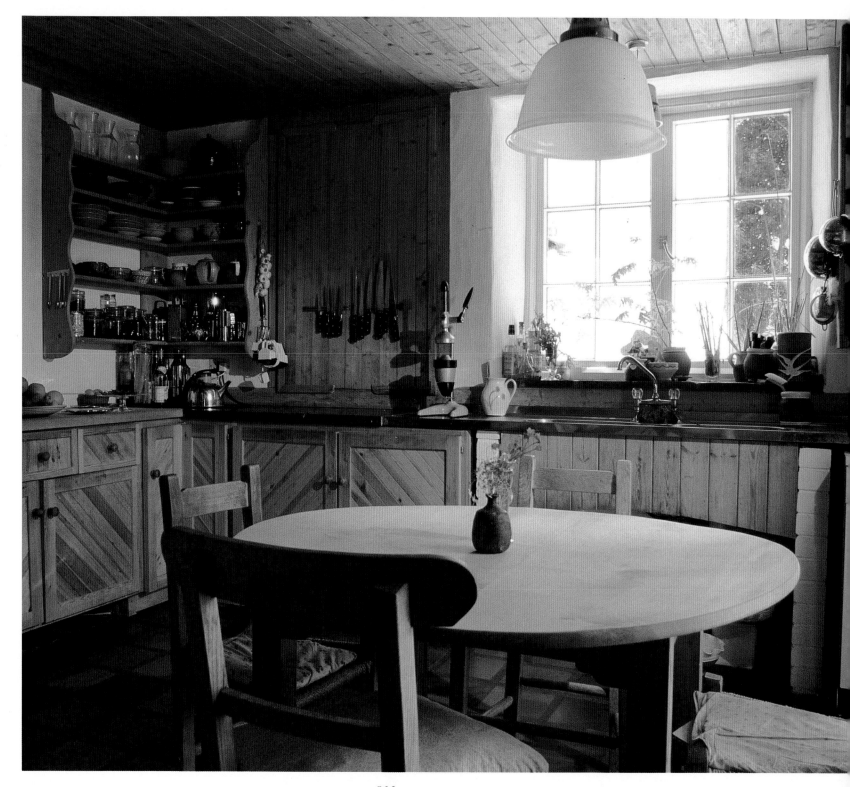

Open shelves in the kitchen hold handmade pots. The ceiling is pine-clad to match the cupboards.

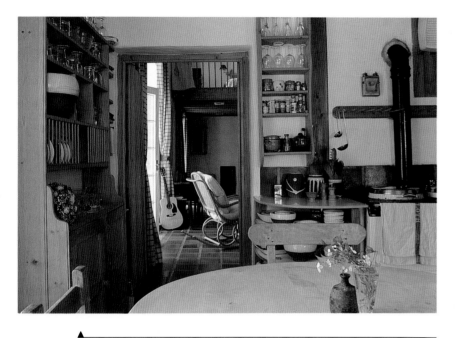

A solid-fuel cooker wards off dampness and vents through the stove pipe. The wooden shelves have a traditional air.

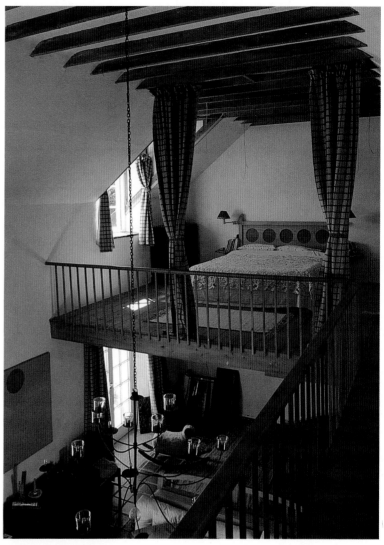

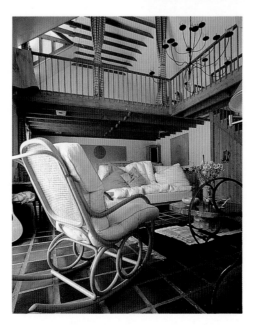

The handmade bed is surrounded by heavy curtains that may be drawn when privacy is required.

Above the living room, the roof beams continue a rhythmic pattern.

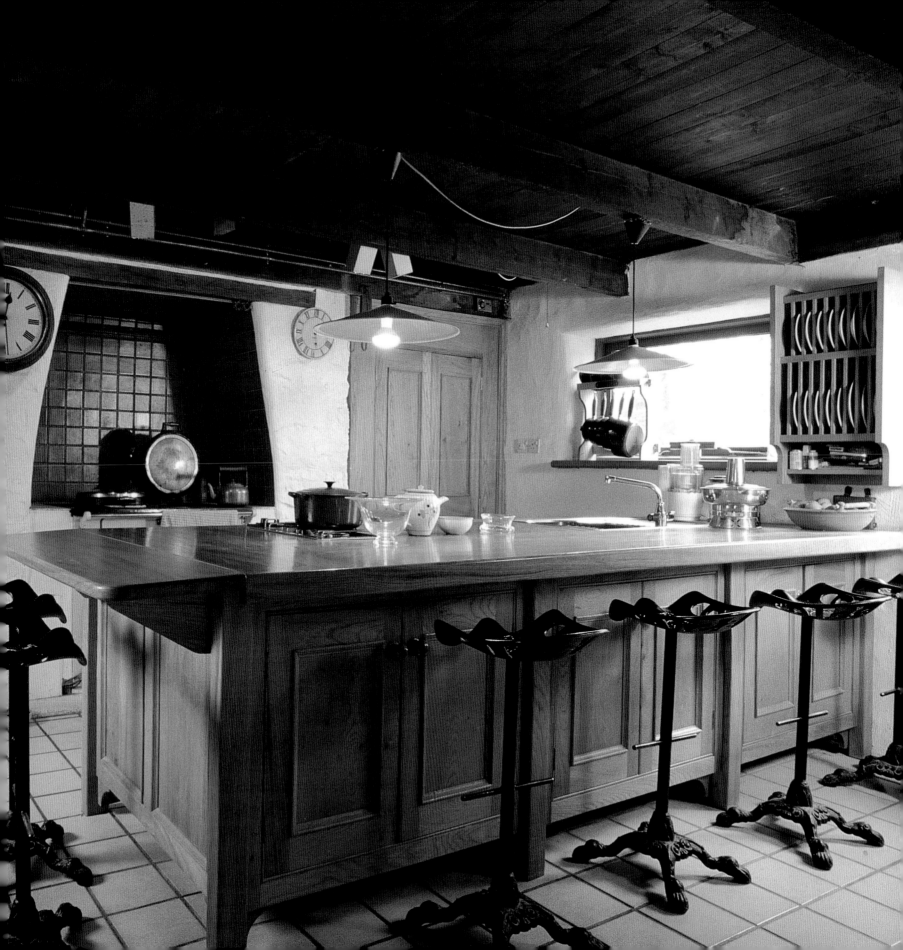

CRAFTSMAN AND COLLECTOR

Michael Jackson, a potter, his wife, Mary, and their two children live in an old cottage near Kilkenny. Planned by glassblower Simon Pearce, the cottage's original renovation was changed and completed some years later by the Jacksons. The house, which consists of five rooms, is a showplace for Jackson's work, as well as for the art glass he collects. All of the surfaces are covered with vessels; these collections are accentuated by their contrast with the humble architecture.

The painted front door opens into the kitchen, which is paneled with pine boards, lined with clay pots on open shelves, and punctuated by plant-filled windowsills. A dining counter with stools made from tractor seats sets the stage for unusual juxtapositions. The brightly colored children's room is off to one side, and down a long hall to the other side lies the living room. There, banks of shelves copied from a sophisticated German design line the far end of the room, filled with a collection of glass that makes a fragile contrast to the rough stone of the walls. Upstairs, a hallway lit by windows with deep reveals divides the guest room from the bathroom and master bedroom.

Behind the cottage lies the showroom and the workshop, where Jackson produces decorated dinnerware, vases, and lamps. A small cottage garden blooms in front, laid out between short gravel paths.

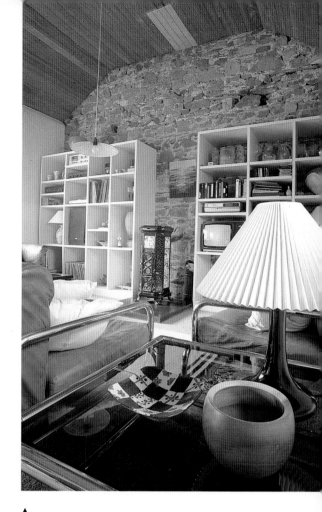

The stone wall of the gabled end of the living room has been left unplastered. The small French coal stove provides extra heat.

The paneled wall that hides the stairway is painted a bold blue.

In the kitchen, tractor-seat stools line up along the central island.

This pine-clad hallway connects kitchen and living room. The rag rug is an example of local Irish craftsmanship.

The dining end of the living room holds an international mix of furnishings. Note the exposed rock at the base of the wall.

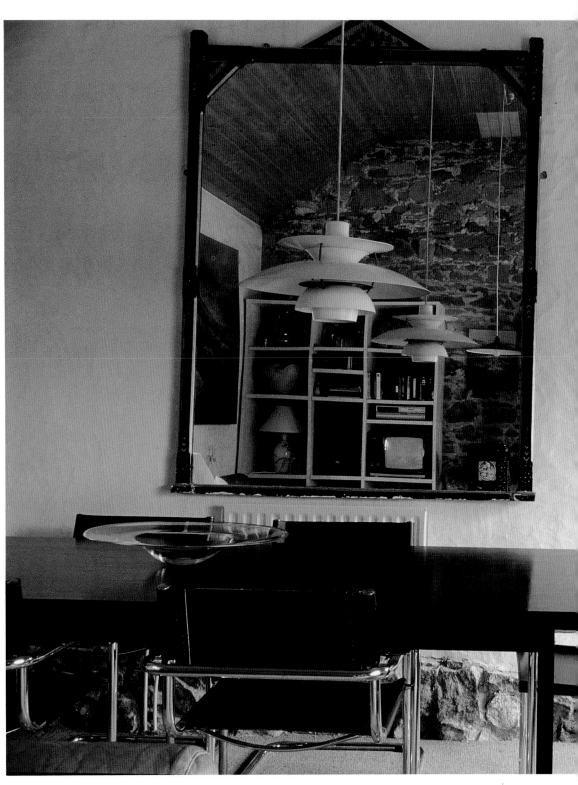

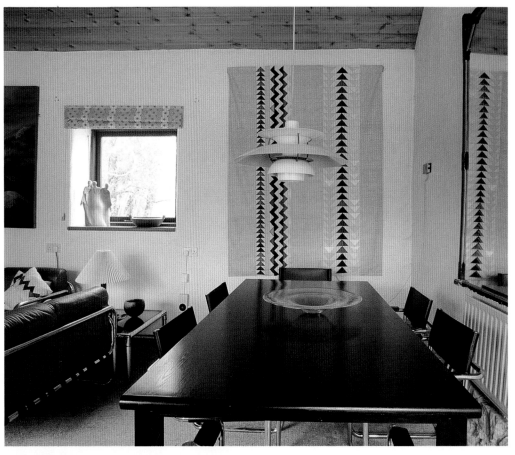

▲
The hanging lamp is a Danish design called PH5. It was designed by Poul Henningsen.

◄
A filigree antique mirror has been painted white, and contrasts with the modernity of the bathroom fixtures.

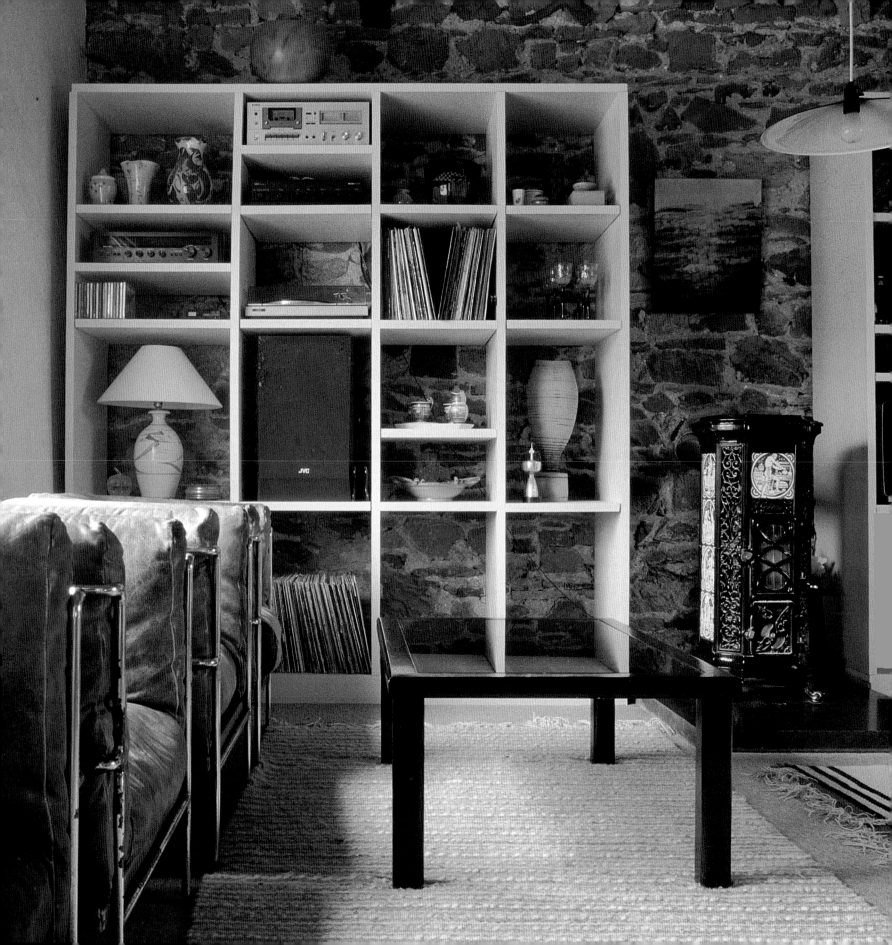

The white shelves are an owner-made adaptation of a design by Interlübke, a German firm.

In front of the cottage, an arrangement of lacy garden furniture creates an outdoor living room.

127

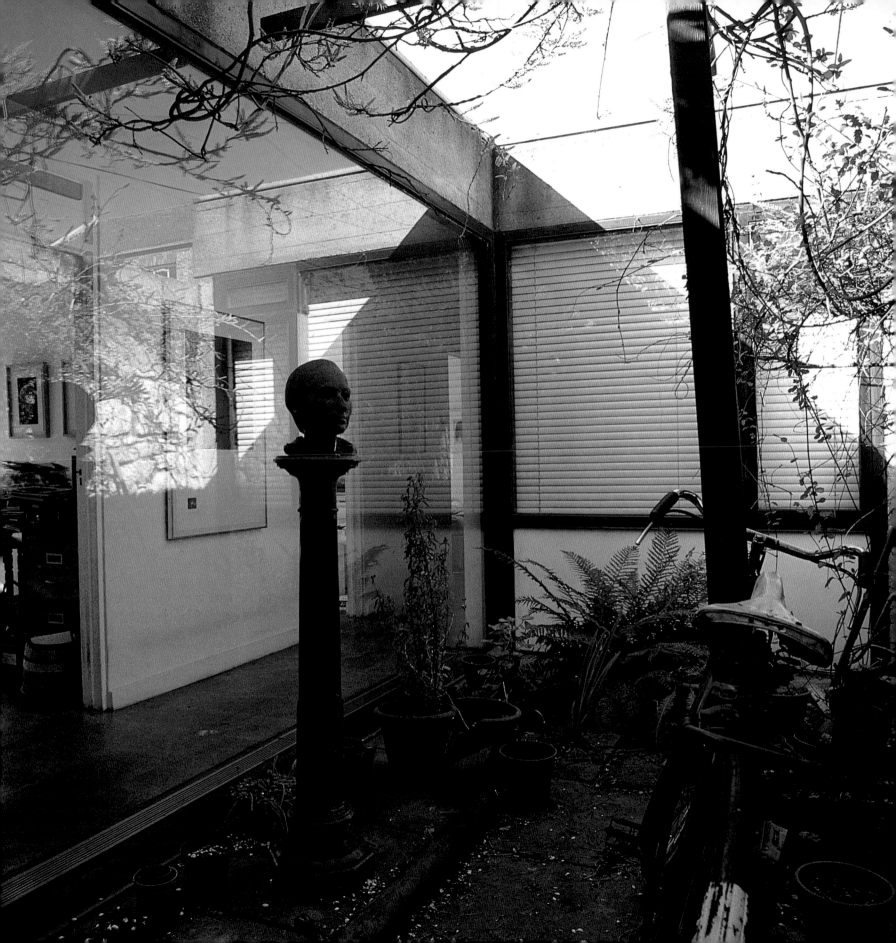



MID-CENTURY MODERN

In the eighteenth century, Dublin town houses had, as ancillary structures, small buildings originally used as stables that faced onto a back alley or mews. More than thirty years ago, architect Robin Walker built a house of Scandinavian/Japanese inspiration on the site of such a mews house in central Dublin.

The house is L-shaped, and, except for the meditative small inner garden it surrounds, occupies the entire site. Designed by the architect for his own family, which includes his wife and four children, it is a fine example of efficient planning. In spite of the limitations of a small plot and the necessity of maintaining privacy on the outer, or street, side, garden views visible through floor-to-ceiling windows from the living room and the bedroom wings make the house seem more spacious. Thanks to those windows, the interior is washed with natural light that changes throughout the day. Rooms are enhanced by that drama, as well as by carefully planned built-in furniture that conserves floor space.

Architect-designed, glass-walled, flat-roofed houses are a notable feature in each of the regions mentioned in this book. Perhaps because they offer such a strong contrast to vernacular housing, they have a special appeal to many who live in Ireland, Scotland, and Wales.

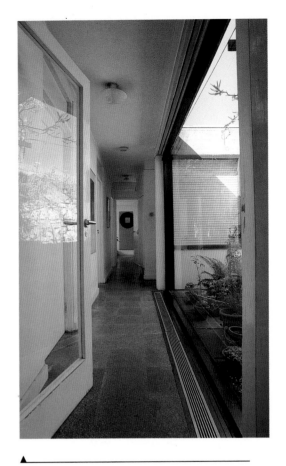

A corridor is awash with light.

Ornamental grasses and a flowering tree create varying textures.

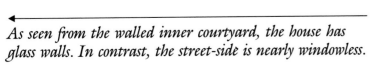

As seen from the walled inner courtyard, the house has glass walls. In contrast, the street-side is nearly windowless.

129

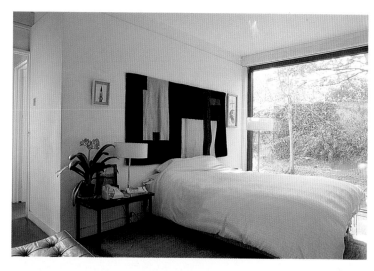

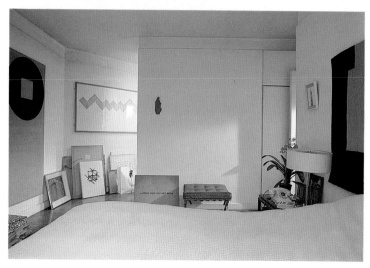

One entire wall of the art-filled bedroom is glass, making the small room seem much larger.

A changing display of pictures rests along the wall.

A generously scaled table fills one end of the living room, where it provides plenty of space for family and friends.

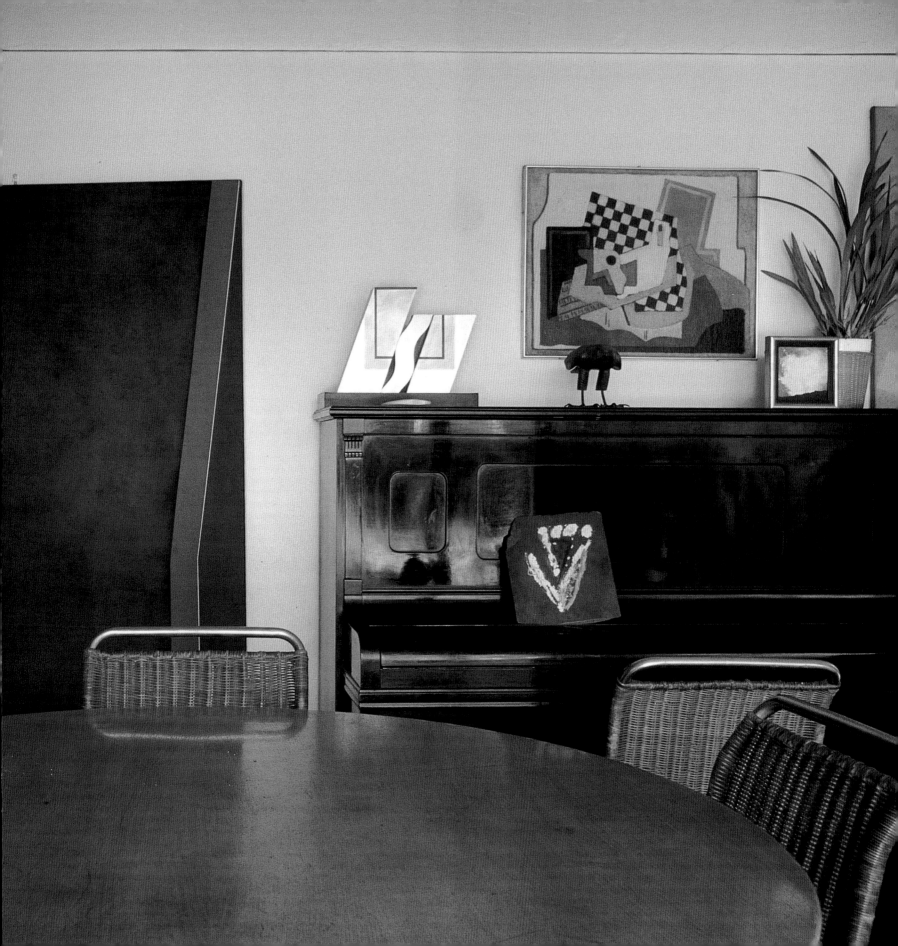

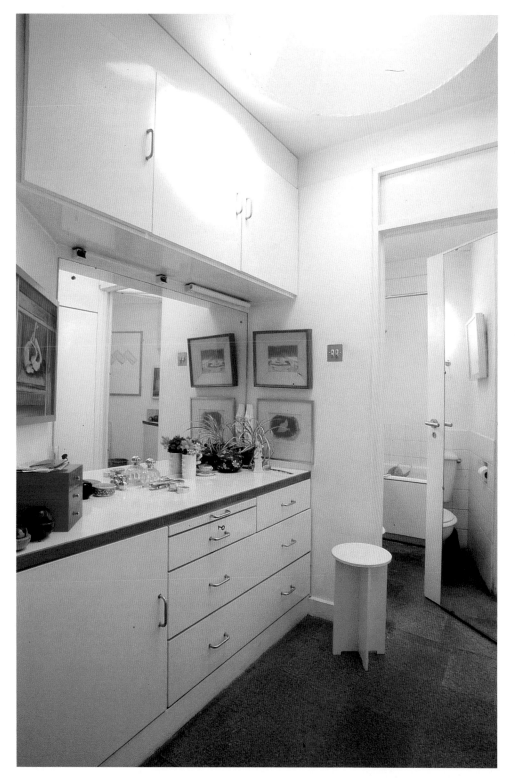

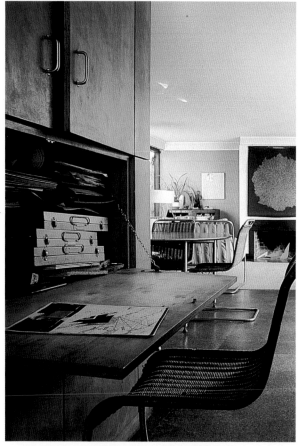

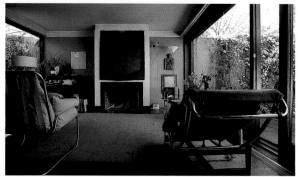

▲
*Overscaled and comfortable seating
faces the fire.*

◀
*The bathroom is lit from above by a
round skylight.*

One ell of the house is filled with bedrooms; this ell is nearly all living room. Together, these ells form two walls of the inner courtyard, which is blocked from further outside viewing by garden walls.

Inside and outside merge through plate glass, making the house's boundaries seem vague.

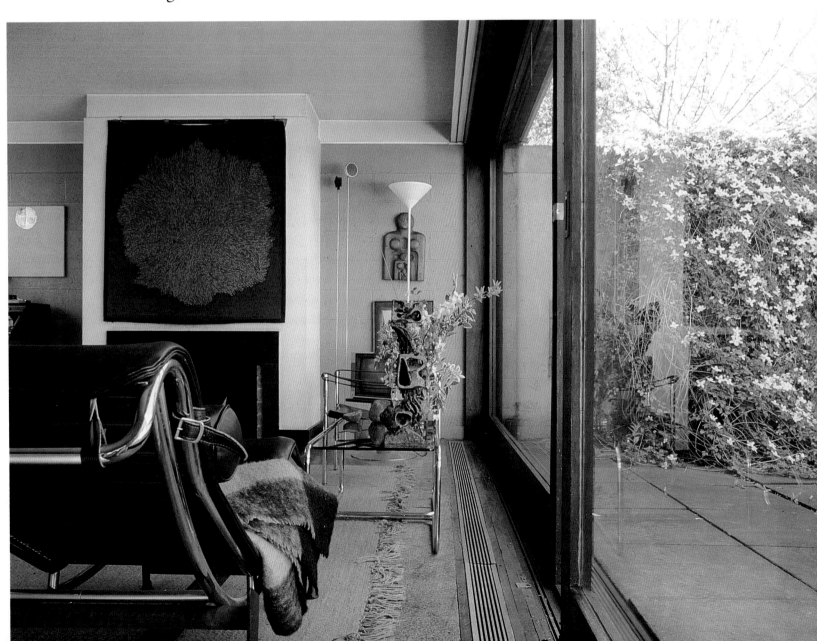

LUGGALA

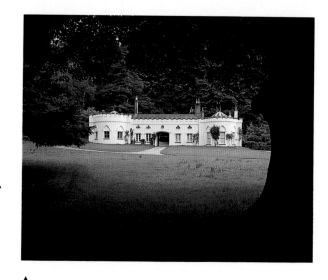

Luggala looks like a fairy-tale castle.

Gilded chairs and a small table have been set up in the foyer.

alled by some "the most magical house in Ireland," Luggala sits in the landscape like a lost piece of wedding-cake sculpture, glowing white against the black Wicklow hills. Luggala was originally built as a Gothic-style hunting lodge in the 1790s, and it is still used for that purpose. Spectacularly set within a seven-thousand-acre estate overlooking Loch Tay, the house is reached by a fearfully empty road edged by rocky fields.

Driving down the road that sweeps toward the loch from the gate lodge, one is suddenly (at least in prehunting season) surrounded by pheasants being fed on the lawn by the gamekeeper. The house, which is built around three sides of a cobbled inner courtyard, faces the pheasant lawn and loch beyond with elaborate turrets, battlements, and quatrefoil windows.

The interior does not disappoint. Imbued with a slightly shabby aristocratic charm, the rooms of Luggala have walls darkened by age-softened color; they are filled with eccentric collections as well as objects of quality.

And yet this is all an illusion. The original Luggala burned to the ground in 1956; the Luggala we see here is an exact replica. The lifestyle of the original inhabitants is also being re-created and can be enjoyed by hunting parties on a commercial basis in season. Now stocked with hundreds of deer and thousands of pheasant, it is the only estate in Ireland that offers gillie-led stalking and shooting.

A view from the blue dining room through to the marble-floored foyer shows that all of the doors are placed along the house's front axis.

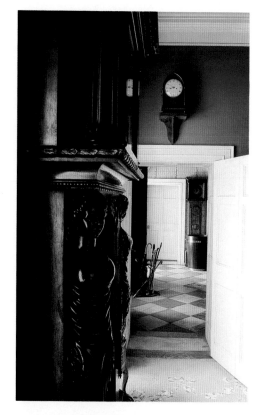

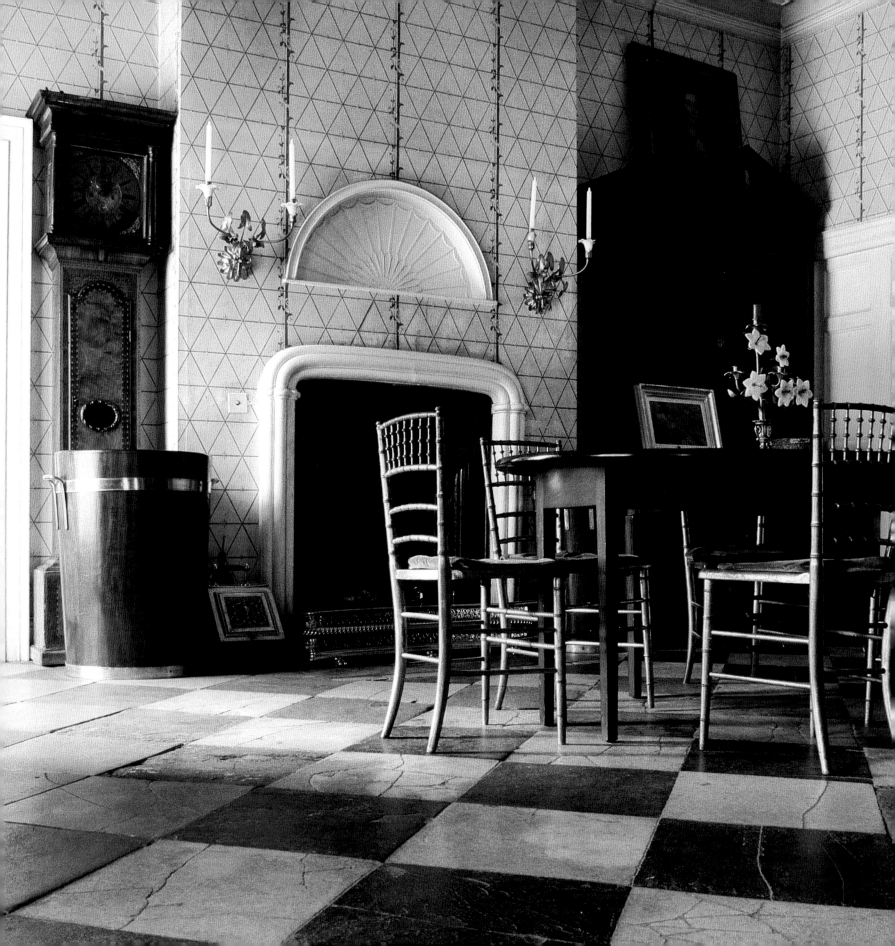

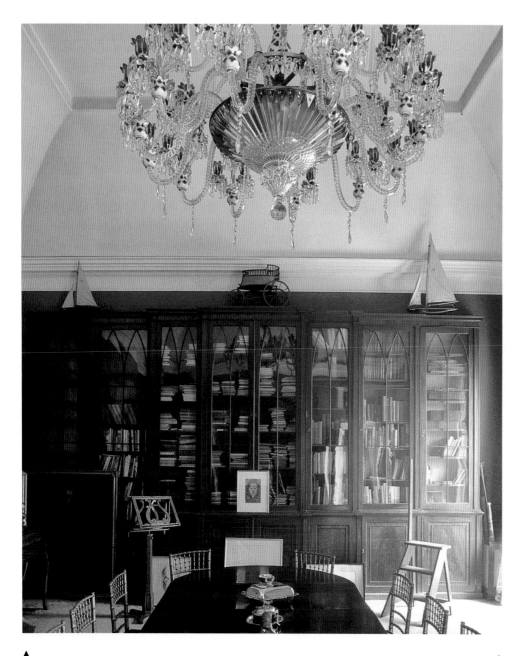

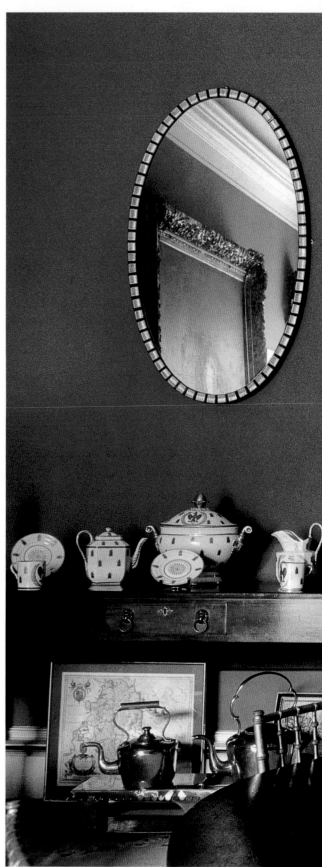

The mahogany breakfront is eighteenth century, and is part of the original furniture saved from the 1956 fire. The chandelier is Venetian glass.

This expansive hunt table is another Irish piece that has always been part of Luggala's furnishings.

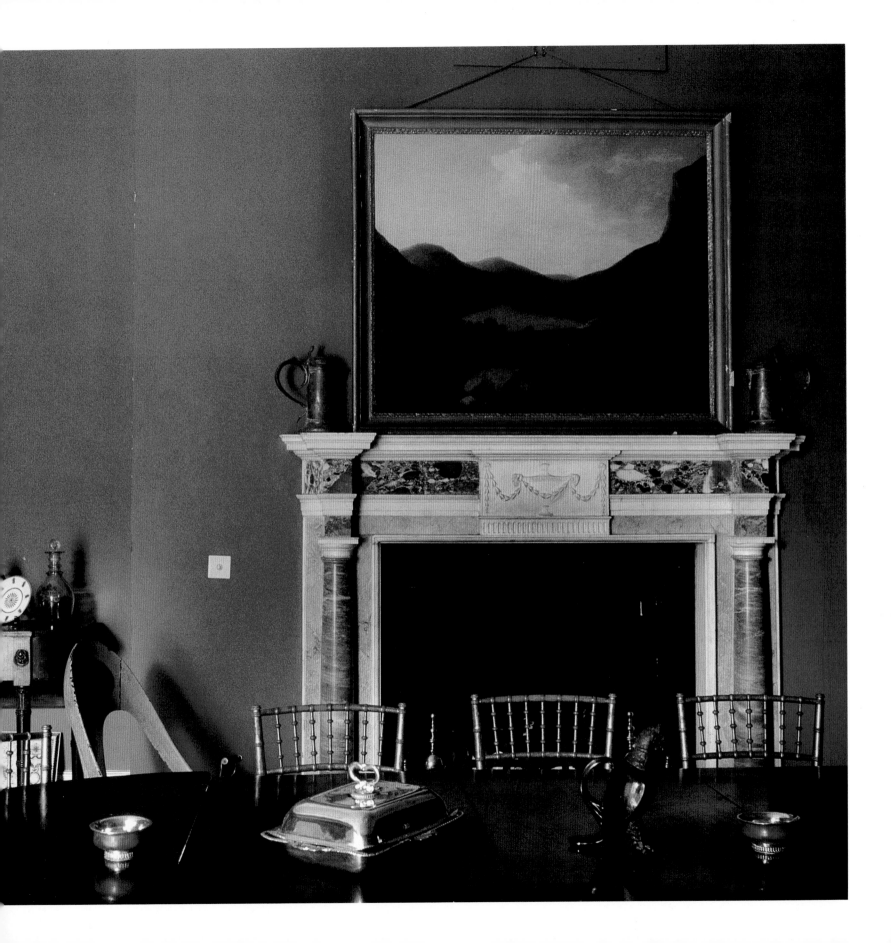

In the scullery (an anteroom of the kitchen), cooking pots of all sizes fill wall-to-wall shelves.

As seen from the shores of Loch Tay, Luggala's magical quality is undiminished by distance.

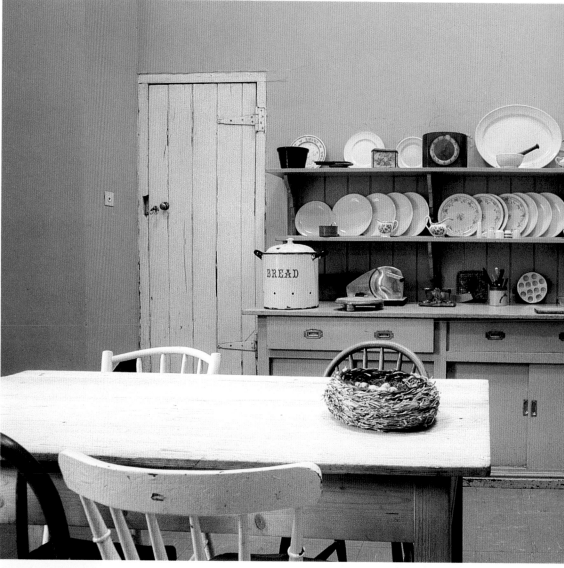

Open shelves in the large kitchen hold crockery above the long work counters that edge the room.

Shades of blue frescoed into plaster and painted on wooden cupboards contrast with touches of blue glaze on crockery.

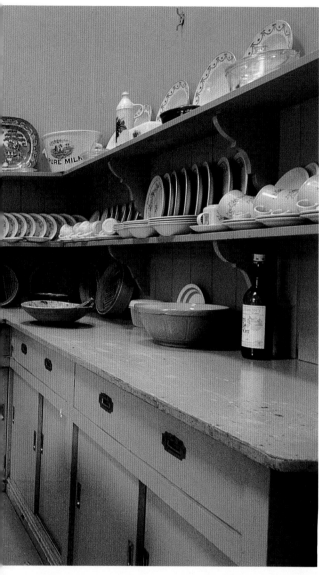

Trellis-patterned wallpaper provides a sunny glow. The large brass-bound bucket holds turf for the fire.

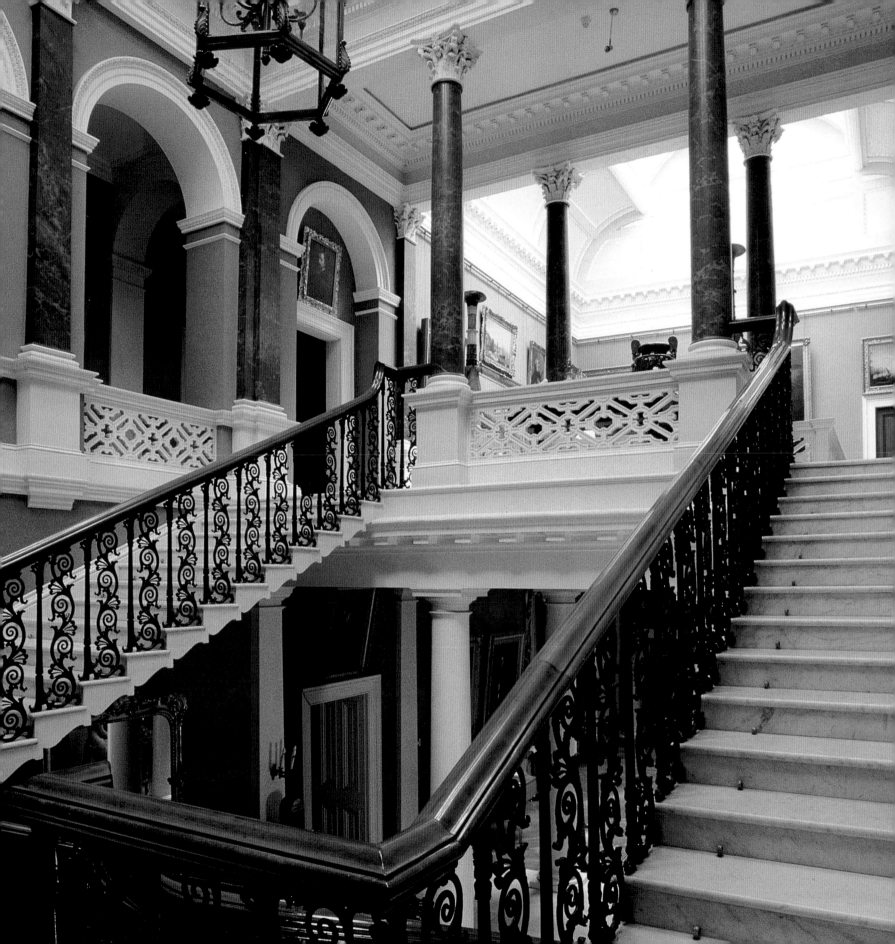

BALLYWALTER PARK

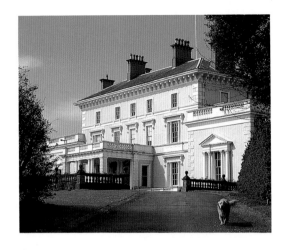

▲
A view of Ballywalter Park from one side of a long entrance drive.

When Lord Dunleath inherited his ancestral home in 1956, he had long been aware of his father's plans to reduce it in size in order to make it more economical to heat and staff. Fortunately, while he was considering what to do with the property, a visit by the poet Sir John Betjeman, who was also an architectural historian, confirmed Ballywalter's unique architectural value and inspired a caring restoration of the house.

In the 1840s, Lord Dunleath's grandfather, linen-mill owner and ex-mayor of Belfast Andrew Mulholland, commissioned Charles Lanyon to rebuild the house, originally a late-Georgian home called Springvale, into the palazzo-style Ballywalter Park. Mulholland wanted a building that would, in its grandeur and scale, reflect his successful status. As a result, Ballywalter Park is a prime and extremely beautiful example of a country house that expresses Victorian admiration for the architecture of Renaissance Florence.

The interior radiates from a central hall, or saloon, which rises to a stained-glass dome above the main stairway, creating an atrium. The staircase itself consists of two grand parallel flights, lined by iron balustrades and pierced stonework along the landing hall. On the ground level, one side of the central hall is marked by the drawing room, dining room, and breakfast room; on the other lies the library, the morning or sitting room, the entrance hall, study, and an office. Breaking the symmetry, the hallway off the breakfast room leads to the billiard room, smoking room, and, around the corner, to a magnificent arched conservatory.

▼
Up the stairs, Wedgwood green walls frame niches that hold sculpture. This single flight of stairs divides into a double return.

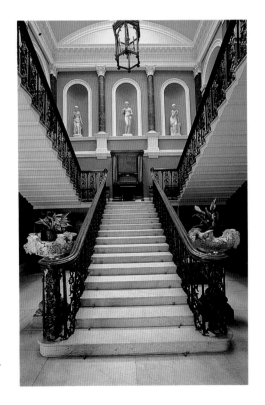

◄

The main staircase rises from the saloon, which is lit by a stained-glass dome.

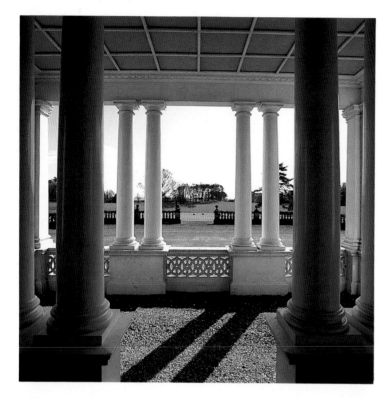

Pairs of columns in the forecourt frame a rolling view.

Sandstone columns pattern the conservatory wing's facade. Note the subtle shaping at the top of each window.

The atrium lights the whole saloon.

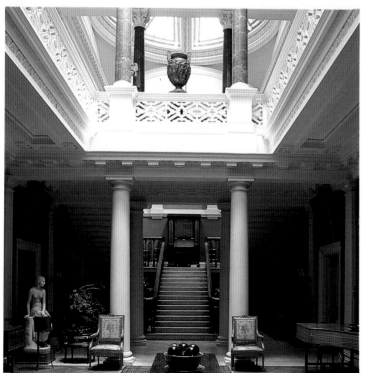

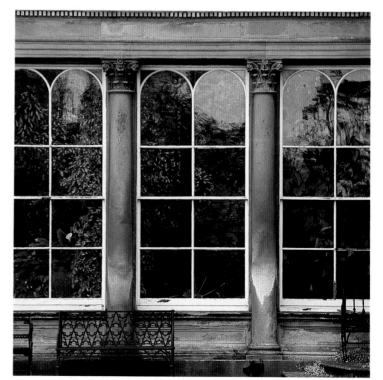

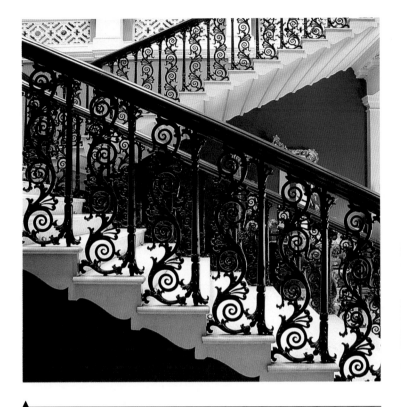

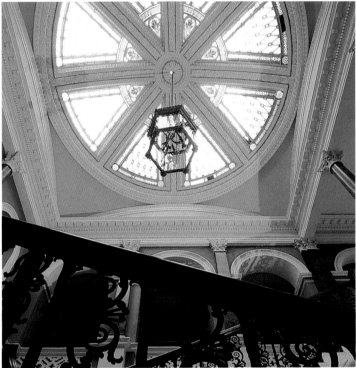

Wrought-iron balustrades delicately trace repeated curves.

The stained-glass saucer dome creates a soft play of sunlight through colored facets.

The saloon is sometimes used as a site for chamber music recitals. This nymph seems to be listening closely.

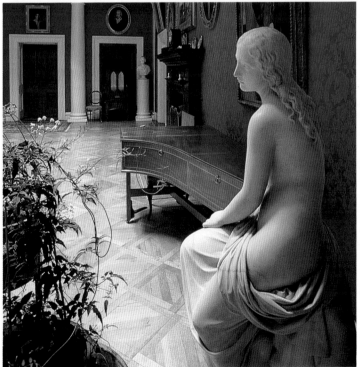

On first entering the house, one sees the sparsely furnished paneled foyer with its trophy-hung walls.

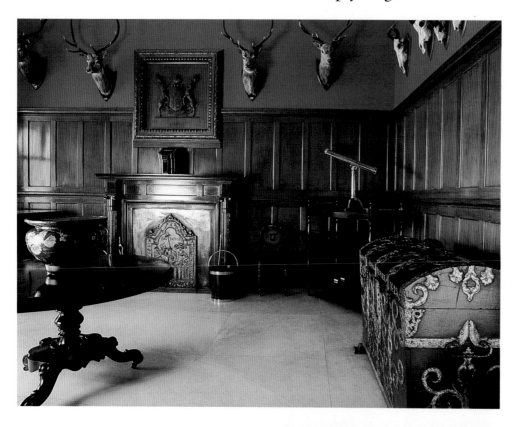

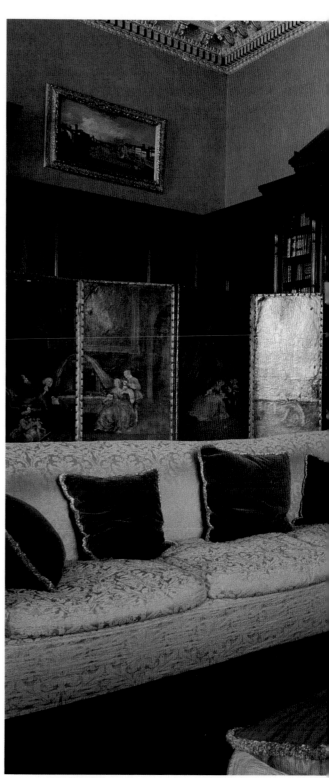

A gilded clock takes center stage on the library mantelpiece.

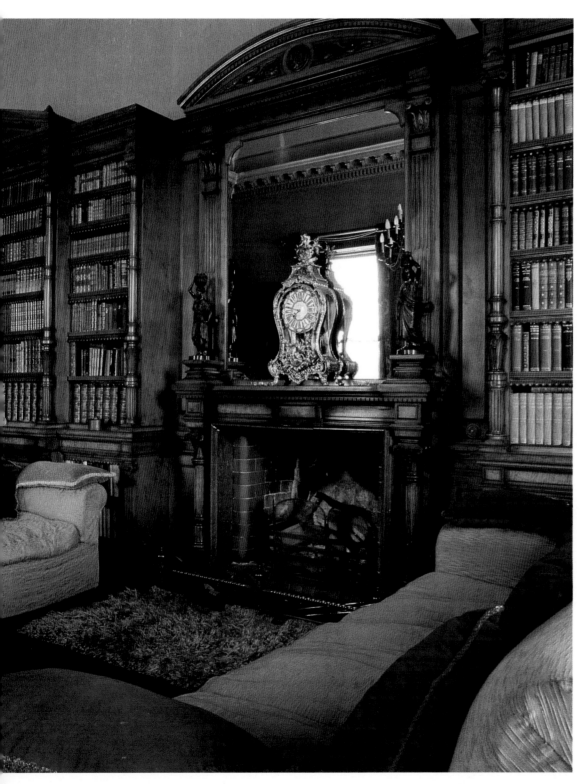

Another view of the library, with a glimpse of the dentillated plasterwork that edges the ceiling.

Nearly all public rooms have two means of access, so that servants can move unobtrusively through the house.

This marble fireplace in the morning room was moved from one wall to another by Lord Dunleath's parents when he was a child. Somehow, when it was put back together again, the figures were inadvertently positioned looking outward. Now the lovers are condemned to face in opposite directions forever.

Ballywalter Park is an outstanding example of palazzo-style architecture.

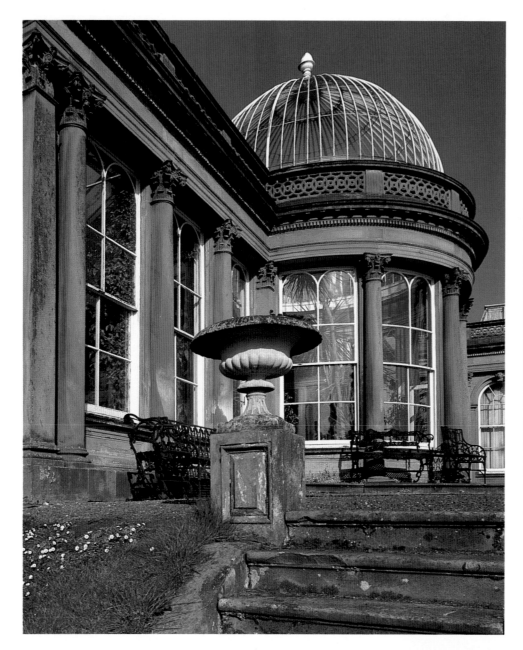

Soaring through the faceted dome to the sky, a palm tree flourishes in the warm atmosphere.

The conservatory has many entrances—inside the house, it can be reached through the billiard room or through the drawing room vestibule. From the outside, gardens and terraces create paths toward it.

Inside the conservatory, all is lush.

Pink sandstone provides a backdrop for a bench on the terrace.

A full-size model, in plastic pipe, has been made of a proposed gazebo to see how it might look in the landscape.

One can look through the conservatory back to the house.

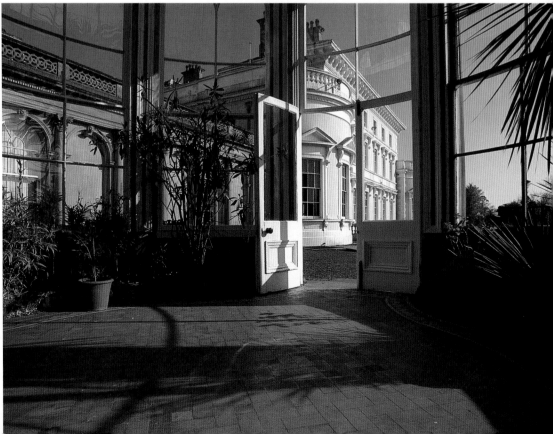

SCOTTISH BARONIAL CASTLE

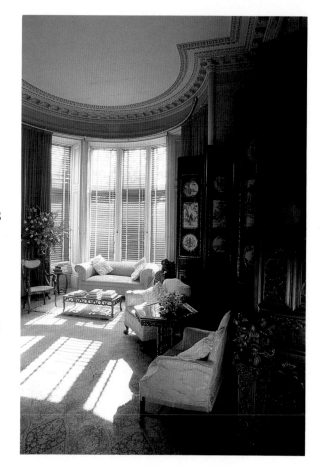

Now lived in by the grandson of the man who purchased the castle soon after its completion, this home (built in 1864–65 by a Glasgow-based architect) is a wonderful example of Scottish baronial style. The owner's grandfather retired after a lifetime's service in business in the Far East, and returned home to Ireland with many souvenirs. He settled his Oriental treasures into rooms papered with William Morris friezes, heated by fireplaces tiled by artisans of the arts and crafts movement, and infilled it with a mix of comfortable old family furniture.

The building is huge. Entering through a square foyer, one continues into a long hall bisected by a grand staircase, which is lit by stained-glass windows patterned with the original family's coat-of-arms. Large reception and dining rooms line the hall on one side, with the family kitchen and an L-shaped wing on the opposite side. Upstairs, rows of bedrooms open off both sides of a central corridor. The castle rambles upward and outward, ending at ground level in the rear with a series of carriage houses, coach houses, stables, and servant accommodations built around a courtyard.

The grandson, who has lived here with his family since the death of his parents, has, happily, done very little to change the structure. The kitchen has been refurbished, some peripheral areas turned into independent rental units, and necessary preservation work has gone on, but much of the appeal of this home rests with its undisturbed mixture of fey and imperial qualities.

A very long Chinese screen, made of carved wood and decoratively patterned platters, stands along the right-hand wall.

Comfortable family furniture is drawn up near the fire. The vase is a Chinese antique.

Elaborate carving on each segment of the screen tells a story.

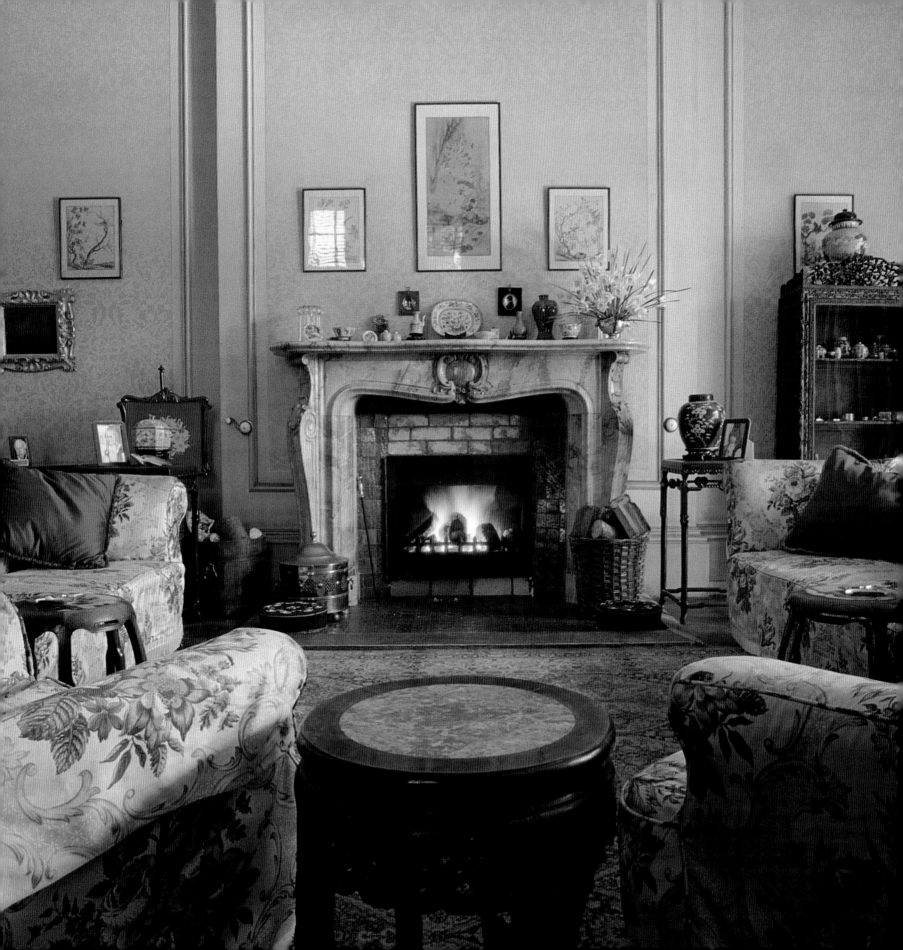

An Oriental chair sits near a
mantelpiece with a lion's head and
barley-twist columns.

The designs on this ceiling trace an
interesting pattern.

Chinese porcelain and daffodils fresh
from the garden line the mantelpiece.

This elaborately carved fireplace heats the study. The multicolored ceramic tiles date from the English arts and crafts movement.

This Chinese desk has many drawers and secret compartments.

An overscaled Chinese vase dwarfs both fireplace and wing chair.

Faux marbleing distinguishes the walls in a sitting room. Both the ornate table and the cupboard are carved and inlaid.

The lower wall is marked by a mosaic pattern.

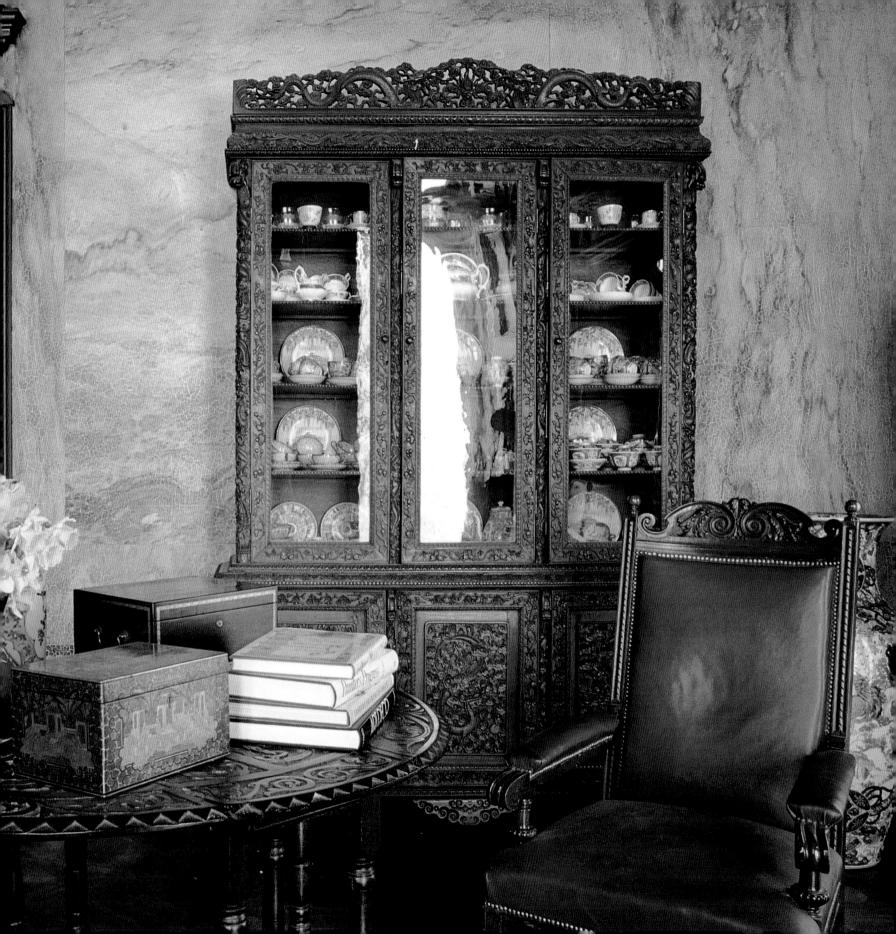

Looming dark against the sky, the castle here looks like the setting for a nineteenth-century novel.

This archetypical Victorian fireplace is made of black marble and lead.

The dining room wallpaper is original William Morris.

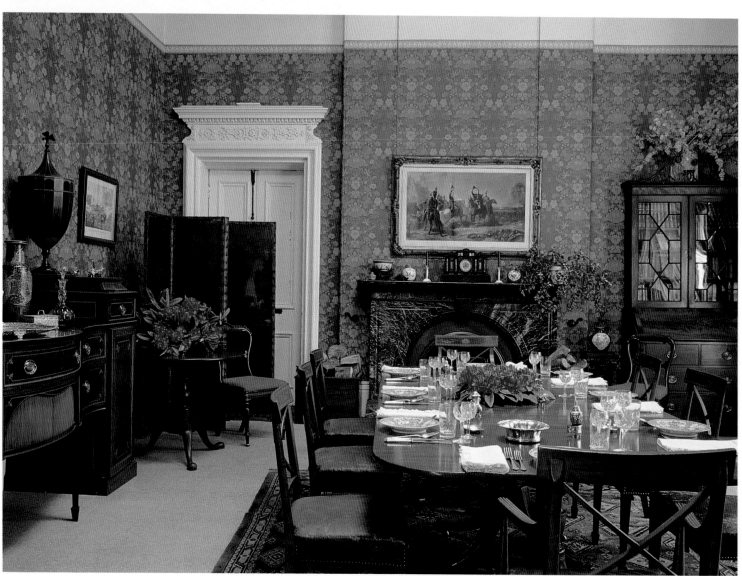

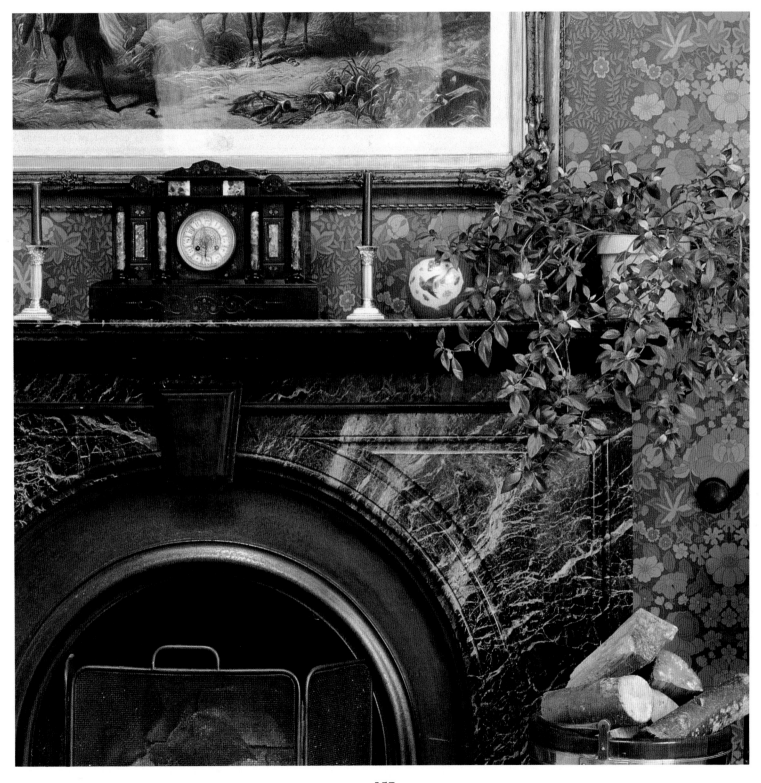

The pink bathroom lifts the spirits of all who see it. It is upstairs, near the family bedrooms.

This bedroom has brass bedsteads that shine in morning light.

The downstairs cloakroom is also a place to wash your hands.

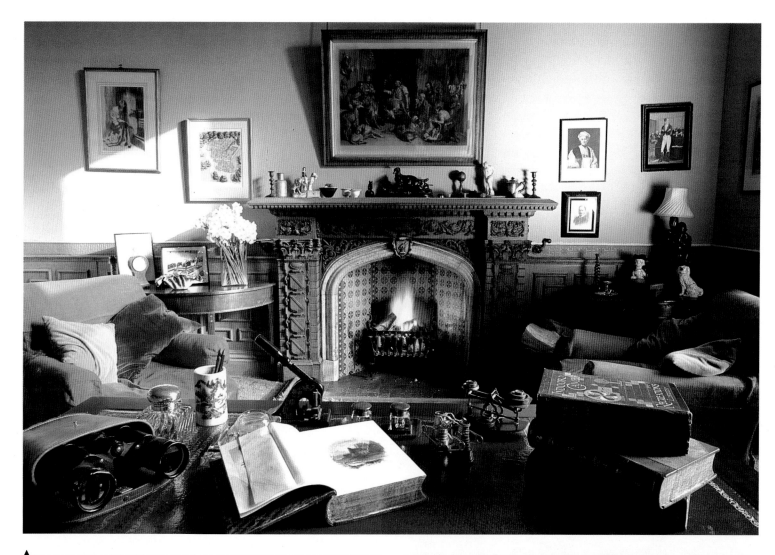

Wainscoting in the study rings the room and matches the patterns on the mantelpiece.

The castle has a more salutary aspect when seen from the approach in sunlight.

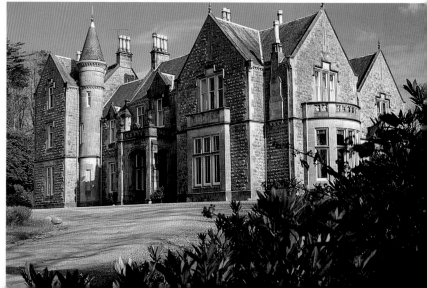

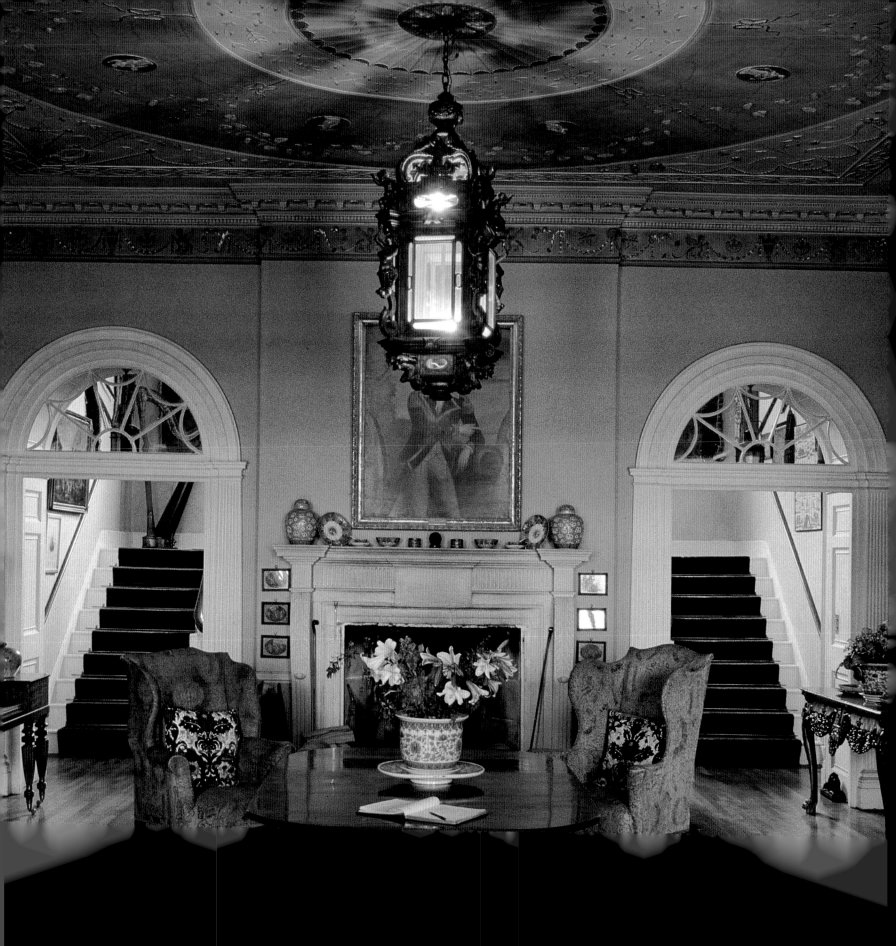

GLIN CASTLE

Glin Castle is owned by Desmond Fitz-Gerald, Knight of Glin. He is a noted art historian, an authority on Irish furniture, a director of Christie's, and an officer of the Irish Georgian Society. He is also the twenty-ninth Knight of Glin to live on the Fitz-Gerald lands in County Limerick.

The castle, which was first built as Glin House in the 1780s, and then fitted with battlements in the 1830s, is a carefully maintained and comfortable showplace of Irish architecture, furniture, and decorative arts through the centuries.

Contrary, perhaps, to appearances, the Glin property was not handed down with a financial endowment to match the magnificence of the setting. The present owners, bound by deep affection for, knowledge of, and loyalty to the property, have dealt with the need to preserve and maintain it with various strategies: portions of the castle are open to the paying public, Glin Castle itself is available for rent in the summers, the land is now under cultivation, and some of the furniture has been licensed for reproduction. But although this is a (sometimes) public property, it is also a family home, and the interiors reflect the history of this particular family, as well as high points in Irish decorative-arts history.

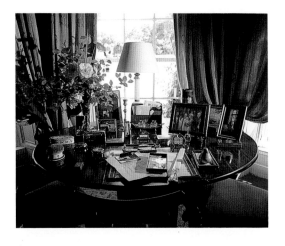

Silver-framed photographs fill this round table set into a bay window.

The plasterwork on the ceiling of the entrance hall is thought to be the work of the "Irish Adam," stuccadore Michael Stapleton. Part of the color scheme of apple green and Pompeiian red has been restored, but the vibrant color combination is integral to the original conception of the interior.

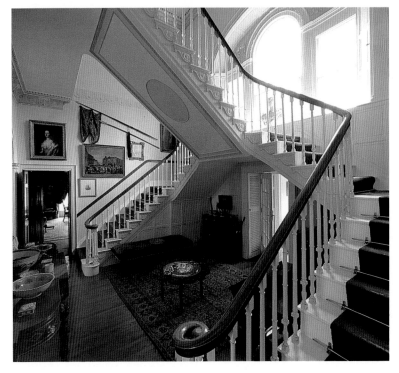

Unique in Ireland, this unusual "double flying" staircase is a smaller version of one designed by Robert Adam for a manor house in Berwickshire, Scotland.

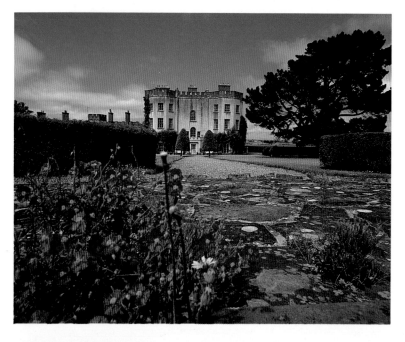

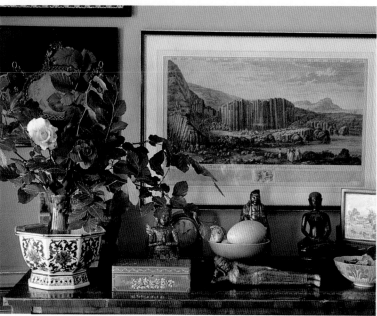

Glin Castle from afar.

A mid-nineteenth-century stenciled frieze on the sitting room cornice draws the eye upward. The walls have been painted gray to match.

In summer, the gardens can be relied upon to furnish fresh flowers. Here, roses enliven a display.

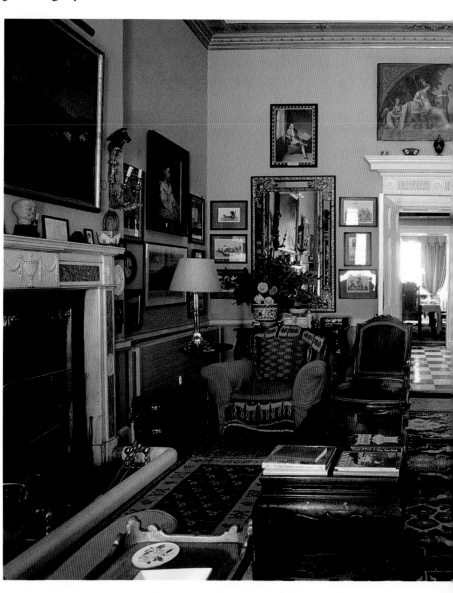

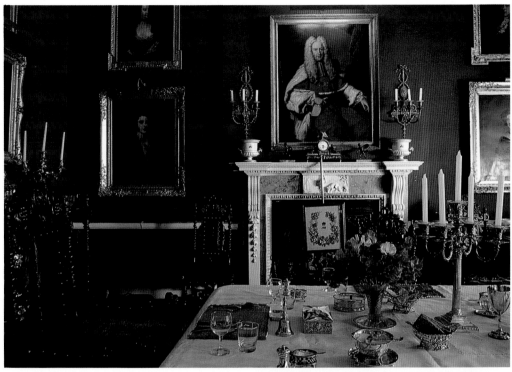

Family portraits surround the Jacobean revival dining table and chairs.

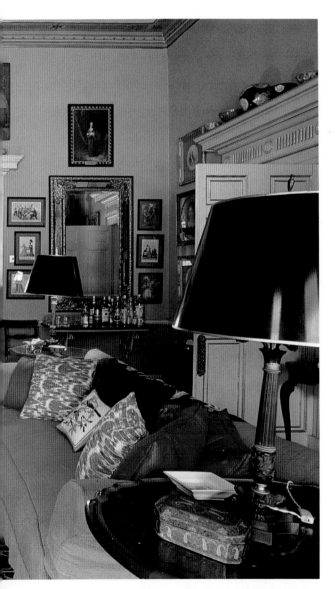

This sideboard, like all of the dining room furniture, is Jacobean revival.

Much of the silver in the dining room was made for John Fraunceis Fitz-Gerald, an early-nineteenth-century Knight of Glin, and some is marked with his coat of arms.

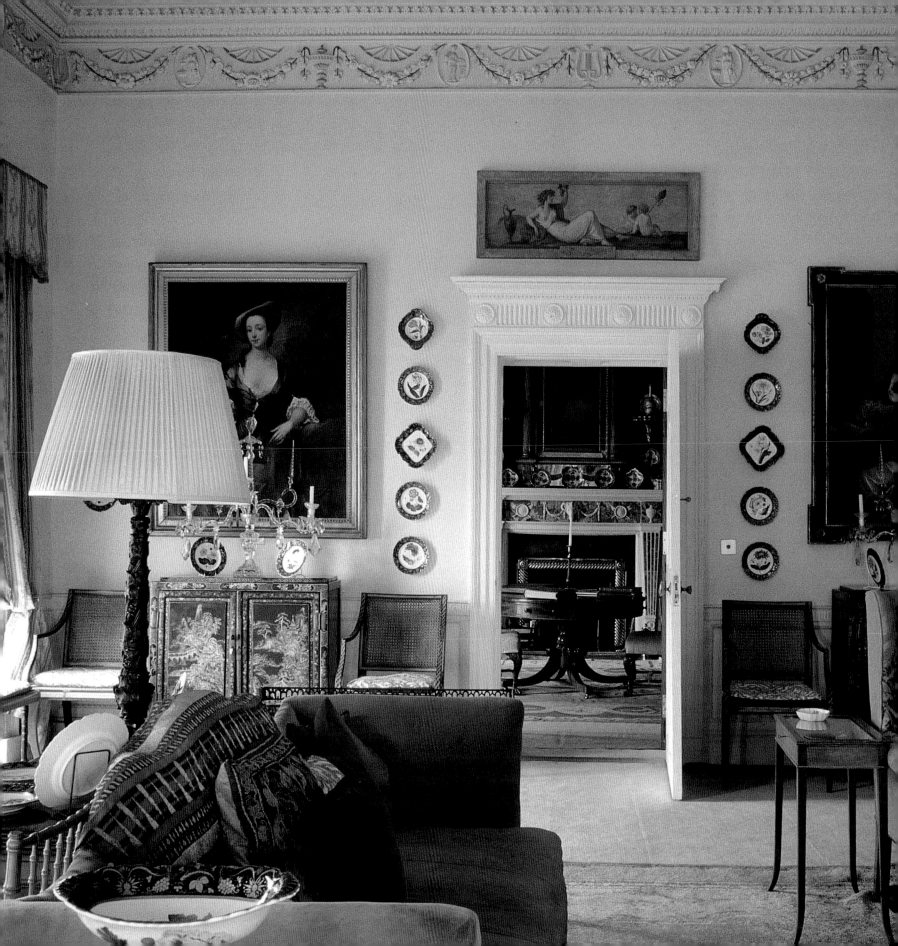

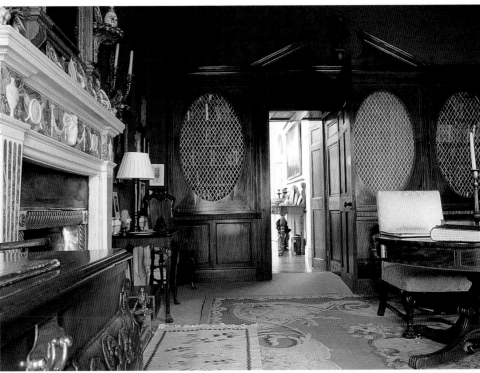

This broken-pedimented mahogany
bookcase in the library was built in
during the construction of the room.
When the middle door is opened, one
can see a secret entrance to the
stairway hall.

The bookcase keeps its secret when the
doors are closed.

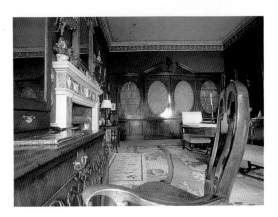

The porcelain plates mounted on the
drawing room wall are from a
botanical set made in 1810. Beneath
them, a pair of late-eighteenth-
century Ch'ien Lung Chinese
lacquer cabinets flank the doorway.

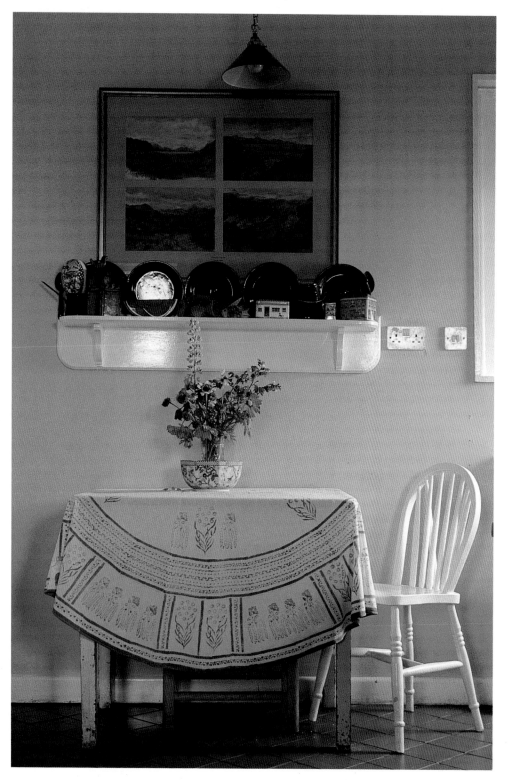

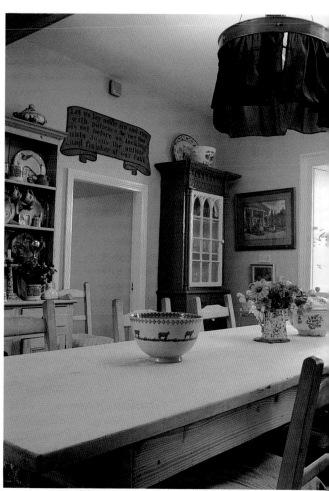

Irish spongeware, some of it newly made by potter Nicholas Mosse, fills the traditional pine hutch.

This painted wall-hung shelf functions as a mantel.

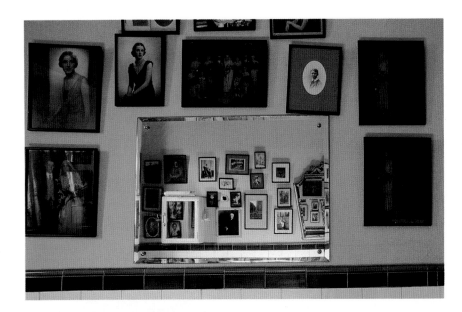

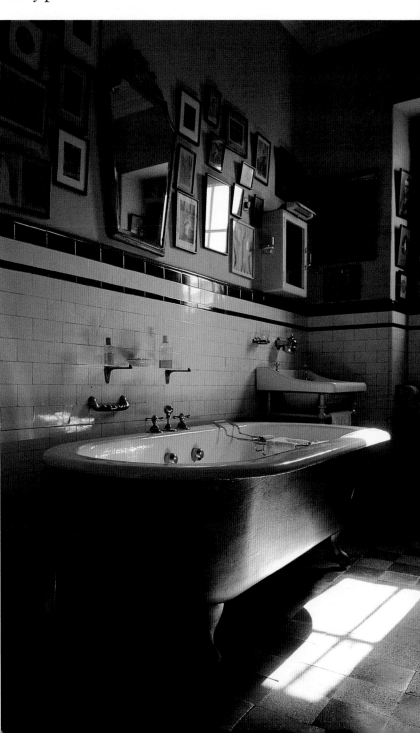

Family pictures line both walls in a bathroom.

The informal family dining room is filled with color and pattern. Even the window reveals are tiled in a blue and white pattern.

This bathtub was installed, along with the plumbing, in 1914.

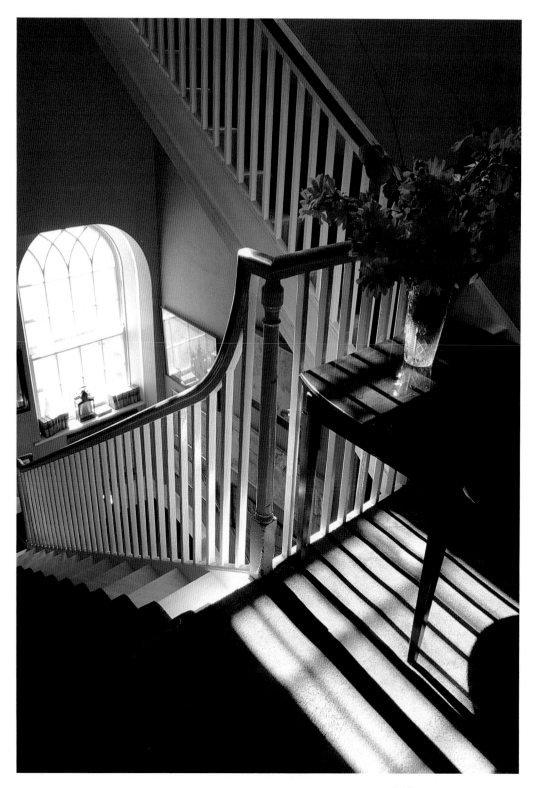

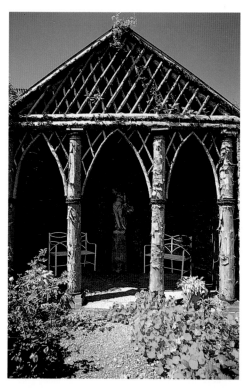

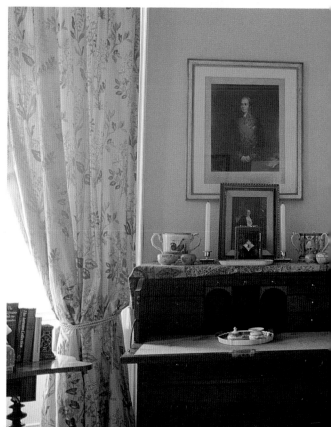

Nasturtiums line a pathway to the rustic pavilion, constructed from tree trunks.

Sunlight stripes the landing through the balustrade.

A feminine sleigh bed is made even more so by the addition of a sheer pink canopy.

Portraits and memorabilia flank this regally draped bed.

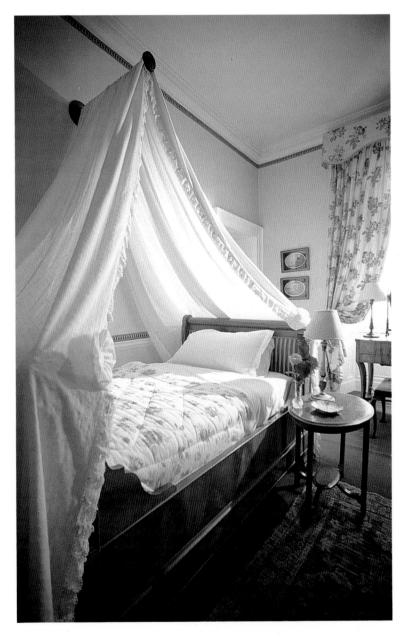

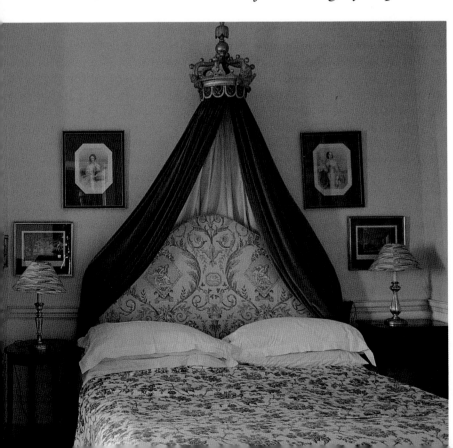

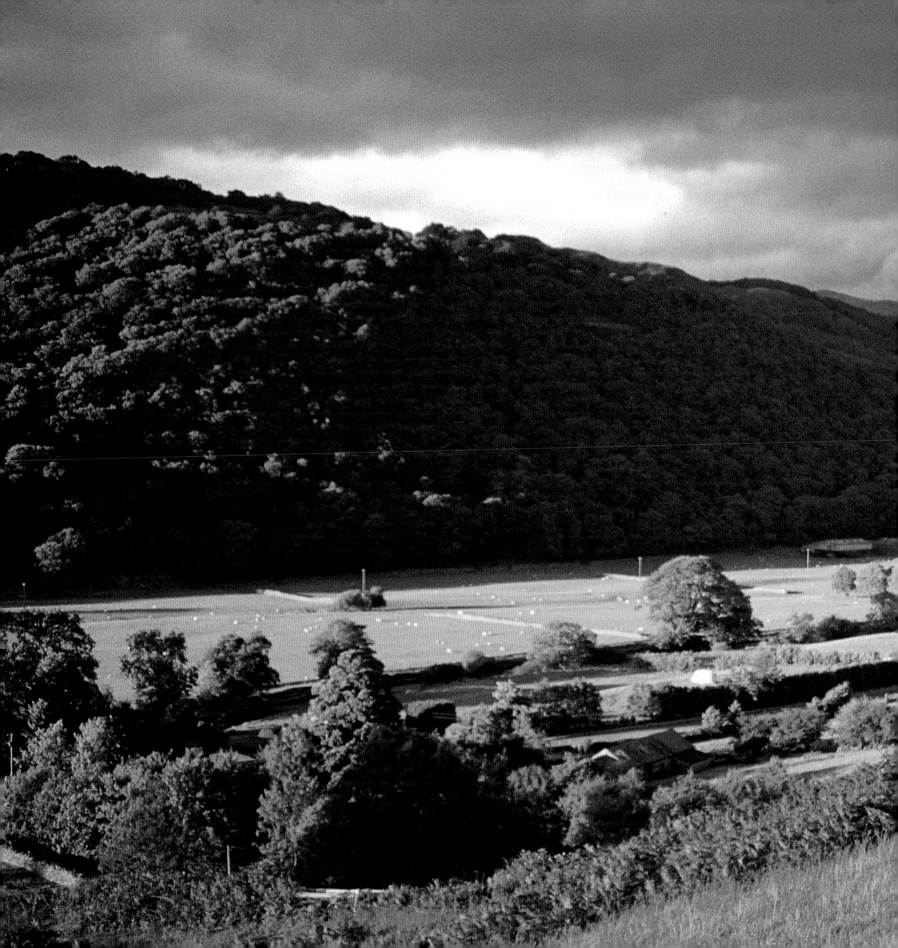

Wales
Cymru

WALES

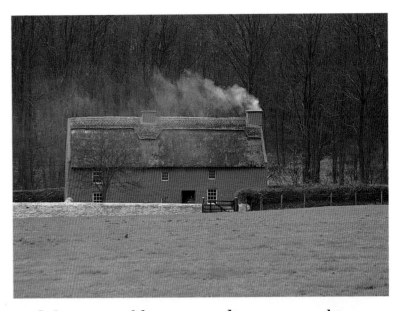

Within the boundaries of Wales, many experiences of place are possible: some are based on geography, some exist only in imagination, and some are shaped by language and by political history.

Between the rocks and the sweeps of green valley bowls, between the seacoasts and the long English border, there are at least four distinct Welsh landscapes and ways of life: South Wales is the urban and industrial belt, containing the bulk of the region's population, its capital city of Cardiff, and, up and down the valleys famed both for the valor of their rugby teams and the valor of their miners, the sad and now unused coal shafts. The western Welsh coast is holy Wales; the cathedral city of St. David's anchors the area with a kind of spiritual pull. Near it, along the coast, are small seaside communities with Celtic and Norse place names that hint at worship of a more animist kind and celebrate the sea and the sun. Mid-Wales marks a kind of transition, an area of spacious settlements, small industry, and agriculture away from the crowds of the south, set within the cushioned greens of farms, towns, and villages. This pretty landscape can suddenly become majestic— great hollows and curves of earth that

undulate, wavelike, across distances, making valleys with walls that range from steep to gentle. North Wales can feel the most distinctly Welsh—it has that flinty hardness of slate-filled mountains and heaps of slag. But North Wales has another face, which shows itself in warm and hospitable Victorian seaside resorts and (now meant for tourists rather than slate) in the famous toylike narrow-gauge railroad that runs through part of its center. North Wales, too, is the fertile island of Môn, or Anglesey, and of small seaport towns that hoped to find prosperity as watering holes or as ports for ships bound for North America.

And then in addition to, or underlying, the Wales of the picturesque, the underdeveloped, or the many rural beauty spots, there is another dimension of Wales still. It is the Wales of the mind: the mythic land of legend—of King Arthur and, before

that, of dragons and mysterious shape-changers. It is the literary Wales of oral tradition, of bards and celebrations of bardic forms. It is also that country dimly perceived through Welsh-authored writing in the English language, which gives us a faint sense of the flavor, rhythm, and sheer wealth of Welsh. Finally, it is the country of Welsh-language speakers, the inheritors of Welsh culture who consciously keep it alive in the land of its birth.

This Wales, the Wales of Celtic language, is another place. It is a place called *Cymru*, and a language called *Cymreag*, and the language encompasses the place and enlarges its dimensions. This soft language can set the Welsh speaker apart from the non-Welsh-speaking Welsh and from the rest of Britain. Like all language, it hides within its folds essences of culture and identity.

Welsh language and culture have survived and have been nourished by and through the translation of the Bible into Welsh, the sweeping incursions of the Industrial Revolution into the Welsh landscape, the temporary ban of that language in favor of English, and the long and permeable border with England. They have survived the incoming waves of English settlers as well as the outgoing waves of Welsh emigrants. In spite of every reason to predict its demise as a living language (and in spite of its being enmeshed in many of the conditions common to Scotland and Ireland that have threatened to make Celtic language there into a sort of museum piece), *Cymreag* has succeeded in maintaining its life force.

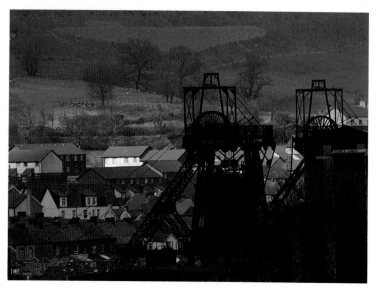

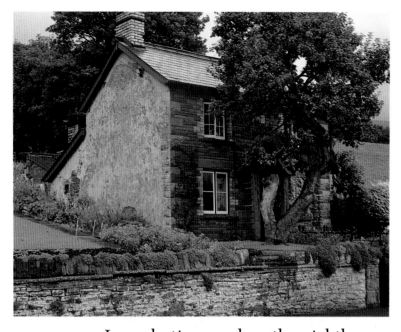

The struggle to maintain Welsh identity can be traced through the forms of the houses, and the marks of man upon the landscape. Starting with the boundaries of the eighth-century earthwork called "Offa's Dyke," which was constructed as a statement of Welsh sovereignty, and which still serves in part to define the border between Wales and England, the land and the structures it has nourished can trace a history. Many elements of that history are visible today, such as the buildings and towns created by Norman, and later English, conquerors; as well as a wide variety of abandoned cottages made empty by disease, enclosure, poverty, and the shifts of population spurred by industrialization and social movements.

In early times, when the eighth-century king Offa built his dyke, the people of Wales were tribal. These tribes or clans, like those in Scotland and Ireland, lived in family-based settlements from which they farmed both the lands of their chief and their own smallholdings. With each succeeding generation the small family farmlands were further divided. And because the land could not sustain constant toil, fields were rotated on a seasonal basis. Traditionally, May Day was the time when farmers moved from their winter home (*hendre*) to their summer place, to take advantage of high common grazing lands. (One of the houses in this section, Hendre Gwenllien, was originally such a winter farm.)

The rural settlement pattern that still characterizes parts of the Welsh countryside, where small dense communities

are scattered across sparsely settled territory, is due in part to this earlier pattern of land use and division. Similarly, the pattern of growth that created cities and towns in Wales (and in Ireland and Scotland) can be traced to Norman times, when the feudal population was reorganized around motte and bailey castles and a central manor.

The political history of Wales is one of waves of conquest and resistance, in which portions of the country were often under siege, and heroes of Welsh independence flowered in succeeding generations. Although Wales became part of the United Kingdom in the sixteenth century, Welsh language and culture struggled (and still continues to struggle) to maintain its separate tradition.

The Act of Union marked a new economic era for Wales. Welsh farmers expanded their markets to England, and began in the process to further open up Wales to English influence.

The income from these diverse ventures into wide-scale commercial farming filtered back to rural Wales, and is evidenced in seventeenth- and eighteenth-century renovations and additions to the typical Welsh farmhouse—grand chimneys, large areas of glazed windows, often an upper story added to a longhouse.

By the nineteenth century, Wales had been affected by the English enclosure movement (as well as by the Industrial Revolution), which put strong economic pressure on the smallest of small holdings, and thus accelerated the drift toward urban settlement and industrial employment. In that process, Wales became the export base of the entire British economy—in addition to

the cattle and textile trades, she exported coal, copper, tin, and pig iron.

In the same era, the coming of the railroads added a new dimension to the pressures on Welsh cultural sovereignty. The railroad provided a new source of employment, gave access to larger markets, opened an escape route for the young, ambitious, or desperate, and created a transportation network that spurred a great burst of industrialization. It carried Welsh resources to English industries and provided a track upon which further English cultural penetration could run back through Wales. All lines led to the great cities of England, making it easier for two Welshmen to meet in London's Paddington Station than in any part of their native land. (Wales had no capital until 1955, when Cardiff was so designated by an Act of Parliament.)

No understanding of Welsh cultural resistance to wholesale Anglicization would be complete without mention of two other important factors: the radical tradition in politics and its connection to chapel, or nonconformist religious practice. The radical tradition emerged via a great many paths—the sense of morality engendered by the Methodist revival movement of the eighteenth century; the influence of the ideas of the French and American Revolutions; outrage at English heavy-handed criticisms of the Welsh educational system; as well as rapid and lopsided industrial development, which created a large working class without simultaneously creating a strong middle class.

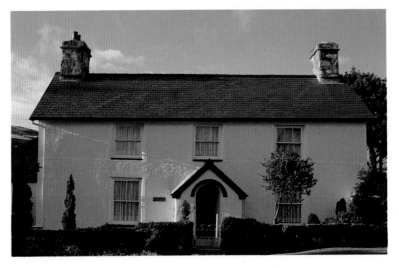

As a result, workers were starkly pitted against bosses. Both the establishment of Welsh-language newspapers as well as the new united (Methodist and Dissenters) Nonconformist religious movement, which published journals and sent charismatic speakers to decry exclusion from the political process, aided the development of Welsh nationalism. In reaction to landless farmers' political support for radicals, as well as in punishment for practicing Nonconformist religion, wealthy (sometimes Tory and Anglican) landowners evicted their tenants, spurring some religious leaders to organize emigrant groups to apply for passage to North America. It was the earliest of these waves of

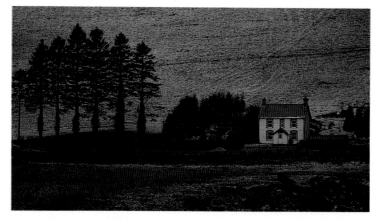

dissent in the late seventeenth century that sent prosperous and skilled Welsh Quakers to settle Pennsylvania and make such a lasting mark on the place names of that state. But later waves of dissent sent Welsh settlers across the American continent and created

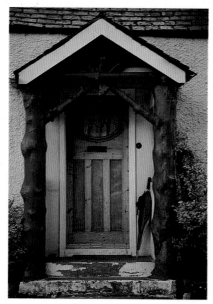

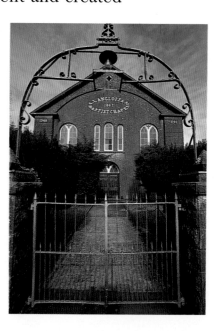

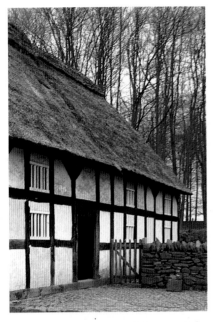

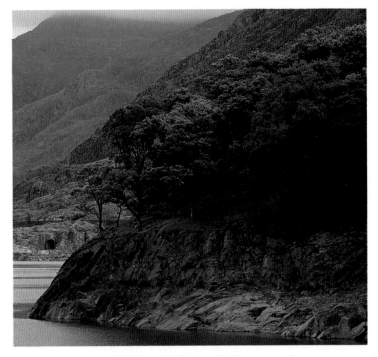

communities with such a strong sense of Welsh identity that there are few states in the American union, as well as across Canada, that do not have St. David's societies. And finally, as a unique South American postscript to this story of dispersal, it was a group of religious settlers who in 1865 created the Welsh community that still exists in Patagonia, the Argentine. In these scattered Welsh settlements it is possible even today to recognize both the native architectural features that were carried unchanged to the New World, as well as the social attributes of Welsh society.

The houses in Wales itself continue to illustrate the region's rich history. Stone farmhouses with their eighteenth-century additions can be discerned throughout the rural landscape. Crowded workers' housing shapes long rows up and down many valley walls. Wales' numerous castles and elegant manor houses are vivid reminders of feudal society. And although many of today's homes are adaptations of buildings originally constructed for other purposes, whether farm buildings, chapels, or train stations, their earlier functions can often be perceived.

Although Wales has long been an attractive place to incomers from other parts of Britain, the majority of the homes on the following pages belong to Welsh speakers who view them as expressions of their identification with Welsh culture.

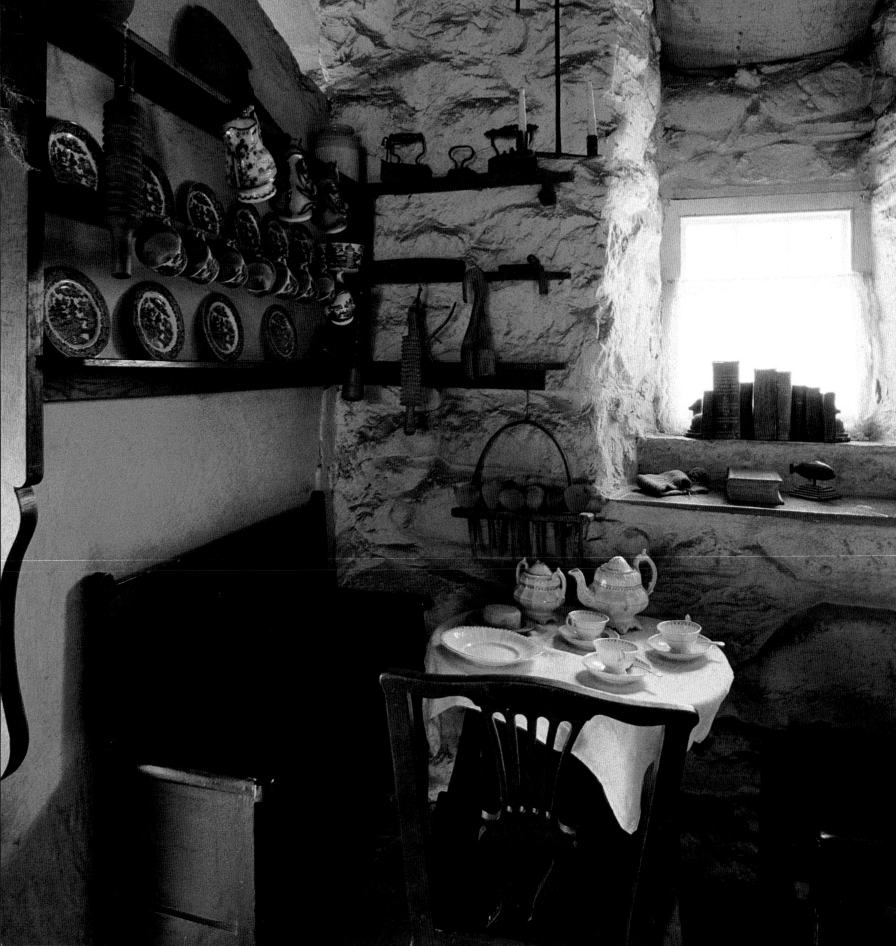

SLATE WORKER'S COTTAGE

This small cottage from North Wales is typical of the homes slate workers and quarrymen lived in. Dominated by a large hearth, which provides both heat and a place to cook, the interior is simply furnished. On one side of the hearth lie the table and chairs, on the other are cupboards for kitchenware and dining. Up the ladder opposite the hearth are sleeping lofts for children. The small alcoves on the ground floor under the loft are for sleeping, or for caring for ill family members.

This house, which belonged to a family of slaters who emigrated to work in Vermont's quarries in the nineteenth century, has been relocated to St. Fagan's Folk Museum in Cardiff. Its careful reconstruction and historical accuracy provide a compelling picture of Welsh cottage life.

The windowless gable end of the cottage is seen through a traditional slab fence, which was reconstructed at St. Fagan's, part of the Welsh Folk Museum (National Museum of Wales).

A small table is set into one corner of the cottage, lit by the back window. Everyday crockery is stored on the rack above the bench.

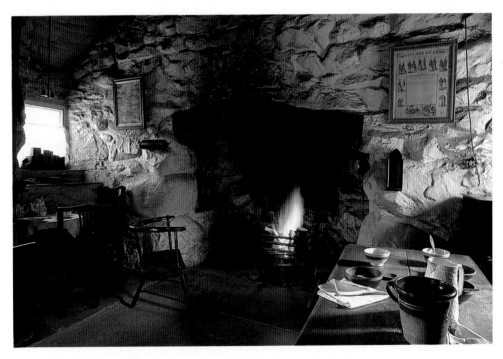

An open hearth is at the center of one wall of the cottage. The small wooden chair to one side is a traditional form common to all parts of the Celtic fringe.

181

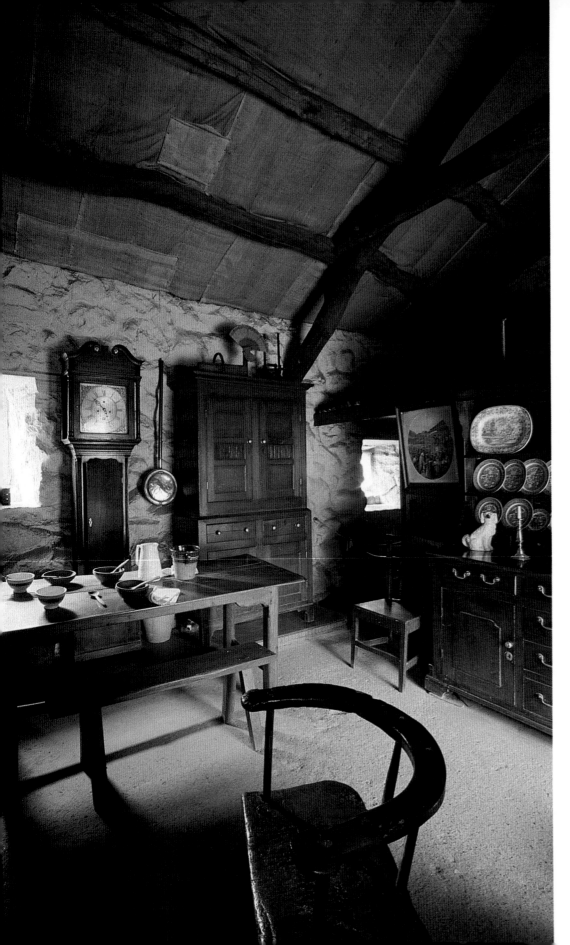

The small adult bedroom (and sometime sickroom) is under the sleeping loft. The bedcover is typical of Welsh patchwork.

Rush matting insulates the inner roof and provides a marked contrast to the elegant standing clock and mahogany dresser.

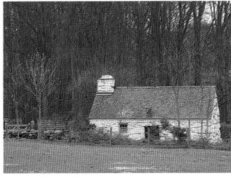

▲
This view of the cottage illustrates its archetypal form. Children still draw a picture like this when asked to show a house.

──────────────────────────────▶

Rows of delft fill the shelves of the dresser, and make a fine contrast to the shining brasses.

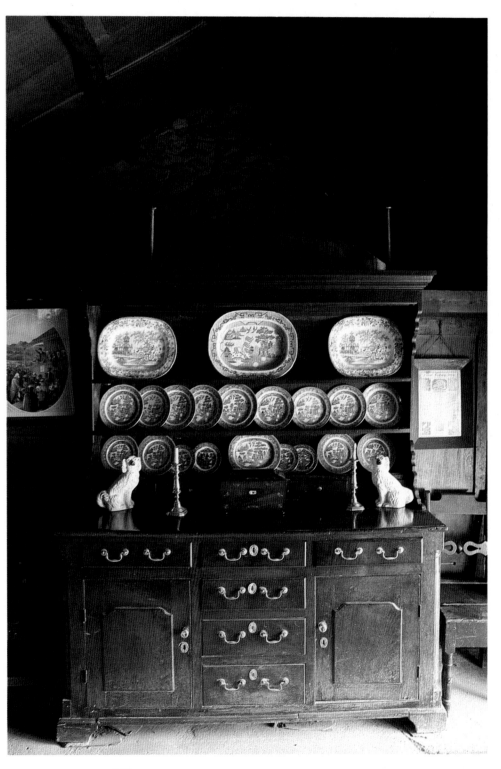

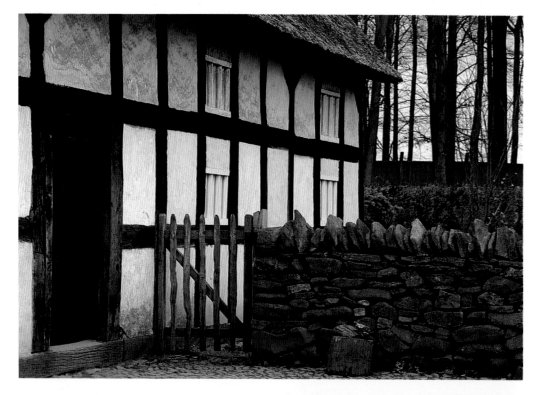

Elsewhere at St. Fagan's, a neighboring timber-framed house illustrates the technique of in-filling the wooden frame with wattle and daub.

This grinder sharpens tools and knives; it sits in the corner of a small sheltered yard.

In Wales, as in America, barns were often roofed with slate. The small holes are for ventilation.

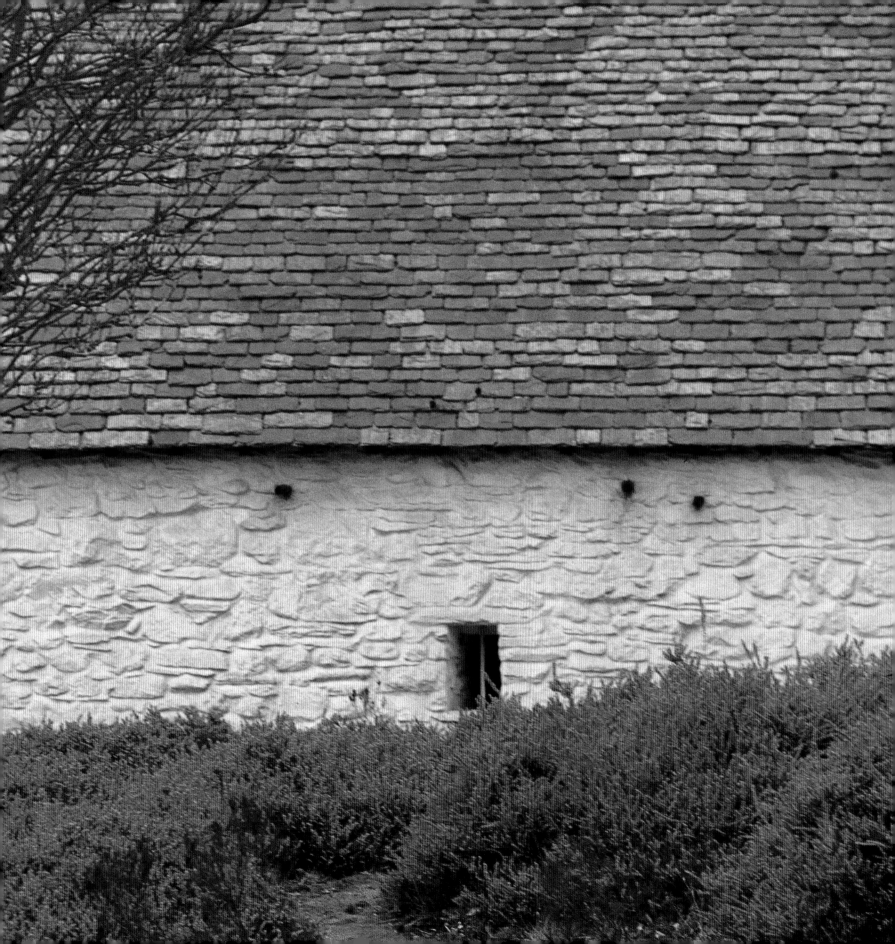

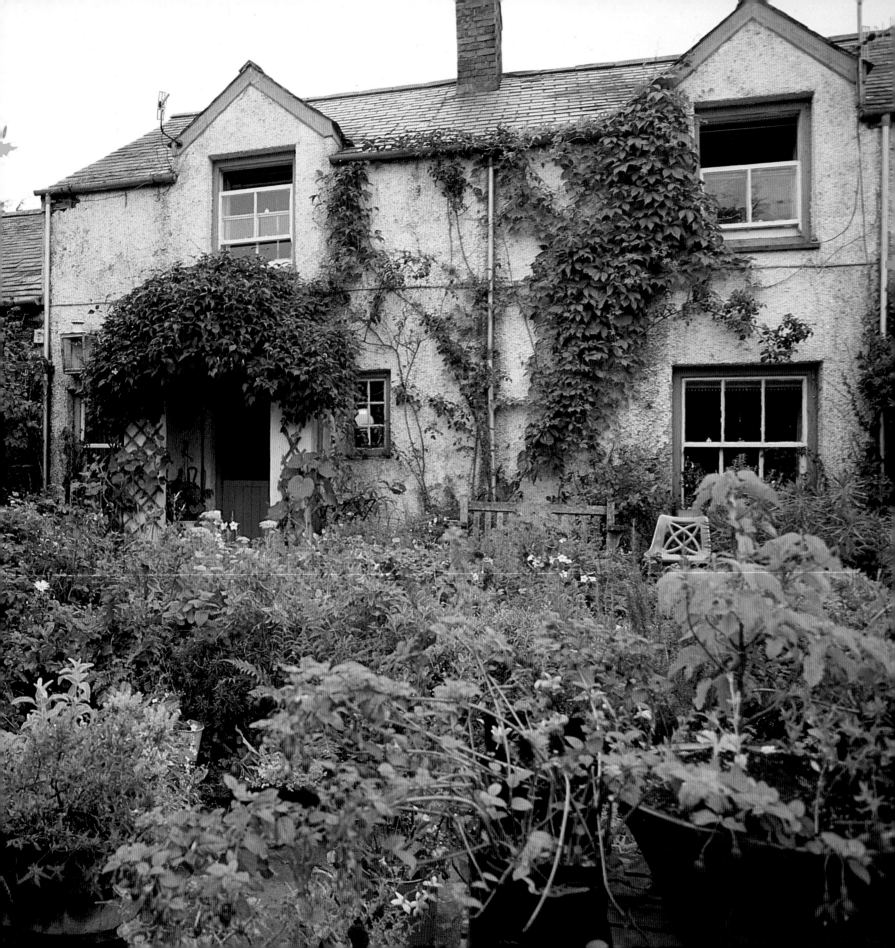

WELSH WORKING FARM

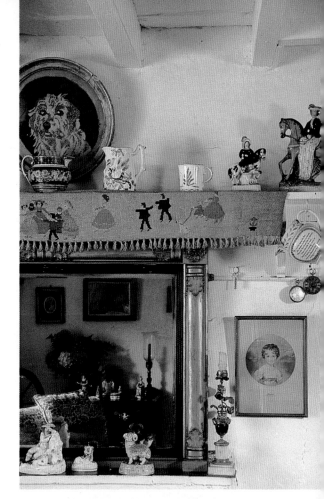

This cottage in North Wales, built around 1780, has been home and hub of the dairy farm worked by the farmer's family for generations. The farmer's mother (now in her eighties) lives nearby, and her old cheese- and butter-making equipment still graces the cottage kitchen. The farmer's wife has been an antiques dealer for much of her adult life, and the prize pickings of her profession mingle happily with the inheritances of the farming family.

A traditional stone cottage built into the corner of two of the confining walls of the farmyard, this was a "home farm" for a large estate. The equipment shed flanks the cottage, and on the opposite side of the cobbled courtyard are the carriage and animal barns. Through a small metal gate at the front of the cottage is deep garden filled with flowers. The high wall along its length supports fruit trees and vines.

The interior of the cottage is divided into six rooms—on the ground floor, the parlor is entered from the garden via a Dutch door surrounded by flowers. The eat-in kitchen, with its packed china cupboards and embroidered samplers, is on one side, and a living room filled with collections of china rolling pins and Welsh furniture is on the other side. Through a door, a steep staircase leads up from the living room to the bedrooms and bath above.

The antiques dealer has turned one of the upstairs bedrooms into what she terms a "sulking room." Furnished with a comfortable chair set next to a window, she claims that time alone in this room cures her of all malaise.

Twin dormers like these are typical of Welsh cottages.

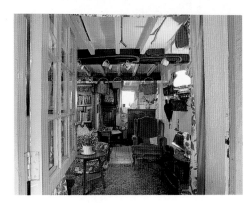

▲
A blue-painted edge frames this view into the parlor.

▲▲
The sitting room fireplace has been modernized and fitted with a gilt-edged mirror, but the embroidered cloth that caps the collection shelf is Georgian.

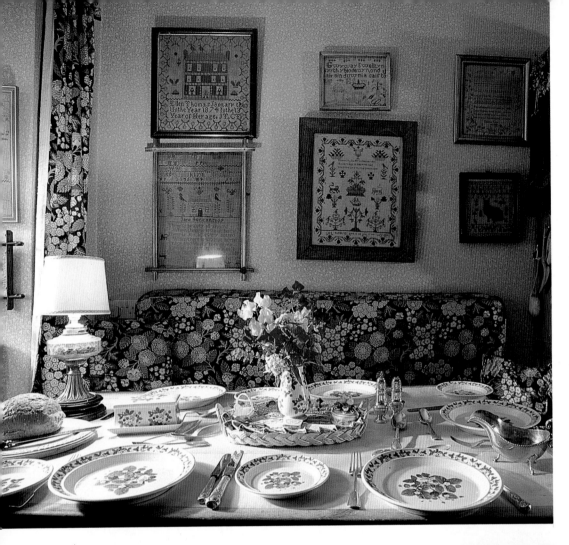

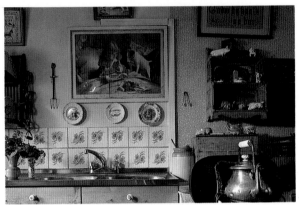

Surrounding the sink are plates and samplers with letters and verses in Welsh; the right-hand one reads Cadw dy hun un buu (Keep yourself pure). A miniature Welsh dresser holds a group of china pigs.

In the kitchen, Portmeirion pottery marks the place, while a group of samplers embroidered in Welsh (except for the one sewn by the owner's English grandmother) act as a backdrop. The pink and white wallpaper is from the very first Laura Ashley collection.

The old Welsh dresser is filled with everyday plates, mushroom collecting baskets, Staffordshire animals, and a group of cream jugs. Farmwife necessities are also stored here—the decorative wooden butter molds belonged to the owner's mother, and are each scaled to weight. The acorn and oak leaf hold half a pound, while the swan shapes a full pound. The rolling pin look-alike near the top of the cupboard is actually an oat-cake crusher.

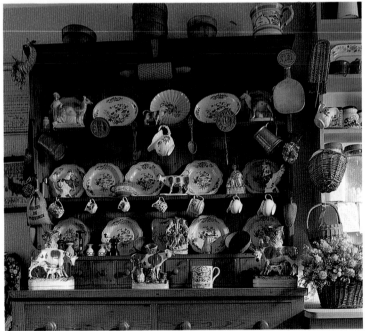

188

The three-legged table sits on the antique Oriental rug, while old china tankards and walking sticks hang from the beams.

The traditional Welsh harp stands ready to provide an evening's entertainment.

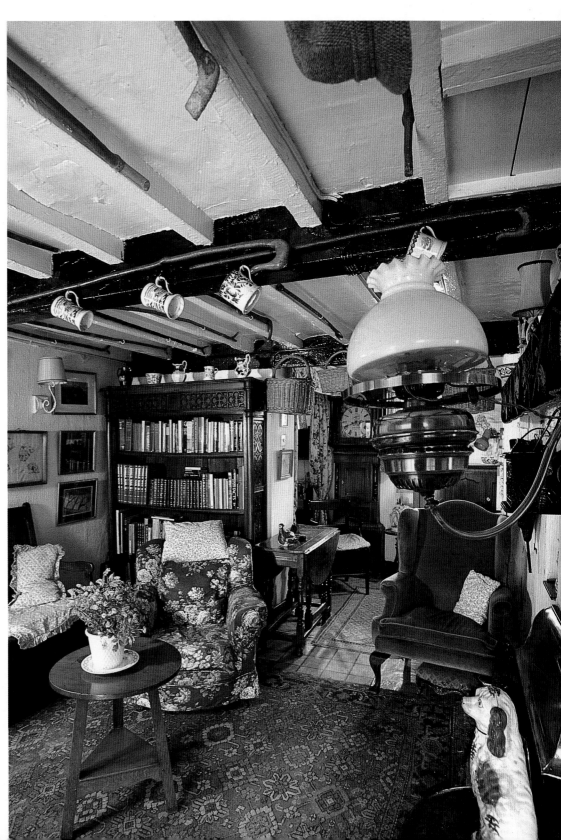

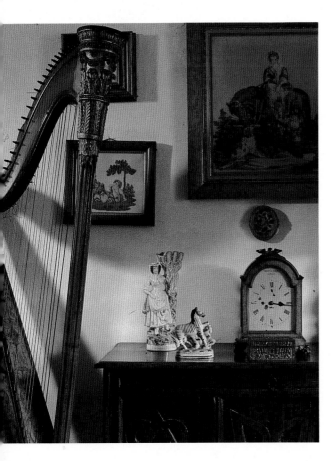

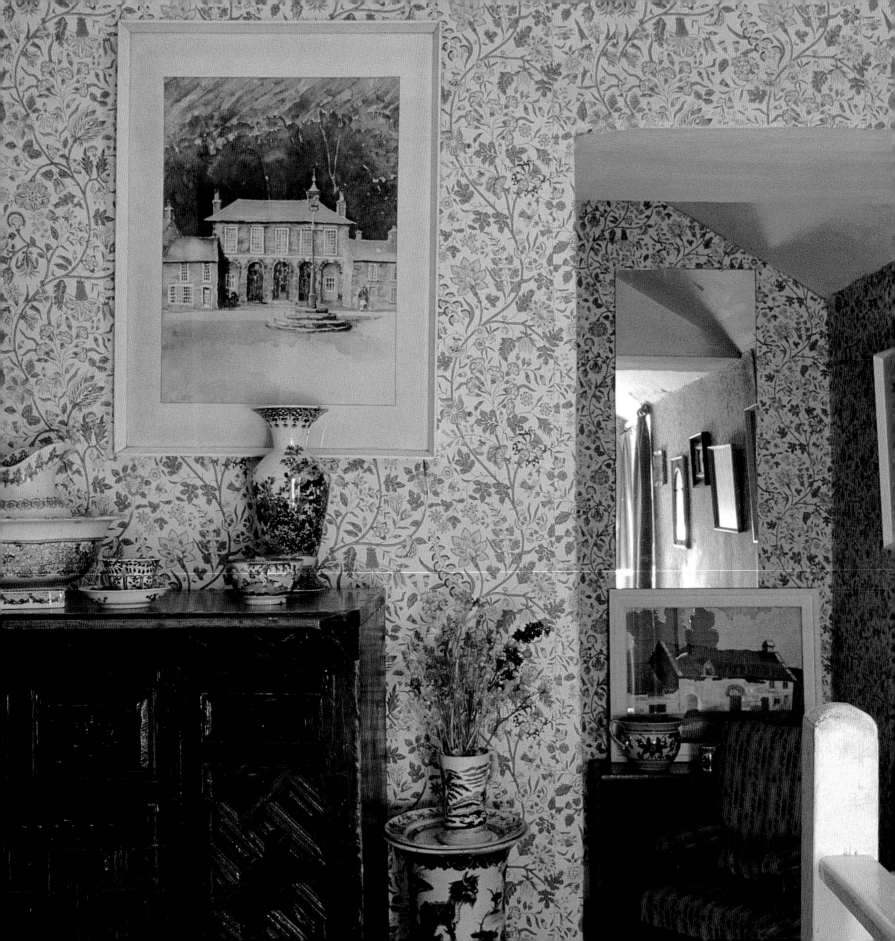

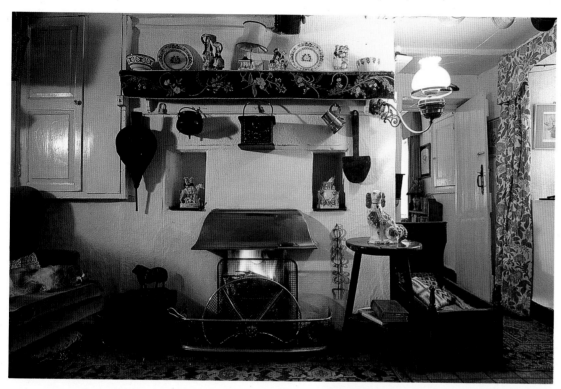

More than a grandfather, this clock in the sitting room dates from before 1800, and was constructed from a tree felled on the family farm.

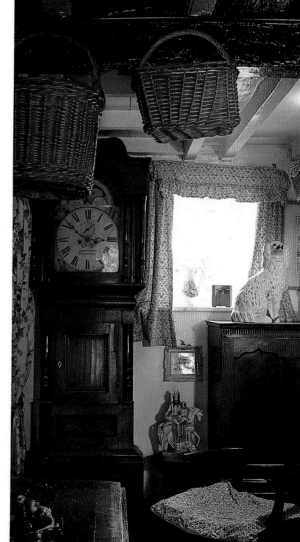

A glowing fire in the parlor warms body and soul, while bellows hang close at hand to keep the embers bright. Niches on either side of the fireplace, as well as the nearby table and shelf above, provide settings for decorative plates and sculptures.

Retreating upstairs to the "sulking room" is a pleasure, not a punishment. Here in this small room, comfortable seating provides a place to reflect and heal.

At the top of the narrow stairway, the landing is papered in blue and white to match the Chinese export porcelain. A bedroom is just visible down the hall.

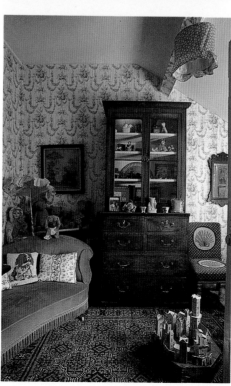

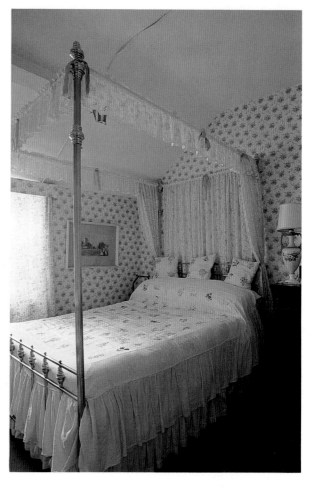

In the guest room, a brass four-poster takes center stage. The bedspread's delicate embroidery echoes the sprigged paper.

A white-painted gate delights the eye as one looks toward the house and its front garden from the farmyard.

A romantic bed is reflected in the bull's-eye mirror of the master bedroom. The miniature chest holds a vase of almost the same scale.

Lush planting, bold color, and changes in scale distinguish this small walled garden, and make it seem larger than it really is.

A closer look at the bed reveals crochet-lace bedclothes. The ceiling beams are papered to match the walls, cushion, and table skirt.

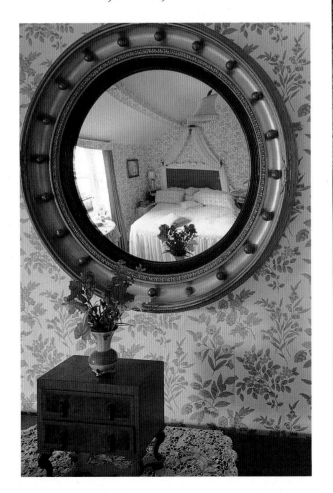

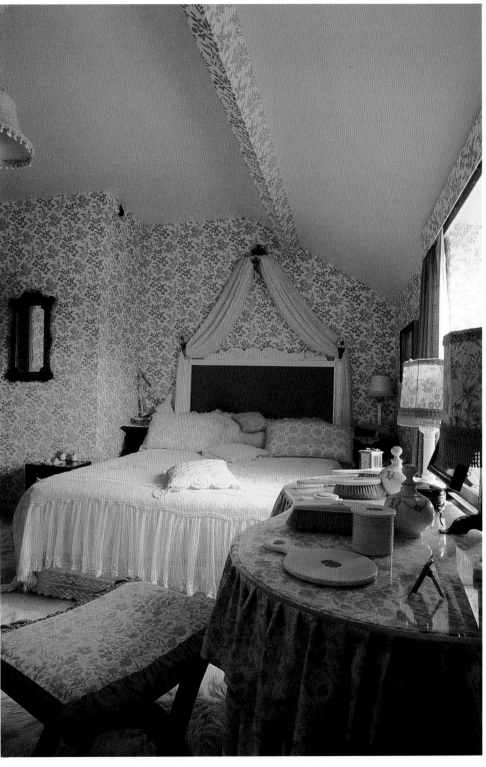

STONE COTTAGE, TRANSFORMED

Tony and Anthea Britnell came to Wales in search of rural peace. After some years of living in the Netherlands and working in the music industry, the Britnells resolved to return to Britain to lead a simpler life, and to support themselves by working with leather. They started their search for a new home in rural England, but could not find a place that was both beautiful and unspoiled. They then resolved to try looking in Wales, and if that didn't suit them, to try Scotland.

Happily, they found a small farm in mid-Wales. Reached by a long, steep, and winding dirt road, the tiny old farmhouse and barns are set halfway up a hill, on a spectacular sweep of rising land. Although the exteriors of the buildings are unchanged, the interiors have been transformed into congenial settings for the Britnells' collection of classic modern furniture. Decorated in a palette of muted gray and white, the simple architecture is a strong foil for the sculptural quality of their furnishings and artifacts.

The barn has been made into an eye-catching showroom for their own work, using perforated cheese-draining tiles for the floor and owner-designed and -built furnishings. Ambitious plans for the grounds include a ha-ha to keep local cows off the lawn.

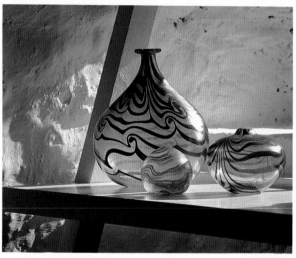

A look up the hill to the farmhouse shows the lush greenery and steep road typical of mid-Wales.

In the barn showroom, Welsh-made art glass catches the sun. The modern ladder-shelves are owner designed and built.

White textures abound in this view through the dining room hallway toward the front foyer. The closet doors are painted and perforated wood; their vertical rhythm is echoed in the door molding and the radiator.

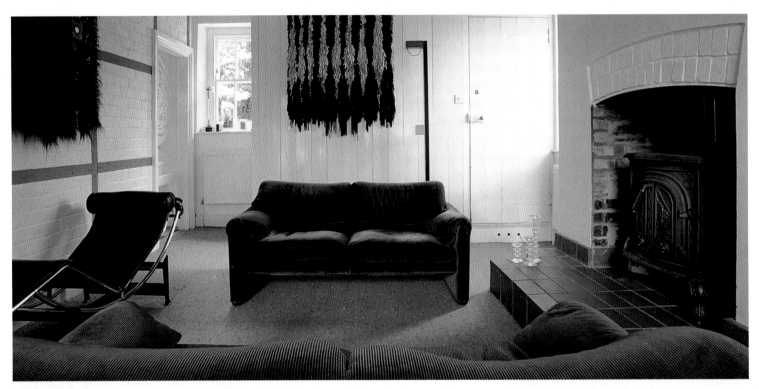

Home to the classic modern furniture the owners collect, as well as to their own wall leather sculptures, the gray-painted beams and white brick walls of the living room provide a strong graphic frame.

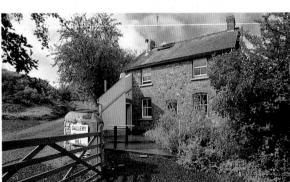

An exterior view of the farmhouse shows the new entrance-foyer addition on the left.

The kitchen's pine cupboards were locally made, and the black countertops and painted ceiling beams continue the whole-house color scheme. Gold records lining the tops of the overhead cabinets are souvenirs from the owners' work in the music business in the Netherlands.

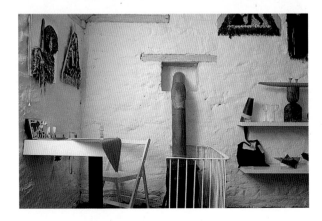

The generous half-round beech dining table is of Dutch design, as are the chairs. A triple tier of shaved-wood fixtures provides light that further textures the old brick.

Primitive masks trailing cascades of straw hair contrast with a leather and chrome Le Corbusier chaise.

The barn showroom is a study in simplicity, as well as a tribute to the owners' skill in design and construction. The triangular one-legged table is an original creation—its single black leg is a painted cardboard tube. The wall hangings are made from knotted strips of dyed calfskin, as is the leather jewelry.

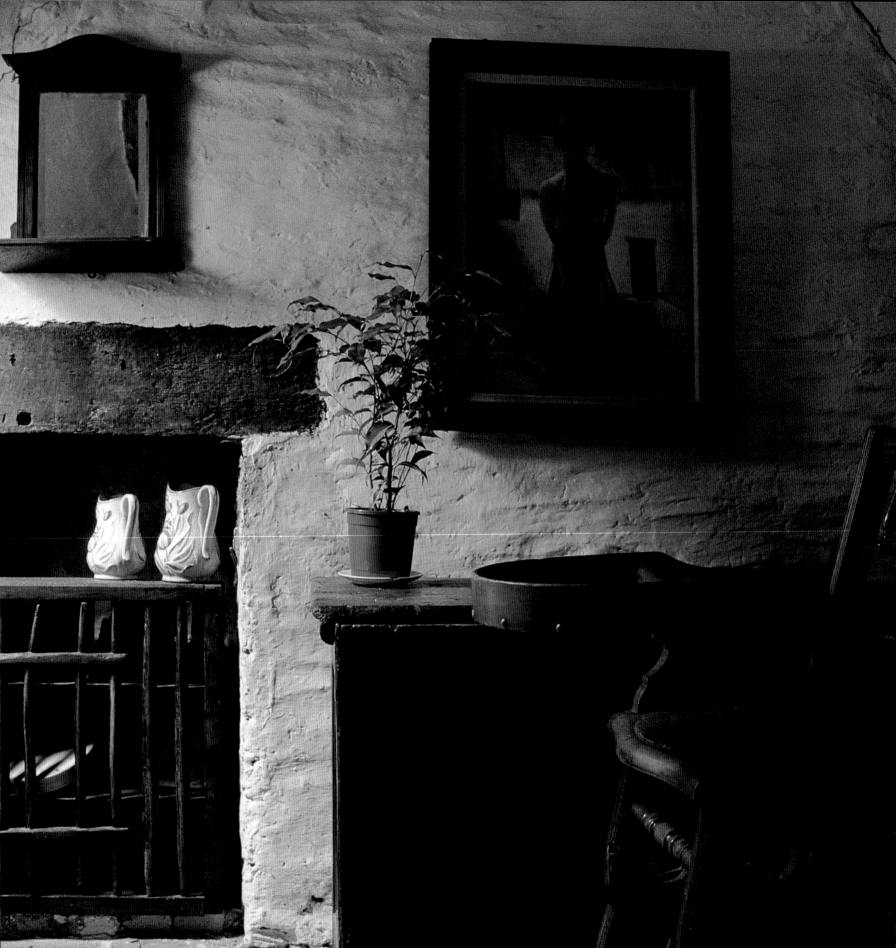

A CARING TENANCY

An artist has brought up two children in this rural timber-framed mid-seventeenth-century house in Powys, working hard to preserve and enhance the structure in the face of the landlord's indifference. Owned by a family that farms the surrounding land but lives elsewhere, the house was abandoned for many years until the artist found it fifteen years ago. Working alone, and with very little ready cash, she tore down decayed plaster walls and false ceilings, peeled back the linoleum that covered the original slate floors, removed the cooking range that blocked the hearth, subjected everything to an extensive cleaning, and put in running water and a kitchen and bath.

Architecturally, little has been changed—the rooms function much as they would have when the house was built. But this home is not a historical preservation, and the interior strongly reflects the inhabitant's serene style.

The artist's sensibility is apparent everywhere. Although most of the walls are colored naturally by the cream of old plaster divided by nearly black beams, some of the doors are painted in deep colors to enhance the soft geometry of the interior architecture. The rough wood of the fireplace mantel has been deliberately left bare, to show off its ample proportions. The gray slate sink in the kitchen has been lovingly maintained, and the richly colored old wood paneling that lines the bathroom was carefully recycled from chapel pews. A good deal of the furniture and decorative objects were found locally, some of them rescued as they were being discarded by people with a less discerning eye.

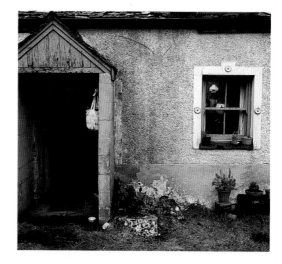

A simple portico shelters visitors waiting for entrance, and provides a small buffer against the weather.

Walls have settled in opposite directions, but the cupboard marks the corner even if it is out-of-true.

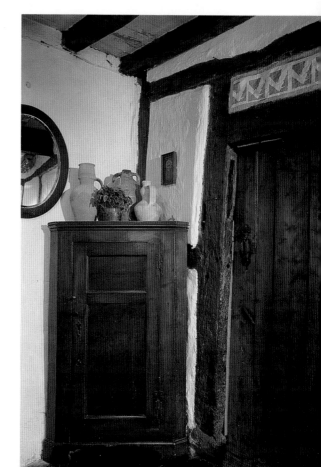

A pair of ironstone jugs rest on the grate of a small fireplace.

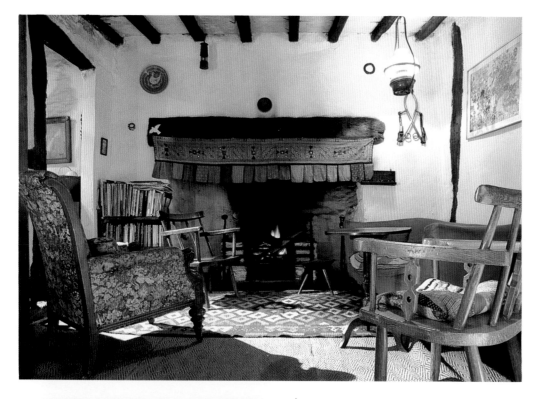

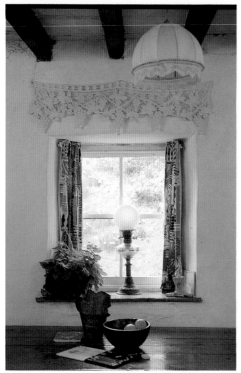

An Indian mirror-cloth valance keeps the fireplace soot and smoke from rising up the chimney-breast, while the kilim on the hearth adds a layer of warmth to the stone floor. The primitive wooden chairs in the foreground and in front of the fire are of traditional Welsh design.

Inside, handmade lace decorates the wall above this front window. In the evening, a kerosene lamp set on the windowsill casts out a beacon of light.

Wales is famous for its daffodils, and this view of the front of the house shows how prolific they can be.

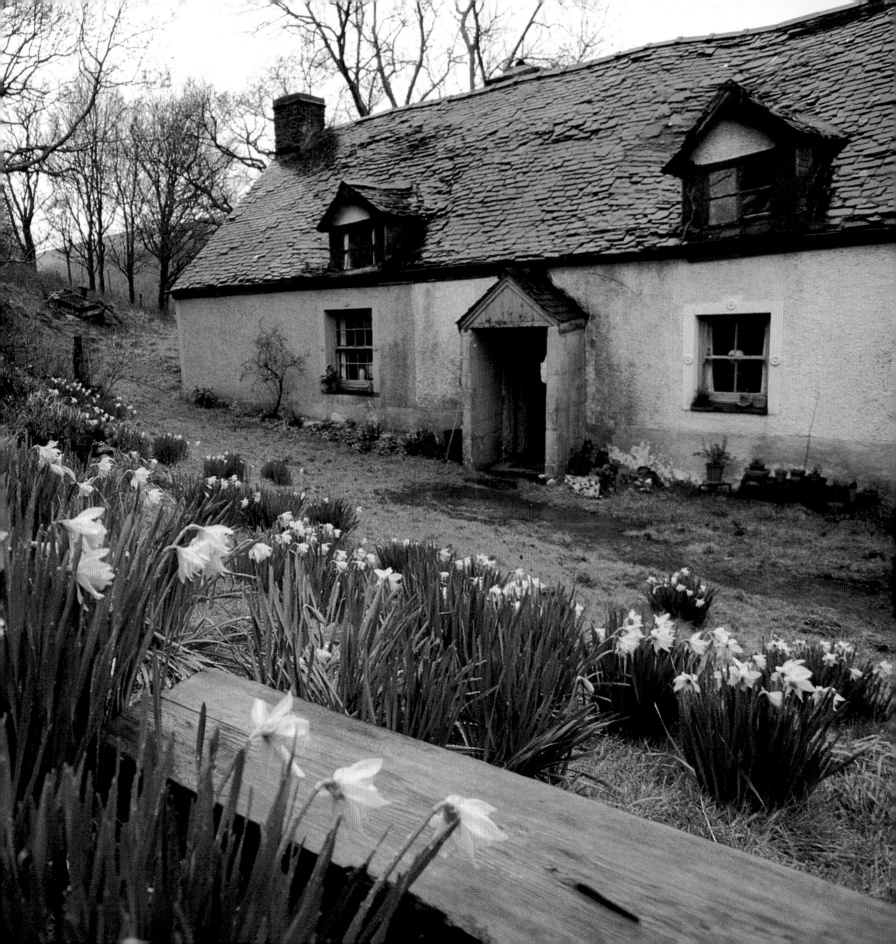

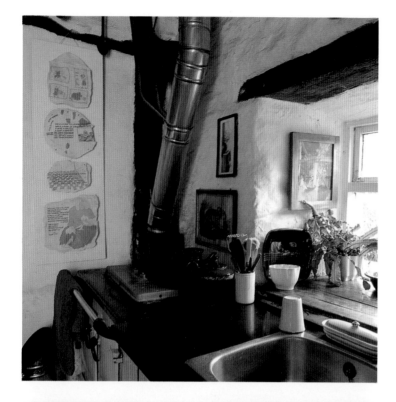

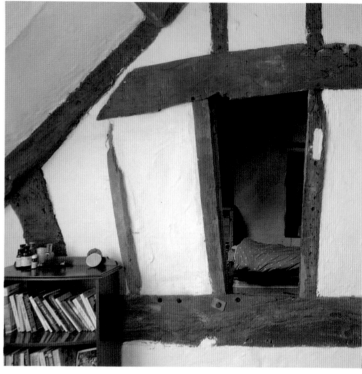

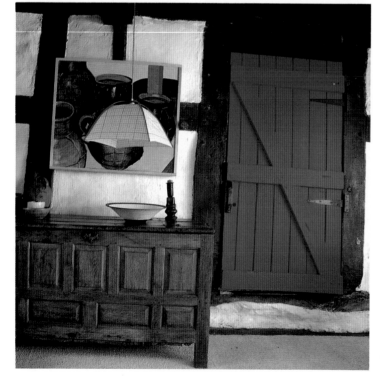

Local black slate forms the kitchen counter, its color echoed by the ancient beams above. The watercolor hung inside the deep window-reveal is a visual pun—its subject is the view of and from that window.

A look from the owner's bedroom through to her son's room shows the settled beams. The opening is new: this back bedroom was originally a hayloft for the barn below.

A red-painted door sets a cheery tone, surrounded by black beams and white plaster.

A china-filled dresser, a Welsh chair, and the edge of a narrow wooden settle form a typical tableau in the morning sunlight.

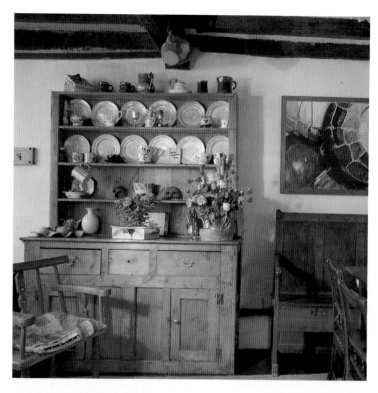

Lots of bookshelves surround the small study window, filled with books, pottery, and plants.

The dining table and chairs are of local origin; their patina comes with age and careful waxing.

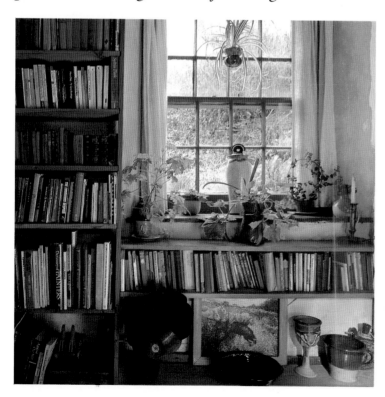

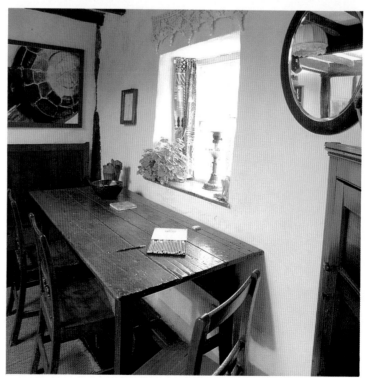

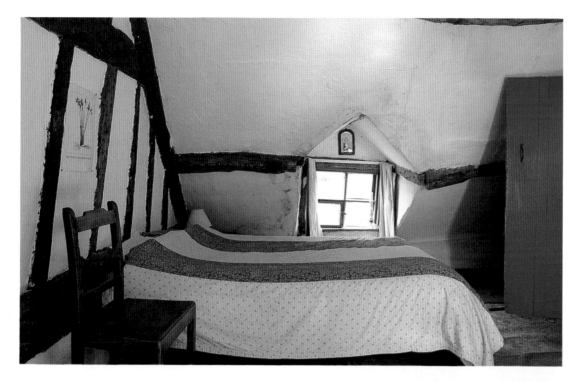

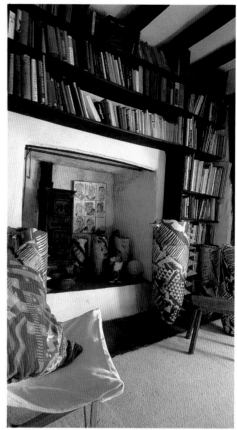

A dormer, also cut through a supporting beam, makes the steep ceiling of this bedroom sag.

A view through to the master bedroom from the upstairs landing shows the cathedral-like struts of the wood forming almost Gothic arches.

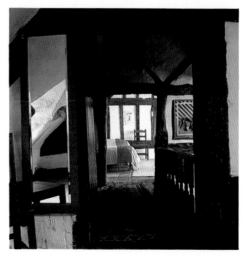

The old fireplace niche in the study is filled with a tiny coal stove and a group of patterned pots. A woven cushion on the chair translates the black and white patterns into color.

The house from the rear, all ochre-colored, shows a massive chimney and the barn and hayloft extension.

Old plaster, like carved butter, surrounds a tiny dormer window. This beam was cut for the window many years ago by previous owners, who didn't understand the consequences of removing structural elements. A sagging roof and unevenly settling walls are the result of such carelessness.

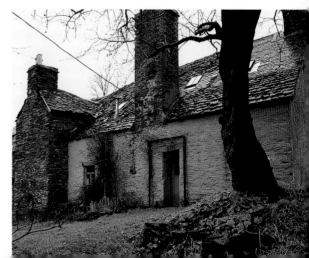

HENDRE GWENLLIEN

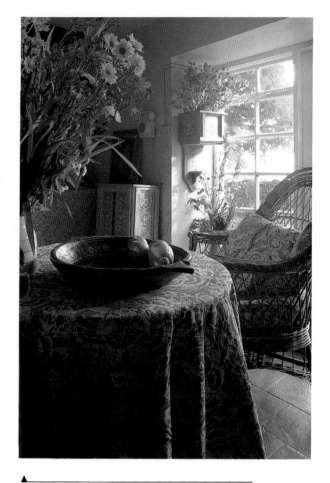

A wickerwork chair, old wooden chests, and printed cottons mark this corner of the farmhouse kitchen, where sunlight streams in through French doors.

Hendre Gwenllien, which means "winter home of the white torrent," and refers to a nearby stream, is a sixteenth-century farmhouse that was the object of a long quest.

Claudia Thomas had loved Wales for many years. After her divorce, she decided to leave London and begin a new life for herself and her daughter. She spent all of her free time walking the soft hills of Snowdonia, looking for the house that would make her heart leap. One day, walking up an old Roman road, she found it. The two and a half years it took to complete the purchase gave her ample time to research the history of the house, and to discover that in the thirties it had been visited by Noël Coward, Bertrand Russell, and Kenneth Clark when they were guests at nearby Portmeirion.

After the purchase was concluded, she was joined in the renovation (as well as in marriage) by Dutch painter Paul Jonkers. The original stables were transformed into a sunny farmhouse kitchen with a homemade stone spiral staircase to the "hayloft" master suite above; and the original kitchen shed was enlarged to become Paul's studio. The main room, which was the entire ground floor of the original longhouse, now functions as a sitting room and dining room. The children's rooms are above, reached by their own stairway.

With characteristic attention to detail, Claudia Thomas hand-smoothed and rounded the new hard edges of the plaster walls as they were being built, to maintain the handmade quality of the original building.

The scrubbed pine table sits in a corner, with a bench along one wall, and an assortment of comfortable chairs along the other side.

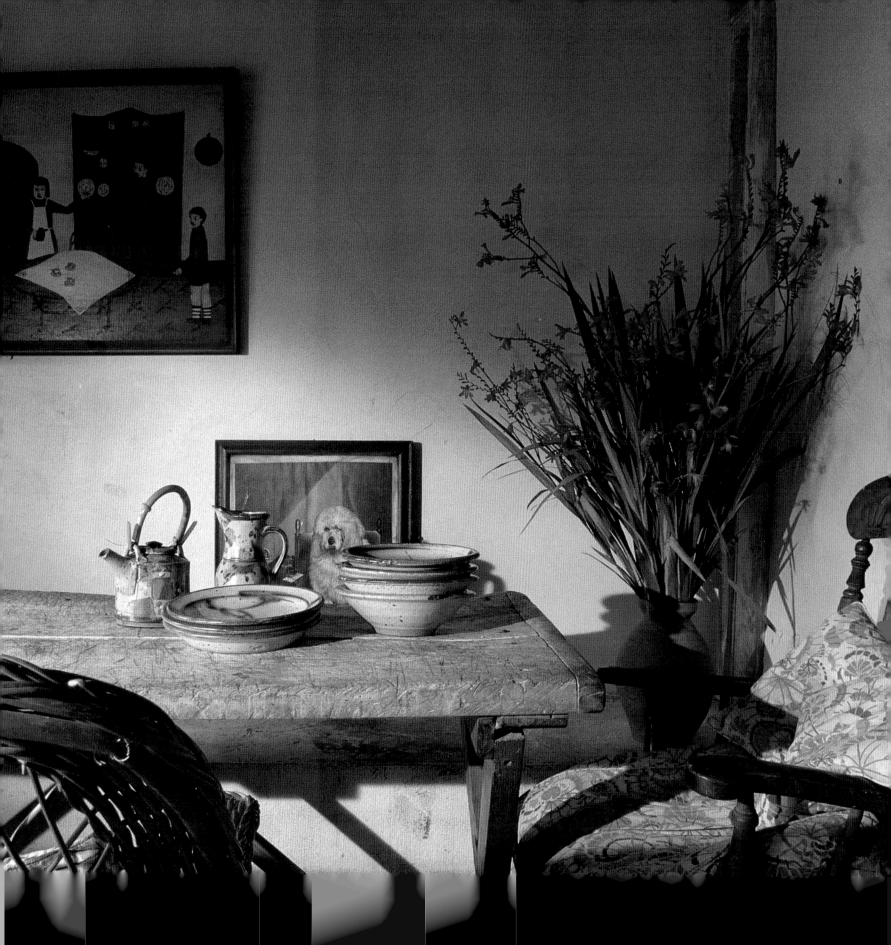

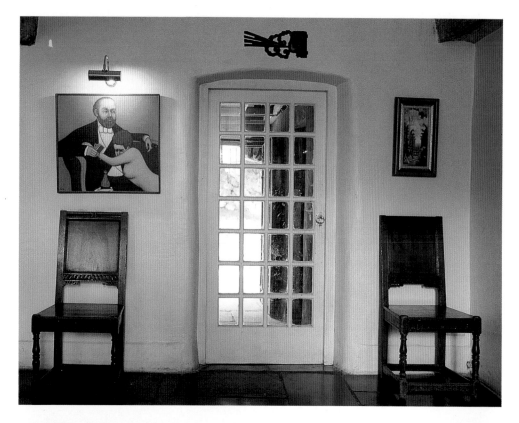

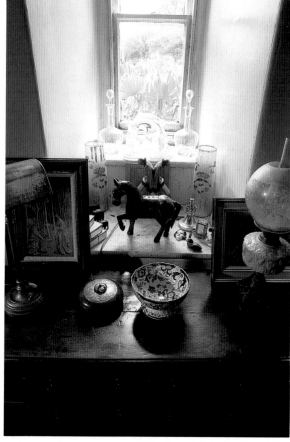

A glass door separates the mudroom and painting studio from the main part of the house.

Glass, brass, small paintings, and chinoiserie compose a still life in the raking light from a small window.

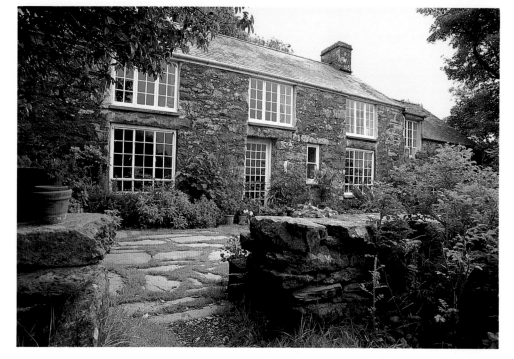

Grass-edged stones pave the front terrace. Crisp white paint on the window frames contrasts with the home's gray stone walls.

The huge opening of most of the original chimney is now filled with wood to supply a more modest fireplace that helps heat the room.

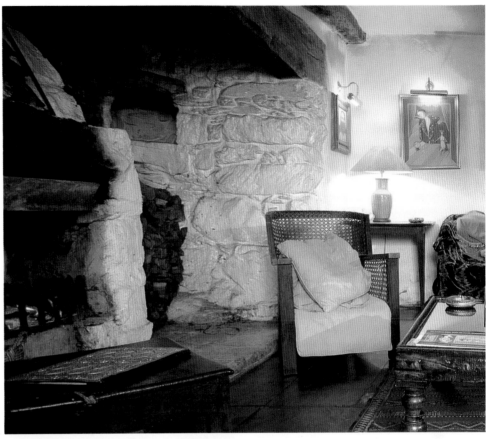

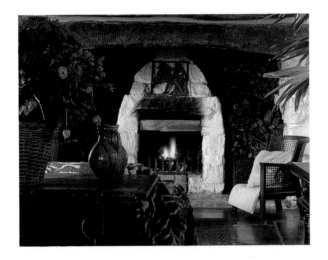

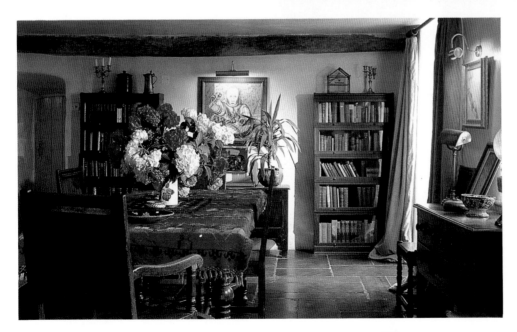

The thick stone walls of the original room-sized fireplace are visible next to the yellow chair. In earlier times, cold-weather living revolved around the massive hearth.

A wool rug from Greece clothes the dining table, draped as in a Dutch still-life painting. The polished slate floor is original to the house, but was removed and then relaid to permit the installation of radiant heating.

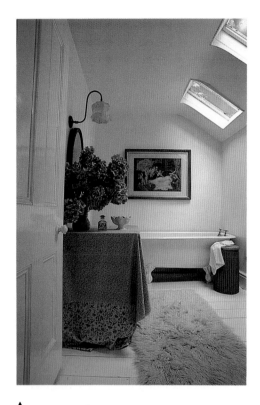

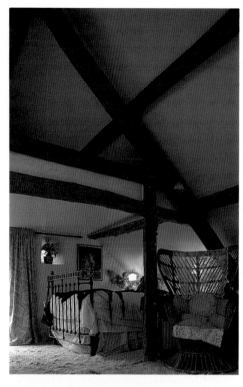

The master bathroom has a Victorian air, thanks to a restored claw-footed tub and a well-draped dressing table. Twin skylights keep the room bright.

The upstairs landing has comfortable seating for two in the hall outside the children's bedrooms.

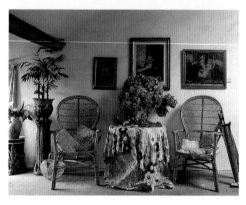

▲▲
A brass-and-iron bed commands the space that once was the hayloft.

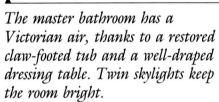

An ever-warm solid-fuel cooker is surrounded by patterned tile and farmhouse-style pine cupboards in the comfortable new kitchen. The work island was made from an old shop fitting.

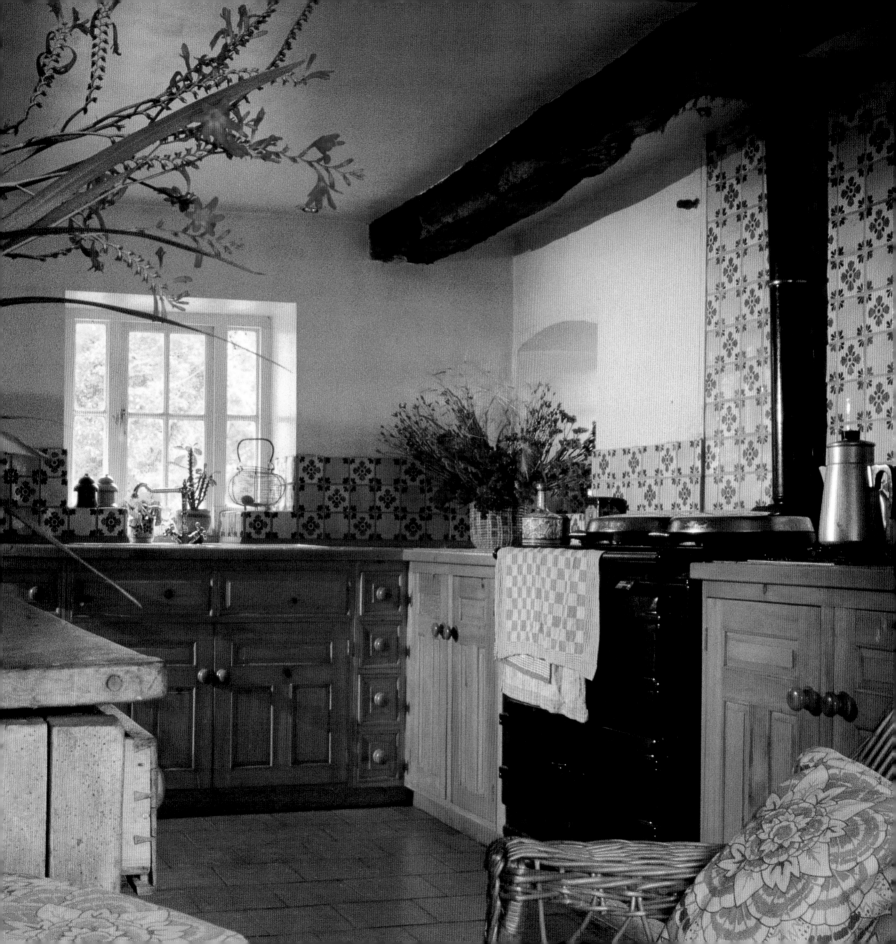

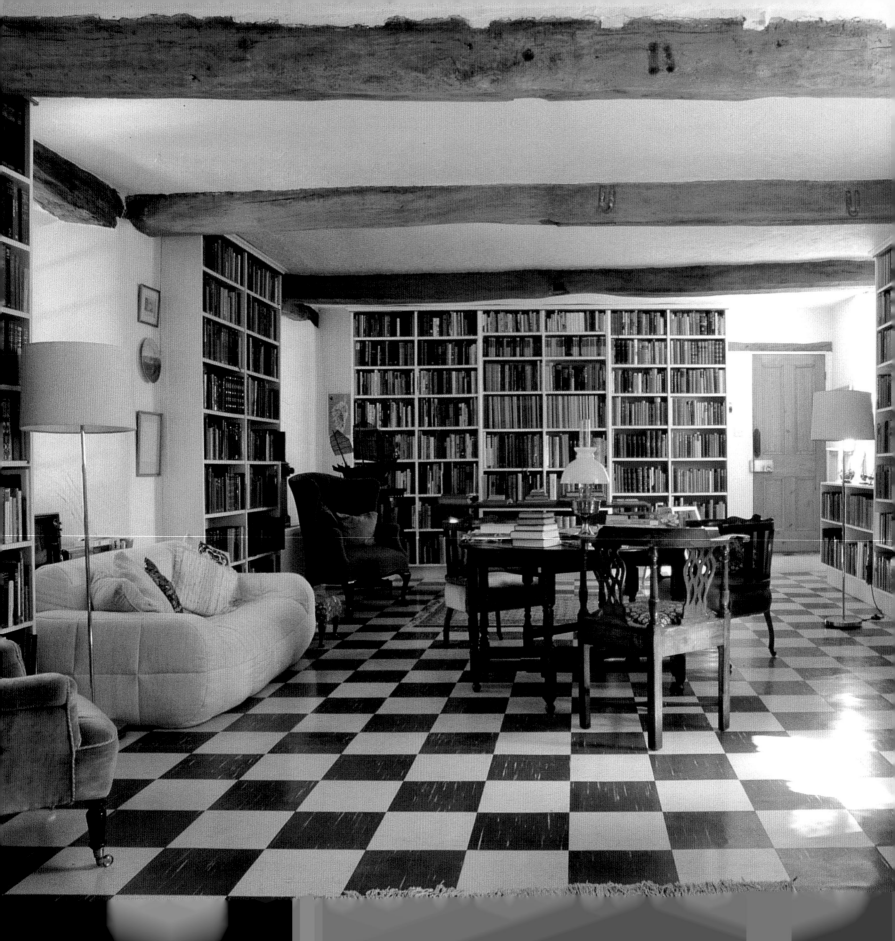

TREFAN MORYS

Author Jan Morris's home is a thoughtfully converted stable block in northwest Wales. Years ago, Morris and family lived in the large and graceful house some distance away from the stables, which was still part of the original estate. When Morris decided to sell off the house and the land surrounding it, she kept possession of the working outbuildings. Her new home is custom-fitted to her habits and pleasures: traveling, writing, and reading.

Planned for easy homecomings, the house is essentially divided in two. The first, and smaller, portion consists of a large downstairs eat-in kitchen with bedroom and bath above it, reached by a narrow winding staircase. This section can be made warm and comfortable rapidly, and functions as a sort of bedroom suite with cooking facilities.

The second, and much larger, portion is a duplex library/study/sitting room. Lined upstairs and down with books and paintings, deep soft sitting places, and tables for reading and working, these spaces are designed for entertaining the mind's companions as well as the heart's.

Morris is deeply attached to this part of Wales, especially the particular landscape near her home. She so cherishes this place that she plans never to leave it—the small and rushing stream nearby is where she would like her ashes scattered after her death.

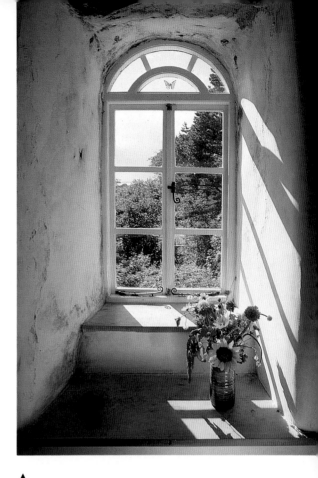

A small window has been engraved Er Cof Am y Tylluanod 1978 *(In Memory of the Owls) in tribute to earlier residents.*

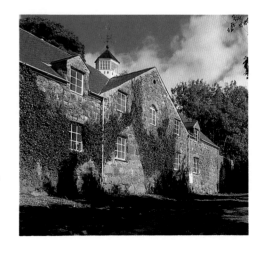

From the road, the ivy-covered building looms large. The cupola hides a television antenna.

In the downstairs library/living room, a bold checkerboard floor illustrates a classic lesson in perspective. A small dining table and chairs can provide a place for research as well as dining.

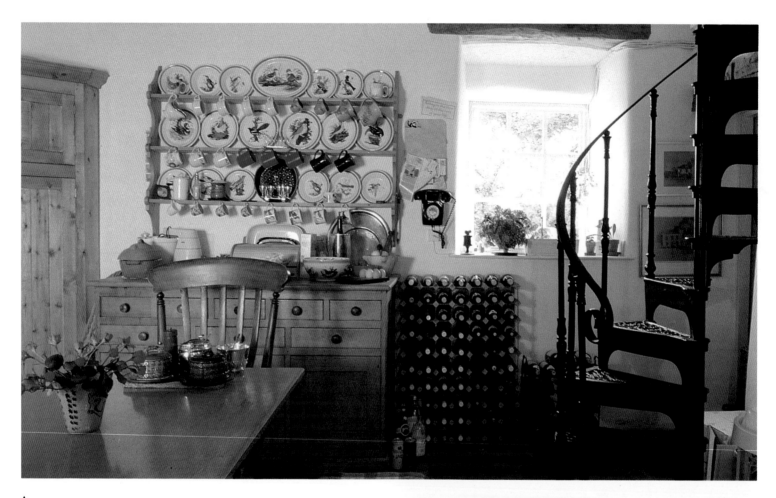

▲
Portmeirion pottery seconds fill the open shelves of the dresser, and a long table to set them on is close by. Wrought-iron stairs spiral up to the bedroom and bath.

→

Well-valued objects line the top of a bookshelf in the upstairs study. The house at right is a model of this former stable-block home.

A portrait of the owner hangs over the stair-rail of the bedroom landing.

A model of a Chioggia fishing boat from Venice sails the roof trusses of the study.

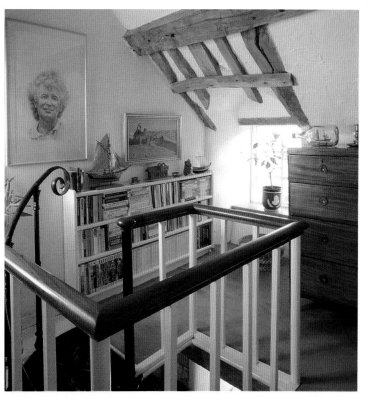

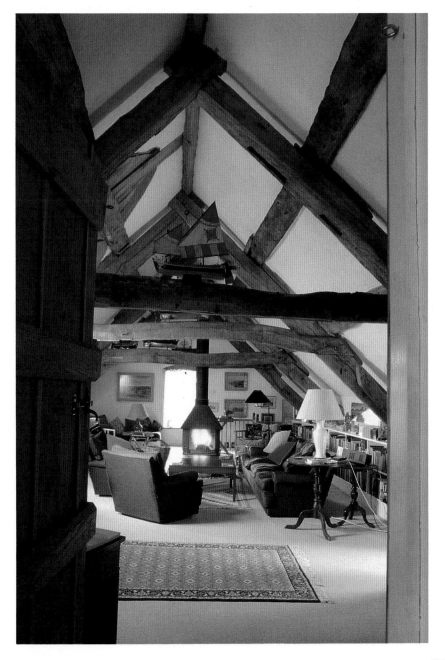

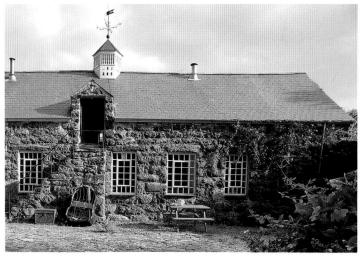

Enclosed by the building on one side, and by stone walls on the other, an inner courtyard is used as a patio. The exterior stairway is original to the building, and is a common feature of stables all over Wales.

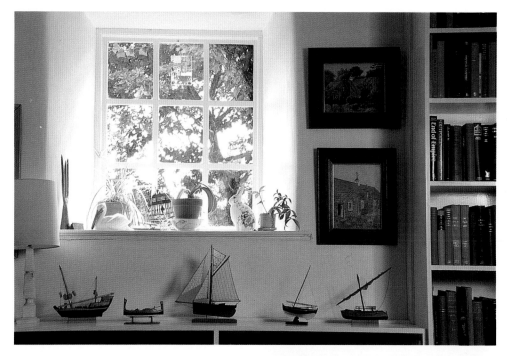

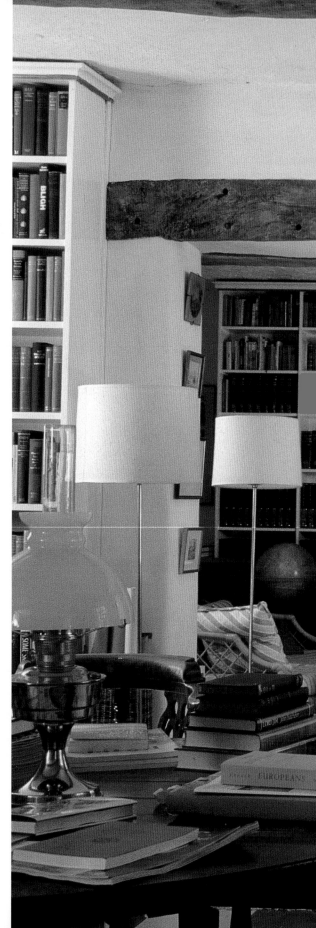

Model boats sail in a "regatta" beneath an upstairs window.

An old, hand-carved eisteddfod chair, awarded to a prizewinning bard, sits in a book-lined corner.

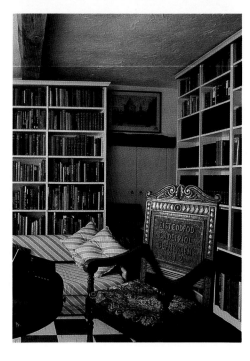

A vast library is a necessity for a rurally based, research-loving author.

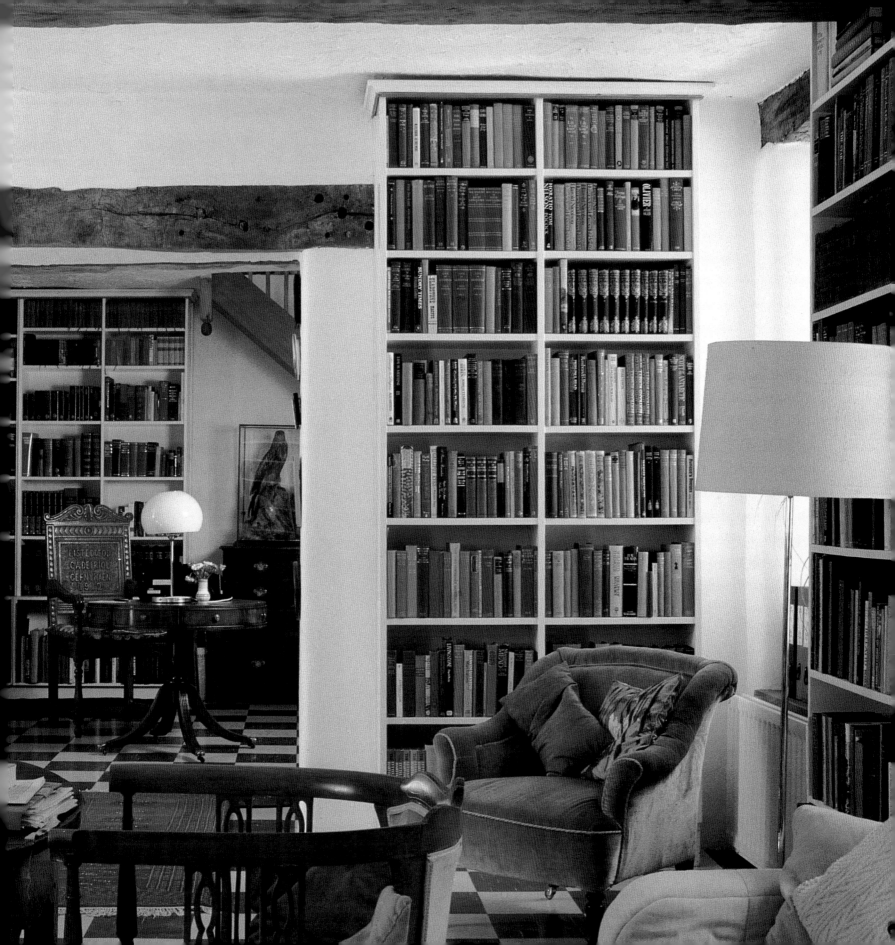

CARNACHENWEN

Jill Morgan and Greg Nuttgens own and operate Carnachenwen, a large and ancient working farm. Surrounded by thousands of sheep and acres of growing vegetables, the eighteenth-century longhouse has been extensively renovated. The interior is distinguished by the presence of an enormous *simdde fawr*—a huge walk-in sit-six-abreast hearth. The adjoining room, which is built of the same stone as the chimney, is the farm's original smokehouse.

The owners directed the renovation with high standards and a tight budget. Unable to afford the thick slate floors she longed for, Jill Morgan painted cast concrete to look like stone. After the old plaster was removed so that the stone walls could be repointed, sealed, and replastered, the cleaned stones looked so beautiful that they were left uncovered.

Rich in Celtic as well as in Christian history, the area around St. David's Cathedral where Carnachenwen is situated has spiritual as well as scenic attractions. Along the nearby roads leading to the coast and the cathedral city are Celtic crosses placed to direct pilgrims. In medieval times, two pilgrimages to St. David's were worth one to Rome. One theory about the circles that surround the local Celtic crosses is that they indicated the diameter of a loaf of bread. If a pilgrim carried bread as big as the ring, he had ample provision for the last stage of his journey.

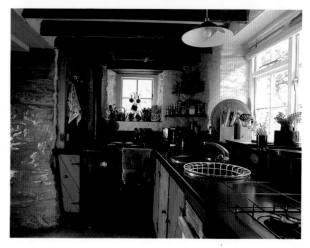

▲
Thick slabs of Welsh black slate make up the countertops and backsplash of this efficient kitchen.

▲▲
Built in the eighteenth century, by the mid-nineteenth century Carnachenwen was a Methodist stronghold, and services were conducted from a pulpit in the old kitchen. Looking at the exterior today, it is not hard to imagine the house in its former guises.

→
An unused doorway in the living room has been fitted with shelves for books. The wooden lintel at the top was exposed when the old plaster was removed.

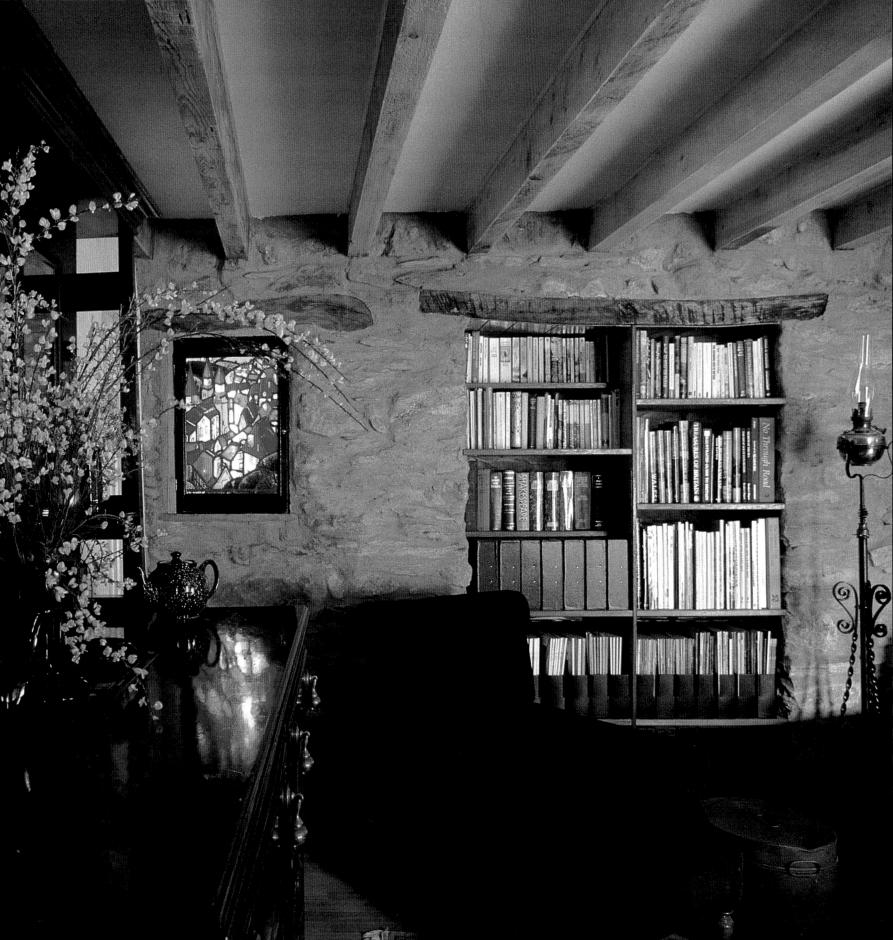

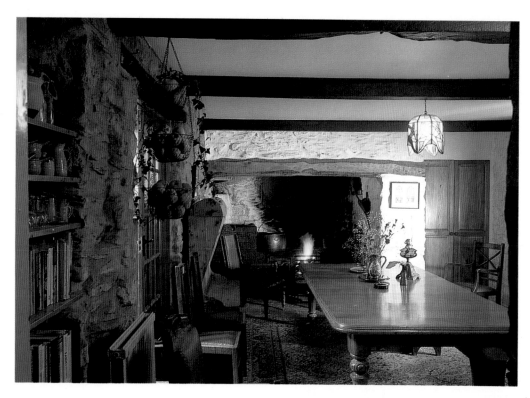

▲

The simdde fawr *makes up the end wall of the dining room; its stone walls are a good yard thick.*

In the living room, disparate soft seating is unified by matching black plush upholstery.

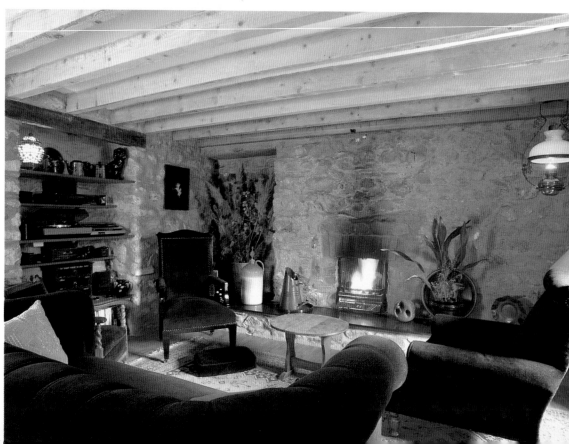

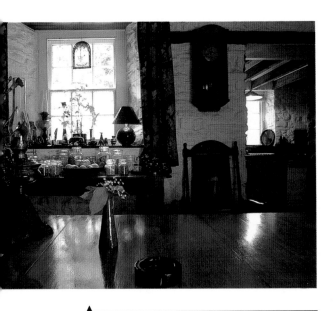

The entrance to the kitchen is visible at right. A table in front of the window holds a container collection.

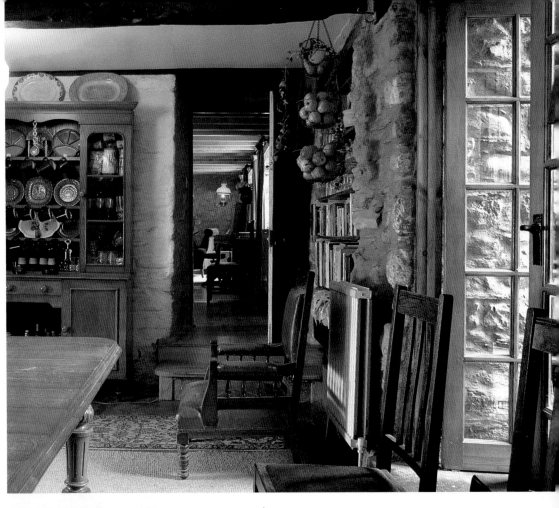

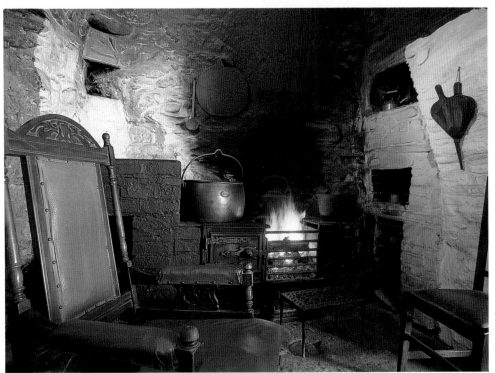

Looking down the length of the house, from dining room to living room, one can see why Welsh houses like this one are called "longhouses."

A smaller grate has been inset into the original chimney, which now burns logs rather than whole trees.

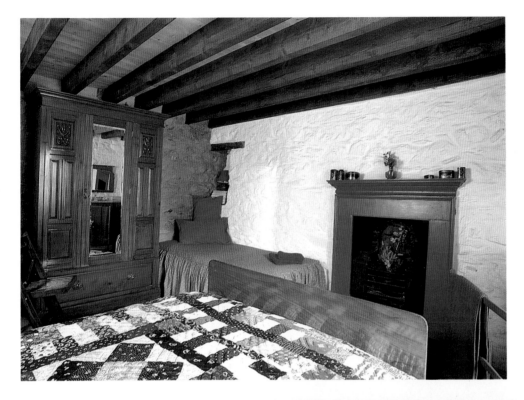

A Welsh-made patchwork quilt and a pink-painted mantelpiece contribute to the charm of this bedroom.

Wooden beams and a lighter pine ceiling provide a pleasant contrast to new plaster walls.

The walls of the upstairs corridor demonstrate how sturdily the house was constructed.

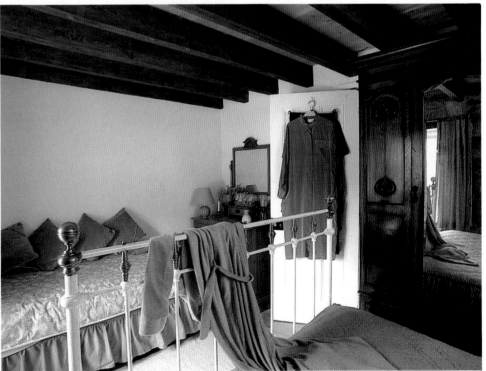

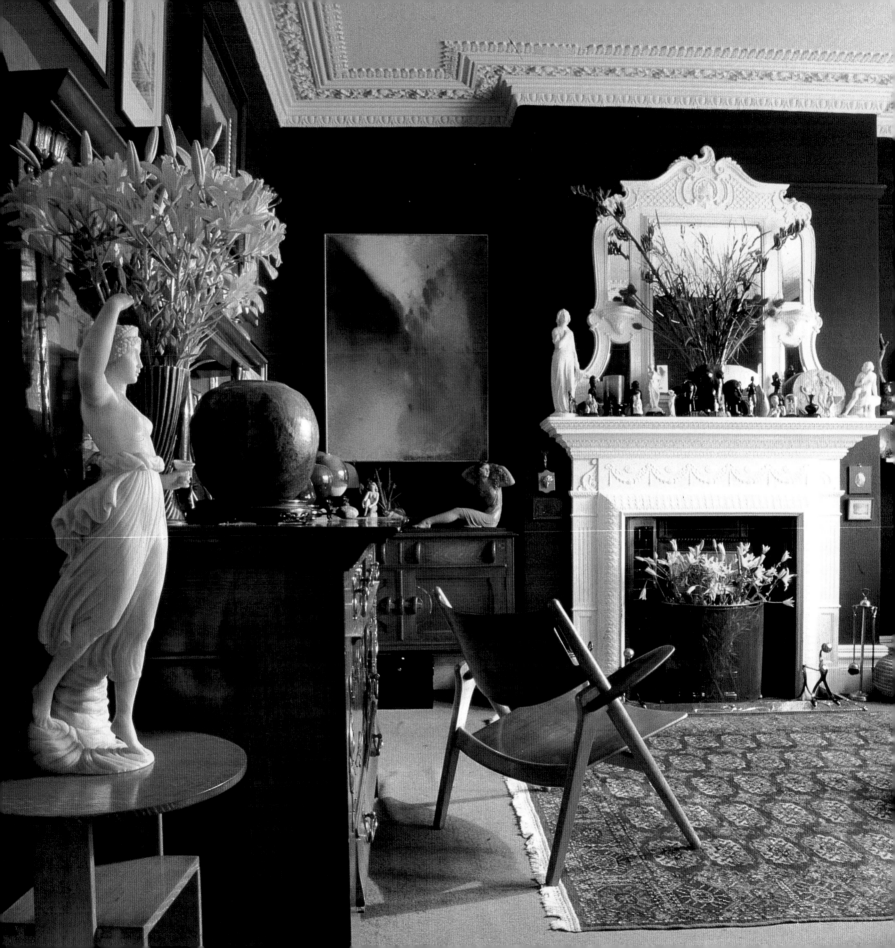

DESIGNER'S EYE

A well-proportioned Victorian terrace house in Cardiff has been transformed, inside and out, by the discerning eye and hand of a designer for Welsh-language television. Part of the owner's job is to research locations, and this involves travel all over Wales as well as trips to the rest of Britain and the Continent. A flea-market regular wherever he is, he combs stalls and tables to spot the treasures that he loves to collect.

Home to a marvelous and wide-ranging group of objects that have caught the owner's imagination and eye, all of the walls are painted in deep or intense colors, the better to set off the artworks. Although the collection is quite eclectic, ranging from "seminaked lady" sculptures to Japanese prints, art glass, ancient Chinese porcelain, and the best of British studio pottery, the dark walls, white-painted ceilings, and matching trim pull it all together.

The garden is another focus of attention and collecting. Although it started as a grassy suburban plot, it now has three ponds with fish and aquatic plants, areas with exotic bushes, a vegetable patch, and a greenhouse. Landscaped with the same attention to detail and form as the interior of the house, it is so private and quiet that one scarcely notices the major road nearby.

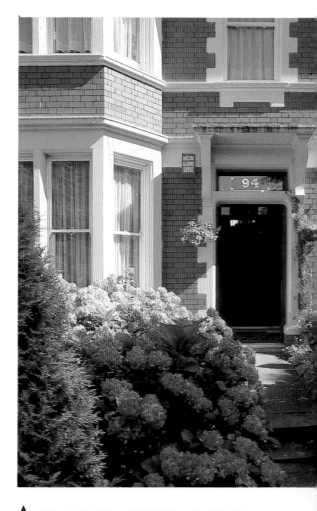

From the street, number 94 looks like any ordinary Victorian terrace house.

The street-facing front sitting room shows the many unexpected and felicitous juxtapositions of this house. Black walls edged with white trim set off an uninhibited mix of nearly naked ladies, abstract art, and furniture that ranges from British Victorian to Scandinavian modern.

Artful changes in texture add interest to this shady corner of the back garden.

A new conservatory, filled with comfortable wicker furniture, a Victorian birdcage, and a classical bust, marks the transition between the kitchen and garden.

Navy-blue walls set off an Oriental pottery collection, featuring a celadon bowl next to two Chinese figures.

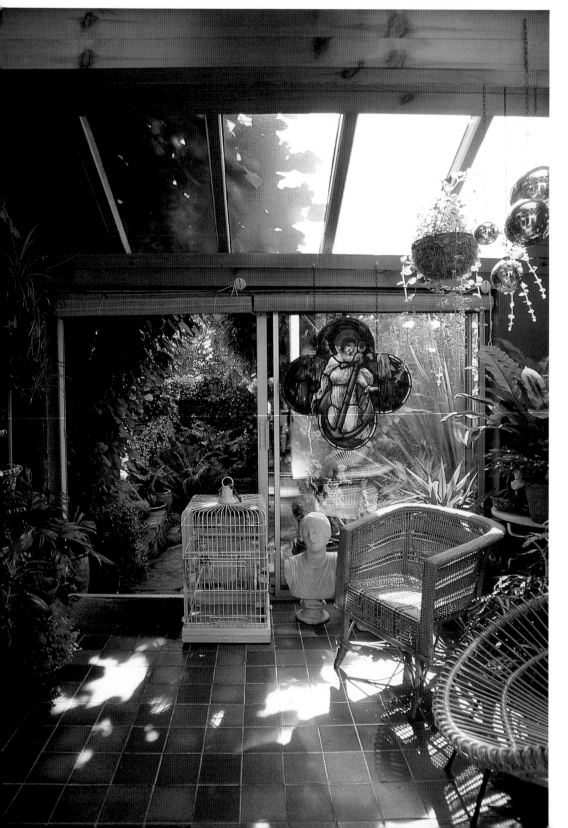

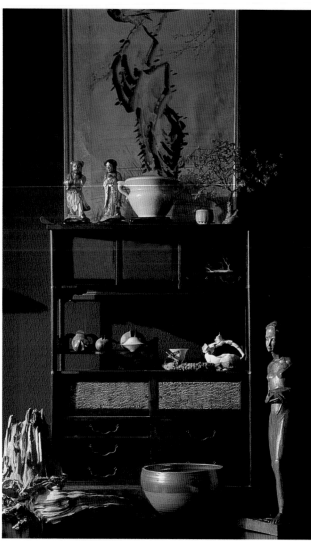

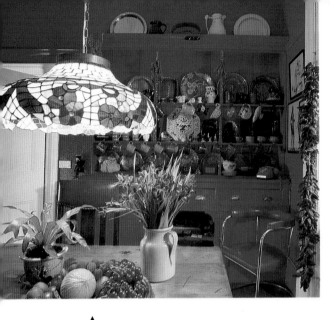

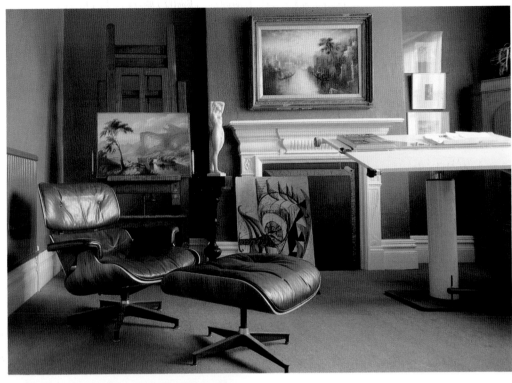

Red walls and fittings give visitors to this kitchen the feeling of being inside a Matisse painting. The door to the conservatory is at the right.

A classic Eames chair in the study echoes the voluptuous curves of the sculpture behind it. The painting is by J. M. W. Turner.

Objects surround the fireplace in the living room: the mirror and glass are art nouveau. Some of the pots are Oriental, and others are by English potter Bernard Leach.

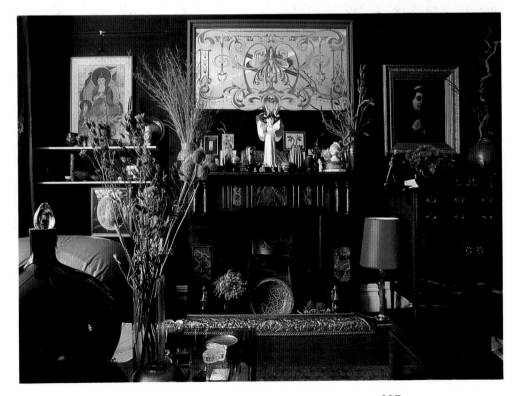

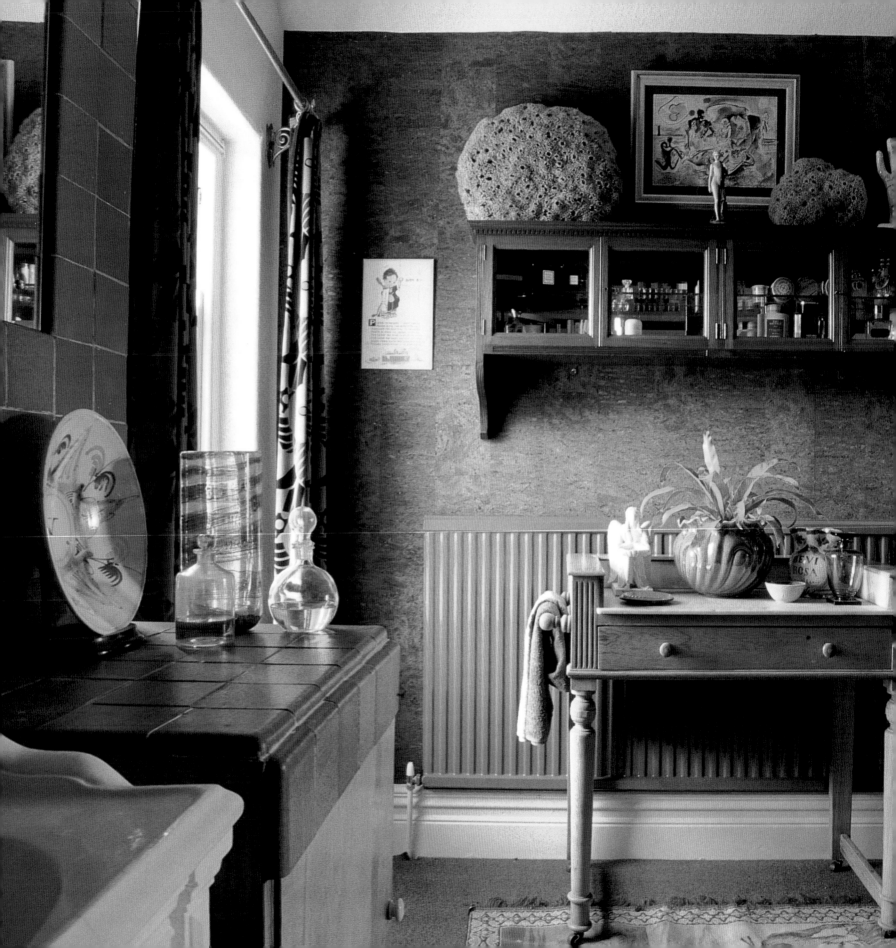

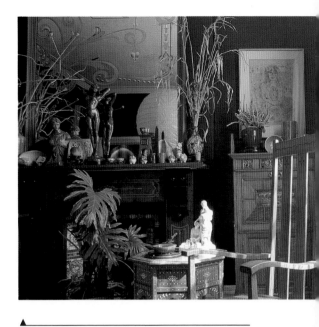

The bathroom, no less than anywhere else in this house, is a site for collections and surprises. The giant sponges were found in Greece, and the fortune-teller's hand is antique. Stained glass inset into the door provides privacy.

An Indian table inlaid with mother-of-pearl rests next to a William Morris chair. The mirror over the mantel is art nouveau.

The master bedroom headboard is a curved balustrade from an architectural salvage operation. The bed quilt is Welsh, and a Leach pot decorates the top of the Chinese chest at the foot of the bed.

A small, paved terrace is edged with a fern collection grown in containers.

A partially draped lady, more suited to an outdoor climate, can be caught in modest disarray in the garden.

The guest room's theme is Oriental, and the fan mounted over the red-painted Victorian headboard illustrates the point.

Charles Rennie Mackintosh designed
the cupboard, which the owner found
in the Cotswolds twenty years ago.
Above it hangs a collection of
Japanese woodblock prints.

One half of an old pub door has been
used to separate the utility closet
from the conservatory.

MANOR HOUSE ON ANGLESEY

Wide to the sun and narrow in depth, the manor house's facade is nearly symmetrical. A neighbor's cows provide a bucolic touch.

The island of Môn, or Anglesey, is called *"Môn on mam Cymru"* (the mother of Wales) because its soil is so flat and fertile. Contributing to Anglesey's productive reputation since the seventeenth century, Henblas, a working farm of two hundred and fifty acres, complete with a manor house, was bought in 1979 by Malcolm and Penny Innes. Their purchase marked the first time in four hundred years that Henblas had been sold to someone not of the original family.

In addition to the manor house and the many outbuildings of the farm, the property is also graced with a huge tithe barn, which was originally used for collecting and storing the portion of grain that served as rent from tenants.

Malcolm grew up on Anglesey, and had long admired Henblas. Beautifully proportioned, with a wide front to the sun and fertile fields (it was one room deep in its original form), the house at Henblas has been much added to over the years. The middle of the house now holds the main hall, with an unusual mezzanine-level sitting room halfway up the stairs. Many of the rooms still contain their original architectural features: built-in shutters fold back into window recesses in the living room, and parlors and bedrooms boast original carved-stone mantelpieces.

Behind the house lies a traditional English garden of herbs and flowers, bordered by a row of stones dividing it from the drive.

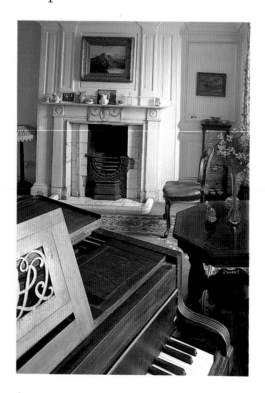

Sunlight and shadow cast the lines of the music room paneling into relief.

The main hall is dominated by a vast hearth that used to hold massive logs to warm the stone structure. Now a more efficient inset stove does the same job, and uses much less timber.

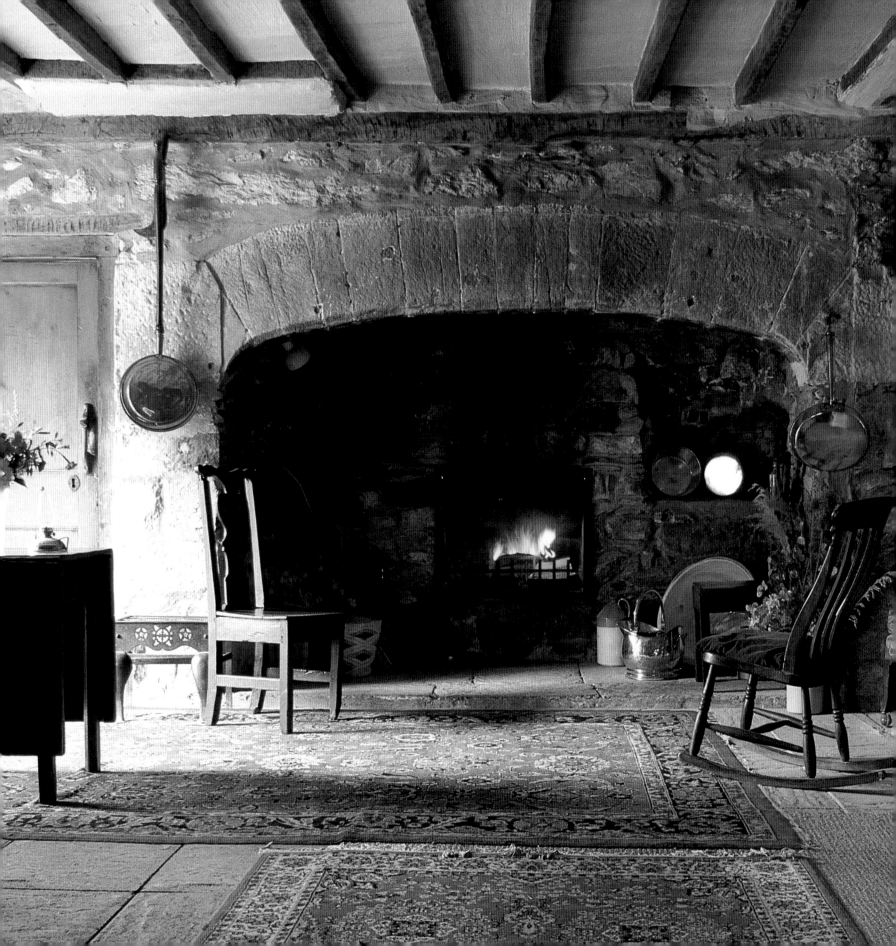

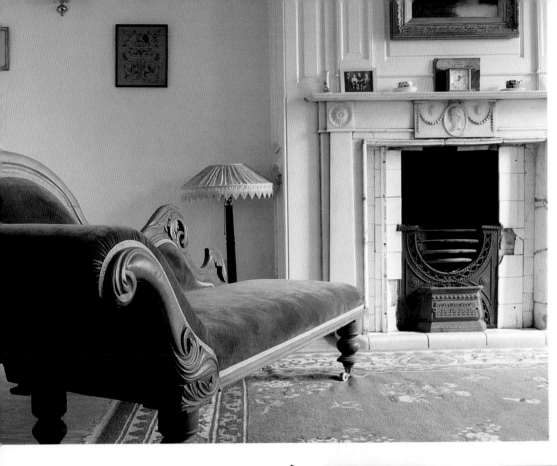

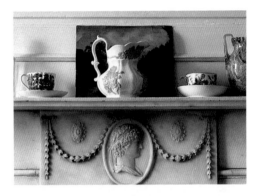

A Victorian fainting couch sits near the fire. The cast-iron grate is from the same period.

Neoclassical motifs distinguish this marble mantel.

Wooden interior shutters look like paneling when open, but can be pulled across the glass to insulate the room from the cold.

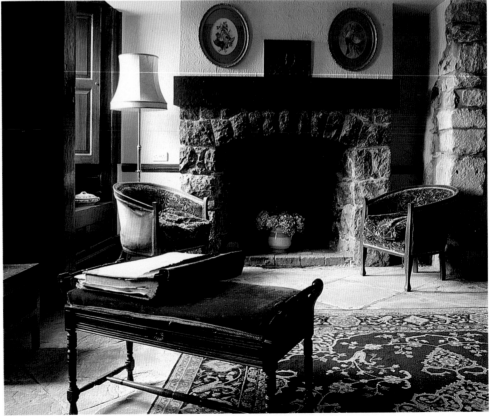

The hall is the crossroads of the house, and holds souvenirs of other passages in the world beyond.

Stairs from the main hall lead up to a half-landing, used as a family sitting room.

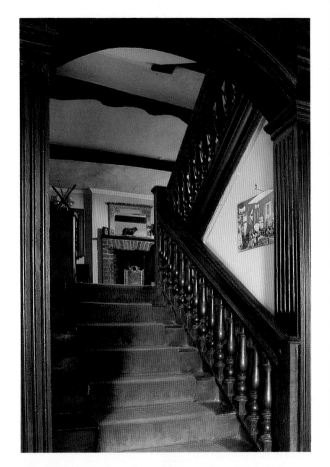

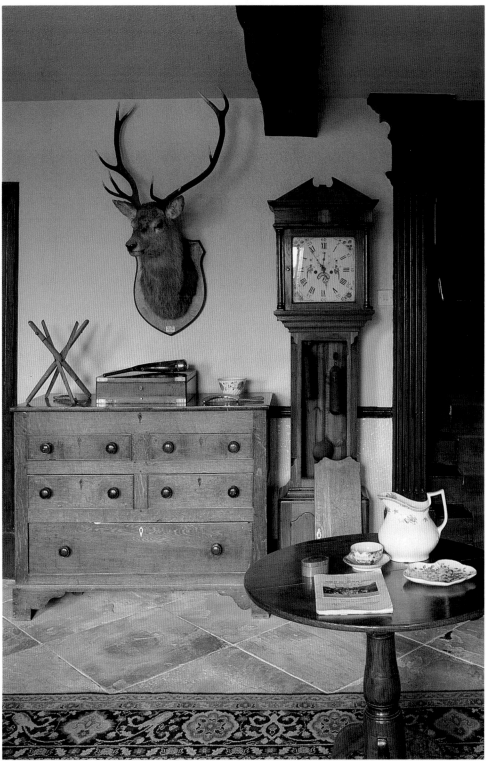

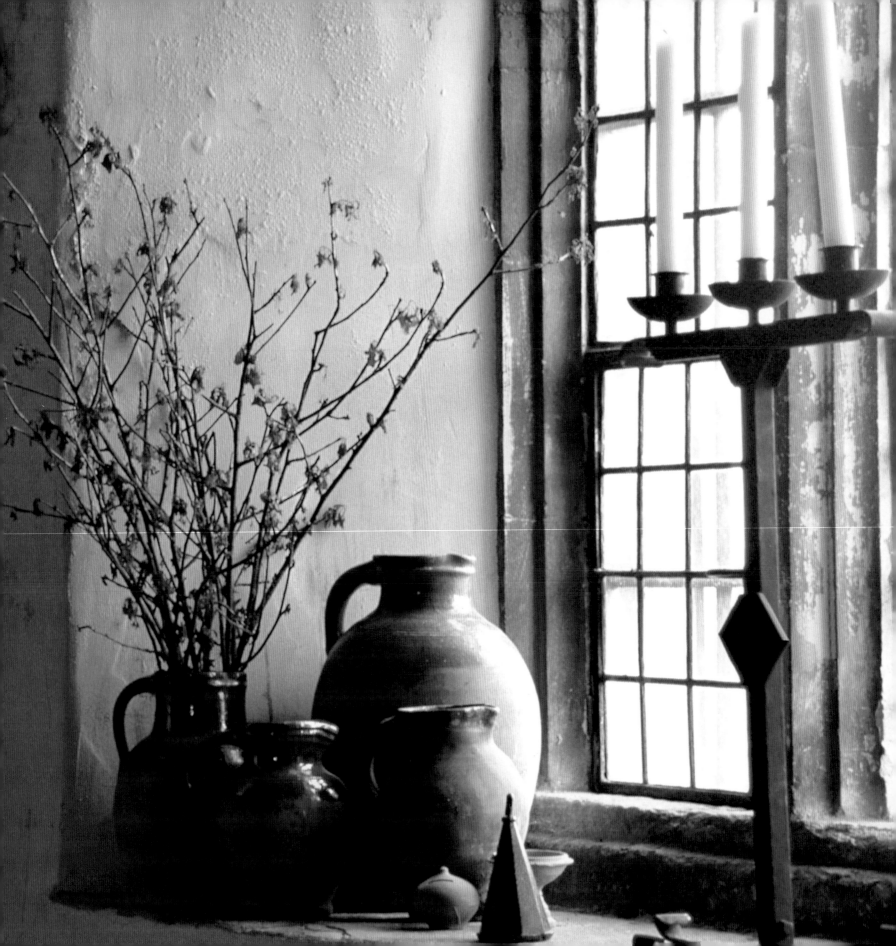

STORYBOOK CASTLE

Penhow Castle is a small, elegant version of the kind of castle children draw when they imagine medieval battles with charging knights. Pedimented, turreted, wrapped around a courtyard guarded by what might once have been a drawbridge, and protected by an awesome metal gate, this is a castle with grace as well as teeth.

Penhow, in the south of Wales on the border with England, was derelict when filmwriter and director Stephen Weeks bought it. Using the kind of imaginative empathy and sleight-of-hand he perfected by working in Hollywood, Weeks has created a series of stop-time tableaux in the public portions of the castle. These rooms feature "please-touch" displays presented in the context of solid historical information on tape (a user-controlled Walkman form invented by Weeks, now in use in other museums as well).

Penhow's private quarters reveal how charming and even intimate life in a small castle can be. Housed within one castle wing, Weeks's home is a cozy series of rooms for himself and for guests. Furnished with the same flair as the public portions, the private section also benefits from an American-influenced attention to comfort. Draft-free, centrally heated, and with ample and luxurious bathrooms, this part of the castle combines twentieth-century amenities with the appeal of the antique.

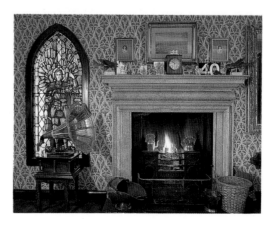

A roofless passage between the public and private wings of the castle shows how portions of it looked before the extensive restoration.

Candles illuminate the oldest portion of the castle. Leaded glass panes divide the windows into decorative segments, and remind us how precious glass was in earlier days.

In the private living room, an antique gramophone provides an atmospheric accent.

237

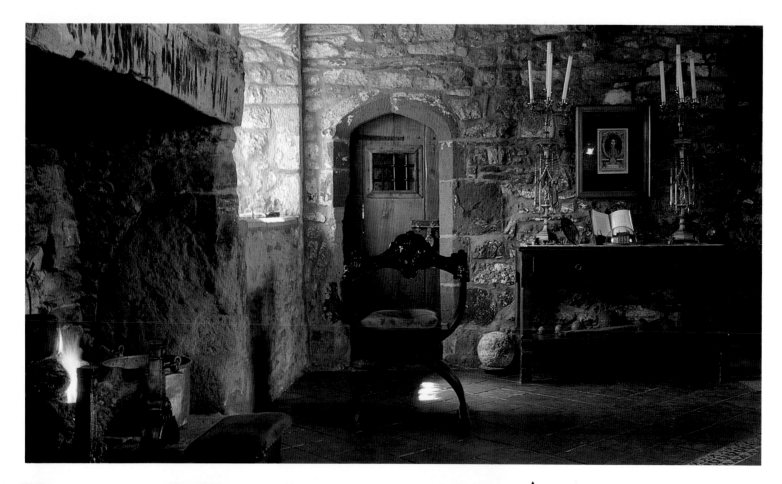

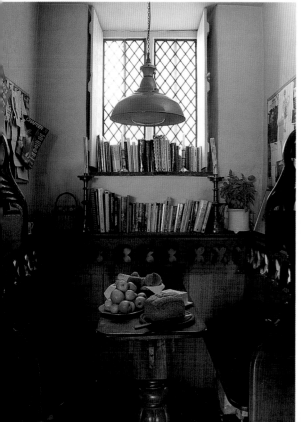

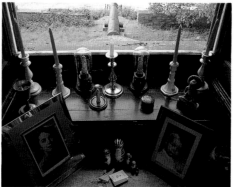

Sparse and portable furniture in the Great Hall conveys the rough-and-ready character of early castle life.

A candlestick collection on the windowsill frames a view of a rather more incendiary object.

Weeks's private kitchen features an American diner-style arrangement fitted up in antique form.

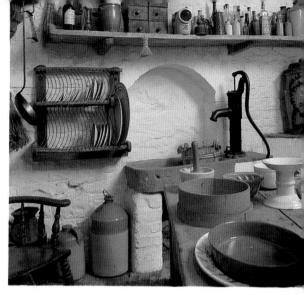

The pump has been let into a stone sink. A wooden wall-hung draining rack holds plates.

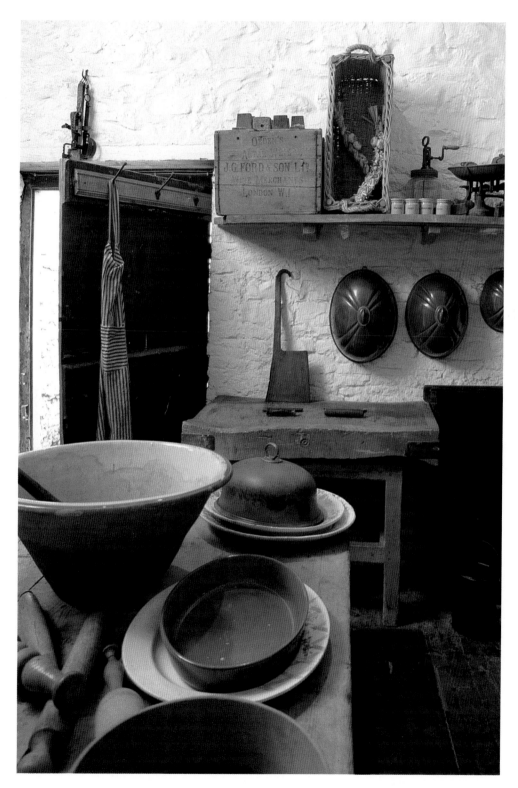

Antique cooking equipment creates a domestic landscape in the museum's primitive kitchen.

Careful stone cutting created the arch that frames this fireplace.

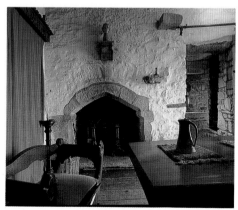

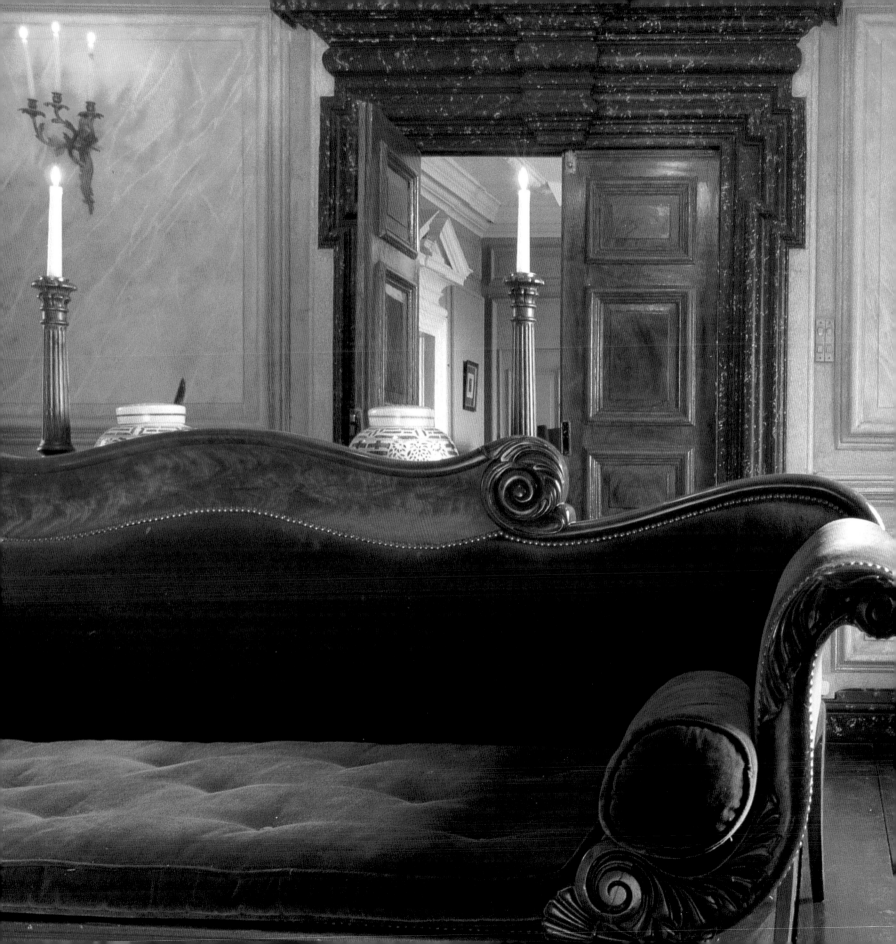

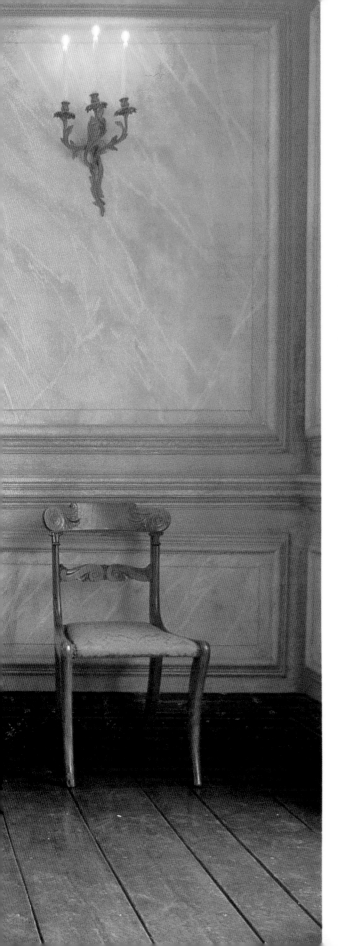

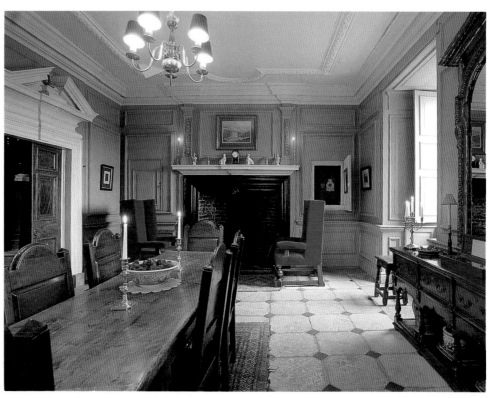

To visitors touring the castle, time advances visually through the chronologically arranged period rooms. Faux-marble paint work decorates the walls of this Victorian sitting room.

The grand eighteenth-century dining room doorway features an overscaled broken pediment.

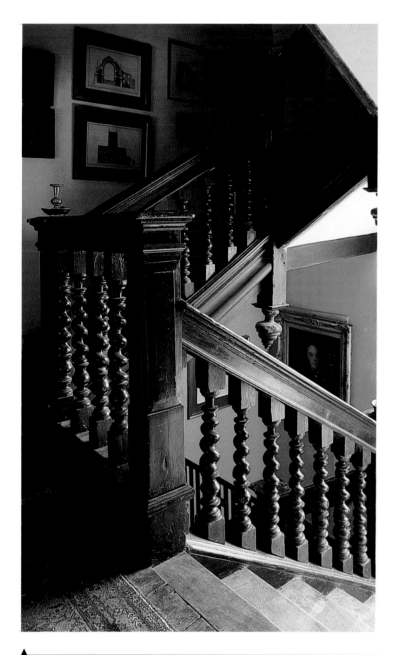

The stairway within the private wing features barley-twist uprights and an Oriental runner.

Simplicity of form and sure handling of disparate elements are a testament to Weeks's delight in creating decorative vignettes.

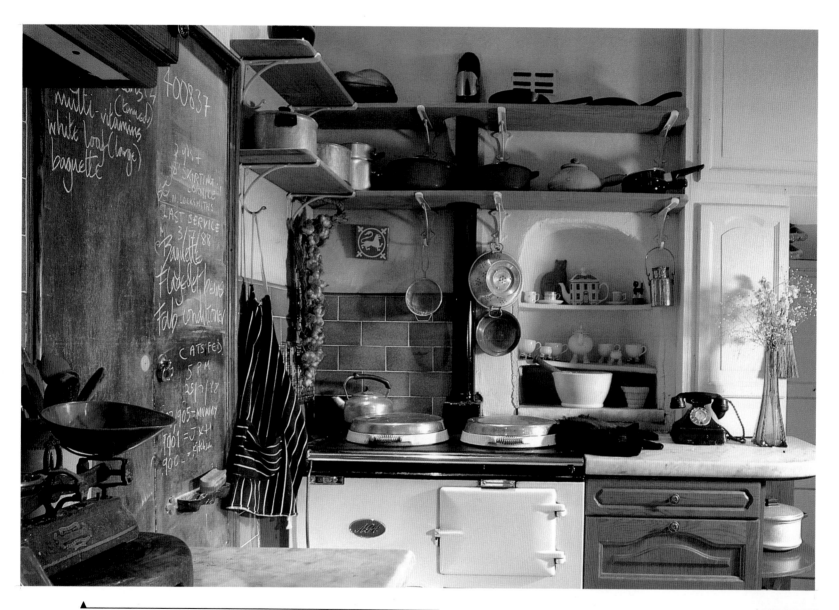

The private kitchen features a blackboard for messages and menus and a marble slab for hot pots or pastry.

The triangular ridge-tiles that edge the castle roof peak were designed to discourage pigeons from roosting.

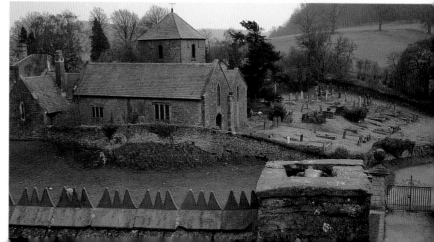

The stairway between the tower's inner and outer walls shows how the architecture was planned for protection. Small passages are easy to defend against invaders.

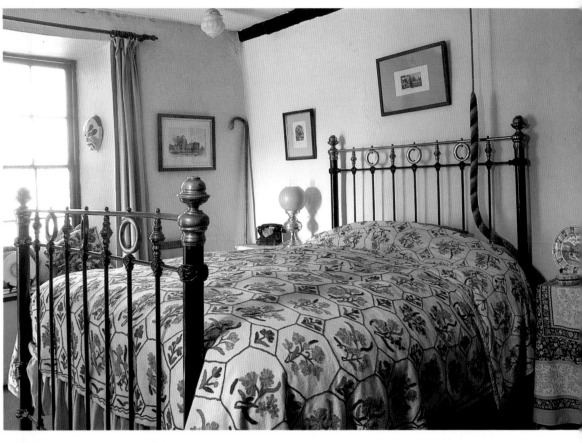

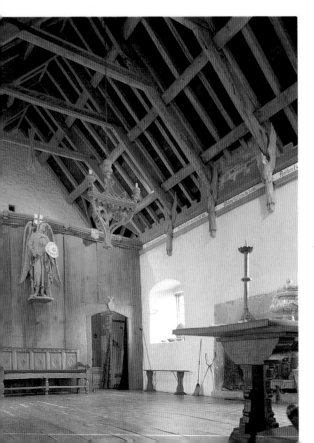

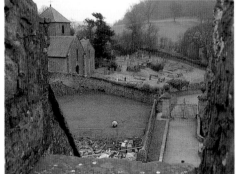

In the private portion of the castle, a brass-and-iron bed is placed beneath a bell pull used for calling servants.

Stone walls mark off castle, pasture, and churchyard, as seen through a small upper window. The thick walls afford protection and also support the unusual height of the structure.

The junction of wall and sky-high beams is marked by wooden angels, encouraging thoughts of ascent.

The topmost floor was the safest from surprise attack, and thus holds the family bedroom. The doorway at rear is the entrance to the steep stairs that lead down from the tower.

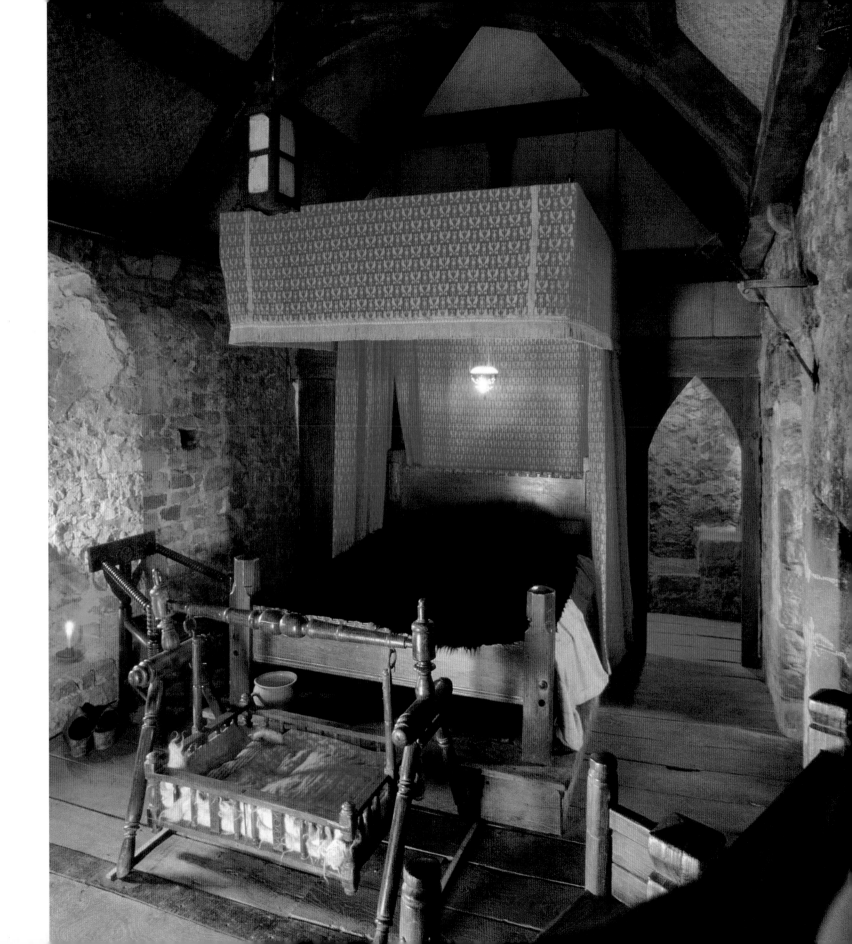

SOURCES

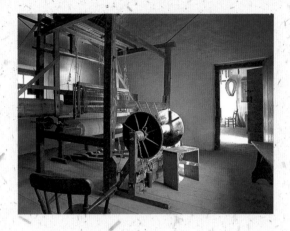

The initials *MO* following an entry indicates the existence of a mail-order department that accepts orders from the U.S. The initial *T* means that the establishment sells to the trade only. All other stores (unless otherwise identified) are retail stores that sell to the general public.

ENGLAND

THE ANTIQUE TEXTILE CO.
100 Portland Road
London W11
Paisleys and other antique textiles.

LAURA ASHLEY
(Office Headquarters, UK)
Braywick House
Braywick Road
Maidenhead, Berkshire

(Mail-order Department)
Box 19
Newtown Powys S16 4LG
Wales
New and reproduction textiles.

THE GREEN ROOM
2 Church Street
Framlinsham
Woodbridge
Suffolk
Paisleys and other antique textiles.

LIBERTY AND CO. LTD. *(MO)*
Regent Street
London WIR 6AH
New and reproduction textiles.

LIMERICKS *(MO)*
Limerick House
117 Victoria Avenue
Southend-on-Sea
Essex SS2 6EL
Irish linen for sheets; wool blankets.

LUNN ANTIQUES
86 New King's Road
Parsons Green
London SW6
Lace and other antiques.

THE PINE MINE
100 Wandsworth Bridge Road
London SW6
Antique pine furniture.

STOW AWAY
2 Langton Hill
Horncastle
Lincolnshire LN9 5AH
Antique pine furniture.

SCOTLAND

THE ADAM POTTERY
76 Henderson Row
Edinburgh EH3 5BJ

ALDRIC YOUNG ANTIQUES
49 Thistle Street
Edinburgh
Seventeenth-, eighteenth-, and nineteenth-century paintings, plus other decorative-arts items.

ANTIQUES AND THINGS
44 Feus
Auchterarder
Pottery and "smalls."

THE ANTIQUES SHOP
Wardend House
Kibbleston Road
Kilbarchan
Furniture and decorative accessories.

THE BARBIZON ART GALLERY
40 High Street, College Lands
Glasgow
Fine Arts.

WALTER BEATON
75 Kinnoull Street
Perth
Pre-1830s British furniture.

MARGERY CLINTON
The Pottery
Newton Port
Haddington
East Lothian EH41 3NA
Ceramic tiles; reproductions of C. R. Mackintosh designs.

COACH HOUSE ANTIQUES
7 Atholl Street
Perth
Antique furniture.

PAUL COUTS LTD.
8–10 The High Street
Musselburgh
Fine furniture.

A. F. DRYSDALE LTD.
35 North West Circus Place
Edinburgh
Reproductions; fabric; wallpaper.

THE FINE ARTS SOCIETY
12 Great King Street
Edinburgh
Nineteenth- and twentieth-century paintings, Regency and Mackintosh furniture; also a branch in Glasgow.

GEORGE AND HELEN GARDINER
Antiques and Decorative Objects
105 West Regent Street
Glasgow G2 2BA

HAND IN HAND
3 North West Circus Place
Edinburgh EH3 6ST
Antique furniture.

MALCOLM INNES GALLERY
67 George Street
Edinburgh
Fine art.

KENNETH JACKSON ANTIQUES
66 Thistle Street
Edinburgh
Eighteenth-century antiques and decorative objects.

MARJORIE MacDOUGALL
10 The Cross
Kilbarchan
Textiles and lace.

MAGPIE ANTIQUES
487 Great Western Road
Glasgow G12 8HL
Antique furniture.

EWAN MUNDY FINE ART
48 West George Street
Glasgow
Nineteenth- and twentieth-century art, including Glasgow School and art nouveau.

THE OLD CURIOSITY SHOP
Templeton Mill
Mill Street
Ayr KA8 8AG
Antique furniture.

SUSAN PROCTER
47–51 Feus
Auchterarder
Oversized antiques and garden furniture.

ANNICA SANDSTROM AND DAVID KAPLAN
Lindean Mill Glass
Galashiels
Selkirkshire TD1 3PE
Handblown glass.

ST. ANDREWS WOOLEN MILL (MO)
The Golf Links
St. Andrews
Fife KY16 9BR
Woolen goods and blankets.

THRIE ESTAITS
49 Dundas Street
Edinburgh EH3 6RS
Antique furniture.

UNICORN ANTIQUES
65 Dundas Street
Edinburgh EH3 6RS
Antique furniture.

WHYTOCK AND REID
Sunbury House, Belford
Mews
Edinburgh
Antique furniture.

There are outposts of Liberty's at 47
George Street, Edinburgh, and at
105 Buchanan Street, Glasgow; of
Laura Ashley at 126 Princes Street,
Edinburgh, 137 George Street,
Edinburgh, and at 215 Sacuchiehall
Street, Glasgow; and of Habitat at 32
Shandwick Place, Edinburgh, 140–
160 Bothwell Street, Glasgow, and
381–383 Union Street, Aberdeen.

THE REPUBLIC OF IRELAND ·EIRE·

ANTHONY ANTIQUES
7–9 Molesworth Street
Dublin 2
Antique furniture.

ARDSALLACH FURNITURE REPRODUCTION
Corrie Cottage
Ardsallagh
Navan, Co. Meath
Reproduction and original furniture.

AVOCA HANDWEAVERS (MO)
Ballinacor House
Church Road
Ballybrack, Co. Dublin
Woolen goods: blankets, handknits, and handwovens.

Avoca Handweavers retail shops
are also located in Avoca, Co.
Wicklow; Kilmacanogue, Bray,
Co. Wicklow; and Bunratty, Co.
Clare.

THE BALLYMALOE SHOP (MO)
Ballymaloe House
Shanagarry, Co. Cork
Woolen goods: blankets, handknits, and handwovens; also carries some pottery and glass.

CENTURY DESIGN IMPORTS
Corrie Cottage
Raheen, Loughrea
Co. Galway
Reproduction and original furniture.

CLEO LTD.
18 Kildare Street
Dublin 2
Handknits, Avoca blankets and spreads, clothing, knitted toys.

CLIFFORD ANTIQUES
5 Parnell Street
Dublin 1
Antique furniture.

CONNEMARA HANDCRAFTS
Letterfrack
Co. Galway
Woolen goods: blankets, handknits, and handwovens.

COOKE ANTIQUES AND RESTORATION
79 Francis Street
Dublin 8
Antique and restored furniture.

COUNTRY PINE ANTIQUES
Glyn Ewing Evans
Sky Cottage
Moneyvolihane, Skibbereen
Co. Cork

CRAFTS COUNCIL OF IRELAND
Powerscourt Townhouse
Center
South William Street
Dublin 2

DEDANAAN ANTIQUES
Teeling Street
Balina, Co. Mayo
Antique furniture.

FOSTER FURNITURE LTD.
Corrie Cottage
Industrial Estate
Navan, Co. Meath
Reproduction and original furniture.

GEOFFREY HEALY POTTERY
9 Duncairn Lane
Bray, Co. Wicklow

HIBERNIAN ANTIQUES
1 Molesworth Street
Dublin 2
Antique furniture.

HICKS OF DUBLIN LTD.
Bow Lane West
Dublin 8
Reproduction and original furniture.

D. HIGGINBOTHAM LTD.
Coolock Industrial Estate
Greencastle Parade
Dublin 5
*Reproduction and original
furniture.*

JERPOINT GLASS
Stoneyford, Co. Kilkenny
Handblown glass for the table.

KATHLEEN'S *(MO)*
The Diamond
Donegal Town
Co. Donegal
*Woolen goods: blankets, handknits,
and handwovens.*

KILDARE ANTIQUES
19 Kildare Street
Dublin 2
Antique furniture.

LUCKPENNY ANTIQUES
Kilmurray House
Shinrone
Birr, Co. Offaly
Antique furniture.

LIDA MAY
Ballydehob
Co. Cork
Blue-and-white decorated pottery.

R. McDONNELL LTD.
16 Kildare Street
Dublin 2
Antique furniture.

MIKE McGLYNN ANTIQUES
Bunratty, Co. Clare
*Antiques; crates and ships to the
USA.*

EAMON McNALLY
Turoe Restorers
Lochrea, Co. Galway
*Fine country furniture; crates and
ships to the USA.*

**MILLARS CONNEMARA
TWEEDS**
Main Street
Clifden, Co. Galway
*Woolen goods: blankets, handknits,
and handwovens.*

**NICHOLAS MOSSE POTTERY
SHOP**
Bennettsbridge, Co. Kilkenny
Reproductions of Irish spongeware.

NATURAL PINE ANTIQUES
101 Frabcus Street
Dublin 8
Antique furniture.

**ERIC PEARCE FINE FURNI-
TURE LTD.**
Flaxfort Barn
Kilbrittain
Brandon, Co. Cork
*Fine furniture designs and custom-
made orders.*

STEPHEN PEARCE
Shanagarry
Co. Cork
*White-glazed terra-cotta dinner-
and cookware.*

PINNACLE
44 MackCurtain Street
Cork
Antique furniture.

ROUGH DEAL
23 Essex Street
Dublin 2
Antique furniture.

**ROXANNE MOOREHEAD
ANTIQUES**
2 Salthill Place
Dun Laoghaire, Co. Dublin
Antique furniture.

SASKIA ANTIQUES
43 William Street South
Dublin 2
Antique furniture.

STONEWARE JACKSON
Bennettsbridge, Co. Kilkenny
Decorated dinnerware and lamps.

TAPESTRIES IRELAND LTD.
Weavers Mill
Drogheda, Co. Louth
*Woolen goods: blankets, handknits,
and handwovens.*

NORTHERN IRELAND

GERARD BOND
375 Sea Coast Road
Limavady, Co. Londonderry
Corn dollies (a traditional craft).

DESIGN WORKSHOP
162 Portaferry Road
Mount Stewart
Newtownards, Co. Down
Traditional Irish patchwork.

FERMANAGH COTTAGE INDUSTRIES
14 East Bridge Street
Enniskillen, Co. Fermanagh
Crocheted and hand-embroidered table linens.

ORIENTAL CRAFT AND FASHIONS
1 Derrytrasna Park
Derrytrasna
Lurgan, Co. Armagh
Manufacturers of crocheted tableware.

W. G. PATTERSON AND SONS
Spade Factory
751 Antrim Road
Templepatrick, Co. Antrim
Handmade spades and turf shovels.

WALES

CILLACRAFT
111 Springvale Industrial Estate
Cwmbran, Gwent
Traditional hardwood carved love spoons.

GALLERY ON THE HILL
Pant Farm
Halfway
Llandovery
Dyfed
SA20 OSF
Leatherwork art, local crafts.

THE HAY GALLERIES LTD.
4 High Town
Hay-on-Wye
Powys
Reproduction furniture.

LLYSWEN POTTERY
The Pottery
Llyswen, Brecon, Powys
Traditional slip-decorated pottery.

BERNARD THOMAS
Springbanks
Llechryd
Dyfed
Mr. Thomas is the last traditional builder of coracles (traditional one-person boats) in all of Wales.

UNITED STATES

LAURA ASHLEY (*MO*)
714 Madison Avenue
New York, NY 10021
(212) 371-0099
Fabrics; wallcoverings.
For locations of other branches across the U.S., call (800) 367-2000.

DON BADERTSCHER IMPORTS
716 North La Cienega Blvd.
Los Angeles, CA 90069
(213) 653-8581
Imported furniture.

BALASSES HOUSE ANTIQUES
Main Street
Amagansett, NY 11930
(516) 267-3032
Antique pine and country furniture.

MIKE BELL ANTIQUE SHOW-ROOMS
60 East 10 Street
New York, NY 10003
(212) 598-4677
and
12110 Merchandise Mart
Chicago, IL 60654
(312) 661-7099
Antique pine and country furniture.

BRITISH COUNTRY ANTIQUES
51 Main Street North
Woodbury, CT 06798
(203) 262-5100
British pine furniture.

P. J. CARROLL AND CO. LTD.
(MO)
2515 East 43 Street
Chattanooga, TN 37422
1-800-255-3933
The Carroll Journal *is a catalog of housewares, furniture, garden furniture, and decorative objects that are mostly made in Ireland.*

CENTURY DESIGN LTD. *(T)*
2224 Cypress Cove Drive
Tavares, FL 32778
(904) 343-9343
Reproduction Irish furniture.

CHERCHEZ
864 Lexington Avenue
New York, NY 10021
(212) 737-8215
Fabrics; wallcoverings.

E. A. CLORE AND SONS *(MO)*
P.O. Box 765
Madison, VA 22727
(703) 948-5821
Handmade American reproduction furniture, some of which looks traditionally Celtic.

CONRAN'S HABITAT *(MO)*
475 Oberlin Avenue South
Lakewood, NJ 08701-1053
(201) 905-8810
New and reproduction furniture. Call for locations of other branches across the U.S.

ENGLISH HERITAGE
8424 Melrose Place
Los Angeles, CA 90069
(213) 655-5946
Antique pine and country furniture.

KNOCK ON WOOD, INC.
1078-R Post Road
Darien, CT 06820
(203) 655-9031
Antiques and reproductions.

LIBERTY OF LONDON
229 East 60 Street
New York, NY 10022
(212) 888-1057
Fabrics, wallcoverings.

Branches located in Chicago, Dallas, and Ardmore, PA.

MILL HOUSE ANTIQUES
Route 6
Woodbury, CT 06798
(203) 263-3446
Welsh, Irish, English, and French antiques.

OLD IRISH PINE
P.O. Box 2783
Sag Harbor, NY 11963
(516) 725-5848

EDGAR NEOGY-TEZAK *(T)*
37 Bridge Street
Brooklyn, NY 11201
(718) 625-3463
Reproduction Irish furniture.

PLEASANT ANTIQUES AND INTERIORS
Box 559 Montauk Highway
Wainscott, NY 11975
(516) 537-3894
Exclusively Irish antiques.

PRINCE OF WALES
1032 Post Road East
Westport, CT 06880
(203) 454-2335
Welsh country furniture.

SCOTTISH PRODUCTS SHOP
133 East 55 Street
New York, NY 10022
(212) 755-9656
Antiques, china, fabric, records, and gifts.

YELLOW MONKEY ANTIQUES
Route 35
Cross River, NY 10518
(914) 763-5848
Antique pine and country furniture.

SCOTTISH IMPORTS

COUNTRY CASUALS
1105 Third Avenue
Spring Lake, NJ 07762
(201) 449-2494

WELSH IMPORTS

THE HARP AND DRAGON
25 Madison Street
Cortland, NY 13045
(607) 756-7372
Welsh books, gifts, and music.

DAVID MORGAN *(MO)*
P.O. Box 70190
Seattle, WA 98107
(206) 282-3300

TREASURES OF THE KINGDOM/THE WELSH DRAGON
211 Main Street
Annapolis, MD 21401
(301) 267-8491
Welsh and British imports.

IRISH IMPORTS

ALFRANK
BAKER, KNAPP & TUBBS, INC. *(T)*
200 Lexington Avenue
New York, NY 10016
(212) 779-8810
Neo-classical metal furniture by Dublin architects Alfred Cochrane and Frank Carroll.

CAROL BROWN IRISH TWEEDS
Caravoca
Putney, VT 05346
(802) 387-5875
Avoca Handweavers, Liberty, knits from Cleo.

DONEGAL CARPETS, LTD. *(T)*
P.O. Box 417
Chester, NJ 07930
(201) 879-6633
Hand-knotted and handwoven carpets and custom work.

McNUTT WEAVERS *(T)*
McNutt Fabrics America
1359 Broadway
New York, NY 10018
(212) 967-6208
Furnishing fabrics; hand- and machine-woven wool upholstery fabrics.

MACROOM CARPETS, LTD. *(T)*
Distributed by Arama Enterprises, Inc.
919 Third Avenue
New York, NY 10022
(212) 750-8727

MUNSTER CARPETS LTD. *(T)*
Distributed by Concepts International
c/o Budd Looms
306 East 55 Street
New York, NY 10021
(212) 758-4460
Woven velvet Wilton carpeting.

NAVAN CARPETS USA *(T)*
919 Third Avenue
New York, NY 10022
(212) 832-6900
Axminster carpeting.

SIMON PEARCE
The Mill
Quechee, VT 05059
(802) 295-2711
39 Main Street
Freeport, ME 04032
(207) 865-0464
385 Bleecker Street
New York, NY 10014
(212) 924-1142
Glassware, pottery, Irish antique furniture.

TINTAWN CARPETS, INC. *(T)*
964 Third Avenue
New York, NY 10022
(212) 355-5030
Carpeting and area rugs.

BIBLIOGRAPHY

Alexander, Christopher. *The Timeless Way of Building*. Oxford University Press, 1979.

Blake, Liam and Jackson, John A. *Irish Cottages*. Bray, Co. Wicklow, Ireland: Real Ireland Design, Ltd., 1985.

de Breffny, Brian, and ffolliott, Rosemary. *The Houses of Ireland*. New York: Thames and Hudson, 1984.

Curtis, Tony, ed. *Wales the Imagined Nation: Essays in Cultural and National Identity*. Bridgend, Mid Glamorgan: Poetry Wales Press, 1986.

Danaher, Kevin. *The Hearth and Stool and All*. Cork and Dublin: Mercier Press, 1985.

———. *Folktales of the Irish Countryside*. Cork and Dublin: Mercier Press, 1988.

Fenton, Alexander. *Country Life in Scotland*. Edinburgh: John Donald Publishers Ltd., 1987.

Glassie, Henry. *Passing the Time in Ballymenone*. Philadelphia: University of Pennsylvania Press, 1982.

Guinness, Desmond, and Ryan, William. *Irish Houses and Castles*. New York: Crescent Books/Thames and Hudson, 1971.

Hartley, Dorothy. *Lost Country Life*. New York: Pantheon, 1979.

Jenner, Michael. *Scotland Through the Ages*. Salem, N.H.: Michael Joseph Ltd., 1987.

Kee, Robert. *Ireland, A History*. Dublin: Abacus Edition, Sphere Books, 1982.

McEwen, John. *Who Owns Scotland*. Edinburgh: Polygon Books, 1981.

McPhee, John. *The Crofter and the Laird*. New York: Farrar, Straus and Giroux, 1986.

Morris, Jan. *Scotland, The Place of Visions*. New York: Clarkson Potter, 1986.

———. *The Matter of Wales, Epic Views of a Small Country*. New York: Oxford University Press, 1986.

———. *Wales*. New York: Oxford University Press, 1982.

Naismith, Robert J. *Buildings of the Scottish Countryside*. North Pomfret, Vt.: Victor Gollancz Ltd., 1985.

Prebble, John. *The Highland Clearances*. New York: Penguin Books, 1969.

———. *The Lion in the North*. New York: Penguin Books, 1971.

Shenker, Israel. *In the Footsteps of Johnson and Boswell*. New York: Oxford University Press, 1982.

Thomas, David, and Morgan, Prys. *Wales, The Shaping of a Nation*. North Pomfret, Vt.: David and Charles, 1984.

Williams, Raymond. *The Country and The City*. New York: Oxford University Press, 1975.

———. *Culture and Society*. New York: Oxford University Press, 1983.

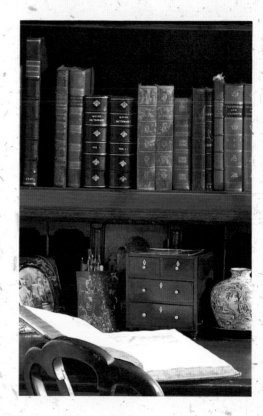